Time to *Travel* in Time

to Germany's finest
stately homes,
gardens,
castles,
abbeys and
Roman remains

Time to Travel *in Time*

to Germany's finest
stately homes,
gardens,
castles,
abbeys and
Roman remains

Official joint guide of the heritage administrations

Baden-Württemberg
Bavaria
Berlin-Brandenburg
Dessau-Wörlitz
Hesse
Rhineland-Palatinate
Saxony
Saxony-Anhalt
Thuringia

SCHNELL + STEINER

Die Deutsche Bibliothek - Cataloguing in Publication Data:

**Time to travel - travel in time to Germany's finest stately homes,
gardens, castles, abbeys and Roman remains :** official joint guide
of the heritage administrations Baden-Württemberg, Bavaria, Berlin-Brandenburg,
Dessau-Wörlitz, Hesse, Rhineland-Palatinate, Saxony, Saxony-Anhalt, Thuringia /
[Engl. transl. by Katherine Vanovitch]. - 2., updated and enl. ed.. - Regensburg :
Schnell und Steiner, 2001
 Dt. Ausg. u.d.T.: Reisezeit, Zeitreise zu den schönsten Schlössern, Burgen, Gärten,
 Klöstern und Römerbauten in Deutschland
 ISBN 3-7954-1411-3

English translation by Katherine Vanovitch
(The chapter on Saxony is abridged from a brochure
translated by Interpress Verlag Hamburg.)
Additional translation by „Übersetzungs- und Dolmetscherbüro
Freiherr Karl von Teuffenbach", Regensburg

2nd edition 2001
© 1999 by Verlag Schnell & Steiner GmbH,
Leibnizstrasse 13, D-93055 Regensburg

German text compiled by:
Erdmute Alex (Dessau-Wörlitz)
Barbara Spindler (Berlin-Brandenburg)
Thomas Wöhler (Bavaria)
Communication Unit

Cover design: Astrid Moosburger
Typography, plates: Visuelle Medientechnik GmbH, Regensburg
Printed by Aumüller Druck KG, Regensburg
ISBN 3-7954-1411-3

Printed in Germany on 100% chlorine- and acid-free age-resistant paper

Contents

Key to the symbols

i	Source of further information
☉	Opening times / Guided tours
♿	Full disabled access
♿	Partial disabled access
✖	Restaurants
P	Parking facilities
DB	Mainline rail network
Ⓢ	Urban rail network
U	Underground rail network
🚌	Scheduled bus/tram service
🛗	Lift
⛴	River boat
M	Museums run by other institutions on the heritage site

WELCOME

In 1990, the public administrators of stately homes and gardens in Germany's various federal states set up a joint working group in order to exchange their long, diverse experience of preserving, maintaining and displaying the valuable cultural and natural heritage in their care and, by virtue of a deeper knowledge, to serve the millions of visitors who pass through their sites each year.

This book is one fruit of that co-operation, and we hope you will find it a helpful and stimulating guide.

Did you know that Wilhelmine of Bayreuth was actually a Prussian princess, or that Queen Elisabeth of Prussia came from Bavaria, the land of palaces? Princess Augusta of Saxe-Weimar, for her part, became an Empress of Germany. Look at the family trees of the old dynasties and you will see how they spread their roots and branches right across Germany, not to mention Europe.

The artists who fashioned the homes of those princes also crossed paths and inspired one another. Galli-Bibiena set his stamp on Bayreuth, but also on Dresden, whereas his pupil Gontard worked in Potsdam. Eyserbeck of Anhalt-Dessau created Potsdam's New Garden, and Schinkel travelled to the Rhine. The list is potentially infinite. Moreover, all of them looked across the borders of their day to Italy, France and Britain.

However, it is not the past alone which the heritage administrations have in common. Above all else, it is the work they do today to maintain and preserve their castles, stately homes and gardens, the research they undertake, and the promotion of this knowledge for the benefit of all future generations.

So whenever you have the time to travel – during a weekend off or on holiday – take the opportunity to travel in time.

Let yourself be enchanted by the castles and palaces of German emperors, kings and local overlords. Experience a fascinating interplay of accomplished art and craftsmanship.

Follow the traces left by local princes great and small and the history of those they ruled.

Relax and enjoy yourself in our delightful historical gardens as you watch stunning displays of water set against the bright hues of floral scenery.

Make the most of myriad cultural events against the comely backdrop of our stately homes, castles, gardens, abbeys and Roman remains.

Germany's heritage administrations look forward to your visit.

**Staatliche Schlösser und Gärten
Baden-Württemberg**
Public Stately Homes and Gardens of
Baden-Württemberg

**Bayerische Verwaltung der Staatlichen
Schlösser, Gärten und Seen**
Bavarian Administration of Public
Stately Homes, Gardens and Lakes

**Stiftung Preußische Schlösser und Gärten
Berlin-Brandenburg**
Berlin-Brandenburg Foundation of Prussian
Stately Homes and Gardens

**Verwaltung der Staatlichen
Schlösser und Gärten Hessen**
Administration of Public Stately
Homes and Gardens in Hesse

**Burgen, Schlösser, Altertümer
Rheinland-Pfalz**
Castles, Stately Homes and Ancient Sites of Rhineland-Palatinate

Sächsische Schlösserverwaltung
Saxon Administration of Stately Homes

**Stiftung Schlösser, Burgen und Gärten
Sachsen-Anhalt**
Saxony-Anhalt Foundation of Stately Homes, Castles
and Gardens

Kulturstiftung DessauWörlitz
DessauWörlitz Cultural Foundation

Stiftung Thüringer Schlösser und Gärten
Thuringian Foundation of Stately Homes and Gardens

GERMAN WORKING GROUP ON STATELY HOMES AND GARDENS

The Working Group "Stately Homes and Gardens in Germany" is composed of specialists in the field and serves the exchange of experience and the promotion of common projects by the heritage administrations as public bodies.

The administrations set up as stewards of Germany's stately homes and gardens serve the aims of preservation, investigation, completion and education, centred on a heritage which is in each case a unique and holistic constellation of art and history. The heritage consists of buildings, gardens, museums, artistic assets and cultural landscapes.

The listed sites in the care of the heritage administrations are total art works (Gesamtkunstwerke) of major artistic or historical significance which have helped to shape the cultural identity of a federal state and its art and whose preservation serves the public interest.

A total art work (Gesamtkunstwerk) is understood to be an ensemble of historical buildings which have evolved over the centuries along with the art works which embellish their rooms and grounds. These include museum exhibits which originated as period interiors, and also collections. A further component are the topographical interventions, notably gardens and landscaped scenery, including bodies of water.

To appreciate these total art works fully, we must explore the historical contexts they render visible, such as local dynasties and territorial frontiers.

The German heritage administrations are dedicated to preserving and maintaining the buildings, gardens and art works consigned to their care as a public asset. They have to deepen our knowledge of these sites through scientific research and to restore, repair and complete where required. Last but not least they have to make the sites accessible to visitors in an appropriate manner, presenting and explaining their aesthetic and historical significance as total works of art, and to derive use from these listed sites without damage or detriment to our heritage.

Today's administrations see themselves very much as institutions in the service of the public. They also aim for cost efficiency, assuming that there need be no contradiction between cultural and economic principles.

At a time when tourism is expanding, along with growing demand for access to these sites, while at the same time the financial and human resources required to ensure sound management are under pressure, it is vital to ensure that the specialised competence for fulfilling these aims remains vested in a single body. To carry out all the tasks required in an appropriate and responsible manner, it is essential that we found our work on scientific principles.

Reflecting the complexity of the total art works in their care, the heritage administrations structure their work around specific listed sites, conducting scientific research of their own on this basis, while integrating services and other activities under a single management. The major fields of responsibility are as follows:
Buildings: architecture and related interior decoration which respects the history of the fabric and the requirements of conservation
Museums: research, inventory of artistic assets and integrity of collections
Restoration: conservation and restoration
Garden landscaping: maintenance of gardens and landscaping which respects the history of the grounds and the requirements of conservation
Public relations and communication: presentation of sites for public enjoyment, publications, guided tours, heritage and museum education, exhibitions, advertising etc.
Property management: maintenance and improvement of assets, cost-effective stewardship and prudent use of heritage sites with particular attention to the specifics of each.

The administrations carry out initial and continuous training to ensure that the procedures particular to their responsibilities are implemented efficiently. In this manner, they help to upgrade the skills of personnel for all aspects of their work.

Chairman:

Dr. Kai R. Mathieu,

Director of the Administration of Public Stately Homes and Gardens in Hesse

Deputy Chairmen:

Professor Dr. Hans-Joachim Giersberg,

Director General of the Prussian Foundation of Stately Homes and Gardens

Dr. Helmut-Eberhard Paulus,

Director of the Thuringian Foundation of Stately Homes and Gardens

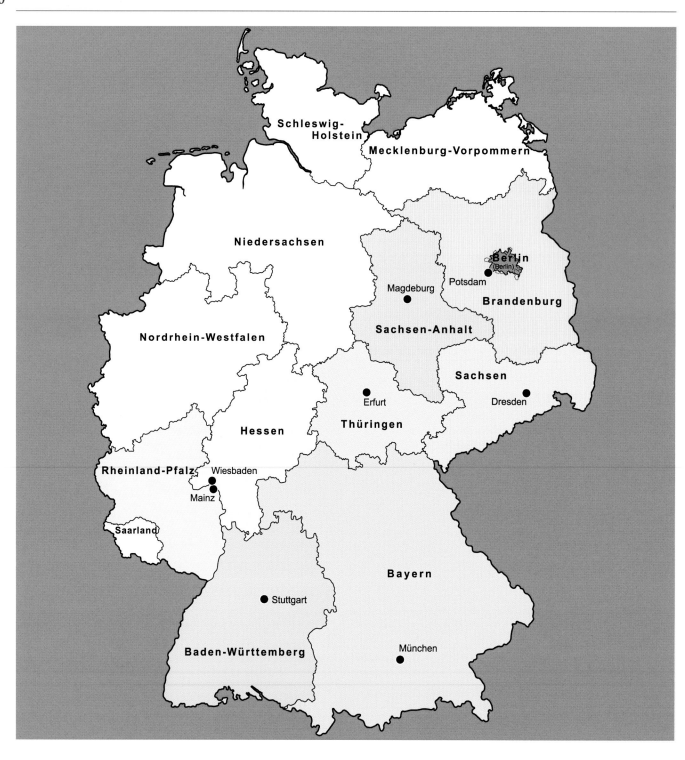

Note:
This publication is the *official guide issued by the heritage administrations in Germany*. The book presents only the properties owned by these authorities, arranged by Land, for the Länder which have such an institution.

Baden-Württemberg

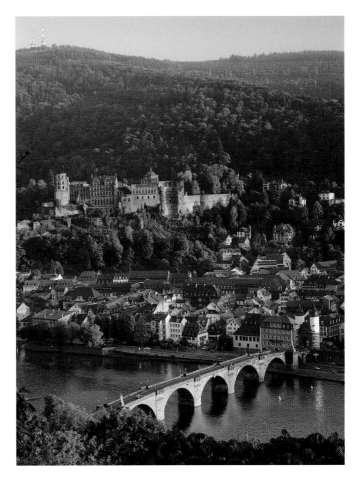

STAATLICHE SCHLÖSSER UND GÄRTEN
BADEN-WÜRTTEMBERG

PUBLIC STATELY HOMES AND GARDENS OF
BADEN-WÜRTTEMBERG

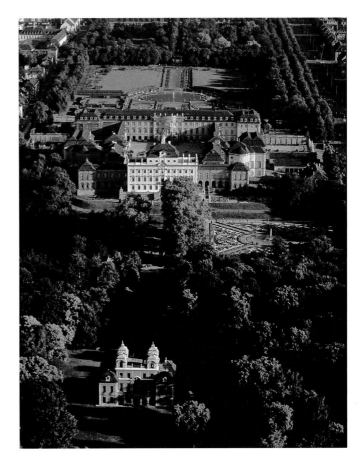

Staatliche Schlösser und Gärten Baden-Württemberg

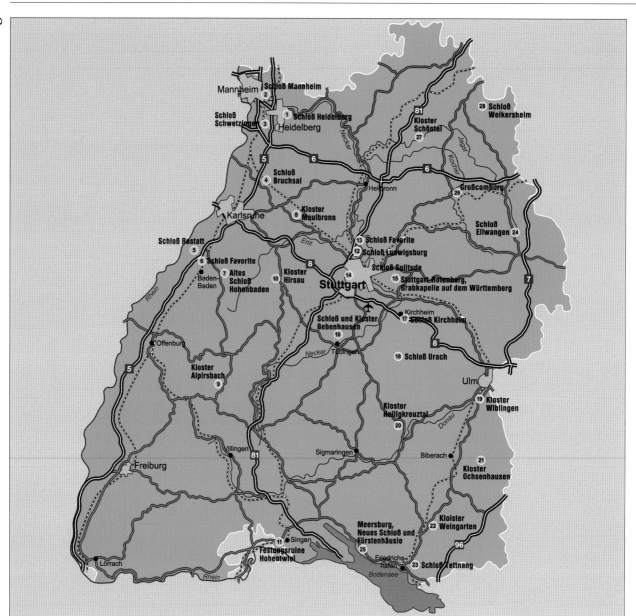

Heidelberg
(1) Schloss Heidelberg
 pp. 14–15

Mannheim
(2) Schloss Mannheim p. 16

Schwetzingen
(3) Schloss Schwetzingen
 and Gardens pp. 17–18

Bruchsaal
(4) Schloss Bruchsal p. 19

Rastatt
(5) Schloss Rastatt pp. 20–21
(6) Schloss Favorite pp. 22–23

Baden Baden
(7) Old Hohenbaden,
 Baden-Baden p. 23

Maulbronn
(8) Maulbronn Monastery
 pp. 24–25

Alpirsbach
(9) Alpirsbach Monastery
 p. 26

Calw
(10) Hirsau Monastery p. 27

Singen
(11) Ruined Fort of
 Hohentwiel p. 27

Ludwigsburg
(12) Schloss Ludwigsburg
 pp. 28–29
(13) Schloss Favorite p. 30

Stuttgart
(14) Schloss Solitude p. 31

Stuttgart-Rotenberg
(15) Memorial Chapel on
 Württemberg p. 32

Tübingen
(16) Schloss Bebenhausen
 and Monastery p. 33

Kirchheim unter Teck
(17) Schloss Kirchheim p. 34

Bad Urach
(18) Schloss Urach p. 34

Ulm-Wiblingen
(19) Wiblingen Monastery
 p. 35

Altheim
(20) Heiligkreuztal
 Monastery p. 36

Ochsenhausen
(21) Ochsenhausen
 Monastery p. 37

Weingarten
(22) Weingarten Monastery
 p. 37

Tettnang
(23) New Palace p. 38

Ellwangen
(24) Schloss Ellwangen p. 38

Meersburg
(25a) New Palace p. 39
(25b) Prince's House p. 39

Schwäbisch Hall
(26) Greater and Lesser
 Comburg p. 40

Schöntal
(27) Schöntal Monastery
 p. 40

Weikersheim
(28) Schloss Weikersheim
 p. 41

Heidelberg
View from the Philosophers' Walk to the Palace and Old Bridge

◁

Schloss Ludwigsburg, the palace complex from the north

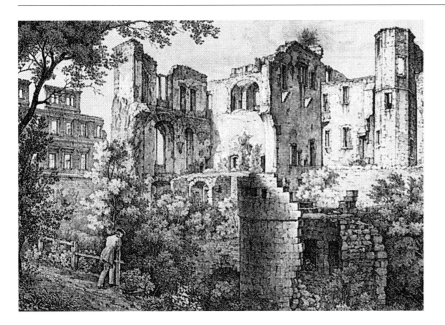

Ernst Fries,
"The Western Part of the Ruins of Heidelberg Palace", lithograph, 1820

"What has been growing here over the centuries is far from dead; it lives on and creates, working as a mysterious bond between the past and the present."

Theodor Fontane

All over the world, palaces, castles and stately homes continue to exert an age-old fascination. Palaces have been associated down the centuries with pomp and circumstance, wealth and luxury, power and intrigue. They have always been an architectural expression of the will to govern and of greatness. Monastic communities, meanwhile, are symbols of the piety which, from the Middle Ages, led to the foundation of so many monasteries and churches. Baden-Württemberg was the cradle of Germany's foremost dynasties: the Guelphs, Hohenstauffens, Habsburgs and Hohenzollerns, and in the course of over a thousand years princes great and small, ecclesiastical and temporal, built many a palace, castle and monastery. They are scattered across the state, and have survived the passage of time to display an extraordinary architectural diversity. The stately homes, the ruins, the historical gardens and the old monasteries are part of the cultural heritage of Baden-Württemberg, and more than 250 sites of the highest order now find themselves in the meticulous administrative care of the *Staatliche Schlösser und Gärten Baden-Württemberg*. The noble and celebrated clients for whom they were built, many of them closely connected to the Imperial court, belonged to the greater and lesser dynasties who ruled in the south-western territories of Germany.

- The dukes, and eventually kings, of Württemberg built enduring landmarks along the middle course of the River Neckar, where they established prestigious palaces at Ludwigsburg and Stuttgart, also commissioning summer residences and hunting lodges amid extensive gardens.
- The margraves of Baden, descended from the celebrated Zähringen dynasty through the two lines of Baden-Baden and Baden-Durlach, eventually became the grand dukes of Baden; it was they who developed Ras-

tatt and Karlsruhe as early seats of residence inspired by Versailles, setting their stamp on the local landscape with planned settlements along the Upper Rhine.
- The Palatine electors built magnificent palaces and gardens as centres of courtly culture at Heidelberg, Schwetzingen and Mannheim.
- The counts of Montfort-Tettnang and the counts of Hohenlohe commissioned summer residences and hunting lodges with orangeries, pleasure gardens and sweeping parklands in Tettnang and Weikersheim.
- The prince-bishops of Speyer established the only ecclesiastical residence on the upper reaches of the Rhine at Bruchsal.

Apart from these dynastic territories, there was a proliferation of middling and smaller principalities and counties until Napoleon redrew the map of political administration. German secularisation in 1803 put an end to autonomous rule by high-ranking clergymen, reflected in numerous monastery estates. All this had created the proverbial "patchwork" which then constituted southwest Germany. It is this fragmentation which explains the great number of stately homes, gardens and monasteries which have been preserved down the centuries, often finely appointed. The heritage administration has invested substantial resources in restoring these buildings, researching into their artistic history, ensuring the integrity of their period interiors and tending their gardens, and now presents these sites to the public flanked by a broad programme of museum education. Set against the specific charms of the Upper Rhine, the Neckar, Lake Constance, Upper Swabia or the Black Forest, these attractions offer millions of visitors insights into the lively history and rich culture of this federal state, and ensure that tourists are able to make the most of their stay in Baden-Württemberg.

Staatliche Schlösser und Gärten Baden-Württemberg

ℹ Schloßverwaltung
Heidelberg
Schlosshof 1
D-69117 Heidelberg
Tel. (+49/0) 6221/538411
Fax (+49/0) 6221/167702
Ticket office 6221/538414

🕐 The palace courtyard,
Great Wine Vat and
Apothecary's Museum
are open for viewing
throughout the year
at 8 am–5.30 pm daily
Guided palace tours
in German, English
and other languages
Special tours

✗

🅿 Coach park

🆎

🚋 tram, cable railway

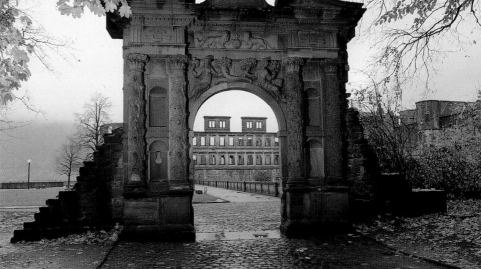

Elisabeth's Gate

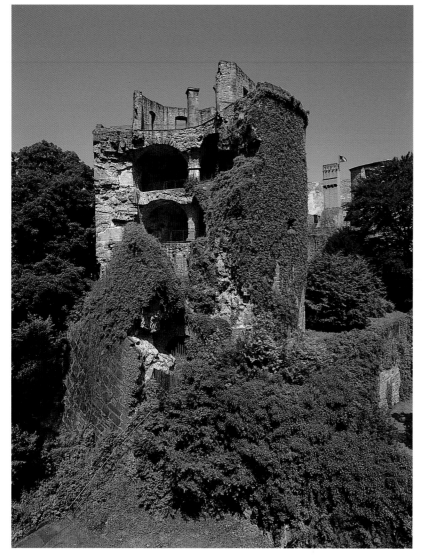

Schloss Heidelberg – The World's Best-Known Palace Ruins

This red sandstone palace, the jewel of the Electoral Palatinate and the very incarnation of a picturesque Romantic castle, towers majestically above the valley of the River Neckar. The former seat of the Palatine Electors is a historically impressive and architecturally delightful structure. The ivy-covered walls of its diverse wings conceal centuries of Wittelsbach history which are well worth decoding. The complex, a reflection of its owners' aspirations, evolved from a castle fortress around 1300 to one of the grandest residences of the High Renaissance, designed to represent the power and glory of its masters. Ruprecht's Wing, the Glass Hall, Ottheinrich's Wing, the English Wing and the other buildings served each successive Elector's requirements of personal comfort and courtly ostentation. Destroyed in 17th- and 18th-century wars, the sturdy ruins testify to the one-time magnificence of this seat of princes. In the 19th century, the palace was an atmospheric backcloth for Romantic contemplation.

Ravaged tower

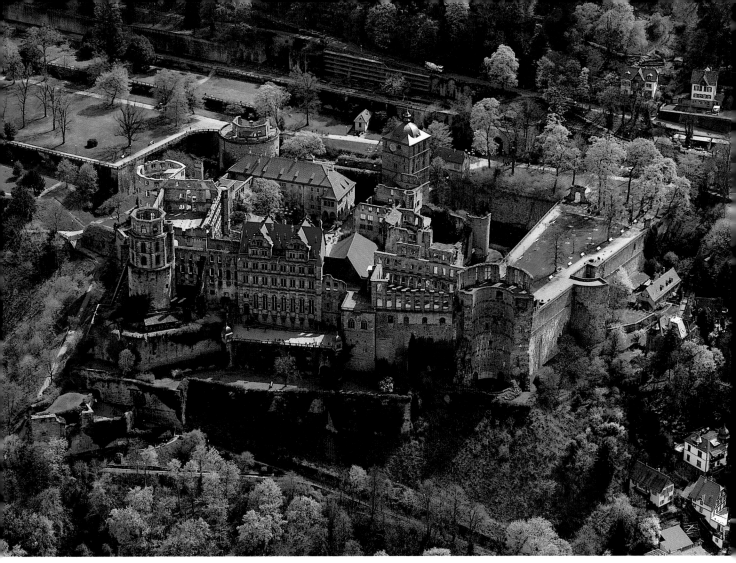

Schloss Heidelberg – aerial view of the palace complex, 1998

The rooms of Friedrich's Wing have been restored in Renaissance Revival style. They now contain a palace museum with a display of courtly living in the 17th and 19th centuries. Walking in the grounds, visitors will stumble across the remains of a fine garden high up on the terraces. This was once an extraordinary work of art, known as the "eighth wonder of the world". It is the Hortus Palatinus, the "Palatine Garden", laid out at the dawn of the 17th century during the reign of the young Elector Friedrich V, the "Winter King". In the foreground is an arboretum of magnificent lone-standing trees, while one of the upper terraces has been recreated in outline, conveying at least an impression of Heidelberg's golden age, the Renaissance, while providing that world-famous view.

A second-floor room in Friedrich's Wing

Staatliche Schlösser und Gärten Baden-Württemberg

Schloss Mannheim
Universität
Rittersaal (guided tours)
D-68131 Mannheim
Tel. (+49/0) 6 21/2 92 28 90
Fax (+49/0) 6 21/2 92 28 93

🕐 1 April–31 October:
Tu–Su 10 am–1 pm
1 November–31 March:
Sa/Su 10 am–1 pm, 2–5 pm
General tours
Special tours

P

DB

S

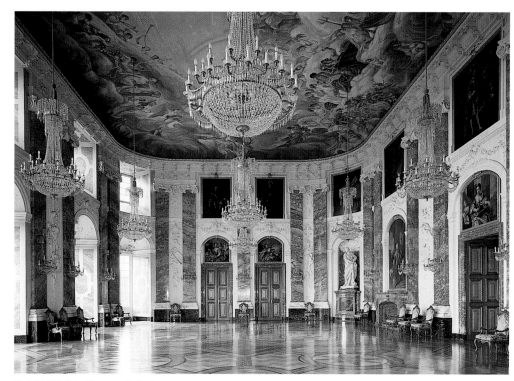

Knights' Hall in the corps de logis

Schloss Mannheim – A Monument between Absolutism and Enlightenment

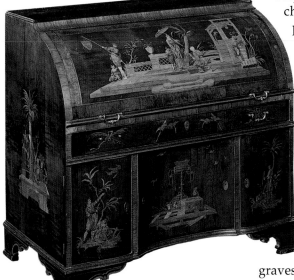

Cylinder bureau by David Roentgen, Neuwied, c. 1772

Thousands of students come and go, probably without giving any thought to the fact that the offices of Mannheim University inhabit the finest residence to grace the banks of the Rhine in the 18th century. Monumental in size, it dominates the modern townscape with its strictly chequered ground plan. The foundation stone for a new palace, inspired by the great prototype at Versailles, was laid by Elector Carl Philipp in 1720. This new residence for the Palatine Electors was to replace Heidelberg. Like the residences built by the margraves of Baden on the Upper Rhine – Rastatt (1700) and Karlsruhe (1715) – it is an excellent expression of absolutist aspirations. This palace took many decades to complete, and under Carl Theodor and Elisabeth Auguste it became a Court of Muses extolled far and wide. Epoch-making music was composed here and stage productions attracted wide acclaim. Mozart and Voltaire were among the most prominent guests.

The palace was all but destroyed in the Second World War. It was rebuilt with replicas of the central tract and its magnificent stairs, the grand Knights' Hall and the two adjoining rooms, and now conveys an admirable impression of the splendour which surrounded the Palatine Wittelsbachs. The museum, with its exhibition of Courtly Art in Schloss Mannheim, opened in 1995 and is still expanding. It tells the graphic story of this exceptional listed building from its origins to the days of the grand dukes of Baden, who lived here during the 19th century.

Schloss Schwetzingen and Gardens – Summer Residence of 18th-Century Palatine Electors

Schwetzingen, not far from Mannheim and Heidelberg, is especially beautiful in summer.

"In the summer season the great lords generally take to their pleasure palaces and hunting lodges, seeking diversion in the hunt and all manner of pleasantries" (Julius Bernhard von Rohr, 1729). Like their 18th-century peers, the Electors of the Palatinate withdrew to the delightful fresh air of Schwetzingen during the warmer months, along with a large proportion of their entourage from Mannheim. They had extensions built to the old hunting lodge and magnificent gardens laid out. The central tract of solid stone, a castle-like structure, was converted for the greater comfort of the Elector and Electress and their courtiers, and the rooms were lavishly fitted. With Carl Theodor supervising, accomplished architects created a total art work of

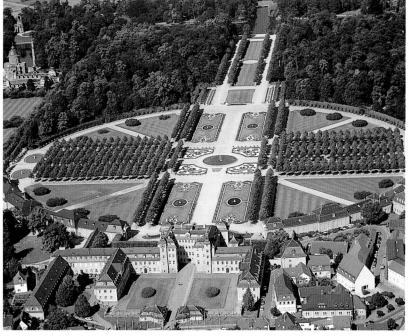

Bird's-eye view of the palace and gardens at Schwetzingen

exceptional beauty within the space of a few decades. The pleasure garden and rotundas, perfectly regular and symmetrical, followed clear mathematical princi-

ℹ Schloßverwaltung
Schloss Mittelbau
D-68723 Schwetzingen
Tel. (+49/0) 6202/81484
Fax (+49/0) 6202/81386

Rococo court theatre by Nicolas de Pigage

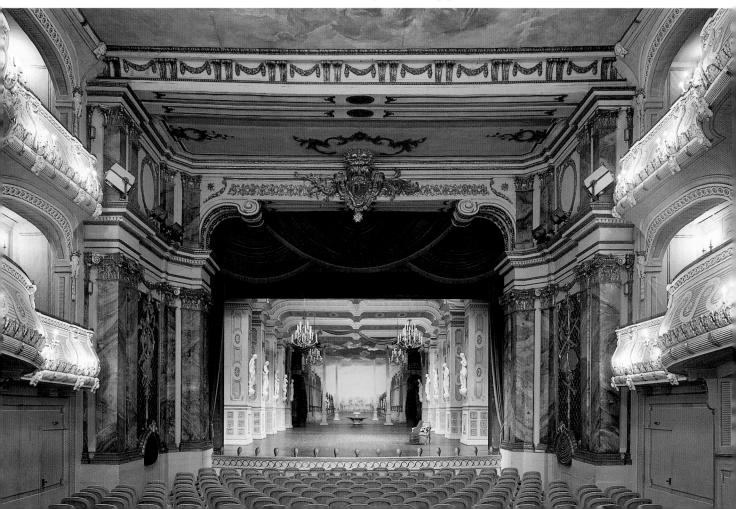

Staatliche Schlösser und Gärten Baden-Württemberg

Temple of Apollo

Mosque built by Nicolas de Pigage

Railings with sun's face

Guided tours
⊘ 1 April–31 October:
Tu–Su 10 am–4 pm
1 November–31 March:
Sa, Su, public holidays
11 am–3 pm
Fr 2 pm only

Palace Garden
⊘ March: 9 am–6 pm
1 April–30 September:
8 am–8 pm
October: 9 am–6 pm
1 November–end of
February: 9 am–5 pm
General and special tours
can be booked at the
ticket office:
Tel. (+49/0) 62 02/8 14 81
Fax (+49/0) 62 02/8 13 86

✕

🅿 Coach park

DB

ples. Creating a continuum with the palace architecture, the gardens were an outdoor extension of the living quarters, a fit setting for glittering courtly occasions and princely amusements.

As a crowning achievement of baroque garden architecture, Schwetzingen is a cultural monument of European significance. The rococo theatre, orangery, baths, temple, mosque, waterworks and artificial ruins constitute a world of their own. The angloises, bosquets, Elector's private garden and English garden illustrate successive stylistic eras. The formal geometry of baroque and rococo yield to a three-dimensional landscape painting with modelled surfaces, silent waters, meandering walks and a judicious sprinkling of architecture and art. The beauty and diversity of flowers, plants, trees, structures and sculptures is impressive. As in the days of the "great lords", all manner of diversions still take place in the palace and its gardens, from playful games and colourful spectacles to concerts and drama, from light-hearted garden festivals in historical dress to thematic tours, lectures and exhibitions.

Pan on the Rock by Peter Simon Lamine

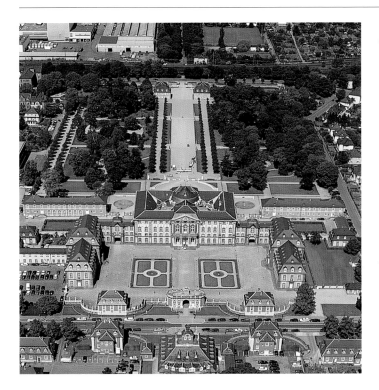

Schloss Bruchsal – aerial view of the palace and gardens

ℹ Schloßverwaltung Bruchsal
Schloßraum 4
D-76646 Bruchsal
Tel. (+49/0) 72 51/74 26 61
Fax (+49/0) 72 51/74 26 71

🕘 Tu–Su 9.30 am–5 pm, also
Mondays if public holidays
Guided tours,
special tours

Also open for viewing:
the exhibitions "Schloss
Bruchsal Built, Destroyed
and Resurrected" and
"Baroque Court Art", and
the Museum of Mechanical
Musical Instruments

✗

🅿 Coach park

DB

Schloss Bruchsal – Rococo Splendour under Clerical Rule

Damian's Gate grants awe-inspiring admission to a colourful baroque world of distinctive charm. The size of the complex, with more than fifty buildings, is overwhelming. Architectural features painted by illusionists, rich gilt stucco ornament and huge, glittering gold dragons spouting water add princely elegance to the façade of the central structure. The architecture, painting and stucco blend to form an artistic whole, spiriting the visitor into the world of the late 18th-century court. Schloss Bruchsal was begun in 1720 as a residence for the prince-bishops of Speyer and bears the clear stamp of Damian Hugo von Schönborn, the man of influence and connoisseur of art who commissioned it. Not only did he express his opinions during the planning stage; he also intervened in construction. Several architects had already been involved when, in 1728, Balthasar Neumann, the well-known master builder from Würzburg, agreed to design the central building. By re-organising the stair well and the adjacent banqueting halls, he accomplished a structural masterpiece, a unique and ingenious specimen of baroque architecture. Under Prince-Bish-op Franz Christoph von Hutten, who succeeded Schönborn, the interiors for the Prince's Hall and Marble Hall were completed with decorative rococo tributes to the role of the prince-bishops, and the palace itself was finished in 1760.

After suffering severe damage in the Second World War, the complex was rebuilt, faithfully recreating the central structure with Balthasar Neumann's stairs in the middle. Once again, we gain a powerful impression of the magnificence which reigned at the only seat of the ecclesiastical aristocracy on the Upper Rhine.

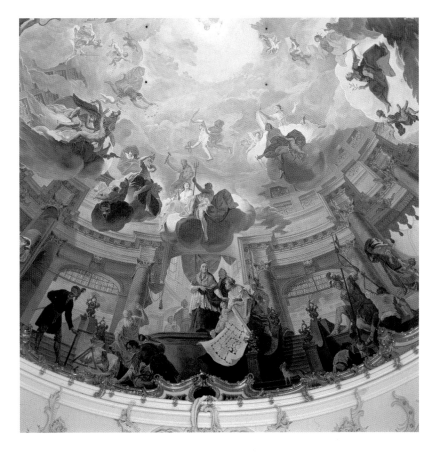

Restored ceiling fresco in the oval dome above the stairway – detail

Staatliche Schlösser und Gärten Baden-Württemberg

ℹ Schloss Rastatt
Herrenstrasse 18
D-76437 Rastatt
Tel. (Info-Centre)
(+49/0) 72 22/97 83 85
Fax (+49/0) 72 22/97 83 92
Tel. (local tourist office)
(+49/0) 72 22/97 24 62
Fax (+49/0) 72 22/97 21 18

🕐 Guided tours every hour
1 April–31 October:
Tu–Su 10 am–5 pm
1 November–31 March:
Tu–Su 10 am–4 pm
Group tours in English or
French can be booked in
advance
Special tours all year round

✕

🅿 coach park

DB

Ⓢ

Ⓐ Also open for viewing:
Memorial to German
Freedom Movements
Tel. (+49/0) 72 22/3 94 75
Military History Museum
Tel. (+49/0) 72 22/3 42 44

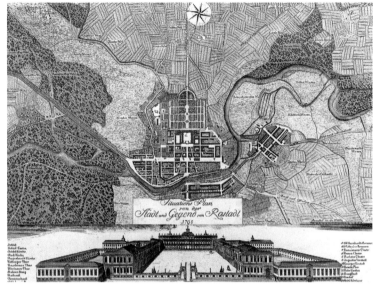

"Location Plan of the Town and Environs of Rastatt", 1798

Schloss Rastatt – The Oldest Baroque Palace on the Upper Rhine

The oldest baroque palace of residence on the Upper Rhine still receives its guests much as it did almost 300 years ago, with a vast cour d'honneur framed by three monumental wings, a grand structured façade, and the glittering gold figure of Jupiter casting thunderbolts with a gesture of divine supremacy from high on the roof of the corps de logis. A truly baroque spirit pervades the entire complex, designed with a clear order and strict symmetry. Schloss Rastatt was the first noble residence on German soil to be inspired by the great prototype at Versailles as the 17th century turned to the 18th.

In 1698 Margrave Ludwig Wilhelm of Baden-Baden had the foundation stone for a hunting lodge laid here in Rastatt, but before long it grew into an imposing seat of residence. The expanses of the Rhine Plain gave "Turk Louis", the hero of the Turkish campaigns, an opportunity to express his legitimate claims to political power. The new palace, park and town were to be the three integral components in a coherent whole conceived as a total work of art and reflecting the baroque aspirations of the nobility at that time. The complex was also to be protected by walled fortifications, and the town was to have a planned layout and model housing. The Italian architect Domenico Egidio Rossi, well-known at the Viennese court, was commissioned to translate this audacious project into reality. But the dream of absolutist glory was short-lived,

for Baden's ruler died in 1707, just as his palace was completed with its "Symmetry and Magnificenza". It would take several more years until, in 1715, his widow Sibylla Augusta truly succeeded in inspiring prestige and glamour into the life of the residence.

Much of the palace has survived the passage of time as a unique and authentic specimen of a seat of residence in the early 18th century. Today we can see the rituals of an absolutist court in our mind's eye as we proceed through an unchanged formal sequence of rooms, the same in both State Apartments on the piano nobile: ante-chamber, hall of audience or throne room, and ceremonial bedroom. The focus of the overall arrangement is the Ancestral Hall, the venue for festive baroque receptions, which still displays all its original splendour. Huge pilasters of red-and-grey stuccolustro with Turkish prisoners sculpted in plaster impose an ordering pattern on this space. The colourful ceiling fresco illustrates the very apotheosis of a sovereign ruler as Hercules is welcomed on Mount Olympus. Imaginative decoration lavishly finished with gold embellishes this splendid ballroom, while noble ancestors observe the proceedings with serene composure from solemn rows of portraits on the walls.

Ancestral Hall ▷

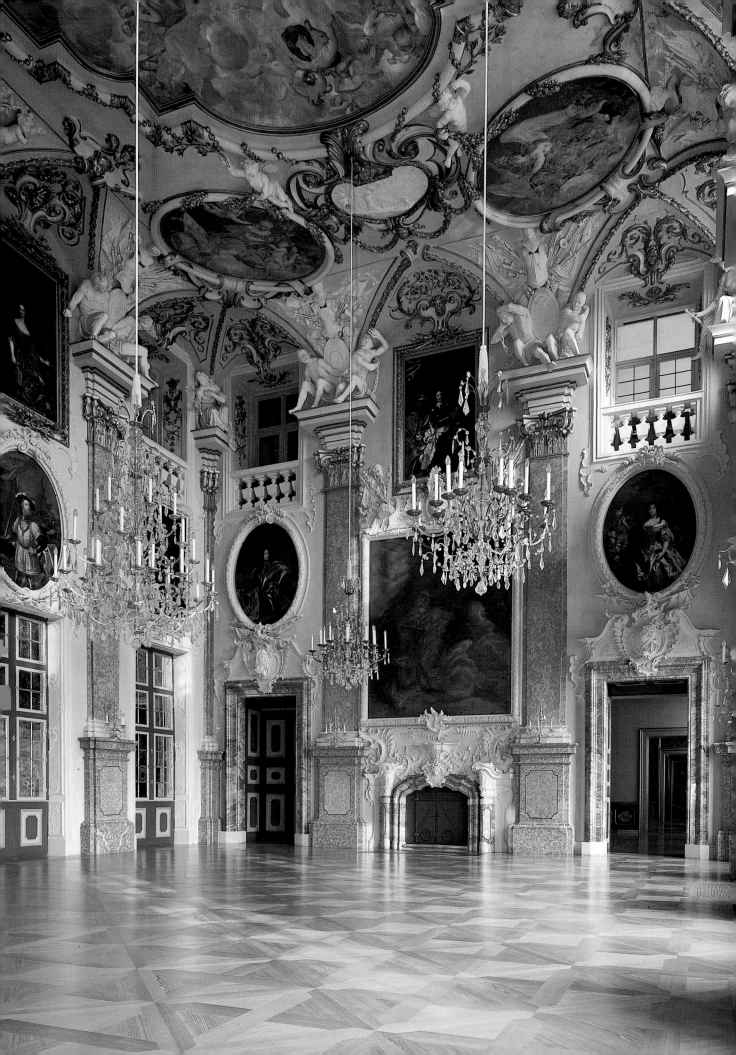

ℹ Schloss Favorite
Rastatt-Förch
D-76437 Rastatt
Info Centre:
Tel. (+49/0) 72 22/4 12 07
Fax (+49/0) 72 22/40 89 57

🕐 Guided tours every hour
16 March–30 September:
Tu–Su 9 am–5 pm
1 October–15 November:
Tu–Su 9 am–4 pm
Guided tours in English
and French for groups by
prior arrangement

✗

🅿

Also open for viewing:
Hermitage, Magdalene
Chapel
Guided tours on Saturdays
at 11 am and 2 pm
Special park tours for
groups

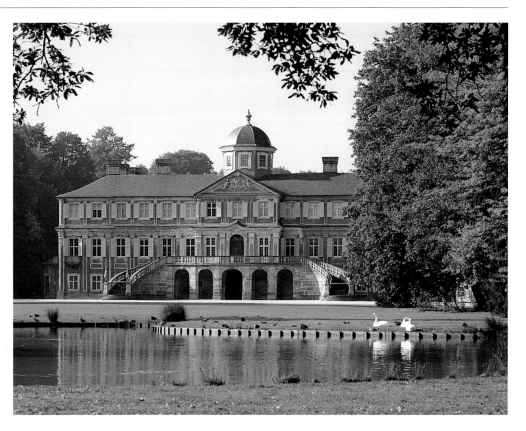

Schloss Favorite from the park

Schloss Favorite –
A Porcelain Palace for Margravine Sibylla Augusta of Baden-Baden

*Böttger stoneware, painted black
and gold, Meissen, c. 1710–1715*

"In the middle of a handsome park stands Schloss Favorite ... with much that is interesting both outside and in." This is how Freiherr Karl von Beust, writing in the late 19th century, described the summer residence once built outside Rastatt for Margravine Sibylla Augusta. Upon the death of Margrave Ludwig Wilhelm, famous for his sally against the Turks, his young widow took the reigns of office in Baden. She dismissed the Italian architect Rossi and appointed Ludwig Michael Rohrer, a master builder from Bohemia, to carry out repairs and extensions at the seat of residence in Rastatt. In 1710/11 she asked him to build a summer-residence-cum-hunting-lodge in an idyllic meadow valley nearby. Schloss Favorite was literally her favourite summer abode. Its distinctive character derives from its personal, intimate appeal and a clear predilection for decorative crafts. Gently curving steps ascend from the garden to the first-floor rooms, furbished with elegance and grace. Coloured scagliola floors, lavish stucco and fresco ceilings, splendid hangings with rare embroidery on the walls, once popular papier maché ornaments and select furnishings blend harmoniously to form a unique total art work in baroque mode. Precious collections of porcelain and faience, including exquisite works of Meissen china, were on display in these rooms and renowned even in the

Margravine's day. In the "princely pleasure-garden" the mistress and her retinue amused themselves on summer days with extravagant costumed festivals, music and dance, while hunters tracked game in the pheasant wood. Away from the court revelry, where the trees were thickest, the penitent first lady of the land commissioned a hermitage and a Magdalene Chapel for pious hours in solitude.

Along with the hermitage, Schloss Favorite – as Germany's oldest porcelain palace and the only one to retain its original appearance – and the sweeping "English-style" parkland, with cross-vistas over meadows and pools and linear vistas along avenues and water courses, constitute a distinctive ensemble which expresses the baroque delight in design.

Garden Hall

Old Hohenbaden

Hohenbaden's Ruined Castle – First Home of Baden's Margraves

The ruins of Old Hohenbaden rise majestically from a high hill in Baden-Baden. This rocky outcrop is the steep western tip of the Baffert. Hermann II, the first Margrave of Baden, built the castle in the early 12th century as a home and ancestral seat. Thick walls, towers and gates surrounded Hermann's Building, clearly and austerely Romanesque, in this medieval fortress designed to defend the dynasty. As centuries passed there were several extensions to the castle, and each new margrave set the stamp of fashion. Until 1479 the sturdy complex was the seat of the margraves of Baden, but this status was then transferred to their new palace in Baden-Baden. Today the romantic ruin veiled in legend is a meeting-place for the many ramblers who stop here to rest, explore and enjoy the unrivalled view across the plains of the Rhine.

i Altes Schloss Baden-Baden
D-76532 Baden-Baden
Tel. (+49/0) 72 21/2 69 48
(restaurant)

🕒 Tu–Su throughout the year
(opening times may be
restricted in winter)

�器

🅿

Baden-Baden –
Old Hohenbaden, full aerial view

<div style="writing-mode: vertical">Staatliche Schlösser und Gärten Baden-Württemberg</div>

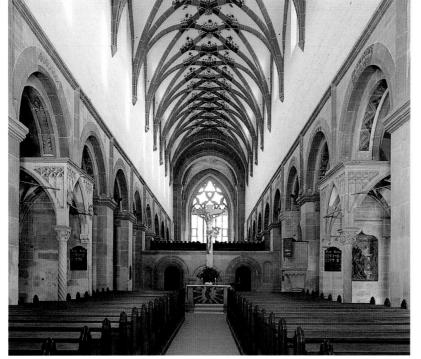

ℹ Kloster Maulbronn
Klosterhof 5
D-75433 Maulbronn
Info-Centre:
Tel. (+49/0) 7043/926610
Fax (+49/0) 7043/926611

🕘 1 November–28 February:
Tu–Su 9.30 am–5 pm
1 March–31 October:
daily 9 am–5.30 pm
Guided tours at 11.15 am
and 3 pm
Tours in English and French
for groups by prior arrange-
ment
Special tours

♿
✗
🅿
DB

Abbey church with choir screen and east window of choir

Maulbronn Monastery – From Cistercian Monastery to World Heritage Site

The monastery of Maulbronn is set in undulating hills among the woodlands and waters of the Kraichgau, where the Cistercian Order has left many traces. Monks from Alsace came to this remote Salzach valley in 1147 and began building the monastery in accordance with Cistercian rules. For 390 years monks and lay brothers lived, built, prayed and worked in Maulbronn. In 1556, after the Reformation, Duke Christoph of Württemberg established a Protestant school here. In 1807 it became a Protestant seminary, and as such it still exists today. Some eminent names in the arts and sciences, such as Johannes Kepler, Friedrich Hölderlin and Hermann Hesse, took or gave instruction here, suffering somewhat in the process.

An impressive and variegated assortment of buildings extends around the monastery courtyard, enclosed by medieval walls and towers. The abbey church, a Romanesque pier basilica with three aisles, was consecrated in 1178. It is the oldest building here and aspires to Bernhard of Clairvaux's ideal of bare, unadorned architecture. The celebrated "Paradise", the porch built around 1220 and the refectory illustrate the transition from Late Romanesque to Early Gothic. The Gothic cloisters with their bright vaulting, the water-house with its forever bubbling spring, the abundant utility and residential buildings are silent proof of construction which continued for many centuries. When exploring the precinct it is easy to imagine the ascetic routine of the Cistercian Order. The monastery

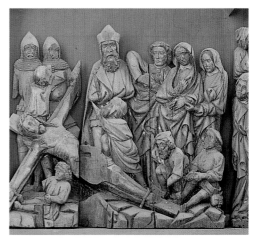

Christ nailed to the Cross, altar relief, c. 1394, Parler School

museum provides helpful background information about the twists and turns of abbey history from its foundation until secularisation, about the life of the monks in white cassocks, the "Maulbronn heads" and much else besides.

The former Cistercian abbey, now over 850 years old, is regarded as the most fully preserved and thereby impressive medieval monastery north of the Alps, and 1993 it was placed on the UNESCO list of world heritage sites.

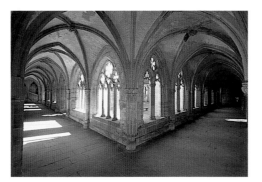

Cloisters from the north-west

Aerial view of Maulbronn Monastery ▷

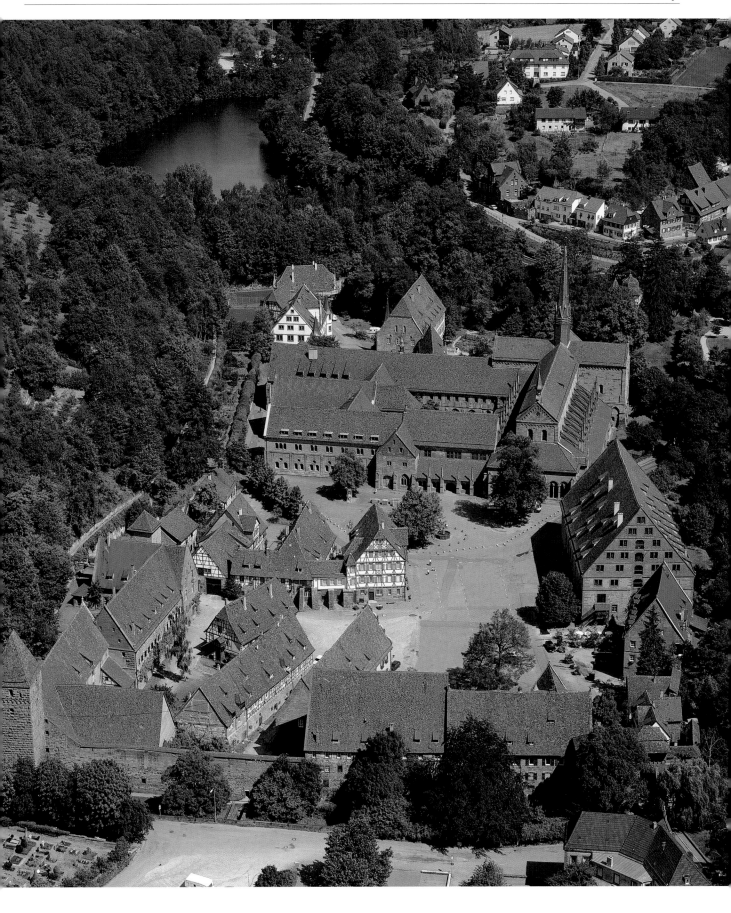

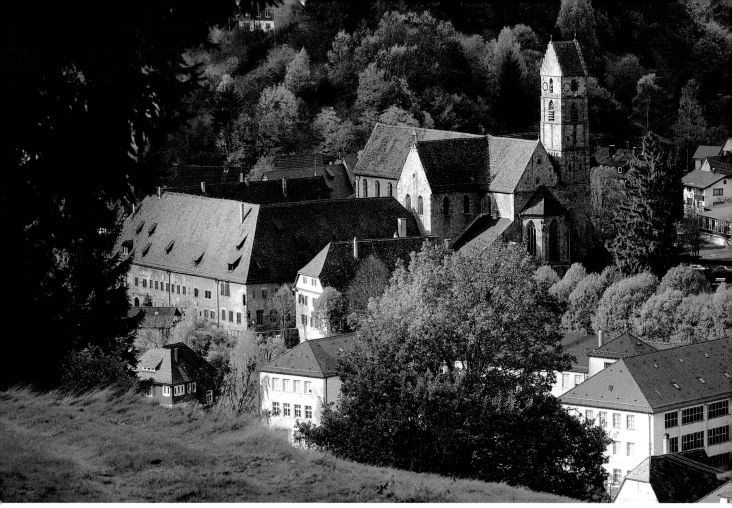

Alpirsbach monastery from the south-east

Alpirsbach Monastery

Alpirsbach Monastery – 900 Years of History in Stone

i Kloster Alpirsbach
Klosterplatz 1
D-72275 Alpirsbach
Info-Centre:
Tel. (+49/0) 7444/51061
Tourist Information:
Tel. (+49/0) 7444/9516281
Fax (+49/0) 7444/9516283

🕑 15 March–1 November:
Mo–Sa 9.30 am–5.30 pm
Su/public holidays
11 am–5.30 pm
2 November–14 March:
Th/Sa 1.30–3 pm
Guided tours at 10, 11 am
and 2, 3, 4 pm
Tours in English and French
for groups by prior arrange-
ment
Special tours

P

DB

Nestling in the valley of the River Kinzig, deep in the northern Black Forest, is Alpirsbach. The centre of this little town is an imposing arrangement of red sandstone buildings, the mason's testimony to bygone eras. These walls tell the story of great medieval piety, the political and social upheaval of the Reformation, when the abbey school was founded, down to the secularisation of the German empire

Lion's head door knob

in 1803. The former Benedictine monastery was part of the 11th-century reform movement in south-west Germany and a vivid example of Cluniac architecture. A walk through the four-wing complex, still complete, reveals the strict clarity of its Romanesque order. The church is a three-aisle Romanesque pier basilica in the form of a cross. The monastery proper – the enclosure buildings around the cloisters – adjoins it to the south. Although no longer an abbey, this is still a place of prayer, used by Protestant and Catholic parishioners alike. In the Late Gothic cloisters, redeveloped at the close of the 15th century, the medieval vaults still exude meditative tranquillity, and concerts are held here in the summer months.

BADEN-WÜRTTEMBERG

Frieze rich in detail on the Owl Tower

Hirsau Monastery –
Impressive Remains of Romanesque and Gothic Years

Between the densely forested slopes of the Black Forest, halfway between Nagold and Pforzheim, the Romanesque and Gothic remains of Hirsau, a once-famous Benedictine abbey, are cupped by the steep Nagold valley. The older Aurelius Monastery was followed in the late 11th century by the Monastery of SS. Peter and Paul and what was then the biggest church far and wide. The Church of St Aurelius is the oldest Romanesque basilica in the Black Forest. Its western arm still stands, conveying a powerful sense of the weighty austerity so typical of Romanesque architecture. The sprawling ruins of SS. Peter and Paul testify to the monumental dimensions of the first monastery to be built by the reform movement in south-west Germany. Above them looms the Owl Tower with its enigmatic frieze. The riddle of the bearded man chiselled in stone, flanked by symbolic beasts and humans, has never been solved.

i Calw-Hirsau Verkehrsamt D-75365 Calw

St Aurelius' Church: Catholic congregation
🕐 10 am–5 pm daily Special tours

Monastery of SS. Peter & Paul: Verkehrsamt Calw (tourist information office) Tel. (+49/0) 70 51/96 88 66 or 96 88 55

🕐 Guided tours April–October: Su 11 am and 3 pm Special tours by prior arrangement

Monastery Museum Tel. (+49/0) 70 51/5 90 15

Hohentwiel

Hohentwiel –
Germany's Oldest Ruined Fort and One of Its Biggest

The climb to Germany's oldest fort on Hohentwiel is rewarded by a breathtaking panorama. The fort was built in AD 914 on the most distinctive hill in the Hegau volcanic rocks near Singen. It served as a base for Alemanni tribes and then as a seat for Swabian dukes. Various owners set their stamp on the site as centuries passed, the last being Duke Ulrich of Württemberg who, in the 16th century, developed this as one of his seven territorial fortresses. It withstood every siege and was never taken by military force. In 1800/01, however, it was surrendered to the French without a battle, and Napoleon had it razed to the ground. In 1855 the ruins were restored to more poetic fame by "Ekkehard", the novel by Joseph Victor von Scheffel. Today, it is an atmospheric backdrop for many tourists. The fort's eventful history is told in graphic form at Hohentwiel Info-Centre.

i Singen/Hohentwiel Verkehrsamt D-78224 Singen/ Hohentwiel Tel. (+49/0) 77 31/8 52 62 Fax (+49/0) 77 31/8 52 43 Fort Info-Centre: Tel. (+49/0) 77 31/6 91 78

🕐 1 April–30 September: 8.30 am–6.30 pm daily October: 9 am–5 pm 1 November–31 March: 10 am–4 pm Special tours

✗ ℙ

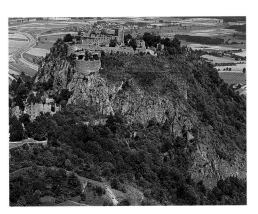

Aerial view of the ruined fortress

Staatliche Schlösser und Gärten Baden-Württemberg

i Schloßverwaltung
Schloßstrasse 30
D-71460 Ludwigsburg
Tel. (+49/0) 71 41/18 64 40
Fax (+49/0) 71 41/18 64 34

🕐 Mid-March–31 October:
9 am–12 noon, 1–5 pm
1 November–mid-March:
10 am–12 noon, 1–4 pm
Guided tours all day
Group tours and special
tours must be booked

Museum shop
Opened daily
Tel. (+49/0) 71 41/18 64 54

Theatre Museum
Great Vat in vat cellar
Palace festival
Open-air concerts
"Blossoming Baroque" with
Fairy Tale Garden and
historical games in the Park

✕

P

DB

Ⓢ

🚌

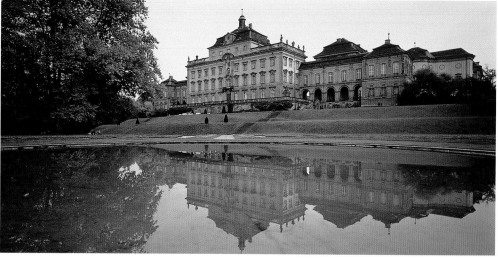

Schloss Ludwigsburg

Schloss Ludwigsburg, garden front of the old corps de logis

There are few baroque palaces where visitors can tread so authentically in the footsteps of absolutist rulers. This residence of Württemberg dukes, spared the ravages of war, is one of the biggest and finest baroque stately homes in Europe. Built originally as a hunting lodge in 1704, it was expanded under Duke Eberhard Ludwig until, by 1733, it epitomised all that a contemporary absolutist might

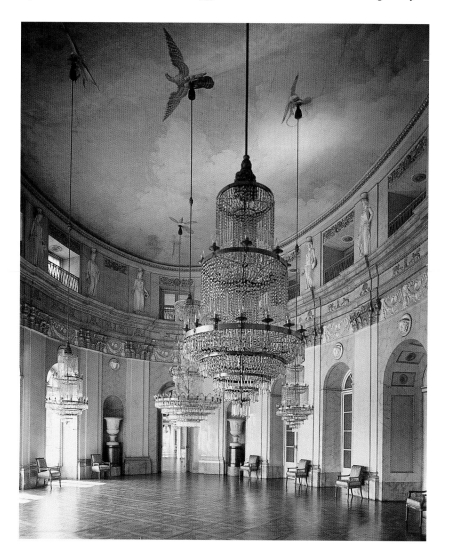

Marble Hall

expect of his seat of residence. The three wings designed by Johann Friedrich Nette did not, with time, satisfy the requirements of official ceremony. Donato Giuseppe Frisoni, who succeeded Nette as architect, converted them into a four-wing arrangement. For fifteen years Ludwigsburg took Stuttgart's place as the duke's seat of government. The furbishing of the new corps de logis was carried out from 1758 under Carl Eugen, and the Duke's Apartment in the attic storey, designed by Philippe de la Guêpière, has been exceedingly well preserved. Friedrich I, the first King of Württemberg, only used Ludwigsburg as a summer residence. Around 1800 to 1815 he had many of the rooms modernised in French Empire style by Nikolaus von Thouret. The splendour of the Württemberg court is still reflected in long sequences of rooms sumptuously fitted out with furniture, wall-hangings, paintings and sculpture. The palace theatre, uniquely preserved in its entirety, offers a glimpse of glittering courtly entertainment, with its opera, ballet, theatre and society banquets.

True to type, Ludwigsburg is set in extensive gardens, laid out originally with all the formal symmetry of the baroque style. King Friedrich I had the East Garden transformed into an English landscape park. Among the features which have survived are the Emichsburg (an artificial ruined castle) and the Bowl Lake.

Schloss Ludwigsburg,
Records Office

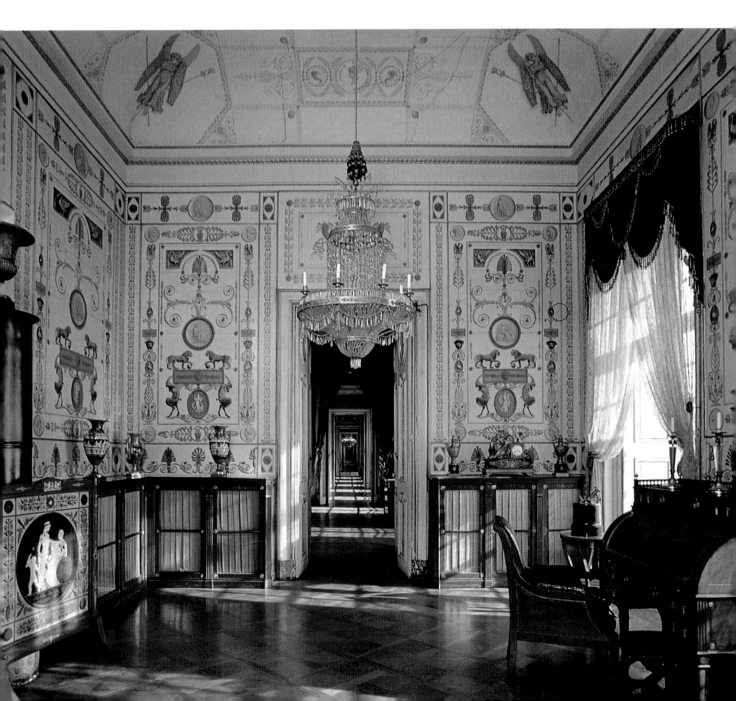

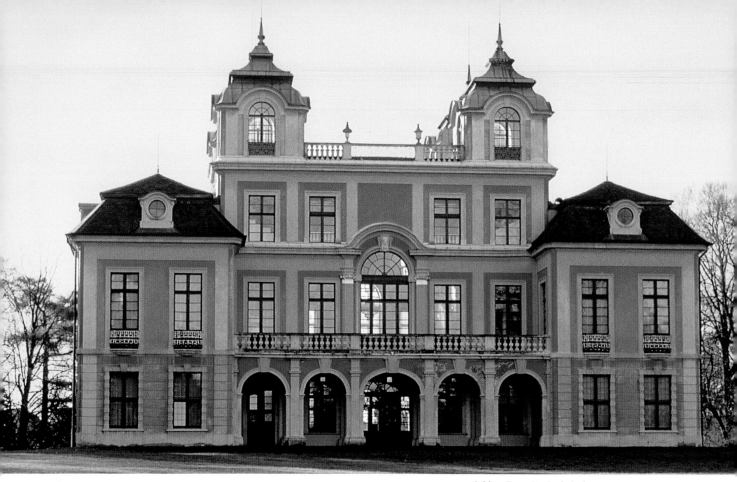

Schloss Favorite, Ludwigsburg

i Schloßverwaltung
Schloßstrasse 30
D-71460 Ludwigsburg
Tel. (+49/0) 71 41/18 64 40

🕐 Mid-March–mid-October:
daily 10 am–5 pm.
Mid-October– mid-March:
Tu–Su 10 am–4 pm
Guided tours all day
Children's tours must be
booked

P – **DB** – **S** – 🚌

Schloss Favorite

The grounds of Schloss Ludwigsburg include another palatial baroque building: Schloss Favorite, conceived as a hunting lodge for Duke Eberhard Ludwig. Perched on its knoll to the north, it also served as a "point de vue". Located in the ducal hunting grounds, it was designed in 1715 by Donato Giuseppe Frisoni. Carl Eugen subsequently used it for summer amusements and festive occasions. Duke Friedrich II, later King Friedrich I, had most of the interiors refurbished in neo-classical style by Nikolaus von Thouret, as he did in Schloss Ludwigsburg itself. The little palace is set within a picturesque park landscape offering long and delightful walks.

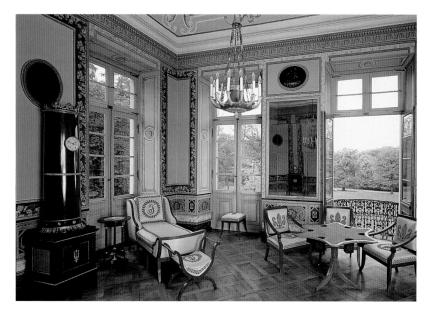

North-West Room

Schloss Solitude

ℹ Schloßverwaltung
D-71087 Stuttgart
Tel. (+49/0) 7 11/69 66 99

🕐 Viewing with guide only
1 April–31 October:
Tu–Sa 9 am–12 noon,
1.30–4 pm
1 November–31 March:
Tu–Su 10 am–12 noon,
1.30–4 pm
Special tours must be
booked

Classical open-air concerts
Schloss Solitude Academy

Schloss Solitude

Schloss Solitude

As its name suggests, Schloss Solitude was built from 1763 as a retreat for Duke Carl Eugen, enabling him to enjoy some private life away from the ceremony of state. There are numerous ancillary buildings, making this one of the outstanding architectural ensembles of the 18th century in southern Germany. A 9-mile avenue linked the palace with Ludwigsburg, the seat of government at that time. Duke Carl Eugen founded his "Militair Academie" in the grounds of Schloss Solitude. This eventually became the "Hohe Carls-Schule", and its best-known pupil was undoubtedly Friedrich Schiller. The little palace originally stood in extensive gardens, and in the years until 1772 it underwent redevelopment as an official summer residence. Architect Philippe de la Guêpière designed the interiors for the banqueting halls, the White Hall, and the Music and Assembly Rooms in late rococo style. Schloss Solitude is popular with ramblers, for it is set in a large area of forest with a game park. There is a magnificent view, which reaches to the borders of the Swabian low country.

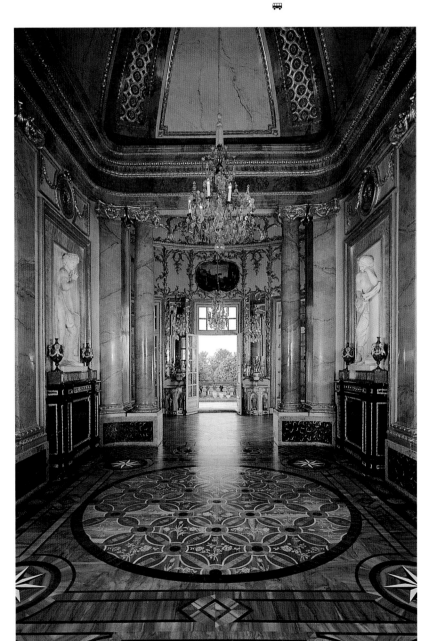

Marble Hall

Staatliche Schlösser und Gärten Baden-Württemberg

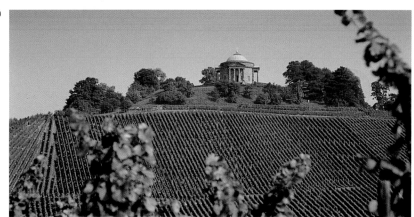

Memorial Chapel on the hill

ship. The slopes of the Württemberg, formerly known as the Rotenberg, are covered in vineyards. This is still a popular place for outings, and visitors come from far and near to enjoy a fine view of the Neckar valley.

i Verwaltung der Grabkapelle
Rotenberg
D-70327 Stuttgart
Tel. (+49/0) 7 11/33 71 49

🕐 1 March–1 November:
Su/public holidays
10 am–12 noon, 1–6 pm
Fr/Sa 10 am–12 noon, 1–5
pm. We 10 am–12 noon
Closed from 2 November
to 28 February
Guided tours by prior
arrangement

P

DB

S

🚌

Queen Katharina of Württemberg ▷
(1788–1819)

Württemberg Memorial Chapel

Perched on the Württemberg hilltop above the River Neckar, the Memorial Chapel is visible from afar. It was built for Queen Katharina, who died in the full blossom of her youth at the age of 30. Wishing to foster the eternal memory of his wife at her favourite haunt, King Wilhelm I had the 11th-century ancestral castle of the Württemberg dynasty, which once stood here, torn down in 1820. His court architect Giovanni Salucci designed a neo-classical rotunda crowned with a dome. Below the chapel itself is the crypt where Wilhelm I was also laid to rest in later years. Katharina was a member of Russia's royal family, and so the chapel was equipped for Russian Orthodox wor-

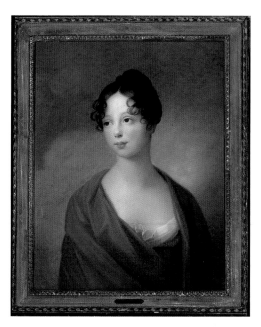

"Memorial Chapel on Rotenberg",
idealised view of the chapel
interior, 1819/20

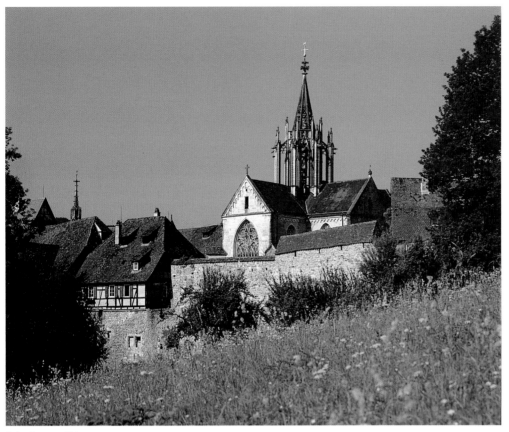

Bebenhausen Abbey

i Schloßverwaltung
Bebenhausen
Schloss
D-72074 Tübingen
Ticket office (Schloss):
Tel. (+49/0) 7071/602180
Fax (+49/0) 7071/602182

Closed on Mondays
(opened on public holidays)

Monastery
⊙ 1 April–31 October
Tu–Fr 9 am–6 pm
1 November–31 March
Tu–Fr 9 am–12 noon,
1–5 pm
Closed on 1 January and
24, 25, 31 December
Group tours by prior
arrangement
Guided tours Sa/Su/public
holidays

Schloss
⊙ Open all year round except
1 January, 24, 25, 31 Decem-
ber
Guided tours daily
Group tours by prior
arrangement

Permanent exhibition on
the monastery's history

Cloister concerts

P

🚌

Schloss Bebenhausen and Monastery

Not far from the university town of Tübingen with its rich traditions, in the middle of Schönbuch Natural Park, lies one of Württemberg's major heritage sites. The abbey founded in the late 12th century by the count palatine Rudolf of Tübingen ranks alongside Maulbronn as one of the few medieval monasteries to have survived almost in its entirety. The abbey was dissolved in 1556 during the Reformation, and the buildings were occupied by one of the newly founded Protestant abbey schools. When this was closed in its turn at the beginning of the 19th century, King Friedrich I used Bebenhausen as a lodge for extravagant court hunts. After the abdication of Germany's monarchs in 1918, the last royal couple in Württemberg, Wilhelm II and his wife Charlotte, spent the remaining years of their lives in Bebenhausen. Wilhelm had been an attentive king, loved and revered by his people. His relatively modest private quarters and the work rooms have been preserved more or less as they were, providing many insights into the domestic lifestyle of the comfort-able classes in the latter 19th and early 20th centuries. Thanks to its long and colourful history, Bebenhausen boasts features of every style from Romanesque to Art Nouveau.

Bebenhausen Monastery and Palace, aerial view

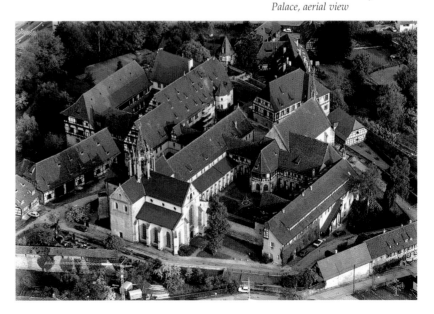

Pädagogisches Fachseminar
Alleenstr. 22
D-73230 Kirchheim
Tel. (+49/0) 7021/974554

ℹ Schloßverwaltung
Schloß Ludwigsburg
Schlossstrasse 30
D-71460 Ludwigsburg
Tel. (+49/0) 7141/186440
Fax (+49/0) 7141/186434

◷ Entrance Alleenstraße
We–Fr 2–5 pm
Sa/Su/public holidays
11 am–4 pm

Special tours by prior
arrangement
Tel. (+49/0) 7021/974554

DB

🚌

Schloss Kirchheim, palace museum, reception room

Schloss Kirchheim unter Teck

The stately home at Kirchheim unter Teck was built in 1538–43 as a result of the ambitious programme of fortress construction undertaken by Duke Ulrich of Württemberg. From 1628 it served as a home for the widows of deceased dukes. Its most distinguished residents were Franziska von Hohenheim, the widow of Carl Eugen (from 1795), and Henriette of Württemberg, who lived here until her death in 1857. Today's museum conveys a vivid impression of their domestic surroundings.

Schloss Urach

ℹ Schloßverwaltung
Im Schloss
D-72574 Bad Urach
Tel. (+49/0) 7125/158490
Fax (+49/0) 7125/158499

◷ Tu–Su 9 am–12 noon,
1–5 pm
Group tours by prior
arrangement

DB

🚌

🄰 Historical exhibition of
ceremonial sledges by
Württemberg Regional
Museum in Stuttgart

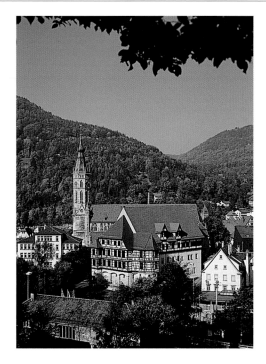

Schloss Urach

Schloss Urach

From 1442 until 1482, while the medieval county of Württemberg was divided, Urach was the seat of its southern half. In 1443 Count Ludwig I had a new palace built, inspired by the castle in Stuttgart. The ground floor incorporates the former Knights' Hall, a four-aisle structure preserved until this day. Of the living quarters and banqueting halls above, the Hall of Palms (with the genealogical credentials of Eberhard the Bearded) survives, as does the Golden Hall. The latter was first created for the wedding in 1474 of Count Eberhard and Barbara Gonzaga of Mantua. It was converted by Duke Johann Friedrich around 1620 into one of the finest Renaissance halls extant.

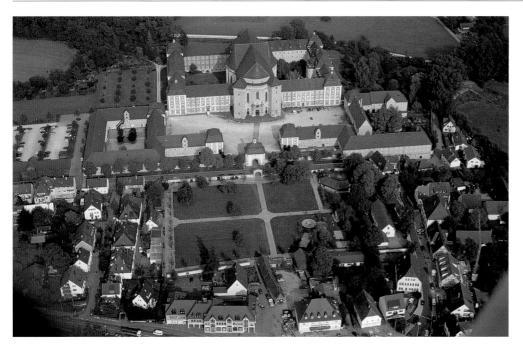

Wiblingen Monastery

i Staatl. Vermögens- und
Hochbauamt Ulm
Tel. (+49/0) 7 31/50-2 89 75
or 2 89 12
Fax (+49/0) 7 31/50-2 89 25

◷ St Martin's Basilica
daily 9 am–6 pm
in winter 9 am–5 pm
Library
1 April–31 October:
Tu–Su/public holidays
10am–12 noon, 2–5 pm
1 November–31 March:
Sa/Su/public holidays
2–4 pm
Closed on 24, 25, 31 December

Permanent exhibition on
"900 Years of Wiblingen:
Monastery, Village, Suburb"
diagonally opposite
the church front
Im Kloster 26a
Opened as Library

P

DB

🚌

Wiblingen Monastery

Wiblingen, founded in 1093, suffered the same fate as all other medieval monasteries when it was radically restructured in the 18th century. The result was an architectural ensemble of impressive dimensions in the baroque style. The abbey church, completed in 1781, is a rare example in Upper Swabia of neo-classical interior design seeking to recreate the formal idiom of the Ancients. The ceilings painted by Januarius Zick rank among the finest frescoes in southern Germany. The Library has been exceptionally well preserved and is valued by art historians for the complex theological and philosophical themes which underlie its wealth of figurative ornament and its fresco ceiling.

Baroque Library

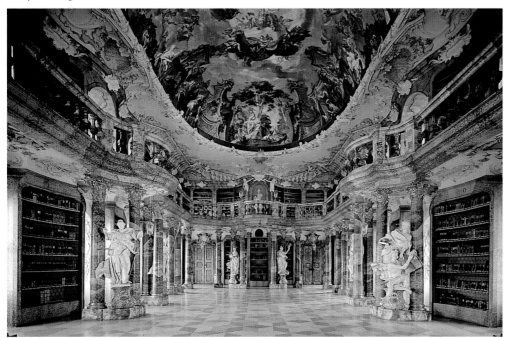

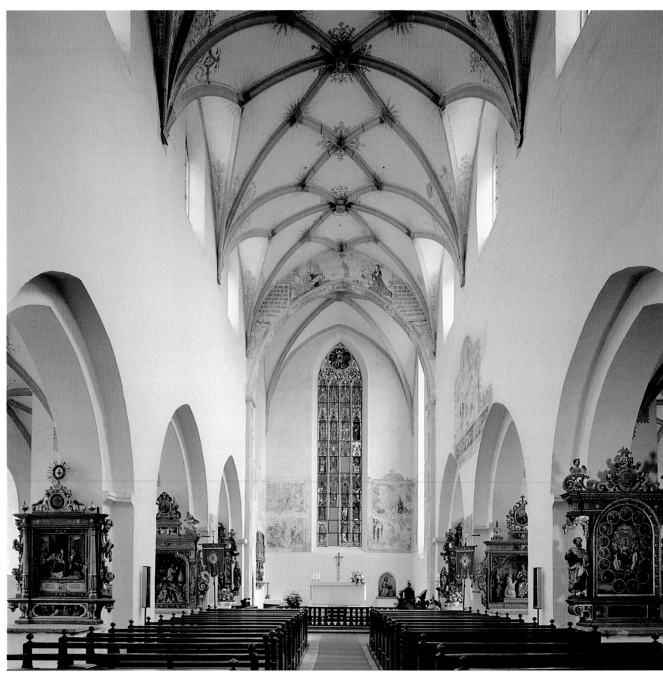

i Staatl. Vermögens- und
Hochbauamt Ulm
Tel. (+49/0) 7 31/50-2 89 12
Fax (+49/0) 7 31/50-2 89 25

🕐 Abbey: daily 9 am–7 pm
Church: 8 am–5.30 pm
Please book guided tours
with the Stefanus-
gemeinschaft:
Tel. (+49/0) 74 71/18 60

Permanent exhibition in the
Church of Brothers:
"Pious Women Testify to
Their Faith – Religious Art
in Heiligkreuztal Abbey"
1 April–31 October:
Su/pub. hols. 2–5 pm
Closed on Good Friday

P

Heiligkreuztal Abbey

With its little spire, blunt choir and thrifty architectural ornament, the abbey church consecrated in 1319 is a typical specimen of the Cistercians' simple formal idiom. Inside, its choicest works of art are the beautifully crafted Renaissance altars and the early 14th-century group of figures around Christ and John. The great tracery window in the choir has survived in almost perfect condition with its medieval stained glass. The plain pier basilica has a spacious nuns' gallery, and below it is the church reserved for lay brothers. The abbey, set in rolling landscape, is one of the best preserved late medieval monasteries in Württemberg.

Heiligkreuztal Abbey, inside the church

Ochsenhausen Abbey, church front

Ochsenhausen Abbey

This Benedictine abbey was founded in 1093 and in 1488 it was placed under direct imperial supervision. The Counter-Reformation unleashed a wave of building which left the complex much as we see it today: the magnificent baroque façade of the new monastery and the rising baroque of the abbey church reflect the ecclesiastical and temporal power exercised by the Imperial abbey. The 18th-century observatory illustrates the scholarship promoted by Ochsenhausen during the Enlightenment Age.

ℹ Staatl. Vermögens- und
Hochbauamt Ulm
Tel. (+49/0) 7 31/50-2 89 12
Fax (+49/0) 7 31/50-2 89 25

Catholic congregation:
Tel. (+49/0) 73 52/82 59
🕐 1 March–31 October:
Sa 10 am–12 noon, 1–5 pm
Su 1–5 pm
Guided tours
1 March–31 October:
Su/pub. hols. 3 & 4 pm
for groups only by prior
booking

Monastery museum
1 March – 31 October
Tu–Fr 10 am–12 noon,
2–5 pm
1. Nov.–28./29. Feb.
Sa/Su/public holidays
2–5 pm
Inquiry for groups
Tel. (+49/0) 73 52/94 14 60
Fax (+49/0) 73 52/94 14 61
Out of opening hours
Stadtverwaltung
Ochsenhausen
Tel. (+49/0) 73 52/9 11 00
Fax (+49/0) 73 52/91 10 16

Convent building, prelate
building, staircase by
Johann Michael Fischer and
refectory can only be visited
on guided tours.
1 March – 31 October
Mo–Sa, public holidays 2 pm
Advance bookings at the
Landesakademie f. d.
musikalische Jugend in
Baden-Württemberg
Tel. (+49/0) 73 52/91 10-0
Fax (+49/0) 73 52/91 10-16

🅿 – DB – 🚌

Weingarten Abbey

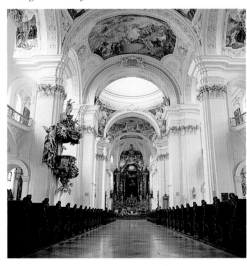

Weingarten Abbey, inside the basilica

Weingarten Abbey

This was once the richest abbey in Swabia. It is visible from afar on Martinsberg over the Schussen valley. Founded in 1094, it owed its major religious role to the famous Relic of Holy Blood, still venerated each year in a horseback procession when the "Blood rides out". During baroque redevelopment a new abbey church of monumental size was built in 1715–24. It is over 320' long and one of the biggest sacred buildings north of the Alps. The glorious ceiling and dome frescoes are an early work by C.D. Asam.

ℹ Staatl. Vermögens- und
Hochbauamt Ravensburg
Minneggstrasse 1
D-88214 Ravensburg
Tel. (+49/0) 7 51/8 06 25 88

Abbey:
Tel. (+49/0) 7 51/5 09 60

🕐 Basilica 8 am–12 noon,
2–7 pm

Special tours must be
booked in the abbey
Tel. (+49/0) 7 51/5 09 60

🅿

DB

🚌

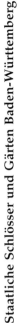

ℹ Schloßverwaltung Tettnang
Neues Schloss
D-83069 Tettnang

Tourist Information Office:
Tel. (+49/0) 75 42/51 02 13
Schloss guides:
Tel. (+49/0) 75 42/51 91 48
Palace Museum:
🕑 1 April–31 October:
10.30 am, 2.30 and 4 pm
Special tours by
prior arrangement

🅿

DB Friedrichshafen

🚌

Schloss Tettnang

New Palace, Tettnang

The magnificent Neues Schloss owned by the counts of Montfort in Tettnang is one of the outstanding stately homes in the region of Lake Constance and Upper Swabia. The dynasty lived here from 1260 until 1780. In 1712 Count Anton III had a four-wing complex built on the site of the old castle, destroyed in the Thirty Years War. However, this was devoured by flames shortly before completion. Austria provided financial backing for its reconstruction. The Count's Apartments and the palace chapel were lavishly furbished by the region's best artists with all the light elegance of the rococo period. Joseph Anton Feuchtmayer created the marvellous stucco, aided by Johann Georg Dirr. In 1780 the counts of Montfort faced bankruptcy. They were obliged to hand over their little county, which only stretched from Tettnang to Langenargen, to Austria. In Napoleonic times their estate passed into Bavarian hands, and then to Württemberg.

Schloss Ellwangen

ℹ Staatl. Vermögens- und
Hochbauamt Schwäbisch
Gmünd
Rektor-Klaus-Strasse 76
D-73575 Schwäbisch-Gmünd
Tel. (+49/0) 71 71/60 20

Palace Museum:
Tel. (+49/0) 79 61/5 43 80

🕑 Tu–Fr 2–5 pm; Sa/Su/pub.
hols. 10 am–12 noon,
closed on Mondays 2–5 pm

✕

🅿

DB

Schloss Ellwangen

Schloss Ellwangen

The former Benedictine monastery of Ellwangen on the River Jagst dates back to AD 764. In the mid-15th century it became a secular college of canons presided over by a prince-provost. Württemberg's rulers acquired Ellwangen under the Act of Secularisation. Until 1806 it housed the new territorial government established through Napoleon. Major rooms of state, such as the Throne Room, bear witness to a turbulent history high on a hill above the idyllic town of Ellwangen.

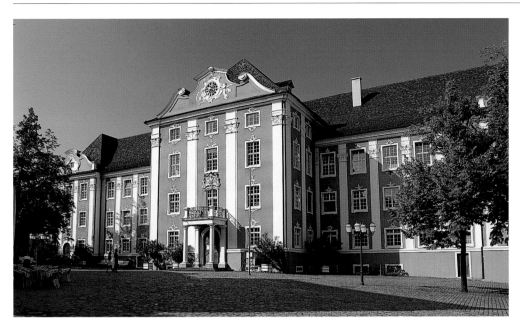

New Palace, Meersburg

New Palace, Meersburg

Meersburg, in its delightful setting above Lake Constance, is crowned in turn by the New Palace. The prince-bishops of Konstanz moved their residence to the Old Palace in Meersburg in the early 16th century, after the town of Konstanz, their previous seat, adopted the Protestant faith. To keep abreast of the times, they began the new building in 1710. As a political gesture, its magnificent show façade was built facing the minster in Konstanz on the other side of the lake. The sumptuous baroque palace was not finished until the reign of Damian Hugo von Schönborn. The stairs were designed by the celebrated architect Balthasar Neumann. The chapel was superbly decorated by sculptor Joseph Anton Feuchtmayer and painter Gottfried Bernhard Goez. Together, the palace, the riders' court and the priests' seminary form a unique ensemble high above the "Swabian Sea".

i Staatl. Vermögens- und
Hochbauamt Ravensburg
Minneggstr. 1
D-88214 Ravensburg
Tel. (+49/0) 7 51/8 06 25 88

Meersburg Tourist
Department
Tel. (+49/0) 75 32/43 11 10

⊘ 1 April–31 October:
10 am–1 pm, 2–6 pm
1 November–end of March
closed
Special tours by arrangement

P

🚐

A Municipal Gallery
Dornier Museum of
Aviation History
Palace Museum on the
piano nobile of the
Prince-Bishop's Quarters

Prince's House, Meersburg

Set amid vineyards high above Meersburg is the former summer retreat of the prince-bishops of Konstanz, known in dialect as the "Fürstenhäusle", the "Prince's little house". This gem was purchased in 1843 by Annette von Droste-Hülshoff (1797–1848). The rooms behind the climbing vines now house the Droste Museum in memory of the writer.

i Staatl. Vermögens- und
Hochbauamt Ravensburg
Minneggstr. 1
D-88214 Ravensburg
Tel. (+49/0) 7 51/8 06 25 88

Prince's House
Tel. (+49/0) 75 32/60 88

⊘ Easter–mid-October:
10 am–12.30 pm, 2–5 pm
Sundays and public
holidays 2–5 pm
Guided tours all day

P

🚐

Prince's House, Meersburg

Staatliche Schlösser und Gärten Baden-Württemberg

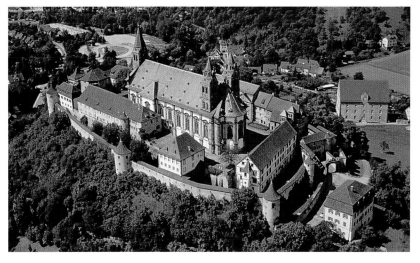

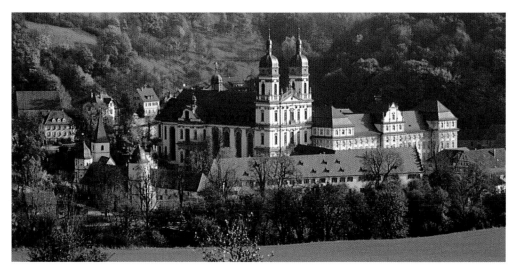

Greater Comburg Monastery

i Staatl. Vermögens- und
Hochbauamt Heilbronn
Postfach 3427
D-74024 Heilbronn

Information and Media
Centre with Museum Café
Tu–So 10 am–9 pm
Tel. (+49/0) 791/938185
Fax 791/938186

Tourist Information Office
in Schwäbisch-Hall:
Tel. (+49/0) 791/751386

🕑 Monastery: unrestricted
access Collegiate church:
visits on guided tour only
Closed on Good Friday
1 April–31 October:
Tu–Fr 10 and 11 am,
Tu–Su and pub. hols.
2, 3 and 4 pm
1 November–31 March:
Guided tours by arrange-
ment

✕ – 🅿
DB Schwäbisch Hall – 🚌

Greater and Lesser Comburg

The former Benedictine abbey of Greater Comburg, surrounded by its defensive wall, stands high above the Kocher valley. It was founded in 1078 by Count Burkhard II of Comburg-Rotenburg, who converted the castle on this site into a monastery. The gatehouse with the former Chapel of St Michael, the hexagonal Chapel of St Erhard, the cloisters and the chapter room are the vestiges of its medieval heyday. Two fine and extremely rare works of art have been preserved in the church: a gilt altar front and a huge wheel lantern, with twelve towers symbolising the celestial city of Jerusalem. In 1488 the Benedictine monastery was turned into a chapter of canons for men of noble birth. The buildings subsequently underwent many conversions and extensions. Today, the dome of the hill is tightly packed with the architecture of eight centuries. Facing Greater Comburg is St Gilgen, a religious community founded in 1108 with a well-preserved Romanesque pier basilica. Also known as Lesser Comburg, it was briefly home to an order of nuns before housing the provost of Greater Comburg.

Schöntal Monastery

Schöntal Monastery

i Bildungshaus Kloster
Schöntal
Tel. (+49/0) 7943/8940
Fax (+49/0) 7943/894100

Abbey church
🕑 8 am to dusk
Permanent exhibition
on the history of
the abbey buildings
in the Old Abbey
1 May–30 September:
11 am–4 pm
Special tours by arrangement

✕ – 🅿
DB Möckmühl
🚌

Schöntal Monastery

The Cistercian Monastery of Schöntal was founded in the 12th century in a sweeping bow of the River Jagst. It blossomed for the first time in the 15th century, after achieving self-government under Imperial tutelage. In the late 17th and early 18th centuries, Abbot Benedikt Knittel converted the medieval complex into a palatial seat of residence. He was also responsible for sprinkling rhymed inscriptions about the walls, giving birth to the term "Knittelvers" for couplets of this kind. The baroque jewel of Hohenlohe is now much admired for its New Abbey, its magnificent stairway and the Monks' Hall, but it is the abbey church of Schöntal, built from 1708 to drawings by Johann Leonhard Dientzenhofer, which is a true masterpiece of baroque church building with its lavish interior. The tomb of Götz von Berlichingen, the famous knight, is in the cloisters.

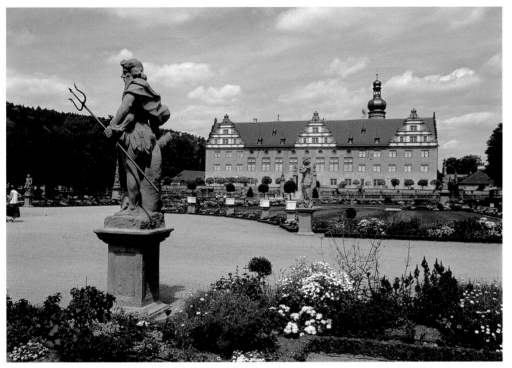

Schloss Weikersheim from the garden

i Schloßverwaltung
Weikersheim
Schloss
D-97990 Weikersheim
Tel. (+49/0) 79 34/83 64
Fax (+49/0) 79 34/83 64

⊘ 1 April–31 October:
Mo–Su 9 am–6 pm
1 November–end of March:
Mo–Su 10 am–12 noon,
1.30–4.30 pm
Special tours

Music school, concerts

P

DB

🚌

Schloss Weikersheim

This stately home at Weikersheim, set against the gentle rolling landscape of Hohenlohe, is one of the stops on the Romantic Road. The counts of Hohenlohe-Weikersheim built their grand residence around 1600, extending it frequently in the years which followed. From 1710 they began to furbish the interior with precious furniture, mirrors, gobelin tapestries and Chinese porcelain, which has survived almost completely. The collection of Ansbach faience, now one of the largest, was also begun. The well-preserved rooms offer rare insights into life at court in the early 18th century. The sumptuous Knights' Hall, decorated around 1600 with its beautifully crafted coffered ceiling, its canvas hunting scenes and life-sized animal sculptures, is a supreme specimen of Renaissance architecture in south-west Germany. From the windows there is a delightful view across the baroque garden, with its mythological statuary, the Gallery of Dwarves and orangery, to the distant Tauber valley. The palace garden at Weikersheim is an outstanding example of garden design in Hohenlohe in the 17th and 18th centuries, and its restoration gives visitors the opportunity to relive the poetic grace and solemnity of a baroque arrangement.

Knights' Hall

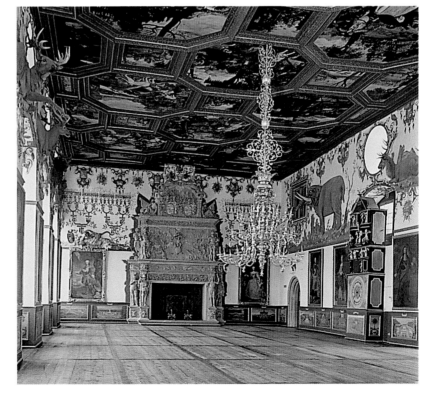

Dilsberg Castle Ruins and Well Springs

D-69151 Neckargemünd-Dilsberg
Tel. (+49/0) 62 23/61 54

Botanical Gardens, Karlsruhe

Indoor displays of exotic plants
D-76133 Karlsruhe, Palace Garden
Tel. (+49/0) 7 21/9 26 30 08

Grand Duke's Memorial Chapel

Garden of Karlsruhe Palace
D-76133 Karlsruhe
Tel. (+49/0) 7 21/69 71 52 (guided tours)

Alt-Eberstein Castle Ruins

D-76530 Baden-Baden, Ebersteinburg
Tel. (+49/0) 72 21/2 88 99 (restaurant)

Yburg Castle Ruins

D-76534 Baden-Baden
Tel. (+49/0) 72 21/2 54 75 (restaurant)

Rötteln Castle Ruins

D-79541 Lörrach
Tel. (+49/0) 76 21/5 64 94 (Rötteln League)

All Saints' Monastery

Ruined monastery (Allerheiligen)
D-77728 Oppenau
Tel. (+49/0) 78 04/12 00 (restaurant)

Bad Mergentheim

(Main-Tauber District)
Fine Renaissance seat of the Teutonic Order, now Museum of the Teutonic Order; church with crypt; café; unrestricted access to the park
Tel. (+49/0) 79 31/5 22 12 (fax 5 26 69)

Blaubeuren

(Alb-Danube District)
Former Benedictine abbey church (with outstanding Late Gothic high altar, wonderfully carved choir stalls by Syrlin the Younger)
Tel. (+49/0) 73 44/63 06 or 42 16 (Luth. seminary)

Blaubeuren

Schubart Room (memorial in Geb. Klosterhof 8 to writers Schubart, Mörike and the family author Agnes Sapper)
Ask at the ticket desk for tours to the High Altar
Tel. (+49/0) 73 44/63 06 or 42 16,
or Ulm Dept. of Public Estates
Tel. (+49/0) 7 31/1 89 30 04 (fax 1 89 30 16)

Kapfenburg

Seat of the Teutonic Order, see Lauchheim-Hülen

Lauchheim-Hülen

(East Alb District)
Kapfenburg, former seat of the Teutonic Order (complex includes Knights' Hall, chapel with painted interior) used in part for local museum, temporary exhibitions, restaurant Closed for conversions until 1 September 1999 (subject to confirmation) Tel. (+49/0) 73 63/56 08 (administration)

Neuffen

(Esslingen District)
Hohenneuffen Castle Ruins (interesting precinct with gun towers and bastions); restaurant and kiosk

Zwiefalten

(Reutlingen District)
Former Benedictine abbey church (rococo interior of particular artistic interest, fine stucco, frescoes, choir stalls, ornamental screen)
Tel. (+49/0) 73 73/6 00 (Catholic parish office)

Source of Illustrations

Fa-Ro Marketing, Munich: p. 12
Grohe: p. 33 bottom
Kohler, Ludwigsburg: p. 28 top
Landesbildstelle Baden, Karlsruhe: p. 11 top, 14 top, 14 bottom, 15 bottom, 16 top, 17 top, 17 centre, 17 bottom, 18 top left, 18 top right, 18 bottom, 19 top, 19 bottom, 22 top, 22 bottom, 23 bottom, 24 top, 24 centre, 24 bottom, 26 top, 26 bottom, 27 top, 27 centre, 27 bottom, 30 top, 31 bottom, 33 top, 33 bottom, 34 top, 35 top, 35 bottom, 38 top, 39 top, 39 bottom, 40 top, 41 top, 41 bottom
Luftbild Elsässer GmbH, Stuttgart: p. 11 bottom, 15 top, 25

Staatliche Schlösser und Gärten Oberfinanzdirektion Karlsruhe: p. 23 top – Exner: p. 20 bottom, 21
Staatliche Schlösser und Gärten Oberfinanzdirektion Stuttgart p. 32 top, 34 bottom, 37 top, 37 bottom, 40 bottom – Feist, Pliezhausen: p. 31 top, 32 centre, 36, 38 bottom
Schlossverwaltung Ludwigsburg p. 29, 30 bottom
Sotheby's: p. 16 bottom
Stadtvermessungsamt Stuttgart: p. 32 bottom
Stadtmuseum Rastatt: p. 20 top

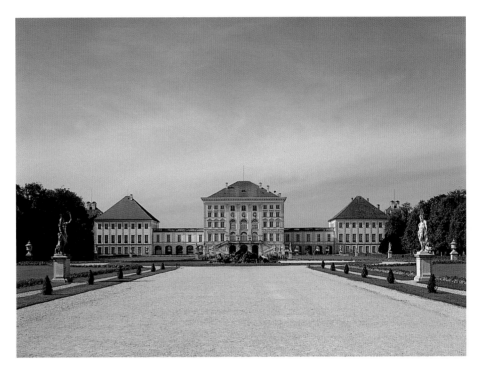

Bavaria

Bayerische Verwaltung der
Staatlichen Schlösser,
Gärten und Seen

The Bavarian Administration
of State Castles, Gardens
and Lakes

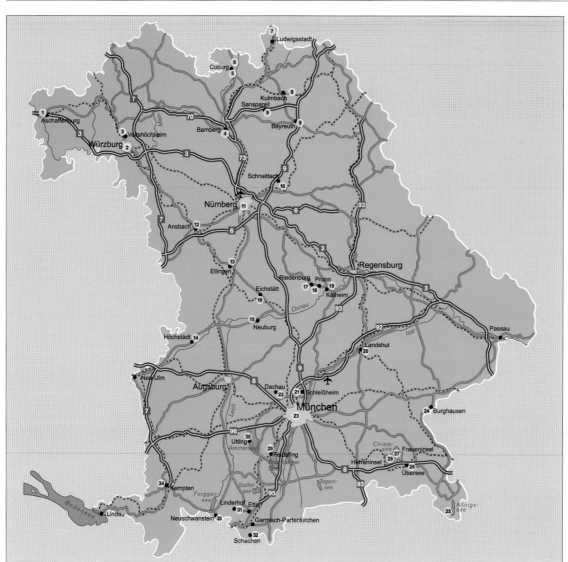

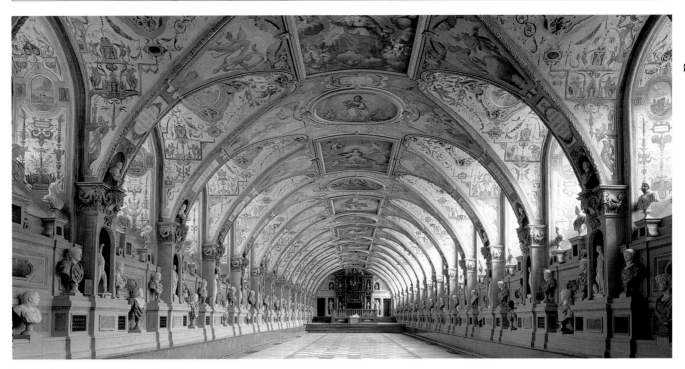

Das Antiquarium der Münchner Residenz

PUBLIC STATELY HOMES IN BAVARIA –
THE ADMINISTRATION OF A PROUD TRADITION

Bavaria is known for its wealth of palatial buildings, unique and well-preserved ensembles of great European architecture and artistic interiors, often set in impressive parks or gardens. They are total art works (Gesamtkunstwerke) which have evolved historically, and about fifty are run by the *Bayerische Verwaltung der staatlichen Schlösser, Gärten und Seen*, the Bavarian Administration of State Palaces, Gardens and Lakes.

The work of this body includes the upkeep of these palaces, castles and gardens, research into their past, the restoration of damaged elements, and a dynamic presentation of their historical significance. The Administration has set itself the task of enhancing the tourist appeal of sites in its care by updating display techniques and organising temporary thematic exhibitions of the precious items they house. Much importance is attached to the "in situ art museum", which, rather than showing objects in isolation from their historical context, embeds them within the original milieu. In this manner, art is not presented simply for abstract pleasure, but experienced in its intended function. Many stately homes and castles provide an authentic scene for concerts, plays and other events, as part of the responsible preservation of natural landscapes and monuments.

The head office of the Administration, with its various departments, is based in Munich.
Properties are managed from here, and central functions such as personnel management, legal services and finan-

cial planning are carried out for an administrative network which stretches across the federal state of Bavaria. Publications and publicity material for all the attractions are planned and produced in Munich.
The Museum Department is responsible for research and the more scientific aspects of this heritage, including the creation and design of museums and exhibitions.
The Construction Department plans, implements and supervises structural works. Scientific research into our buildings ensures that we comply with the requirements of monument preservation.
In-house workshops provide the facilities to care for and restore the items in our artistic collections.
The Gardens Department is responsible for the historical gardens and parks. Its remit also includes nature conservation.

The local administrations ensure orderly operation "in the field". Their work provides indispensable support for the central administration in Munich.

The Administration preserves Bavaria's precious artistic and historical legacy with a staff of under 1,000 people. They are committed to ensuring that our visitors – over five million a year – benefit from a vivid and stimulating encounter with the history of Bavarian art and culture.

Bayerische Verwaltung der staatlichen Schlösser, Gärten und Seen

Residenz Ansbach
Schloß- und Garten-
verwaltung Ansbach
Promenade 27
D-91522 Ansbach
Tel. (+49/0) 9 81/31 86
Fax (+49/0) 9 81/9 58 40

Guided tours of
period interiors and

M the local gallery of
the Bavarian State
Collection of Paintings
1 April–30 September:
9 am–6 pm
1 October–31 March:
9 am–4 pm
Guided tours every hour
Closed on Mondays

Lift available, requirement
at the ticket office

Summer concerts in the
orangery

Court arcades
by Gabriel de Gabrieli

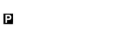

The Residence

This Residence evolved from a medieval complex. The *Gothic Hall* (Gotische Halle) dating from about 1400, now displays faience and porcelain from a manufactory once run by the Margraves of Ansbach, whose seat this was. Between 1705 and 1740 the medieval buildings were restructured to satisfy modern criteria. Architect Gabriel de Gabrieli built the fine, Mediterranean-style courtyard with its arcaded walkways.

The Ansbach Residence primarily acquired its renown on account of the quality and stylistic consistency of its interiors, most of which were completed between 1734 and 1745 by French-trained sculptors and painters under the artistic guidance of architect Leopold Retti. The silk wallpaper, stucco and furniture are of an extraordinary quality. When the Margraves of Brandenburg-Ansbach lost their lands to the King of Bavaria in 1806, few changes were made on the main floor. This is divided into three sequences of rooms used independently for official ceremonies: the *Margrave's Apartment* (Appartement des Markgrafen), the *Margravine's Apartment* (Appartement der Markgräfin) and the *Guest Apartment* (Gästeappartement), with a fixed succession of ante-rooms, halls of audience, bedrooms and private closets.

The Ansbach Residence boasts a *Court Garden* (Hofgarten) with an orangery. This garden was separated from the palace by older buildings. The central

Banqueting Hall (Festsaal), *ceiling fresco by Carlo Carlone, 1734/35*

structure here is the orangery, built from 1726 to 1743 with a parterre in front and a linden hall to each side. The principal axis, formed by two double rows of linden hedge, runs parallel to the front of the building. The spring and summer flower arrangements in the parterre contain a rich diversity of species in keeping with baroque pattern books. The selection of potted plants which appears outside the orangery in summer consists of lemons, pomeranzas, olives, pistachio, laurel and strawberry trees. Memorials and plaques recall the botanist Leonard Fuchs, writer Johann Peter Uz, Freiherr von Benkendorff, who served as a minister in the government of the March, and Caspar Hauser, the foundling murdered in the garden in 1833.

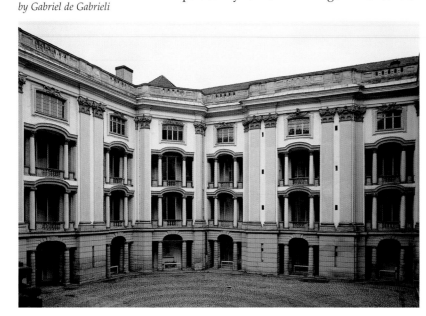

Schloss Johannisburg

The Schloss in Aschaffenburg, built from 1605 to 1614 in red sandstone by a master mason from Strasbourg, Georg Ridinger, is one of Germany's grandest Renaissance palace complexes. Until 1803 it served as a second official residence for the Archbishops and Electors of Mainz. It was named Johannisburg after John the Baptist, the patron saint of Archbishop Johann Schweikart of Kronberg, for whom it was built. The massive plinth wall over the banks of the River Main supports four wings, each three storeys high, and four corner towers 52 metres high. The only asymmetrical feature in this arrangement is the old castle keep. This is the only existing remnant of the earlier building on this site, the medieval castle which burnt down in 1552. Like the façades with their splendid gables, the single-aisle *palace church* thoroughly reflects the formal idiom of the early 17th century. The altar made by Hans Juncker of Franconia in 1614 contains some 150 alabaster figures, either relief or fully sculpted. It is one of the finest specimens of German sculpture from that period.

Apart from the church and the spiral stairways, almost all the rooms in the palace were modernised in the 18th century. Elector Friedrich Carl of Erthal initiated this comprehensive programme in 1774. Architect Emanuel Joseph von Herigoyen furnished the completed rooms in the contemporary style of Louis Seize. These impressive neo-classical apartments suffered widespread damage in the Second World War. The palace itself

Cork Model Collection, Constantine's Arch

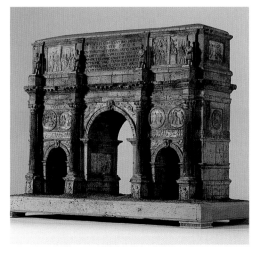

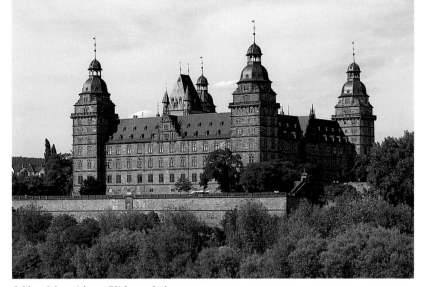

Schloss Johannisburg, Blick von Süden

was gutted and did not re-open until 1964, following major reconstruction. The wing with the *Electorial living quarters* was faithfully copied and fitted with what remained of the original furnishings, including valuable items by Johannes Kroll, a pupil of Roentgen. The items which have survived include magnificent ecclesiastical robes from Mainz Cathedral on display in the *vestment chamber* (Paramentenkammer). Schloss Johannisburg has another unusual attraction to offer: the world's largest *collection of historical cork models*. The permanent exhibition "Carrying Rome Across the Alps" shows 29 of these amazingly detailed models of coloured cork, which illustrate the best-known buildings of Ancient Rome. These replicas, made between 1792 and 1854 by court pastry-cook Carl May and his son Georg, vary in size from the Cestius Pyramid (20 cm) to the biggest cork model anywhere, the Colosseum with a diameter of over 3 metres.

Steps lead down from the Schloss to the *Main Terraces* with broad views over the Main Valley. Visitors will now follow an arcade, crossing the *palace garden* (Schloßgarten) and passing the neo-classical *breakfast pavilion* (Frühstückspavillon), before reaching the *Pompejanum* a few minutes later.

Schloss Johannisburg
i Schloß- und Garten-
 verwaltung Aschaffenburg
 Schlossplatz 4
 D-63739 Aschaffenburg
 Tel. (+49/0) 60 21/38 65 70
 Fax (+49/0) 60 21/38 65 16

☉ Open for viewing of the
 Electorial living quarters
 and cork model collection
 with

 M the local gallery of
 the Bavarian State
 Collection of Paintings
 (focus on Lukas Cranach)
 and

 M Municipal Palace
 Museum
 (local history collections)
 1 April–30 September:
 9 am–6 pm
 1 October–31 March:
 10 am–4 pm
 Closed on Mondays

♿ Lift available, requirement
 at the ticket office

✗

P

DB

Pompejanum
Pompejanumstraße 5
D-63739 Aschaffenburg

ℹ Schloß- und Garten-
verwaltung Aschaffenburg
Schloßplatz 4
D-63739 Aschaffenburg
Tel. (+49/0) 6021/386570
Fax (+49/0) 6021/3865716

🕐 Open for interior viewing
including

Ⅿ the local gallery of
the State Classical
Collections and
Munich Glyptotheque
1 April–30 September:
9 am–6 pm
Closed on Mondays
1 October–31 March:
closed

♿ First floor only accessible
via stairs

🅿

🄳🄱

Pompejanum

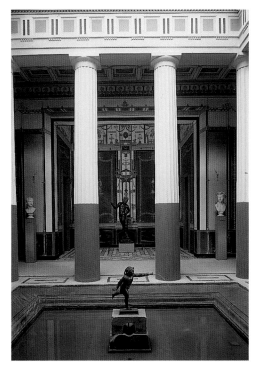

Pompejanum, looking through the atrium to the ala

The Pompejanum stands amid pines, cedars and fig trees on a sloping vineyard above the River Main. Inspired by excavations in Pompeii, Bavaria's King Ludwig I, who cherished a passion for the Ancient world, had this ideal replica of a Roman house constructed by architect Friedrich von Gärtner in 1843–1848. Gärtner's prototype was the House of Castor and Pollux in Pompeii, adding the outside steps and the "belvedere" on the second floor in deference to the scenic surroundings. Ludwig I wanted his reconstruction of a Roman town house in the first century AD to be as true to the original as possible. Ludwig hoped that connoisseurs of Ancient art would derive instructive benefit from his Pompejanum, with its reproductions of Roman wall paintings and its floor mosaics based on authentic typologies.

After severe damage in the Second World War, the interiors have been lavishly restored, in some cases rebuilt. The Pompejanum opened as a museum in 1994.

Aschaffenburg

**Schloss Schönbusch
and Park**
Kleine Schönbuschallee 1
D-63741 Aschaffenburg

ℹ Schloß- und Garten-
verwaltung Aschaffenburg
Schloßplatz 4
D-63739 Aschaffenburg
Tel. (+49/0) 6021/386570
Fax (+49/0) 6021/3865716

🕐 Guided tours every hour
1 April–30 September:
9 am–6 pm
Closed on Mondays
1 October–31 March:
closed

Park open all year round

♿ Historical rooms only
accessible via stairs

�֍

🅿

Schloss Schönbusch

Schloss Schönbusch and Park

Schönbusch Park is one of Germany's oldest landscape gardens. Friedrich Carl of Erthal, Archbishop and Elector of Mainz, had the Electoral Deer Enclosure refashioned into a park from 1775. His Minister of Public Affairs, Count Wilhelm of Sickingen, provided considerable support as artificial lakes and waterways were dug, mounds created and a serpentine path laid round the outside. Architect Emanuel Joseph von Herigoyen designed the built structures in the garden. The first of these was the Electoral Pavilion, built between 1778 and 1782 as a little neo-classical summer residence with exquisite Louis Seize furnishings and known today as *Schloss Schönbusch*. By 1788/89 it had been joined, amongst others, by the *utility building* (Wirtschaftsgebäude), the *herdcots* (Hirtenhäuser) and *hamlet* (Dörfchen) as picturesque rural sets, the *Temple of Friendship* (Freundschaftstempel) and the *House of Philosophy* (Philosophenhaus), the *viewing tower*, the *dining hall* (Speisesaal) and the *Red Bridge*. Friedrich Ludwig

Sckell had been appointed to complete the garden by 1783 at the latest. This was Sckell's first opportunity to apply the landscaping principles he had learnt in England to a completely new park. He left posterity one of Germany's greatest accomplishments in landscape garden design.

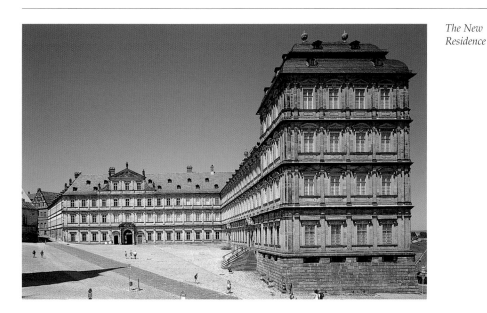

The New Residence

ℹ **Neue Residenz Bamberg**
Staatliche Schloß-
verwaltung Bamberg
Domplatz 8
D-96049 Bamberg
Tel. (+49/0) 9 51/5 63 51
and 5 10 11
Fax (+49/0) 9 51/5 59 23

🕙 Guided tours of
the Rooms of State with

Ⓜ Bamberg State Gallery
The Baroque Gallery and
Old German Gallery contain
paintings from the Bavarian
State Collection, Bamberg
Municipal Collection and
other institutions.
1 April–30 September:
9 am–6 pm, Thu 9 am–20 pm
1 October–31 March:
10 am–4 pm
Open on Mondays

Rose Garden
🕙 1 March–30 September:
9 am–6 pm
1 October–28/29 February:
9 am–4 pm
Closed in winter during bad
weather

♿ Entrance hall accessible by
ramp; Lift available

✗

🅿 – 🚉

Ⓜ Old Court: At the heart of
the Old Court, opposite the
New Residence, there are
still fragments of masonry
from the Great Hall and
Chapel of the seasonal resi-
dence used by the Bishops
in the 11th century. Today
the building houses Bam-
berg History Museum.
Tel. (+49/0) 9 51/87 11 42

The New Residence

With two elongated wings and terminat-ing in the Fourteen Saints Pavilion (Vierzehnheiligenpavillon), the imposing sandstone of the Bamberg Residence hems two sides of the cathedral square. The Prince-Bishops of Bamberg lived and governed here until 1802. Prince-Bishop Lothar Franz of Schönborn commissioned Johann Leonard Dientzenhofer to design Franconia's first full-scale baroque palace in the form of these two wings between 1697 and 1703. They adjoined two older wings at the rear, built in 1613. The impressive exterior, which escaped the ravages of war, is surpassed only by the splendour of the interior. In more than forty magnificent rooms, original stucco ceilings and inlaid floors, and some 500 valuable items of furniture and fittings dating from the 17th and 18th centuries, radiate the authentic atmosphere of a seat of princes. In the *Imperial Hall* (Kaisersaal) Melchior Steidl's frescoes (1707–1709) show sixteen larger-than-life portraits of German Emperors, while the painted ceil-ing illustrates the timeless allegory of Good Governance. Among the most valu-able items in the *Imperial Rooms* (Kaiser-zimmer) are the French woven hangings from Beauvais, made around 1730. Apart from the *Elector's Rooms* (Kurfürstenzim-mer) and the *Prince-Bishop's Chambers* (Fürstbischöfliche Wohnräume), the pub-lic has access to rooms which recall the exile of *King Otto of Greece*, a Wittelsbach, who stayed here with his wife Amalie after being forced to leave Athens in 1862.

Rose Garden

The rose garden, which borders on the residence, is situated on a large terrace. From here the visitor can enjoy a fantastic view of the town of Bamberg. It is divided into four sections where the paths cross at its centre, marked by a round fountain pool. In the summer months the fragrance and beautiful flowers of around 4,500 rose bushes spread all across the garden. The dainty pavilion completed in 1757 provides an architectonic point of reference and today accommodates a cafe.

New Residence, Imperial Hall
Painted by Melchior Steidl, 1707-09

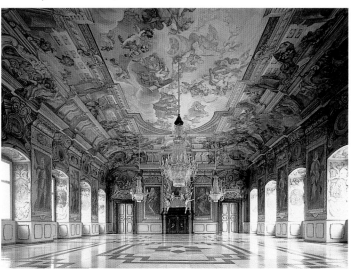

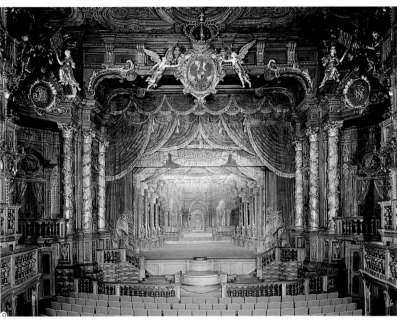

Margravial Opera House

ℹ Schloß- und Garten-
verwaltung Bayreuth-
Eremitage
Ludwigstrasse 21
D-95444 Bayreuth
Tel. (+49/0) 9 21/75 96 90
Fax (+49/0) 9 21/7 59 69 15

Margravial Opera House
Opernstrasse 14
D-95444 Bayreuth

🕙 Open with sound and
lighting display
1 April–30 September:
9 am–6 pm, Thu 9 am–8 pm
1 October–31 March:
10 am–4 pm
Closed on Mondays

♿ Viewing possible

✗ – 🅿 P 7 (guided parking)

DB – 🚌

New Palace
Ludwigstrasse 21
D-95444 Bayreuth

🕙 Open for interior viewing
with faience from Bayreuth
(Rummel Collection)
as Margravial Opera House

Ⓜ Archaeology Museum
of the Upper Franconian
History Society
Tel. (+49/0) 9 21/6 53 07

🅿 P 6 outside the Stadthalle

DB – 🚌

Bayreuth

Margravine Wilhelmine of Bayreuth (1709–1758), the favourite sister of the Prussian King Friedrich II, must take the credit for making the court at Bayreuth a centre of the European arts during the rococo period. In 1731 Wilhelmine had married Friedrich, the heir to Bayreuth who became Margrave in 1734.

The Margravial Opera House

This opera house, built from 1744 to 1748, is a gem among theatres and one of a

handful in Europe to have been preserved in its original form. The building was designed by Joseph Saint-Pierre, and the magnificent interior by Giuseppe Galli Bibiena, a renowned theatre architect from Bologna. It is made of timber on a bell-shaped plan with boxes for the audience. These are arranged on three tiers, reflecting social status. The Margrave and his consort appeared on special occasions in the central Prince's Box. The message conveyed by the architecture and furnishing of this court theatre was that Friedrich and Wilhelmine heralded an age of peace and wisdom in which the arts would prosper. The opera house was inaugurated for the wedding of their daughter Elisabeth Friederike Sophie and Duke Carl Eugen II of Württemberg.

New Palace and Court Garden

After the old palace burned down, court architect J. Saint-Pierre began building the new town residence, or "Neues Schloss" in 1753. Wilhelmine designed her private chambers personally, and special mention should be made of her *Room of the Fragmented Mirrors* (Spiegelscherbenkabinett), with mirrors inlaid within Chinese motifs, and the *Old Music Room* (Altes Musikzimmer). Jean-Baptiste Pedrozzi provided the stucco. The precious woven hangings in the *Inner Ante-Room* (Inneres Vorzimmer) and the *Hall of Audience* (Audienzzimmer) are from Alexander I. Baert's Amsterdam manufactory. *The Palm Room* (Palmenzimmer) in the Margrave's Wing is typical of late rococo in Bayreuth (around 1755), and creates the illusion that one is standing in a grove of palm trees. A wide-ranging *collection of Bayreuth faience* from the manufactory founded in 1716 is on display on the ground floor of this "new palace".
The site of the *court garden* (Hofgarten) has been used as a garden since the late 16th century. The late baroque layout of around 1753/54 made way at the end of that century for the "English fashion". The Monopteros, or Sun Temple, originates from that time.

New Palace, Bayreuth

Hermitage, New Palace Looking south to the Sun Temple and the eastern rotunda

Hermitage

The *Old Palace* (Altes Schloß) was built for Margrave Georg Wilhelm in 1715 as the central feature of a court "hermitage", along with gardens, waterfalls and seven "hermits' holes" which have not survived. From 1735 Margravine Wilhelmine converted the Schloss into a cheerful summer residence. The highlights are her *Audience Chamber* (Audienzzimmer), the *Music Room* (Musikzimmer), the *Japanese Cabinet* (Japanisches Kabinett) and the *Chinese Mirror Cabinet* (Chinesisches Kabinett), where Wilhelmine wrote her celebrated memoirs.

The *garden*, which also bears her stamp, was adorned with baroque elements such as parterres, bosquets, avenues and a canal garden. The water spectacle in the *Lower Grotto* was designed to be watched from the terrace or from Margrave Friedrich's *Hermit House* (Eremitenhaus). A Roman theatre, built around 1745 by J. Saint-Pierre, is the earliest example of an artificial theatre ruin. The garden and adjacent woodland were encircled by a "girdle path", later a typical feature of landscape gardens. The oval plan of the *New Palace in the Hermitage* (Neues Schloß Eremitage) (1753–1757) defined a border for this project. The exterior front of the central *sun temple* (Sonnentempel) and the curving structures of the orangery wing are clad in glittering rock crystal and vitified paste. Apollo with his sun chariot crowns the middle temple structure. In front is a pool with mythical statuary.

Eremitage
ℹ Schloß- und Gartenverwaltung Bayreuth-Eremitage
Ludwigstrasse 21
D-95444 Bayreuth
Tel. (+49/0) 9 21/7 59 69-0
Fax (+49/0) 9 21/7 59 69-15

Old Palace Hermitage
🕙 open for viewing
1 April–30 September:
9 am–6 pm, Thu 9 am–8 pm
Open on Mondays
1 October–31 March:
closed
Inner Grotto with fountains playing in summer

New Palace Hermitage
Outside viewing only

Historical gardens: From May to mid-October the fountains play every day between 10 am and 5 pm on the hour

♿ Wheelchairs can be lent out at the Kiosk on demand; at the moment only one step

✗

🅿

DB – 🚌

Felsengarten Sanspareil, Morgenländischer Bau and Burg Zwernitz
Bayreuth-Sanspareil
Haus Nr. 29
D-96197 Wonsees
ℹ Schloß- und Gartenverwaltung Bayreuth-Eremitage
Ludwigstrasse 21
D-95444 Bayreuth
Tel. (+49/0) 9 21/7 59 69-0
Fax (+49/0) 9 21/7 59 69-15

🕙 Open for viewing
15 April–15 October:
10 am–5 pm
Closed on Mondays
16 October–14 April: closed

♿

✄

🅿

Sanspareil Rocky Garden, Ruined Theatre

Sanspareil

The rocky garden of *Sanspareil* lies beneath the medieval *Hohenzollern castle of Zwernitz* (Burg Zwernitz), which Margrave Friedrich ordered to be restored from 1744 when the garden was being laid out. During the margrave years, the bizarre rock formations here were named after locations in the French novel "The Adventures of Telemachos". Some buildings have survived: the *Ruined Theatre* (Ruinentheater), the *Oriental Building* (Morgenländischer Bau) with its recreated parterre, and the Kitchen. The name is attributed to a guest who allegedly exclaimed: "C'est sans pareil!" – "It has no equal!"

Bayreuth/Donndorf

Schloss Fantaisie and Park
Bayreuth-Donndorf
Bamberger Strasse 3
D-95488 Eckersdorf/Donndorf
ℹ Schloß- und Gartenverwaltung Bayreuth-Eremitage
Ludwigstrasse 21
D-95444 Bayreuth
Tel. (+49/0) 9 21/7 59 69-0
Fax (+49/0) 921/7 59 69-15

About 3 miles (5 km) west of Bayreuth in Donndorf

🕙 Museum of the art of gardening Schloss Fantaisie
1 April–30 September
9 am–6 pm
Closed on Mondays
1 October– 31 March closed

Park and Pavilion opened all year round

♿ Lift available

🅿

Schloss Fantaisie and Park

Elisabeth Friederike Sophie (1732–1780) completed the building begun by her father, Margrave Friedrich of Brandenburg-Bayreuth (r. 1735–1763), in the years between 1763 and 1780, adding a late baroque garden with a pavilion, waterfall and Neptune fountain. In 1793 the property was purchased by Dorothee Sophie of Württemberg (1764–1838), who enlarged it with a landscape garden of the sentimental era, with catacombs, a Column of Harmony and other structural accessories. Under Duke Alexander Friedrich Wilhelm of Württemberg (1804–1881) the building was redesigned and the park acquired a pond, fishermen's huts, terraced vines, exotic shrubs and a diversity of flowers. This resulted in a total art work, a garden with a unique combination of features from different 18th- and 19th-century styles.

Schloss Fantaisie

Burghausen, main precinct from the north-east

Burghausen Castle

Burghausen is one of Germany's biggest castles. It stretches more than 1,000 yards (a kilometre) along a ridge above the Salzach. Duke Heinrich XIII of Lower Bavaria-Landshut (r. 1255–1290) built large sections of the *main precinct castle* (Hauptburg) with the *Great Hall* (Palas), *Knights' Hall* (Dürnitz), inner *Chapel of St Elizabeth* (Innere Burgkapelle St. Elisabeth) and ladies' *Bowers* (Kemenate). The five surviving forecourts date back to the late 15th century. The castle served primarily as a residence for the lady consort of the reigning duke of Lower Bavaria, as the home of the ducal heir, and as a place of safekeeping for the wealth of the "Rich Dukes". To cater for these needs, Duke Georg the Rich (r. 1479–1503) ordered extensions to every building in the main precinct.

The museum display in the *Great Hall* (Palas), with furniture, paintings, sculpture and woven wall hangings of the Gothic and early Renaissance periods, conveys some impression of how the dukes lived. The threat of an Ottoman invasion also prompted the dukes to renew and strengthen their fortifications. The Bohemian master mason Benedikt Ried is believed to have contributed. The sprawling castle at Burghausen thus became an imposing bulwark, defending those inside while demonstrating the power and aspirations to prestige of its overlords. It is seen as an outstanding example of Gothic and early Modern techniques for building castles and defences.

Burg zu Burghausen
Burg Nr. 48
D-84489 Burghausen
Tel. (+49/0) 86 77/46 59
Fax (+49/0) 86 77/6 56 74

i Staatliche Schloß-
verwaltung Landshut
Burg Trausnitz 168
D-84036 Landshut
Tel. (+49/0) 8 71/9 24 11-0
(Info-Line 9 24 11-44)
Fax (+49/0) 8 71/9 24 11-40

⊘ Castle rooms open for
viewing with museum and

M a gallery of the Bavarian
State Collection of Paintings
on the upper floor of the
Great Hall (Late Gothic
panels)
1 April–31 October:
9 am–6 pm; Thu 9 am–8 pm
1 October–31 March:
10 am–4 pm
Open on Mondays

♿ – **P** – **DB**

M The Bowers house the
municipal History Museum,
Tel. (+49/0) 86 77/8 87-1 06

M Municipal museum of pho-
tography, Tel. (+49/0)
86 77/47 34

M Torture Museum (private),
Tel. (+49/0) 86 77/6 41 90
and 6 29 00

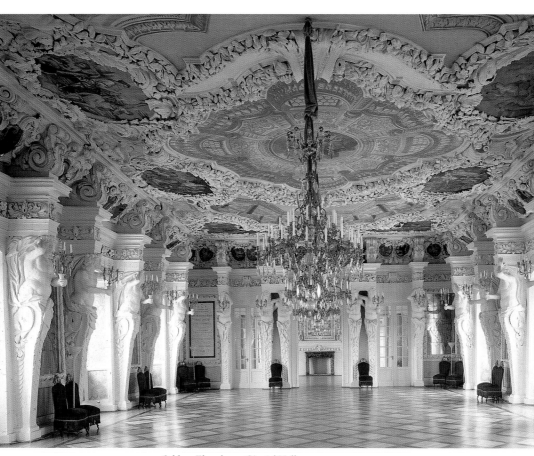

Schloss Ehrenburg, Giants' Hall

Schloss Ehrenburg
ℹ Schloss- und
Gartenverwaltung Coburg
Schloss Ehrenburg
D-96450 Coburg
Tel. (+49/0) 95 61/80 88-0
Fax (+49/0) 95 61/80 88-40

◷ Guided tours every hour
Apartments
1 April–30 September:
9 am–6 pm
1 October–31 March:
10 am–4 pm
Closed on Mondays

♿ by prior arrangement

🅿

DB

Ⓜ Veste Coburg
Tel. (+49/0) 95 61/8 79-0
Fax (+49/0) 95 61/8 79-66
This fortress above the
town is one of Germany's
largest castles. The art col-
lections in Veste Coburg
include valuable prints,
glassware, weaponry and
paintings by old German
masters.

Schloss Ehrenburg

In 1547 Duke Johann Ernst of Saxe-Coburg (r. 1542–1553) moved his courtly entourage downhill from the old fortress to his newly built town seat. It had taken less than five years to build on the site of a dissolved Franciscan monastery. Emperor Karl V (r. 1519–1566) is alleged to have baptised it the "Ehrenburg", or "castle of honour", because the work had been accomplished without socage. After a fire, the building was expanded from 1690 into a baroque palace with three wings. Its church and *Hall of Giants* (Riesensaal) date from this period. This magnificent room takes its name from the pillars disguised as mighty figures of Atlas which support the entablature. The lavish, heavy stucco was made by Carlo Domenico and Bartolomeo Luchese from North Italy. The rococo years are exempli-fied in the stucco of the Andromeda Room, now used for Library lectures. From 1810, under Duke Ernst I (r. 1806–1844) the Berlin architect Karl Friedrich Schinkel produced designs for a

neo-Gothic façade. The apartments were given their decorative Empire splendour by a Frenchman, André-Marie Renié-Grétry. The quality of the interiors with their furniture, bronze and textiles is as impressive as their well-preserved condi-tion. The House of Coburg climbed the rungs of international status in the 19th century, thanks to some strategic mar-riages. Many portraits in Schloss Ehren-burg still recall family links with, for example, the monarchs of Britain, Bel-gium and Sweden. Objects inspired by Historicism illustrate palace life in the late eighteen-hundreds. The Dukes of Coburg also owned a substantial collection of paintings, and two galleries display works by Lukas Cranach the Elder, Dutch and Flemish artists of the 16th and 17th centuries, and Romantic landscapes.

Schloss Rosenau
D-96472 Rödental
Tel. (+49/0) 95 63/47 47
Fax (+49/0) 95 61/80 88-40
i Schloss- und
Gartenverwaltung
Coburg
Schloss Ehrenburg
96450 Coburg
Tel. (+49/0) 95 61/80 88-0
Fax (+49/0) 95 61/80 88-40

BAVARIA

⊘ Guided tours every hour
Schloss rooms
1 April–30 September:
9 am–6 pm
1 October–31 March
10 am–4 pm
Closed on Mondays

✕

P outside the Orangery

M Orangery in Rosenau Park:
Modern Glass Museum of
the Fort Coburg Art Collec-
tions

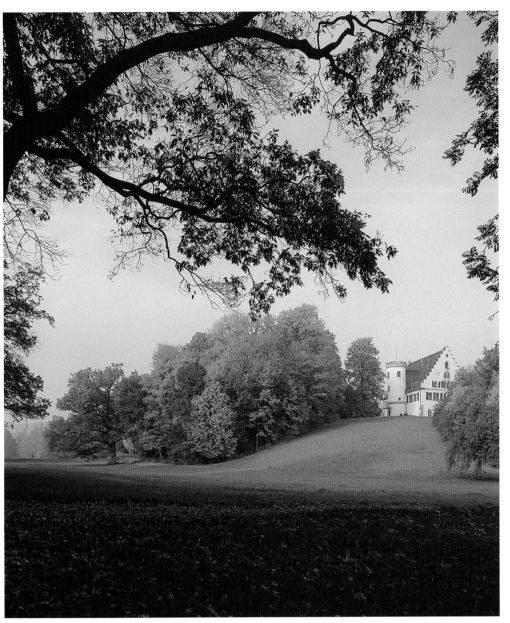

Schloss Rosenau

Schloss Rosenau

Duke Ernst I of Saxe-Coburg-Saalfeld had this palace with its medieval core restructured from 1808 to 1817. Karl Friedrich Schinkel offered suggestions for this astonishingly early specimen of neo-Gothic architecture in Germany. The Duke sought to revive Rosenau in the spirit of medieval chivalry, as the *Knights' Library* (Ritterbibliothek) on the ground floor illustrates. The court also held banquets in "old German costume" in the *Marble Hall* (Marmorsaal) with its three aisles. By contrast, the rooms upstairs are furnished in a cosier Biedermeier style. The Viennese furniture, polished black, matched well with the neo-Gothic wall paintings with their strong hues. The Schloss is located in the middle of a landscape garden. A number of its features have survived, notably the Swan Pond and Prince's Pond, a grotto with a waterfall, stone benches, a hermitage, the tea house (now the Park Restaurant) and the orangery. A Jousting Column (sundial) recalls the "tournaments of knights" held in the park by Ernst I. His son Prince Albert was born at Rosenau in 1819. Albert later married Queen Victoria of Great Britain and Ireland, who said of Rosenau: "If I was not what I am this would have been my real home."

Schloss Dachau
Schlossstrasse 7
D-85221 Dachau
Tel. (+49/0) 81 31/8 79 23
Fax (+49/0) 81 31/7 85 73

ℹ Schloß- und Garten-
verwaltung Schleißheim
Max-Emanuel-Platz 1
D-85764 Oberschleissheim
Tel. (+49/0) 89/31 58 72-0
Fax (+49/0) 89/31 58 72-50

🕐 Open for viewing
Schloss rooms
1 April–30 September:
9 am–6 pm
1 October–31 March:
10 am–4 pm
At present closed for
alterations

✕

🅿

Ⓢ

Schloss Dachau

Schloss Dachau was the first Modern summer residence built by the Wittelsbach dynasty. Duke Wilhelm IV (r. 1508–1550) and Duke Albrecht V (r. 1550–1579) instructed Heinrich Schöll and Wilhelm Egkl, master masons at the Munich court, to transform the medieval castle into a massive four-wing palace. In the early 19th century, building stopped on three-quarters of the complex, and only the wing with the *Festive Hall* (Festsaal) survived. Its pride is the wooden ceiling, regarded as one of the finest Renaissance ceilings in Germany. The iconography has been composed to pay tribute to the House of Wittelsbach, in particular Duke Albrecht V. The exquisite cassettes show the heraldic arms of the two men who commissioned the building and those of their wives. Foremost at the centre are the arms of Ludwig IV, the first German Emperor to issue from Bavaria's ruling family.
Old garden walls, a baroque lime pergola, a formal fruit orchard and a little copse exemplify the different eras of garden art

Schloss Dachau, Hall

which have moulded Dachau's *court garden* (Hofgarten) since the 16th century. Its delightful location on the ridge of a hill offers a magnificent panoramic view across to the Alps.

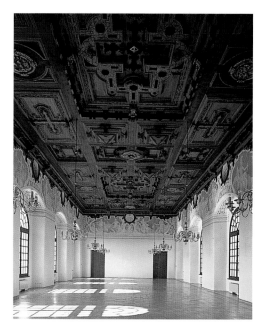

Eichstätt

Willibaldsburg Eichstätt
Burgstrasse 19
D-85072 Eichstätt
Tel. (+49/0) 8421/4730
Fax (+49/0) 8421/8194

ℹ Schloß- und Gartenverw.
Ansbach, Promenade 27
D-91522 Ansbach
Tel. (+49/0) 981/3186
Fax (+49/0) 981/95840

🕐 Open for viewing

Ⓜ Jurassic Museum
(State Natural History
Collections)
Tel. (+49/0) 8421/89450

Ⓜ Museum of Prehistory
and Early History
(Eichstätt History Society)
Tel. (+49/0) 8421/2956
1 April–30 September:
9 am–6 pm
1 October–31 March:
10 am–4 pm
Closed on Mondays

♿ It is possible to visit most
parts of the Jura museum.
Steep descent to the Hortus
Eystettensis

✕ – 🚆

Willibaldsburg

The castle on Willibaldsberg was founded in 1355 by the Bishops of Eichstätt. The conversion from a medieval fort into a prestigious residence was undertaken by Prince-Bishop Johann Conrad of Gemmingen (r. 1595–1612). He appointed the celebrated master mason of Augsburg, Elias Holl, who built one of the outstanding accomplishments of early baroque in southern Germany. In the mid-18th century, the Bishop's household was moved to the new town residence, and some of the complex was razed to the ground in the 19th century. Today the scene is dominated by the *Gemmingen Building* (Gemmingenbau). Today's visitors must imagine the twin-tower front with three storeys and onion-shaped tower tops.
The Administration recreated the *Bastion Garden* (Bastionsgarten), which opened in 1998, from the volume of copper engravings *Hortus Eystettensis* published in 1613 by *Basilius Besler* (1561–1629). This

Willibaldsburg with the newly laid out Bastion Garden

instructional garden, which illustrates the flora described in the engraved work, is surely unique in Germany. Planting observes the seasonal flowering periods outlined in Besler's book. The arrangement also recalls the once renowned botanical garden which Besler made from 1592 for Prince-Bishop Johann Conrad of Gemmingen.

Residenz Ellingen
D-91792 Ellingen
Tel. (+49/0) 9141/3327
Fax (+49/0) 9141/72953
ℹ Schloß- und Garten-
verwaltung Ansbach
Promenade 27
D-91522 Ansbach
Tel. (+49/0) 981/3186
Fax (+49/0) 981/95840

🕗 Guided tours every hour
Schloss rooms
1 April–30 September:
9 am–6 pm
1 October–31 March:
10 am–4 pm
Closed on Mondays

♿ Lift available; requirement
at the ticket office

🅿

DB

Ⅿ East Prussian Cultural
Centre:
Tel. (+49/0) 9141/86440

BAVARIA

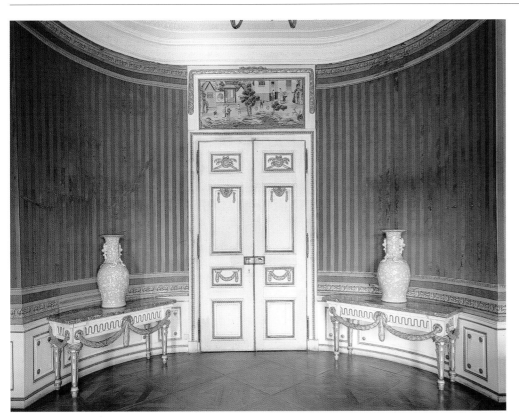

Residenz Ellingen, Vorzimmer (chinesisches Kabinett)

The Residence

Even for the distant traveller, the four wings of the Schloss and the great domed roofs of its corner pavilions dominate the silhouette of Ellingen. From 1216 to 1789 this was the seat of the Franconian Bailiwick of the Teutonic Order. The rooms devoted to the *Teutonic Order* and the former kitchen have been turned into a museum showing the history of the Teutonic Knights in Franconia.

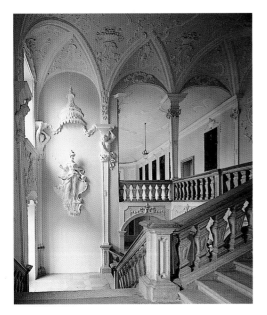

The Residence was built in 1718/20 under the Order's provincial commander Karl Heinrich Freiherr von Hornstein to a design by Franz Keller. It is the Order's most memorable 18th-century palace. These *stairs* are among the oldest great showpieces in Franconia. The original Régence and rococo interiors were renewed from 1774 to plans by the French architect Michel d'Ixnard, with the exception of the *palace church* (Schloßkirche). D'Ixnard also designed the *colonnade* along the east side of the courtyard – a major specimen of neo-classical monumental style in Bavaria. In 1815 King Max I of Bavaria gave Schloss Ellingen to his field-marshal Karl Philipp, Prince of Wrede. Wrede fitted the *Princely Rooms and Marshall's Rooms* (Fürsten- und Marschallzimmer) with furniture of the French Empire and replaced the old wall hangings with silk and paper coverings of a kind rarely found intact today. They include some major early wall prints.
The little *park* with its mature trees invites repose.

Ellingen Residence, stairs

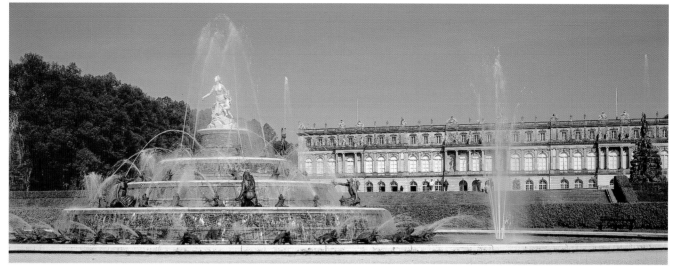

New Palace

**Neues Schloss
Herrenchiemsee
King Ludwig II Museum
Museum im Alten Schloss
Herrenchiemsee**
Staatl. Verwaltung
Herrenchiemsee,
Altes Schloß 3
D-83209 Herrenchiemsee
Tel. (+49/0) 80 51/68 87-0
Fax (+49/0) 80 51/68 87-99

The New Palace
Guided tours
Sumptuous rooms
1 April–30 September:
daily 9 am–6 pm
1 October–31 March:
daily 10 am–4 pm

Fountains:
1 May–30 September:
9.35 am–5.25 pm

King Ludwig II Museum
Open for viewing
1 April–30 September:
9 am–6 pm
1 October–31 March:
10 am–4 pm

The New Palace

To King Ludwig II of Bavaria, Louis XIV of France had personified the very ideal of monarchy. He had long planned to build a "new Versailles" and selected the "Neues Schloss" for this project, intending to create not so much a home as a glittering manifestation of absolutism. His New Palace is not a replica of Versailles. Rather, it quotes this prototype in various typical features, such as the main frontage, the Gallery of Mirrors and the Ambassadorial Stairs. However, even when these quotations appear accurate there are differences in size and proportion. Although Herrenchiemsee was never completed, it remains a self-sufficient testimony to Historicism, the monument of a king who was unable to play his royal role any longer except in the imagination. Some twenty sumptuous rooms are on view.

Anybody wishing to learn more about Ludwig is well advised to visit the *King Ludwig II Museum* in the south wing of the New Palace. It shows the story of the monarch's life until his early death, the planning for his beloved castles, the furbishing for his private apartment and for the Winter Garden in the Munich Residence. There is also a section devoted to his friendship with Richard Wagner.

The Herrenchiemsee Gardens

Again, Ludwig II did not seek to copy the park at Versailles completely when designing his gardens for the New Palace.

The "middle vista" from the central rooms of the Schloss is a pivotal feature, linking the restored *fountains* (Fama and Fortuna, the Marble and Latona Fountains), the Parterre with ornamental flowers and gravel, the Apollo Pool, the Canal and the driveway along the Avenue at the rear. The *Island Park* (Inselpark) is of earlier origins, with woodland, meadows and fruit orchards and pleasantly surprising views of the Alps and the New Palace. There is also a path to the *Chapel of the Holy Cross* (Hl.-Kreuz-Kapelle) (17th century) on the northern tip of the island.

Old Palace Museum

A visit here is an encounter with 1200 years of Bavarian history focussed into three themes: From Monastery to Royal Palace, King Ludwig II's Private Chambers and The Road to a German Constitution – the Herrenchiemsee Conference in 1948. The Benedictine monastery had roots in the 8th century. An Augustine order of canons regular was founded here around 1130. Well-known artists such as Johann Baptist Zimmermann worked on the baroque interiors. Secularisation in 1803 forced the canony to disband. Ludwig II bought the Herreninsel – the "isle of men" in deference to its monastic inhabitants – in 1873 and his private quarters were established in the east and south wings. The Constitutional Convention of 1948 met in the King's former dining-room to formulate a draft for the Parliamentary Council in Bonn.

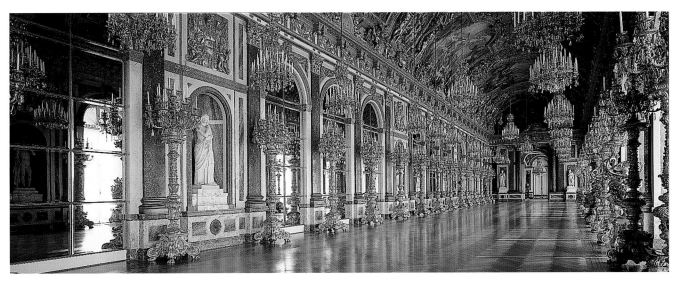

New Palace, Great Gallery of Mirrors

Next to the "Altes Schloss" stands the old parish *Church of St Mary* (St. Maria) with its noteworthy panelled ceiling of 1630.

The *Hall of Planes* (Platanensaal) with its view of the *isle of women* (Fraueninsel) was planted in 1893.

Old Palace Museum

🕑 Open for viewing
1 April–30 September:
daily 9 am–6 pm
1 October–31 March:
daily10 am–4 pm

The Palace and Museums are open on Mondays

♿ Lifts available by appointment at the ticket office or by phone

✕

DB to Prien

⛴ The island of Herrenchiemsee on Lake Chiem is reached by scheduled ferries from Prien and Gstadt.

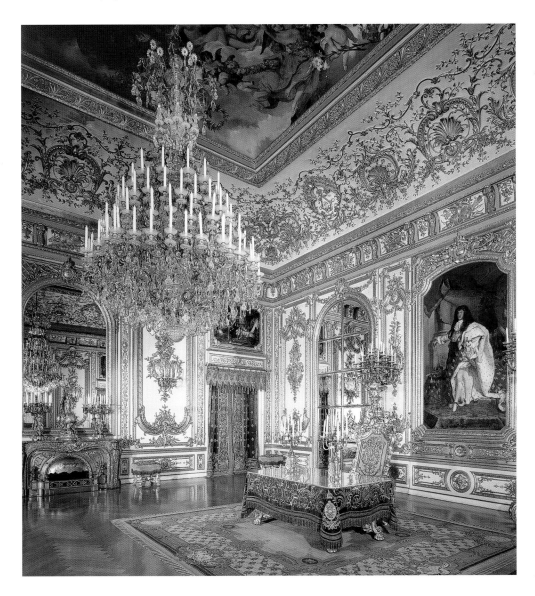

Neues Schloss, Beratungssaal

Schloss Höchstädt
D-89420 Höchstädt/Donau

ℹ Staatliche Schloß-
verwaltung Neuburg
Residenzstrasse 2
D-86633 Neuburg
Tel. (+49/0) 84 31/88 97
Fax (+49/0) 84 31/4 26 89

☉ Guided tours
2–5 pm: first and third Sun-
day in every month and by
arrangement
Tel. (+49/0) 90 74/49 56
(Custodians of local history)

♿ Chapel accessible by some
stairs

🚉 *Schloss Höchstädt*

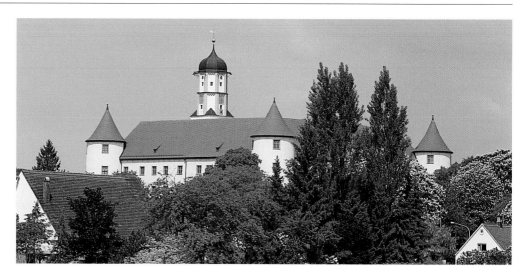

Schloss Höchstädt

Schloss Höchstädt was built from 1589 to 1603 for Count Palatine Philipp Ludwig of Palatine-Neuburg. The four-winged complex with its round corner towers was the work of the court's master mason Sigmund Doctor and Gilg Vältin from Graubünden. The famous painted interior for the *palace chapel* (Schloßkapelle) shows the Salvation Story and is dated 1601. The artist, thought to be Mang Kilian, drew on Michelangelo's paintings for the Sistine Chapel. The chapel in Höchstädt contains the first section of a museum in the process of foundation devoted to German faience and the manufactories of southern Germany.

Kelheim

Befreiungshalle Kelheim
ℹ Verwaltung der
Befreiungshalle Kelheim
Befreiungshallestrasse 3
D-93309 Kelheim
Tel./Fax (+49/0) 94 41/15 84

☉ Open for viewing
1 April–30 September:
9 am–6 pm, Thu 9 am–8 pm
1 October–31 March:
9 am–4 pm
Open on Mondays

♿ Only accessible via stairs

✖

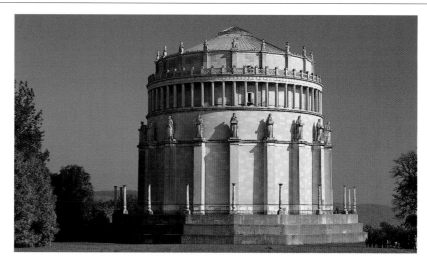

Hall of Liberation

Hall of Liberation

The Hall of Liberation is an imposing rotunda perched on top of Michelsberg where the River Altmühl flows into the Danube. In 1843 King Ludwig I asked his architect Friedrich Gärtner to construct a monument to victory against Napoleon in the Liberation Wars of 1813–1815. After Gärtner's death in 1847, Leo von Klenze modified the plans, completing the work in 1863. Colossal statues, allegories of Germanic tribes, crown the buttresses outside. Inside the monumental domed hall, in front of arcade niches, are thirty-four "victory goddesses" supporting gilded shields of cannon bronze with inscriptions marking victories in the liberation wars. Ludwig von Schwanthaler designed these sculptures in Carrara marble.

The Residence

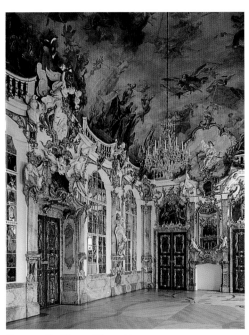

Kempten Residence, Throne Room

Kempten, the seat of Prince-Abbots, was the first monumental baroque monastery in Germany to be built after the Thirty Years War. Under Prince-Abbot Roman Giel of Gielsberg, master masons Michael Beer and Johann Serro transformed the church and residence between 1651 and 1670. The *Prince-Abbot's quarters* in the south wing were decorated and furnished in 1732–1735 under court painter Franz Georg Hermann. His team included well-known stucco artists from Wessobrunn such as J. Georg Üblherr and the Flemish sculptor Aegid Verhelst. The culmination of any visit is the sumptuous Throne Room, reputedly designed by Dominikus Zimmermann (c. 1740). The ceiling fresco by court painter Hermann is a tribute to the Abbey. The Prince-Abbot's quarters present an unusual combination of sacred and secular architecture and ornament and an exceptionally warm and powerful use of colour, making this an agreeable home.

Residenz Kempten
Residenzplatz 4-6
i Finanzamt Kempten
(Revenue Office)
Am Stadtpark 3
D-87435 Kempten
Tel. (+49/0) 8 31/2 56-2 51
Fax (+49/0) 8 31/2 56-2 60

☾ Guided tours
Rooms of State
1 April–30 September:
9 am–4 pm
October:
10 am–4 pm
November, January–March:
Sa 10 am–4 pm
December: see local news-
papers
Closed on Mondays

♿ Lift available

🅿

DB

Kulmbach

Plassenburg

The Plassenburg, high above Kulmbach, is one of the mightiest castles in Bavaria. From 1338 to 1791 it belonged to the burgraves and later margraves of Nuremberg, members of the Hohenzollern family. The Plassenburg is exemplary in blending the defence features of a fortress with the grandiosity of a palace. Margrave Georg Friedrich of Ansbach (r. 1543–1603) appointed the celebrated architect Caspar Vischer to replace the war-torn castle with a new building from 1559. At the centre of the four wings we find one of Germany's finest Renaissance accomplishments known as the "Beautiful Courtyard", framed by impressive arcades with lavish sculpture. The massive High Bastion was not constructed until 1606/08.

The *Margravial and Princely Rooms in the east wing* are now a museum. On display are historical renderings of the construction work and portraits of the margraves who resided here, along with details of their lives. Visitors can also see a magnificent canopied bed which belonged to Margravine Maria around 1630. The *hall of arms* in the Northern wing accommo-

dates the armoury museum of Frederick the Great, a collection of 18th century Prussian militaria.

Plassenburg
D-95326 Kulmbach
Tel. (+49/0) 92 21/41 16
i Schloß- und
Gartenverwaltung
BayreuthEremitage
Ludwigstraße 21
D-95444 Bayreuth
Tel. (+49/0) 9 21/7 59 69-0
Fax (+49/0) 9 21/7 59 69-15

☾ Open for viewing of the
Margravial and Princely
Rooms with

Ⓜ local gallery of the
Bavarian State Collection of
Paintings and

Ⓜ Historical Hunting
Collection (local section of
the Bavarian National
Museum)
1 April–30 September
9 am–6 pm, Thu 9 am–20 pm
1 October–31 March
10 am–4 pm
Closed on Mondays

♿

✕ – 🅿 – DB

Ⓜ German Museum of Tin
Figurines (Kulmbach Coun-
cil). Upper Main Valley
Landscape Museum (Kulm-
bach Council)

Plassenburg, arcades in the "Schöner Hof"

Bayerische Verwaltung der staatlichen Schlösser, Gärten und Seen

 Staatliche Schloß-
verwaltung Landshut
Burg Trausnitz 168
D-84036 Landshut
Tel. (+49/0) 8 71/9 24 11-0
(Info-Line 9 24 11-44)
Fax (+49/0) 8 71/9 24 11-40

Trausnitz Castle
⊘ Guided tours
Castle rooms
1 April–30 September:
9 am–6 pm
Thu 9 am–8 pm
1 October–31 March:
9 am–4 pm
Guided tours every hour
Open on Mondays

✕

DB

The Town Residence
Altstadt 29
D-84036 Landshut

⊘ Guided tours of Residence
rooms with

M local gallery of the
Bavarian State Collection of
Paintings and

M Landshut Town and
District Museum
1 April–30 September:
9 am–6 pm
2 October–31 March:
10 am–4 pm
Closed on Mondays

✕

DB

Trausnitz Castle

Trausnitz is the oldest surviving castle of the Wittelsbach family, founded in 1204 by Duke Ludwig I, the "Kelheim Duke".

The Town Residence

Political considerations prompted the building of the town residence in Landshut. Duke Ludwig X (r. 1516–1545) was simply governor on behalf of his brother, whose residence was in Munich. The new residence in town was to add a prestigious touch to his aspirations as an inde-pendent overlord in Lower Bavaria. In 1536 two master masons from Augsburg, Nicolaus Überreithner and Bernhard Zwitzl, were engaged to build the town palace, which they did in German Renaissance style. It is now known as the German Building. Italian masons from Mantua took charge when three wings were added on the side of the old town between 1537 and 1543 in pure Italian Renaissance style, known as the "Italian Building". The result was the first Renaissance palace on German soil. The the Italian Hall has acquired some fame. Its fittings and furniture date mostly from the period of construction around 1542. The intricate visual programme, with explanatory Latin inscriptions, is inspired by Humanist scholarship. It conveys a motto: "Concord enables even small things to grow, Discord destroys even power." This is a reference to the tussles over inheritance and the rival claims to power which divided Duke Ludwig X and his elder brother Wilhelm IV.

Trausnitz Castle,
Chapel of St George,
Quire with Apostles' Gallery

The Keep, the *Hall* (Alte Dürnitz) and the *Castle Chapel of St George* (Georgskapelle) are vestiges of that first phase of construction. The chapel still boasts its original statuary (c. 1230/35), the finest specimens of 13th-century sculpture extant in Bavaria. The altars of 1420/30, by the master of the Pfarrwerfen Altar, are also well known. The 15th century has set its stamp on the architecture in the form of new fortifications for the gates and ramparts around the outside of the castle. The last major construction was carried out under Duke Wilhelm V: the "Italian annexe" of 1575 in the north-west and the pergolas designed by Friedrich Sustris, which transformed the castle into a Renaissance palace. The decoration for the new rooms included the famous wall paintings for the "Stairway of Fools" (Narrentreppe) with scenes of commedia dell'arte.

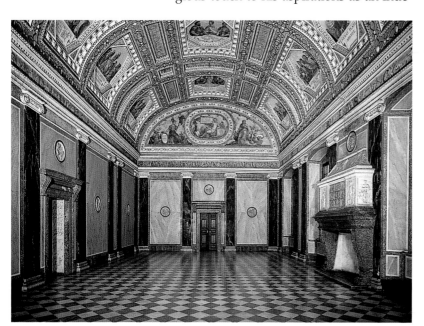

Stadtresidenz Landshut, Italienischer Saal

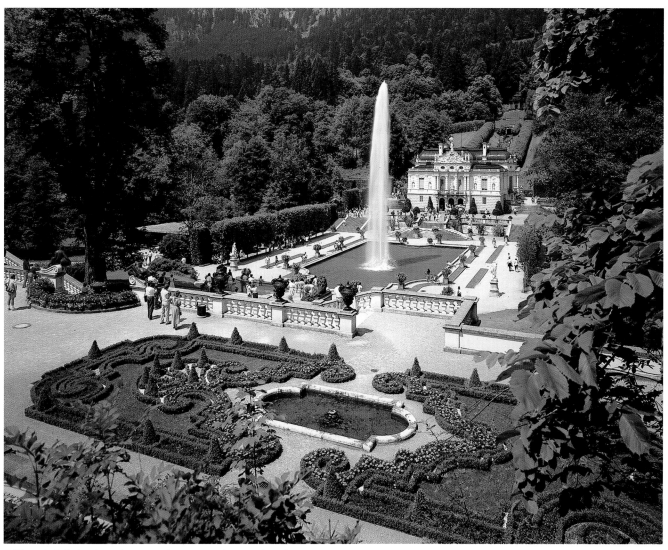

Schloss Linderhof with southern Grand Parterre and Terraced Garden

Schloss Linderhof

Schloss Linderhof was Ludwig II of Bavaria's "Royal Villa", and a unique example of this type among his various palaces. It is also the only palace which the king lived to see completed and often stayed in. His father, Max II, had a lodge (Königshäuschen) on this site. Between 1870 and 1872 Ludwig II's architect Georg Dollmann extended this with a U-shaped building centred on the showpiece bedroom. The new building, like the lodge, was a timber post-and-infill structure. Only in 1874 was the exterior given its stone mantle. The old lodge was pulled down and rebuilt in the park. Ludwig II then completed his Royal Villa with a *Hall of Mirrors* (Spiegelsaal) and a stair struc-

ture. The bedroom underwent conversions and refurbishing in 1884.

The king shunned human company and hoped to use Schloss Linderhof as a retreat. Nevertheless, he did not wish to relinquish the central rooms required for the court rituals of an absolutist monarch. Although the rooms of Linderhof radiate a private atmosphere, he attached particular importance to the *Audience* (Audienzzimmer). Like all the grander rooms used for receiving company, it is furnished in "second rococo" style, with allusions to Sun King Louis XIV and many acclamatory references to the Kingdom of Bavaria.

Schloss Linderhof
ℹ Staatliche Verwaltung
Linderhof, Linderhof 21
D-82488 Ettal
Tel. (+49/0) 88 22/92 03-0
Fax (+49/0) 88 22/92 03-11

🕐 Guided tours
1 April–30 September:
9 am–6 pm, Thu 9 am–8 pm
1 October–31 March:
10 am–4 pm
Guided tours
every hour several times
Open on Mondays

♿ Wheelchairs can be lent out
at the ticket office

✕

🅿 subject to charges

Bayerische Verwaltung der staatlichen Schlösser, Gärten und Seen

Schloss Linderhof
ℹ Staatliche Verwaltung
Linderhof
Linderhof 21
D-82488 Ettal
Tel. (+49/0) 8822/9 2030
Fax (+49/0) 8822/92 03 11

Moorish Kiosk, Moroccan
House, Hundinghütte,
Venus Grotto
🕐 Open for viewing
1 April–30 October
(as seasonal weather
permits):
9 am–6 pm, Thu 9 am–8 pm
Open on Mondays

Fountains
1 April–30 October:
9 am–5 pm (on the hour)

Park
Open all year round
Guided tours of the Park
by request:
1 June–30 September

Venus Grotto

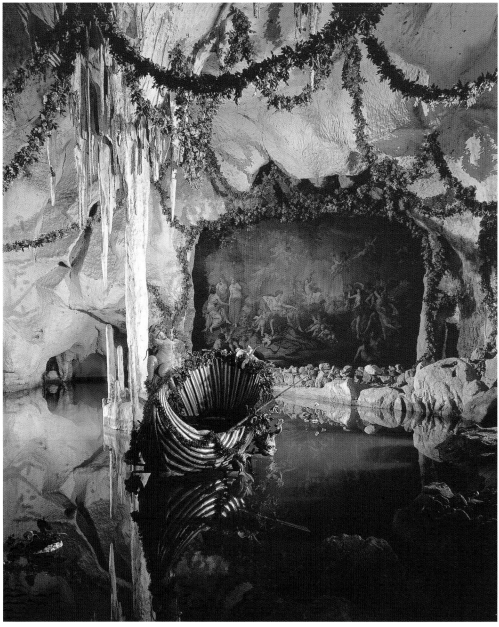

Park and Park Architecture

Linderhof Park is an outstanding example
of Revival garden design. The villa is sur-
rounded by sections of garden which
mimic baroque features, such as the Gar-
den and Water Parterres or the terracing
and waterfalls reminiscent of Italian
Renaissance gardens. The paths into the
landscape garden stretching away into
the surroundings offer diversity, descend-
ing the slopes of a narrow mountain val-
ley through dense clusters of trees and
broad meadows. The terrain was laid out
in 1872–1880 to plans by Carl von Effner,
Director of the Court Gardens.

The park architecture consists of orna-
mental structures, but also "refuges" for
the King. For this purpose, Ludwig II
used the reconstructed hunting lodge
knows as the *Royal lodge* (Königs-
häuschen) and the *Moorish Kiosk*, pur-
chased and brought here in 1876. The
Moroccan House, which originally stood
outside the park, was sold in the late 19th
century but reacquired and opened to
park visitors in 1998 after restoration.
Like the Moorish Kiosk, it evokes an Ori-
ental atmosphere. The *Hunding's Hut*
(Hundinghütte) and the famous *Venus
Grotto* were inspired by settings in
Richard Wagner's operas.

Lauenstein Castle

Lauenstein Castle

The oldest parts of this crest-top castle date back to the 12th century. The main wing, built between 1551 and 1554, is a remarkable example of Renaissance architecture in central Germany. Known as the *Thüna Building* (Thüna-Bau) after Christoph of Thüna, for whom it was built, it has a symmetrical plan, a typical feature of the Modern age. A massive tower links the floors with a spiral stairway. Special mention should be made of the *Knights' Hall* (Rittersaal), the *Prayer Hall* (Betsaal) with its religious frieze dating from the period of construction, and the *Hunting Hall* (Jagdsaal) with an ornate coffered ceiling of wood. The castle was refurbished in late Revival fashion in 1896. Examples are the paintings in the *Orlamünde Hall* (Orlamünde-Saal), which depict medieval aspects of Lauenstein Castle in the form of painted wall hangings.

Visitors have access to more than twenty rooms in the castle museum, where they will find furniture, arms and armour, but also special collections of historical keys, locks and lamps.

Burg Lauenstein
Burgstraße 3
D-96337 Ludwigsstadt
Tel. (+49/0) 92 63/4 00
Fax (+49/0) 92 63/97 44 22
i Staatl. Schloßverwaltung
Bamberg, Domplatz 8
D-96049 Bamberg
Tel. (+49/0) 9 51/5 63 51
and 51011
Fax (+49/0) 9 51/5 59 23

Lauenstein Castle is north of Kronach near Ludwigsstadt in the Franconian Forest Natural Park

⊘ Guided tour
1 April–30 September:
9 am–6 pm
1 October–31 March:
10 am–4 pm
Closed on Mondays

♿

✗

DB Ludwigsstadt, Lauenstein

Munich

The English Garden

In 1789 Elector Carl Theodor decided to establish a public garden in hunting grounds by the River Isar, having consulted Friedrich Ludwig Sckell, the court gardener from Schwetzingen. The project was commenced by Benjamin Thompson (later granted a German peerage as Count Rumford), followed from 1798 by Freiherr von Werneck. The first plantings and architecture took shape, including the Chinese Tower and Utility Building in 1790, the Military Hall (now Rumford Hall) in 1791. The peripheral Military Gardens were dug over in 1799 and incorporated into the parkland together with some 100 ha of Hirschau land. The construction of a lake, Kleinhesseloher See, began in 1800. In 1804 Sckell was appointed Manager of the Bavarian Gardens. He produced drawings and an essay describing how the gardens could be transformed into an aesthetic park. His plans were implemented until his death in 1823. The Monopteros on its artificial hill was built in 1837 to a design by Leo von Klenze.

The English Garden in Munich is an excellent specimen of the Classical landscape garden. Its significance derives not only from its undeniable artistic quality, but also from its social role as the first public garden in Europe.

English Garden, Chinese Tower

Englischer Garten
i Verwaltung des Englischen Gartens
Englischer Garten 2
D-80538 München
Tel. (+49/0) 89/34 19 86
Fax (+49/0) 89/33 51 69

M Japanese Tea House
Ceremonial Japanese Tea:
1 April–31 October
2nd and 4th weekend in the month
Sa: 3, 4, 5 pm
Su: 2, 3, 4, 5 pm
Tel. (+49/0) 89/22 43 19

♿

✗

DB

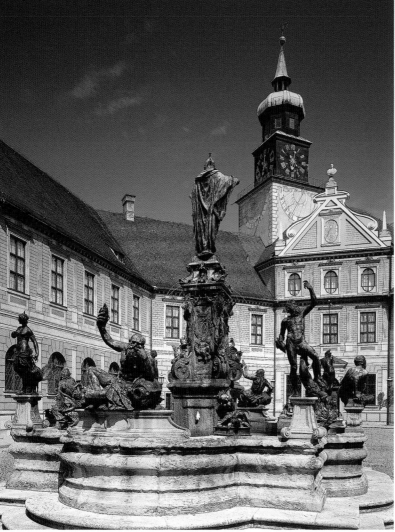

Residence, Fountain Court

i Verwaltung der Residenz
München
Residenzstrasse 1
D-80333 München
Tel. (+49/0) 89/29 06 71
Fax (+49/0) 89/29 06 72 25

**Residence Museum and
Treasury** (entrance on
Max-Joseph-Platz)
⊘ Open for viewing
10 am–4.30 pm
Closed on Mondays
The Museum offers
separate Morning and
Afternoon Tours.

♿ Only accessable via stairs

The Residence

Residence Museum

The history of the Munich Court began in 1255, when Ludwig the Severe moved his household from Landshut to Munich following a division of lands. As Dukes, then Electors, and ultimately Kings of Bavaria, the Wittelsbach dynasty expanded their home here from the small moated castle of 1385 to the sprawling palace built around seven courtyards. For the four centuries until the monarchy was abolished in 1918, the Munich Residence was their seat of government. The complex suffered heavy damage in 1944, although much of the transportable art collection had been placed in safety. The Residence was resurrected thanks to a comprehensive programme of restoration and reconstruction undertaken by the Bavarian Administration of State Palaces, Gardens and Lakes. With some 130 rooms, it now ranks among Europe's leading in situ art museums.

These rooms represent the styles of four centuries. The *Antiquarium* is the biggest Renaissance room north of the Alps. It was built by Simon Zwitzel and Jacobo Strada around 1570 to house Duke Albrecht V's Library and Antiquity Collection, but from 1581 it was converted into a banqueting hall by Friedrich Sustris. The four-winged symmetry created for Duke Maximilian I is typical of 17th-century palace architecture. It includes the *Emperor's Hall* (Kaisersaal), *Treves Room* (Trierzimmer), *Stone Room* (Steinzimmer) and *Rich Chapel* (Reiche Kapelle). Court rococo inspired sumptuous rooms such as the *Ancestral Gallery* (Ahnengallerie) and what are known as the *Rich Rooms* (Reiche Zimmer), furbished from 1729 to 1737 to designs by architect François Cuvilliés for Elector Carl Albrecht. The Classical apartments in the *Royal Palace* (Königsbau) were built for King Ludwig I around 1830. Leo von Klenze designed not only the architecture, but the furniture, too. At the same time, Julius Schnorr von Carolsfeld painted the walls and ceilings in the *Nibelungen Halls* (Nibelungensäle). These are the first monumental interpretations of the medieval Song of Nibelungen. While the rooms of the museum themselves display a wealth of exquisite furniture, paintings, sculptures, bronze, clocks and wall hangings, there are also *collections* of major significance, such as the Silver Chambers, the Relics and Paramenta, the Miniatures, collections of 18th- and 19th-century porcelain and the Far East Porcelain Collection.

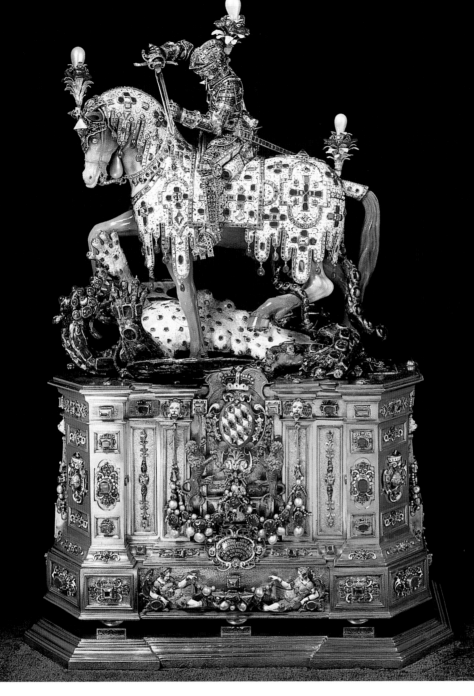

⊙ Court Garden: fountains
1 April–31 October:
10 am–2 pm
1 November–31 March:
closed

♿

DB

🚌 Service 33

U 3/4/5/6

✗ Pfälzer Weinprobierstube
Welser Kuche
Käfer's am Hofgarten

P Multi-storey car park on
Max-Joseph-Platz

M State Collection of
Egyptian Art
Tel. (+49/0) 89/28 92 75 15

M State Coin Collection.
Tel. (+49/0) 89/22 56 28

Residence Treasury,
Statuette of the Knight St George,
1586/97 and 1638/41

The Court Garden

Munich's *Court Garden* (Hofgarten) began as a Renaissance garden in 1613. The Pavilion by Heinrich Schön the Elder stood at the centre of a grid of perpendicular and diagonal paths. After severe war damage, the Court Garden was recreated as a compromise between the 17th-century arrangement and the tree garden of around 1790.

The Treasury Vault

The original Wittelsbach treasury was founded in 1565 by Duke Albrecht V. Today these priceless objects occupy ten rooms in the Royal Palace. The collection – ranked as one of the finest of its kind – includes precious works of enamel, rock crystal and ivory and unique creations by goldsmiths over nine centuries. Among the best-known exhibits are early medieval monastic acquisitions such as the Arnulf Ciborium, dated around 890,

Old Residence Theatre
(Cuvilliés Theatre)
Entrance on Residenzstr. 1/
Brunnenhof
🕐 Open for viewing
as Residence Museum

Ruhmeshalle and Bavaria
Theresienhöhe 16
D-80339 München
ℹ Verwaltung der Residenz
München
Residenzstrasse 1
D-80333 München
Tel. (+49/0) 89/290671
Fax (+49/0) 89/2906 7225

🕐 Open for viewing
1 April–15 October:
9 am–6 pm
during the Oktoberfest
9 am–8 pm
16 October–31 March:
closed
Closed on Mondays

🅿 Theresienwiese

Ⓤ 4/5 Theresienwiese

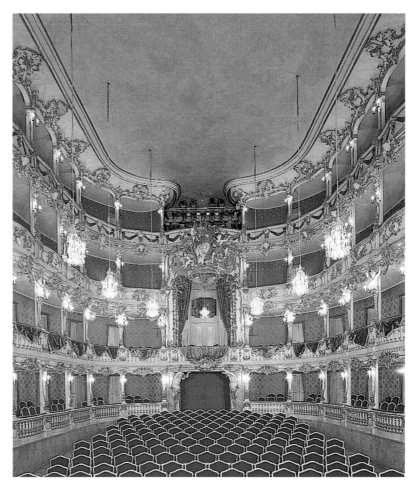

*Old Residence Theatre
(Cuvilliés Theatre)*

*Hall of Fame and
Bavaria*

Emperor Heinrich II's cross reliquary and the Cross of Queen Gisela. Further highlights are: the statuette of St George, the Bavarian Crown insignia of 1806, some exotic specimens of decorative craft, jewellery such as the Palatine Pearl, and exquisite tableware.

Old Residence Theatre
(Cuvilliés Theatre)

The Old Residence Theatre, named after its architect François Cuvilliés the Elder, was built between 1751 and 1755 after Elector Max III Joseph commissioned a "new opera house". It was destroyed in the Second World War, but its tiers of boxes had been stored in safety and were reinstalled in 1958 on the "apothecary's floor". Once again, the theatre enchants visitors with its lavish interior in the style of South German rococo.

Hall of Fame and Bavaria

The Hall of Fame and its colossal bronze statue of Bavaria were built for King Ludwig I from 1843 to 1853. The busts on display in the columned hall were intended to honour celebrated Bavarians, a tradition which recommenced when the hall opened again in 1972.

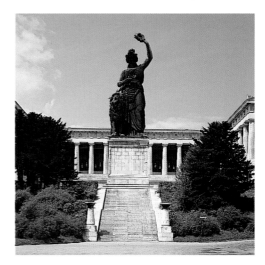

Schloss Nymphenburg,
Stone Hall, centre of the ceiling fresco

Schloss Nymphenburg

In 1664, to celebrate the birth of their son and heir Max Emanuel, Elector Ferdinand Maria and his wife Adelaide of Savoy appointed architect Agostino Barelli to build *Schloss Nymphenburg*. From 1701 Max Emanuel had this cubic "villa suburbana" extended by Enrico Zuccalli, who added lateral galleries and pavilions with apartments. From 1714 Joseph Effner designed two four-winged buildings to flank it and modernised the front of the central structure to reflect French fashion. By now the simple hunting lodge had become a spacious summer residence for an absolute monarch. The rooms were rearranged under Elector Max III Joseph. One outstanding feature is the *Great Hall* (Steinerner Saal), a late specimen of Bavarian rococo which extends through several storeys, constructed under the supervision of Johann Baptist Zimmermann and François Cuvilliés the Elder. The rondels built in a semicircle between 1729 and 1758 provide a clasp for this sprawling complex when viewed from the town. King Ludwig's internationally acclaimed "Gallery of Beauty", painted by Joseph Stieler, is now exhibited in Schloss Nymphenburg. Visitors also have

Amalienburg, Hall of Mirrors

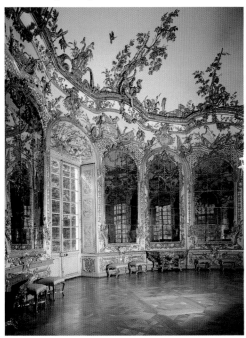

an opportunity to look inside the room where King Ludwig II of Bavaria was born.

The *Royal Stables Museum* (Marstallmuseum), another well-known feature, houses the lavishly ornamented carriages and sledges used by Bavaria's rulers. The coaches are total art works, combining skilful techniques of textile-making, sculpture, gilding and painting. In addition, they played their part in major historical events. The Parisian Coronation Carriage of Elector Carl Albrecht, for example, was used in 1742 when he was crowned Emperor in Frankfurt. The two Munich Coronation Carriages of 1813/1818, designed by J.C. Ginzroth and made by G. Lankensberger, bore Bavaria's first King, Max I Joseph. The great, magnificent vehicles which belonged to Lud-

i Schloß- und Gartenverwaltung Nymphenburg,
Schloss Nymphenburg,
Eingang 1
D-80638 München
Tel. (+49/0) 89/17 90 80
Fax (+49/0) 89/17 90 86 27

Schloss Nymphenburg and Amalienburg
⊘ Open for viewing
1 Apr–15 Oct: 9 am–6 pm
Thu 9 am–8 pm
16 Oct–31 March: Closed

Badenburg, Pagodenburg (currently closed) and Magdalenenklause
⊘ Open for viewing
1 Apr–15 Oct: 9 am–6 pm
Thu 9 am–8 pm
1 Oct–31 March: 10am–4 pm
Open on Mondays

♿ Romms only accessible via stairs

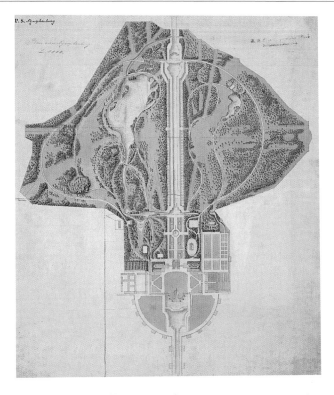

*Plan of the Palace and Gardens
by Friedrich Ludwig von Sckell, 1801/04*

The Park and its buildings

The Park covers about 180 hectares and began as a baroque garden, transformed into a landscape garden in the early 19th century by Friedrich Ludwig von Sckell. Sckell left the Middle Canal with its waterfall and the basic pattern of the Grand Parterre with its twelve marble gods designed by R.A. Boos, D. Auliczek and G. Marchiori. However, he enlivened the diagonal vistas emanating from the palace by creating versatile landscapes with artificial hills and lakes. The architectural markers in this expansive parkland were the Monopteros, built in 1865, and the ornamental 18th-century buildings.

The *Pagodenburg* was inspired by the Baghdad Pagoda in Istanbul popularised by engravings and is considered an outstanding example of the 18th-century fashion for China. Almost 2000 tiles on the walls and ceilings compose landscapes and figurative and ornamental scenery. The *Badenburg* opposite was a bath-house. The pool could be heated and the original heating system has been preserved. The *Magdalenenklause* is a hermitage of part-plastered brickwork and one of the earliest "ruins" designed for a garden. All three structures were commissioned from Joseph Effner between 1716 and 1725 by Max Emanuel. François Cuvilliés the Elder designed the *Amalienburg*, built in 1734–1737, as a hunting lodge for Electoress Maria Amalia. It is a fine piece of European rococo with exquisite carving and stucco by J. Dietrich and J.B. Zimmermann.

**Royal Stables Museum
and Bäuml Collection of
Nymphenburg Porcelain**

🕑 Open for viewing
1 Apr–30 Sep: 9 am–5 pm
1 Oct–15 Oct: 9 am–4 pm
16 Oct–31 March: 10 am–4 pm
Closed for lunch
12 noon–1 pm
Closed on Mondays

♿ Royal stables Museum accessible, Bäuml Collection by appointment

✖

🅿

🆔

🚌 Bus no. 41, 68 – Tram 17

Ⓜ Museum of Man and Nature (Schloss Nymphenburg, north wing)

wig II are nostalgic reminiscences, in the Revival spirit, of 18th-century prototypes. The collection is rounded off by horse brasses and paintings of horses by specialist F.W. Pfeiffer. Upstairs the choice *Bäuml Collection* documents almost the entire output of the Nymphenburg Porcelain Manufactory from its foundation by Elector Max III Joseph in 1747 until 1930. Albert Bäuml acquired a lease on the Manufactory in 1887. His entrepreneurial spirit resulted in the world's largest inventory of 18th- and 19th-century Nymphenburg porcelain. He used these specimens to produce belated editions of original models. The collection was reorganised in 1998, and visitors can admire works by the celebrated Franz Anton Bustelli alongside pieces by D. Auliczek, J.P. Melchior, J. Wackerle and others.

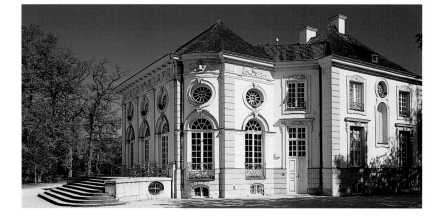

Badenburg

Schloss Neuburg

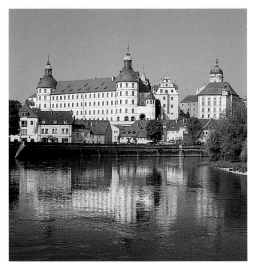

Schloss Neuburg

The silhouette of Neuburg, a former seat of Dukes, and the stately home which dominates it is both memorable and, quite rightly, famous. The Wittelbachs' medieval castle was converted from 1527 into a Renaissance palace by Count Palatine Ottheinrich (1502–1559) for the capital of his newly founded territory Pfalz-Neuburg. The courtyard front of the west wing, painted in the sgrafitto technique, was completed by his successor. Neuburg acquired its flavour as a baroque residence under Count Palatine Philipp Wilhelm of Pfalz-Neuburg (1615–1690): the four-storey east wing flanked by two towers was built between 1665 and 1670. *Neuburg Palace Museum* opened here in 1987. It is divided into three sections. The one devoted to Pfalz-Neuburg contains the celebrated Ottheinrich Tapestries. The others focus on Prehistory and Church Baroque. Other highlights include the restored baroque *grottoes* on the ground floor of the east wing and the important paintings for the ceiling of the *palace chapel* (1543) by Hans Bocksberger. This work is regarded as the fountain of baroque painted ceilings in Bavaria.

Schlossmuseum Neuburg/Donau

ℹ Staatliche Schloß-
verwaltung Neuburg
Residenzstrasse 2
D-86633 Neuburg
Tel. (+49/0) 8431/8897
Fax (+49/0) 8431/42689

◔ Open for viewing of
the museums and grottoes
with

M Prehistory and Early
History Section in the east
wing
(local museum of the State
Prehistory Collection)
1 April–30 September
9 am–6 pm, Thu 9 am–8 pm
1. October–31 March
10 am–4 pm
Ticket office open 9 am
Open on Mondays

♿ Entrance accessible by
ramp; lift available

DB

Schloss Neuburg, Grottenanlage, Grotte des Hirschen

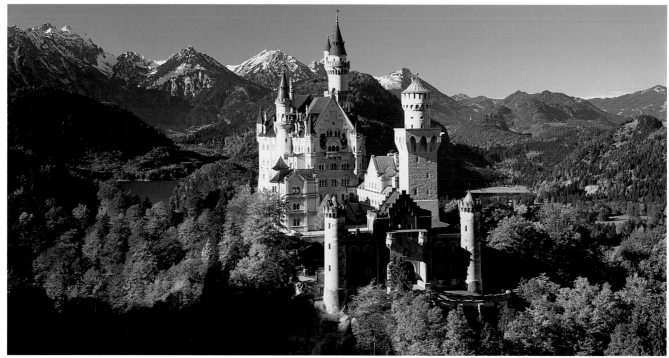

View from the north-east

Schloss Neuschwanstein
i Staatliche Schloß-
verwaltung
Neuschwanstein
Neuschwansteinstrasse 20
D-87645 Schwangau
Tel. (+49/0) 83 62/8 10 35
and 8 18 01
Fax (+49/0) 83 62/89 90

◯ Guided tours
1 April–30 September:
9 am–6 pm, Thu 9 am–8 pm
1 October–31 March:
10 am–12.15 pm,
12.45–4 pm
Open on Mondays

♿ Rooms accessible only via
stairs

✕

P

Schloss Neuschwanstein

King Ludwig II of Bavaria began building Neuschwanstein in 1868. It stands on a rugged rock, Tegelberg, at an altitude of almost 2000 m (over 6000 feet). In a letter to Richard Wagner, Ludwig describes what prompted him to initiate this project: "It is my intention to have the old castle ruins by the Pöllat Gorge rebuilt in the authentic style of the German knights' castles of old." Neuschwanstein was to be a monument and also a retreat, far removed from the Munich Residence he detested, whereas he knew and loved the mountains. Ludwig II was a determined client. The plans for Neuschwanstein were modified constantly as the King changed his mind. Set designer Christian Jank supplied the preliminary design. Jank described the shift from a little fortress with Late Gothic features for a "robber baron" to a monumental "Romanesque" castle with borrowings from the Great Hall of the Wartburg near Eisenach. Neuschwanstein does not replicate a real medieval building, but reinvents one with the nostalgia characteristic of Historicism. The foundation stone was laid in 1869. Planning was initially entrusted to municipal architect Eduard Riedl; architect Georg Dollmann assumed charge in 1874. The *Minstrels' Hall* (Sängersaal) played a major role from the outset. After a new production of "Tannhäuser" in Munich, the King wished to recreate the venue of the minstrels' contest, and taking the Festive Hall on the Wartburg as his prototype. The idea for a *Throne Hall* (Thronsaal) came later. This magnificent hall with its sacred aura was inspired by Byzantine architecture and above all by the Court Church of All Saints at the Residence in Munich. This Throne Hall, for which Julius Hofmann delivered the final design in 1881, transformed the young king's "Wartburg" into Parsifal's "castle of the Grail". Ludwig II supervised every detail of the castle's furbishing. He devoted particular care to the wall paintings. Although the subjects were drawn predominantly from the world of Wagner's operas, he ordered that the figures should be based on the saga, not the librettos. Only the five-storey *Great Hall* (Palas) was finished before the King's death in 1886. All too symbolically, the Throne Room still lacked its throne when the King was deprived of his powers and removed to Schloss Berg on Lake Starnberg.

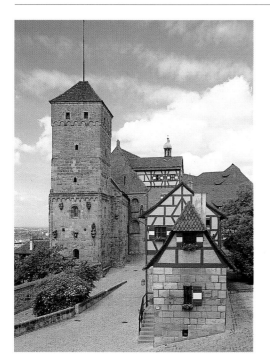

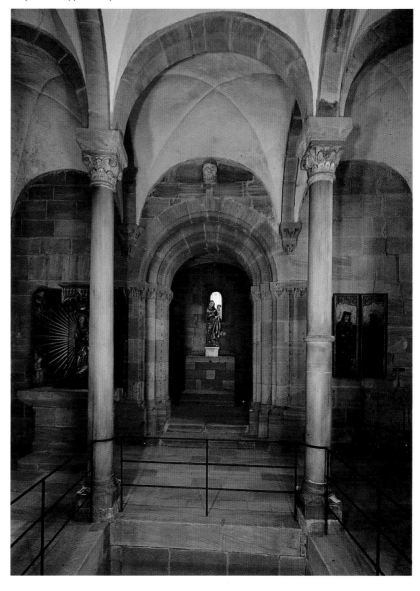

Forecourt with Emperor's Chapel and Well-House

saal) dates back to this period. In 1945 the Imperial Castle was severely damaged in air raids, but the imperial chapel, large sections of the Great Hall and the valuable Romanesque towers survived. The ravaged Bowers were rebuilt and now house the Kaiserburg Museum, a local section of the Germanic National Museum. A visit to the museum includes the double chapel and also the rooms in the Great Hall used by the Emperors as living quarters and for matters of state.

i **Kaiserburg Nürnberg**
Staatliche Burgverwaltung
Nürnberg
Auf der Burg 13
D-90403 Nürnberg
Tel. (+49/0) 9 11/22 57 26
Fax (+49/0) 9 11/2 05 91 17

🕐 Guided tours
Castle rooms

DB

Open for viewing of Deep Well and Sinwell Tower with

M local section of the Germanic National Museum in the Bowers
1 April–30 September:
9 am–6 pm
Thu 9 am–8 pm
1 October–31 March:
10 am–4 pm
Open on Mondays

Emperor's (Upper) Chapel

The Imperial Castle

Nuremberg Castle was one of the key seasonal residences used by the German Emperors during the Middle Ages.
Between 1050 and 1571 every King and Emperor of the Holy Roman Empire spent some time here. In 1356 Emperor Karl IV decided that the first Diet of every Emperor's reign should be held in Nuremberg. Between 1485 and 1495 the Imperial Crown-Jewels were kept here in the castle chapel.

The castle evolved through three phases of construction. The King's Castle was built for Salian overlords in the first half of the 11th century. Under the Hohenstaufen Emperor Friedrich Barbarossa and his successors, this Salian fortress developed into an impressive seat for a feudal Kaiser. We can still witness this grandeur in the perfectly preserved *double chapel* with its quire tower, the most significant architectural monument in the precinct. It cleverly combines three functions, being the Emperor's private chapel, the court chapel and the castle chapel. The upper (or imperial) chapel was earmarked for the court, and the balcony added in the west was for the Emperor's family. During Friedrich III's reign in the 15th century, the Hohenstaufen's *Great Hall* (Palas) and *Bowers* (Kemenate) were replaced by new buildings in late Gothic style. The two-aisle *Knights' Hall* (Ritter-

Burg Prunn
D-93339 Riedenburg
Tel. (+49/0) 94 42/33 23
Fax (+49/0) 94 42/33 35
ℹ Verwaltung der Befreiungs-
halle Kelheim
Befreiungshallestrasse 3
D-93309 Kelheim
Tel./Fax (+49/0) 94 41/15 84

🕘 Guided tours
1 March–30 September:
9 am–12 noon, 1–6 pm
Th 9 am–8 pm
1 October–31 March:
10 am–12 noon, 1–4 pm
Closed on Mondays

Prunn Castle

High above the village of Prunn, Prunn Castle on its chalk outcrop was the seat of the lords of Prunn, and is first mentioned in the records in 1037. All that remains of the medieval fabric are the *Keep* and the foundations of the Great Hall. The *Castle*

Chapel (Burgkapelle), restructured in 1700 and well worth a visit, illustrates the baroque building work carried out here by the Jesuits in residence between 1672 and 1773. In the 19th century King Ludwig I of Bavaria rescued Prunn from looming decay. In 1827 he decreed that the medieval castle should be preserved as a monument to German history.

A tour of the Museum takes visitors to the chapel and the rooms of the *Great Hall* (Palas) with their original furniture and fittings. Fragments of medieval frescoes are exposed to view in the former guard-room. Those who know their Middle High German poetry will be reminded of the Song of Nibelungen, as the 14th-century "Prunner Codex" is the Book of Chreimhilden (now in the Bavarian State Library).

Prunn Castle

Schachen

Königshaus am Schachen
Above Garmisch-Partenkirchen
(1866 m/6122 ft above sea level)
Tel. (+49/0) 88 21/29 96
Can only be reached on foot

ℹ Staatliche Verwaltung
Linderhof, Linderhof 21
D-82488 Ettal
Tel. (+49/0) 88 22/92 03-0
Fax (+49/0) 88 22/92 03-11

🕘 Guided tours
from May/June to early
October: 11 am, 2 pm and
as required

The King's House is only accessible within walking distance

✂

The King's House on Schachen

The "royal hunting-lodge on the Schachen Alp" was built for Ludwig II of Bavaria in 1872 to drawings by Georg Dollmann, with the rugged Wetterstein

The King's House on Schachen, Turkish Hall

mountains as its backcloth and a view of the Loisach valley. Initially Dollmann planned a post-and-infill structure which resembled a prototypical Swiss chalet from the outside, but it had the ground plan and room arrangement of a modern Parisian villa, its central salon projecting forwards. Ludwig II then had the central section raised by one storey, creating the famous *Turkish Hall* (Türkischer Saal) furbished in the Moorish style. The bright colours of this interior, evoking the Orient with its rich textiles, peacock's feathers and fountain, are reinforced by stained glass windows. The Bavarian King always spent his birthday on the 25 August here on the Schachen.

The historical *Alpine Garden* below the King's house is also open to visitors. It is now run by the Botanical Gardens in Munich.

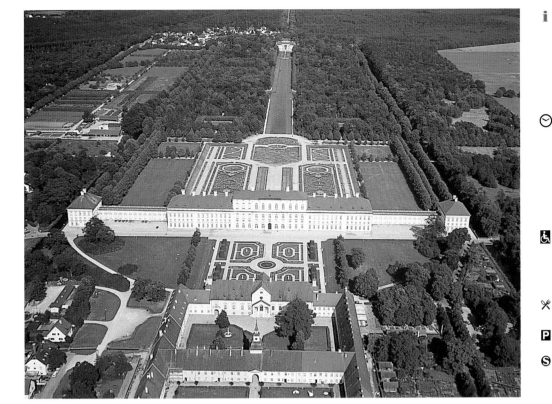

i Schloß- und Garten-
verwaltung Schleißheim
Max-Emanuel-Platz 1
D-85764 Oberschleissheim
Tel. (+49/0) 89/31 58 72-0
Fax (+49/0) 89/31 58 72-50

Neues Schloss Schleißheim
⊙ Besichtigung
1 April–30 September:
9 am–6 pm
1 October–31 March
10 am–4 pm
Closed on Mondays
The park is open all year
round

♿ Entrance hall and ground
floor accessible by two
steps; entrance to the first
floor only via stairs

✕

🅿

Ⓢ

Schleissheim, Old and New Palace with park

The Gardens

Schleissheim boasts one of those rare
baroque gardens which have barely been
altered by subsequent ages. Enrico Zuc-
calli established its basic canal structure
in 1684. The bosquet area was completed
by 1705. The parterre and waterfall were
constructed from 1715 to designs by
Dominique Girard, a pupil of Le Notre.
Many baroque refinements were carried
out at the same time, and the vista along
the principal avenue acquired its wonder-
ful depth. The middle canal was built to
old plans around 1781. In 1865 Carl von
Effner supervised a major programme of
reconstruction. The rehabilitation of the
waterfall (1999) is another important step
towards restoring the garden after it was
heavily damaged in the Second World
War.

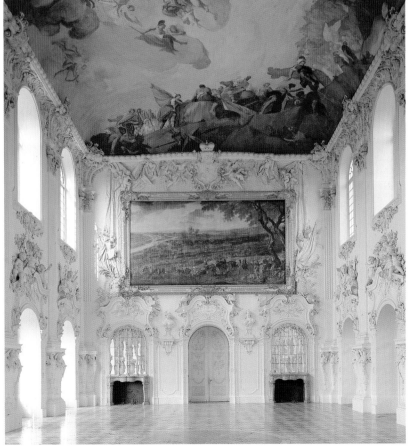

Schleißheim, Neues Schloss

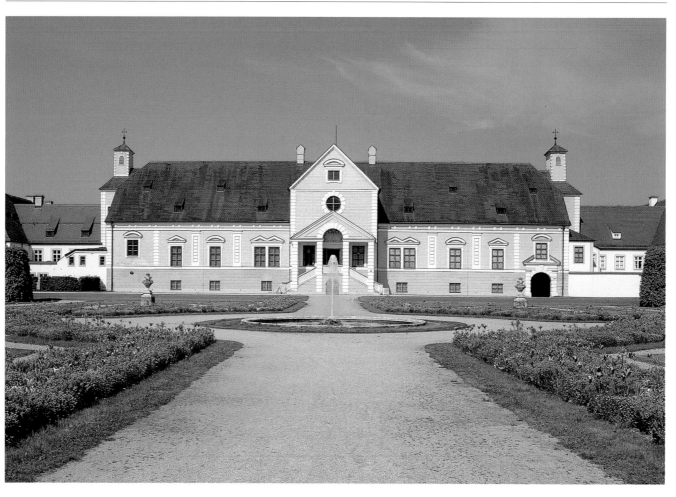

Schleißheim, Altes Schloss

A Altes Schloss Schleißheim
Tel. 0 89/3 15 52 72
Religiöse Sammlung Weinhold und Sammlung zur Landeskunde Ost- und Westpreußens

A Schloss Lustheim
Tel. 0 89/3 15 52 72
Sammlung Schneider (Meißner Porzellan)

Altes Schloss Schleißheim und Schloss Lustheim

Das *Alte Schloss*, 1598 als Eremitage Herzog Wilhelms V. begonnen, wurde ab 1617 nach Plänen Heinrich Schöns d.Ä. erbaut. Anlässlich seiner Vermählung mit der österreichischen Kaisertochter Maria Antonia beauftragte Kurfürst Max Emanuel den Architekten Enrico Zuccalli, das Jagd- und Gartenschlösschen *Lustheim* zu errichten (1684–1688). Deckenfresken von F. Rosa, G. Trubillio und J. A. Gumpp verherrlichen die Jagdgöttin Diana.

Gartenanlage Schleißheim

In Schleißheim befindet sich einer der wenigen, kaum veränderten Gärten der Barockzeit. Enrico Zuccalli legte bereits 1684 die Grundstruktur mit den Kanälen fest. Bis 1705 war der gesamte Boskett-Bereich fertig gestellt. Ab 1715 wurden Parterre und Kaskade nach Plänen von Dominique Girard – einem Schüler Le Nôtres – angelegt, viele hochbarocke Verfeinerungen durchgeführt und die großartige Tiefenwirkung der Hauptachse herausgearbeitet. Der Mittelkanal entstand – nach alten Planungen – um 1781. Carl von Effner führte 1865 umfassende Rekonstruktionsarbeiten durch. Mit der Sanierung der Kaskade (1999) ist ein weiterer wichtiger Schritt zur Wiederherstellung des 1945 stark zerstörten Schlossgartens erfolgt.

Exter's House

Julius Exter (1863–1939) was part of the art reform movement in Munich during the days of the Prince Regent and later became a versatile avant-garde painter. The expressive works of his later years are among the outstanding artistic accomplishments of southern Germany at the dawn of Modernism. In 1892 he co-founded the Munich Secession. Exter turned repeatedly to religious themes, playing a key role in the renewal of Christian painting around 1900. From 1917 he lived permanently in his converted farm-house in Übersee on the shores of Lake Chiem.

Exter's house in its idyllic setting is now a museum. His paintings are on permanent display in the large atelier, enabling visitors to appreciate his works in the context where they were created. Temporary exhibitions with works by other artists are also shown.

Julius Exter, "Path with Barges in Feldwieser Bay on Chiemsee"

Museum Künstlerhaus Exter
Blumenweg 5, D-83236 Übersee
Tel. (+49/0) 86 42/89 50 83, Fax 89 50 85
ℹ Staatliche Verwaltung Herrenchiemsee
Altes Schloss 3, D-83209 Herrenchiemsee
Tel. (+49/0) 80 51/6 88 70, Fax 68 87 99

🕗 Open for viewing
During exhibitions:
Daily 5–7 pm
and by arrangement
Closed on Mondays

Utting/Holzhausen

Gasteiger's House

The museum in *Gasteiger's House* and the adjoining *landscaped park* are on the western shores of Lake Ammer. At the turn of the last century, sculptor Mathias Gasteiger (1871–1934) was one of Munich's best-known artists. He was married to the painter Anna Sophie Gasteiger (1877–1954), who gained a particular reputation for Late Impressionist paintings of flowers.

Today works by the couple are on show in the atelier and living quarters of the summer villa. Also worth a visit are the original wall fixtures and furniture of the living-room and parlour. They date from 1908 to 1912 and constitute a significant group of Munich-style art nouveau designs. The idyllic property, with its park, home and little museum, also reminds us that many Munich artists came to live along the western shores of this lake around 1900. The landscaped park and the geometrical sections of garden closer to the house have been recreated from original plans and photos.

Anna Sophie Gasteiger,
"House in Flower Garden", after 1913

Museum Künstlerhaus Gasteiger
Eduard-Thöny-Strasse 43, D-86919 Holzhausen
Tel. (+49/0) 88 06/26 82 and 20 91
ℹ Staatl. Seeverwaltung Ammersee, Landsberger Strasse 81, D-82266 Inning/Stegen
Tel. (+49/0) 81 43/9 30 40, Fax 93 04 30

🕗 Open for viewing
1 April–31 October:
Sundays only 2–5 pm
1 November–31 March:
closed

♿

✗

Bayerische Verwaltung der staatlichen Schlösser, Gärten und Seen

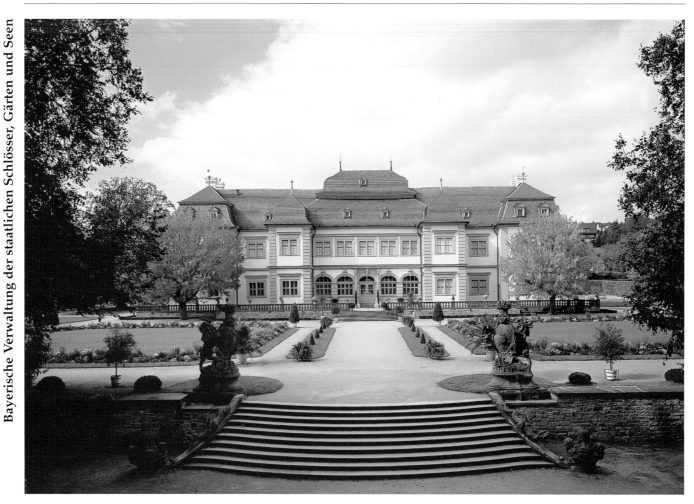

Schloss Veitshöchheim

Schloss Veitshöchheim
Hofgarten 1
D-97209 Veitshöchheim
Tel. (+49/0) 9 31/9 15 82
ℹ Schloß- und Garten-
verwaltung Würzburg,
Residenzplatz 2, Tor B
D-97070 Würzburg
Tel. (+49/0) 9 31/35 51 70
Fax (+49/0) 9 31/5 19 25

⊘ Schloss open for viewing
1 April–3 September:
9 am–6 pm
Closed on Mondays
1 October–31 March:
closed

Rococo Garden,
fountains
⊘ 1 April–31 October: daily
1–5 pm on the hour
Guided tours of the garden
by request
Tel. (+49/0) 9 31/35 51 70

⛵ Boat services to Würzburg
and elsewhere

♿

Schloss and Park

Schloss Veitshöchheim, built as a hunting lodge in 1680/1682, served the Prince-Bishops of Würzburg as a summer residence. It is set in one of Germany's finest rococo gardens. Work first began on an ornamental garden with terraces and lakes in 1702. Then, after Balthasar Neumann built his extensions to the lodge in 1749–1753, Prince-Bishop Adam Friedrich von Seinsheim (r. 1755–1779) had the *garden* redesigned on a grand scale. The Würzburg court sculptors, J.W. van der Auvera, F. Tietz and J.P. Wagner, made about 200 impressive sandstone figures for a garden which drew its lively contours from hedges, pergolas, fountains and water art. Gods, beasts and allegories combined in a great cosmological programme. The sculptures were replaced by casts to ensure preservation. The finest originals are on display in the *Mainfränkisches Museum* in Würzburg. Inside

Schloss Veitshöchheim visitors can see the *Prince-Bishop's quarters* and also the *apartment of Grand Duke Ferdinand of Tuscany* with the original rare paper wall-coverings dating from about 1810.

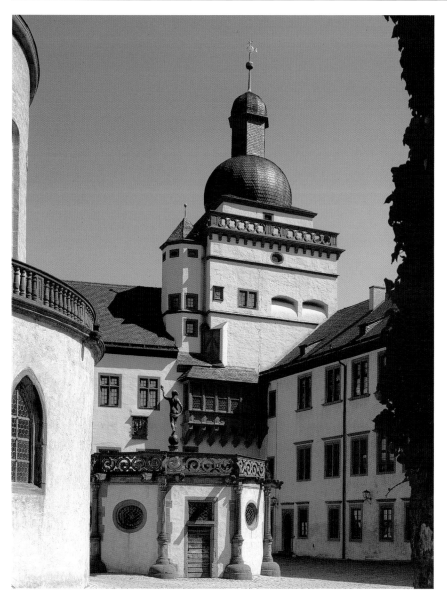

Fortress Marienberg, Sun Tower and Fountain Temple in the inner courtgard

Fortress Marienberg

The silhouette of Fort Marienberg is a towering Würzburg landmark. This is the very incarnation of a medieval castle which, over the centuries, became first a Renaissance palace and then a baroque stronghold. Until the Residence was built in town, the fortress was the seat of the Würzburg Bishops. The oldest and most important buildings in the precinct are clustered around the innermost courtyard: the *keep* with its massive masonry of rubble is an architectural vestige of the year 1200. *St Mary's Church* (Marienkirche) – its nucleus also dating back to the turn of the last millennium – was converted around 1600 into a Renaissance chapel on a centralised plan by Prince-Bishop Julius Echter of Mespelbrunn. He

also commissioned the *Fountain Temple* (Brunnentempel). The east wing of the castle, the *Prince's Building* (Fürstenbau) which is now a museum, dates for the most part from the period around 1500. The *Prince's Hall* (Fürstensaal) is especially impressive with its early Gothic wall articulation and a tapestry eight metres (26') wide with life-size portraits of the Echter family, made in 1563. A particular attraction in the museum is the *Prince-Bishop's treasure and paramenta chamber*. The spacious *Prince's Garden* with its eight-part rose parterre and the fountain waterfalls on each side was restored in 1937/38 using early 18th-century drawings of the fort.

Festung Marienberg
D-97082 Würzburg
Tel. (+49/0) 9 31 4 38 38
ℹ Schloß- und Gartenverwaltung Würzburg
Residenzplatz 2, Tor B
D-97070 Würzburg
Tel. (+49/0) 9 31/35 51 70
Fax (+49/0) 9 31/5 19 25

Prince's Building Museum
🕗 Open for viewing with

M Department for local history of the citadel and town at the "Mainfränkisches Museum"
1 April–15 October:
9 am–6 pm
16 October–31 March:
10 am–4 pm
Closed on Mondays
Thematic tours by request

♿ Rooms only accessible via stairs
It is possible to visit the circular staircase and fountains

✗

DB

M Armoury
Main & Franconia Museum: inc. works by Tilman Riemenschneider and the original sandstone statues by F. Tick and J. P. Wagner from the castle gardens in Veitshöchheim (on loan from the Bavarian Administration of Stately Homes)

Bayerische Verwaltung der staatlichen Schlösser, Gärten und Seen

Residenz Würzburg

ℹ The Würzburg
Administration
Residenzplatz 2, Tor B
D-97070 Würzburg
Tel. (+49/0) 9 31/35 51 70
Fax (+49/0) 9 31/5 19 25

🕐 Guided tours of
Residence rooms
with

🅜 the local gallery of the
Bavarian State Collection of
Paintings (17th. and 18th-cen-
tury Venetian masters)
1 April–30 September:
9 am–6 pm, Thu 9 am–8 pm
1 October–31 March:
10 am–4 pm
Open on Mondays

Guided tours outside nor-
mal hours and garden tours
by request

♿ Lift available

The Residence

The seat of the Prince-Bishops of Würz-burg is one of Europe's finest baroque palaces. The skeleton was constructed between 1720 and 1744 to plans by Balthasar Neumann. The clients were Prince-Bishop Johann Philipp Franz von Schönborn and his brother and eventual successor Friedrich Carl von Schönborn. The *staircase* (Treppenhaus) of the Resi-dence combine two major works of Euro-pean architecture and painting in a pow-erful total art work: to decorate Neu-mann's famous stairwell with its unbut-tressed vaulting, Giovanni Battista Tiepo-lo of Venice painted the world's largest fresco ceiling, the Allegory of the Four Continents, in 1752/53. In 1751/52 he had already painted frescoes for the *Imperial Hall* (Kaisersaal), so that Tiepolo gave the Residence two of the era's major works.

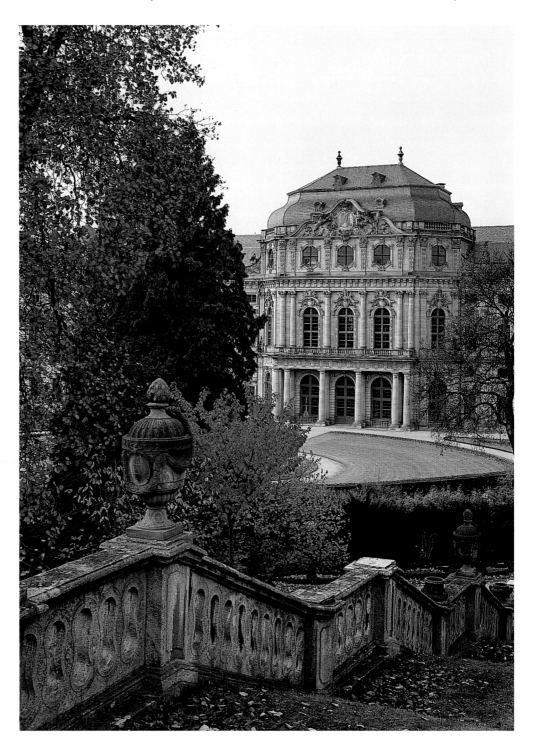

Würzburg Residence,
Emperor's Pavilion, garden front

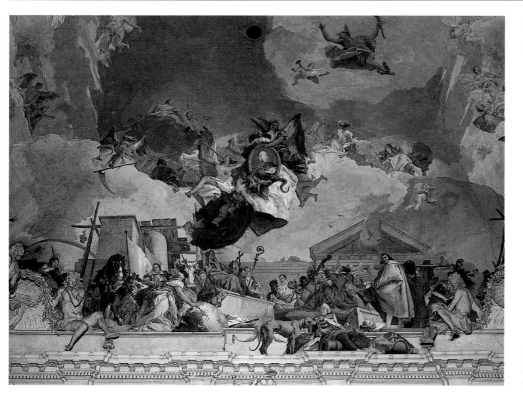

⚔

🅿

DB

M Martin von Wagner
Museum
(Würzburg University)
in the South Wing

Würzburg Residence:
In the Rennweg Rooms the
State Gallery are displaying
17th- and 18th-century Venet-
ian paintings (local gallery
of the Bavarian State Collec-
tion of Paintings). The south
wing contains Würzburg
University's *Martin von
Wagner Museum.*

*Residence, stairs
Detail from the ceiling fresco by
G.B. Tiepolo, 1753*

The other grand rooms also offer the visi-
tor splendid interiors and artistic objects
of superb quality from the Régence via
Würzburg rococo to early neo-classicism.
The *Court Church* (Hofkirche), with an
entrance on Residenzplatz, is a major
achievement of sacred art in Würzburg.
After considerable war damage the recon-
struction of this stately home was com-
pleted in 1987 with a replica of the unique
Mirror Cabinet (Spiegelkabinett). Since
1981 the Würzburg Residence, along with
Residenzplatz and the Court Garden, has
been listed in the UNESCO cultural her-
itage.

The Court Garden

The court garden of the Würzburg Resi-
dence is situated close to the baroque
town fortifications, the massive support-
ing walls of which still form the Eastern
boundary of the area. In the late 18th cen-
tury the court gardener Johann Prokop
Mayer (1735–1804) was commissioned to
plan the court garden of the Residence.
Mayer skilfully divided the garden,
which was characterised by a compli-
cated lay-out and steep incline up to the
bastions, into individual, symmetrically
structured and self-contained areas. In
keeping with rococo style, he planted an
abundance of fruit trees cut into shape,
tub plants, flower-beds, hedges, espaliers
and leafy passages in the various parts of
the garden. The so-called orchard, which
is located in the extension of the main axis
of the Residence, rises over three terraces
up to the peak of the limiting bastion. The
rectangular Southern garden by contrast
is completely level. In the middle, it has a
round water basin with a big tuff mono-
lith, from which a small jet of water rises
even in the winter months. For some
years already, the borders of the flower-
beds in the orchard and the Southern gar-
den have been planted according to his-
torical models and the recently restored
kitchen garden below the orangery once
more includes shaped fruit trees, which
are cultivated according to old cutting
methods. The side bordering onto the
town includes a small landscaped area
from the early 19th century; behind this
the strictly geometrical parts of the gar-
den then begin.

Bayerische Verwaltung der staatlichen Schlösser, Gärten und Seen

Bamberg – The Old Court

At the heart of the Old Court opposite the New Residence there are remains of the Great Hall and Chapel masonry from the 11th-century Bishop's palace. The Old Court now accommodates Bamberg's municipal History Museum.

> ℹ Historisches Museum
> Domplatz 7
> D-96049 Bamberg
> Tel. (+49/0) 9 51/87 11 42

Feldafinger Park and Isle of Roses Lake Starnberg

In 1850 King Maximilian II bought the island of Wörth in Lake Starnberg near Feldafing, later renamed the Isle of Roses. Prussia's famous court gardener Peter Joseph Lenné drew plans for gardens on the "Roseninsel" and for a landscaped park at Feldafinger on the shores of the lake. They were implemented by his pupil Carl von Effner. In 1850 architect Franz Jakob Kreuter was appointed to build the Royal Villa on the island and lay out the Rose Garden.

> ℹ Passenger steamers:
> Bayerische Seenschiffahrt GmbH
> Dampfschiffstrasse 5
> D-82319 Starnberg
> Tel. (+49/0) 81 51/69 75
> Fax (+49/0) 81 51/72 04 45

Fraueninsel/Chiemsee Frauenchiemsee Convent

This Benedictine Abbey is one of Germany's oldest convents. Behind the mid-9th-century Carolingian Gate Hall is the early Romanesque abbey and clergy church with its famous Romanesque wall frescoes. This Imperial institution was secularised in 1803, but refounded in 1837 by Ludwig I of Bavaria. In the 19th century the nearby restaurant Zur Linde was the cradle of landscape painting on Lake Chiem.

> ℹ Staatliche Verwaltung Herrenchiemsee
> Altes Schloss 3
> D-83209 Herrenchiemsee
> Tel. (+49/0) 80 51/68 87 0
> Fax (+49/0) 80 51/68 87 99

Königssee St Bartholomew's Church

The palace and Pilgrim Church of St Bartholomew were founded by the Prince-Provostship of Berchtesgaden. The original building dates back to 1134. The church was rebuilt from 1697 with a triple concha plan. From 1810 the peninsula, now so widely popular, was a favourite haunt of the Bavarian kings. St Bartholomew's, set against the Watzmann Range, has inspired many a landscape artist since the Romantic era.

> ℹ Passenger steamers:
> Bayerische Seenschiffahrt GmbH
> Seestrasse 55,
> D-83471 Schönau am Königssee
> Tel. (+49/0) 86 52/9 63 60; Fax (+49/0) 86 52/6 47 21
> St Bartholomew's can only be reached by boat and is open during ferry operation.

Munich – Schloss Blutenburg

Schloss Blutenburg was a summer residence and hunting lodge of the Bavarian dukes with their official seat in Munich. The site is famous for the Palace Church of the Holy Trinity, built from 1488 onwards – a self-contained gem of Old Bavarian Late Gothic. Jan Polack's altars are major examples of panel painting. The palace now houses the International Youth Library.

> Schloss Blutenburg
> Obermenzinger Strasse,
> D-81247 München
> ℹ Schloß- und Gartenverwaltung Nymphenburg
> Schloss Nymphenburg, Eingang 1
> D-80638 München
> Tel. (+49/0) 89/17 90 80; Fax (+49/0) 89/17 90 86 27

Nuremberg – Cadolzburg near Fürth

First mentioned in records in 1157, this castle fell to the burgraves of Nuremberg in the mid-13th century. The two circular walls around the living quarters date from that period. A castle museum will open in the near future.

> ℹ Staatliche Burgverwaltung Nürnberg
> Auf der Burg 13,
> D-90403 Nürnberg
> Tel. (+49/0) 9 11/22 57 26;
> Fax (+49/0) 9 11/2 05 91 17

Nuremberg – The Tucher Palace

This summer residence for the Tucher family, patricians of Nuremberg, was built between 1533 and 1544. The little palace from the Tucher Trust has been converted into a museum. A celebrated banquet service by Wenzel Jamnitzer is among the exhibits.
The building belongs jointly to the Free State of Bavaria and the City of Nuremberg. The Nuremberg Museums are responsible for running this museum.

> ℹ Tucherschlösschen
> Hirschelgasse Nr. 9-11
> D-90403 Nürnberg
> Tel. (+49/0) 9 11/2 31 54 21

Riedenburg – Rosenburg Castle

Rosenburg Castle fell to the Dukes of Bavaria in the late 12th century. The castle was repaired after the ravages of both the Peasants' War (1525) and the Thirty Years War (1618–1648). The wall paintings in the castle chapel, which date from around 1560, are a notable attraction. Rosenburg Castle is now privately run as a falconry accompanied by a Museum of Hunting and Falconry.

> Falkenhof
> D-83339 Riedenburg
> Tel. (+49/0) 94 42/27 52; Fax (+49/0) 94 42/32 87
> ℹ Verwaltung der Befreiungshalle Kelheim
> Befreiungshallestrasse 3,
> D-93309 Kelheim
> Tel./Fax (+49/0) 94 41/15 84
>
> Open for viewing
> 1 March–31 October: 9 am–5 pm
> 2 November–28 February: closed
> Closed on Mondays
> NB: The castle can only be visited together with the (privately run) Falconry.

Schnaittach – Fort Rothenberg

The medieval castle, in the hands of the Bavarian Electors since 1628, was rebuilt as a baroque fortress after it was destroyed in 1703. The casemates can be visited with a guide.

> ℹ Heimatverein Schnaittach
> Festung Rothenberg
> D-91220 Schnaittach
> Tel. (+49/0) 91 53/77 93

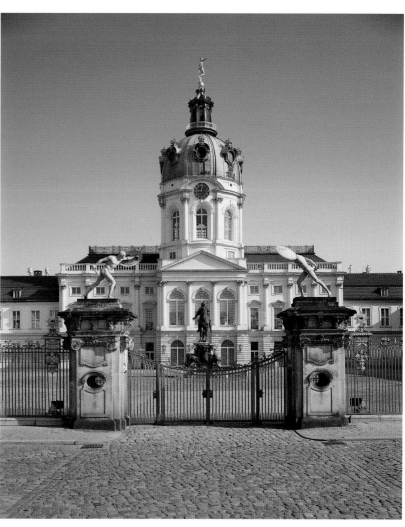

Berlin & Brandenburg

STIFTUNG PREUSSISCHE SCHLÖSSER
UND GÄRTEN
BERLIN-BRANDENBURG

THE PRUSSIAN HERITAGE
OF STATELY HOMES AND GARDENS

Stiftung Preußische Schlösser und Gärten Berlin-Brandenburg

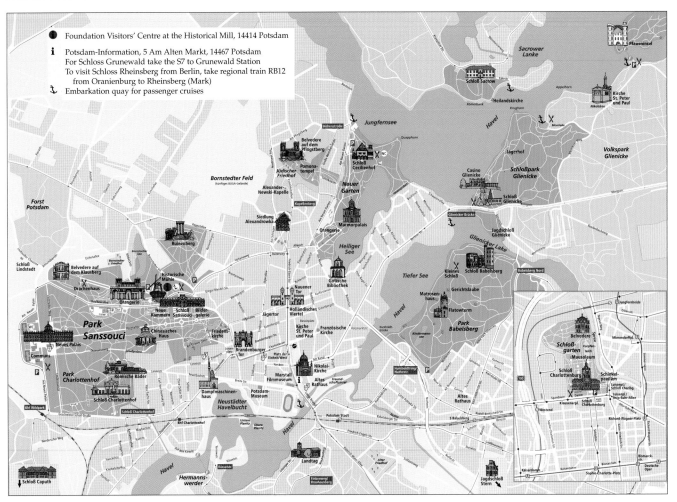

Foundation Visitors' Centre at the Historical Mill, 14414 Potsdam

Potsdam-Information, 5 Am Alten Markt, 14467 Potsdam
For Schloss Grunewald take the S7 to Grunewald Station
To visit Schloss Rheinsberg from Berlin, take regional train RB12
 from Oranienburg to Rheinsberg (Mark)
Embarkation quay for passenger cruises

Stately homes and gardens in Berlin

Schloss Charlottenburg, Old Palace and
 New Wing pp. 86–87
Belvedere p. 88
Mausoleum p. 88

New Pavilion p. 89
Grunewald Hunting Lodge p. 89
Pfaueninsel p. 90
Schloss Glienicke p. 91

**Stately homes and gardens in
Potsdam and Brandenburg**
Sanssouci Park p. 92
Schloss Sanssouci with Ladies' Wing and
 Palace Kitchen pp. 93–94
Picture Gallery p. 95
New Chambers p. 96
New Palace pp. 97–98
Chinese House p. 99
Belvedere on Klausberg p. 99
Schloss Charlottenhof p. 100
Roman Baths p. 101
Lindstedt p. 101
Orangery Palace p. 102
Church of Peace p. 103
Historical Windmill p. 104
Engine House p. 104
New Garden p. 105
Marble Palace/Orangery p. 106
Schloss Cecilienhof p. 107
Belvedere on Pfingstberg p. 108
Temple of Pomona p. 108
Schloss Babelsberg and Park pp. 109–110
Flatow Tower p. 110
Stern Hunting Lodge p. 111
Sacrow Park and Schloss p. 111
Caputh Park and Schloss p. 112
Schloss Königs Wusterhausen p. 112
Rheinsberg Park and Schloss p. 113

◁ *Schloss Charlottenburg, Old Palace*

PRUSSIAN STATELY HOMES AND GARDENS IN BERLIN AND BRANDENBURG

Compared with other aspects of the Prussian heritage, the stately homes and gardens of Berlin and Brandenburg are no doubt its most visibly artistic feature. Their origins are closely interwoven with the evolution of the region's rulers from Prince Electors of Brandenburg to Kings of Prussia and ultimately Kaisers of Germany.

The Mark of Brandenburg was originally granted to the Hohenzollern family as a fief in the early 15th century. After 1440 they built a castle on an island in the River Spree which formed part of the twin towns of Berlin and Cölln. As the centuries passed, this residence grew into one of Europe's biggest royal homes, especially around 1700 under Friedrich I, the first King of Prussia (Elector Friedrich III of Brandenburg until 1701). The building was severely damaged in the Second World War and was pulled down in 1950, but in those days it triggered a proliferation of royal residences and gardens across Berlin and Potsdam. There had been predecessors: in 1542 Elector Joachim II built his hunting lodge at Grunewald as a first outpost, but it was only after 1660 that Friedrich Wilhelm, the "Great Elector", developed Potsdam in keeping with the general European fashion for palaces such as Versailles, with which Louis XIV had set the tone outside the gates of Paris. The town palace in Potsdam was joined by smaller summer retreats in Potsdam's rural environs, such as Bornim, Glienicke and Caputh, the last being the only one to have survived almost completely intact. Later monarchs retained this preference for Potsdam in the warmer months, and a corona of stately homes and gardens sprang up around the town during the 18th and 19th centuries. The best-known are Sanssouci, the New Garden and Babelsberg Park, but there were others, such as Pfaueninsel, Sacrow and Glienicke.

Halfway between his two seats in Berlin and Potsdam, Elector Friedrich III began building a palace for his lady consort Sophie Charlotte in 1695. After her death, it was renamed Charlottenburg in her honour in 1705, and its extensions and conversions continued into the 19th century. Today, with the official seat demolished, it has acquired the status of Berlin's principal palace, even though it was itself gutted by fire in the air raids of 1943.

Whereas in Potsdam every king, and later various princes, insisted on building his own palace, usually accompanied by a garden, almost every king resided at some point in Charlottenburg and set some personal stamp on the building. As a result, the palace enjoys a particular significance in the history of both the monarchy and the arts.

The House of Hohenzollern proved adept at winning the best architects, garden landscapers and artists in the country (such as Georg Wenzeslaus von Knobelsdorff and Karl Friedrich Schinkel) for their projects, and also masters from abroad. Moreover, most of them were themselves well-educated patrons with clear expectations. The result, after two centuries, was a plethora of palaces and gardens which Peter Joseph Lenné combined into a total art work with his Improvement Plan of 1833.

The buildings in particular are not simply artistic accomplishments, but have been the sites of historical events from the Edict of Potsdam (signed in 1685 in the Potsdam town palace, damaged in 1945 and demolished in 1959/60) to the Potsdam Conference (held in Schloss Cecilienhof in 1945).

The *Stiftung Preussische Schlösser und Gärten Berlin-Brandenburg* was set up as a foundation in 1995 on the basis of an agreement between the two states of Berlin and Brandenburg and with financial support from the federal German government, and is continuing the work begun by the Prussian administration established in 1927 to manage the former palaces after the Hohenzollern abdication and the declaration of a Republic. The Foundation is now responsible for more than 150 historical buildings, including 30 palaces, which date from the late 17th to the early 20th century. Its park assets amount to over 700 hectares and enable the visitor to walk through 300 years of political and art history in Brandenburg and Prussia. At present, 25 palace museums are open in summer and 11 in winter, attracting over two million visitors a year, testimony to the appeal of this cultural landscape. Additional tribute was paid to the Potsdam and Berlin sections in 1990, when they were included in the UNESCO world heritage as a cultural treasure of the highest international order.

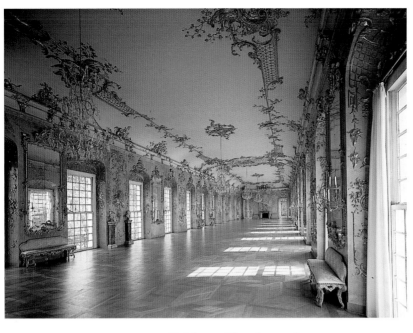

Schloss Charlottenburg, New Wing, Golden Gallery

i Old Palace
Tel. (+49/0) 30/32 09 12 75

Visitors' Centre
Tel. (+49/0) 3 31/96 94-2 00
and -2 01
Fax (+49/0) 3 31/9 69 41 07

⊘ The park is open daily all
year round from daybreak
until dusk.

Old Palace
⊘ Tu–Fr 9 am–5 pm
Sa/Su 10 am–5 pm
Closed on Mondays

New Wing
⊘ Tu–Fr 10 am–6 pm
Sa/Su 11 am–6 pm
Closed on Mondays

♿

✕

🅿

Ⓢ S45, S46

Ⓤ U2, U7

🚌 109,110,121,145, X21

M Other museums:
Langhans Building:
Museum of Pre- and Early
History
New Wing: Prussia's
cultural heritage, Gallery of
Romantic Art
Opening times as for New
Wing
Orangery: temporary
exhibitions

*Schloss Charlottenburg,
New Wing, Winter Chambers*

Schloss Charlottenburg

Schloss Charlottenburg was the only palace in Berlin to be reconstructed after severe war-time damage. As a result, it is the only palace in the capital which illustrates the culture of the Hohenzollern court from the 17th to the late 19th century. The original nucleus for the future palace and gardens was Schloss Lietzenburg, a small summer residence built for the Elec-

tress from 1695 by Arnold Nering. A major programme of conversion and extension under Eosander Göthe began in 1701 and was completed in 1713. The baroque elements, such as the Porcelain Room and the Chapel, can still be witnessed more or less in their original state on the ground floor of the Old Palace.

The complex was substantially enlarged after Friedrich the Great ascended the throne. In summer 1740 Georg Wenzeslaus von Knobelsdorff began constructing the New Wing, with splendid banqueting chambers such as the Golden Gallery and the White Room, and also apartments for Friedrich and his wife, although Elisabeth Christine never resided here. Antoine Watteau's paintings in the King's second apartment rank among the outstanding art works at the palace.

Friedrich Wilhelm II also commissioned improvements after his accession to the throne in 1786. His particular concern was to transform the baroque garden into a sentimental landscape. To this end he summoned garden architect Johann August Eyserbeck from Wörlitz. He appointed Karl Gotthard Langhans to build a new theatre west of the orangery

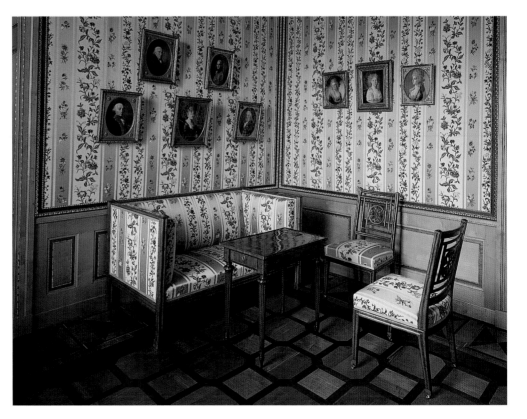

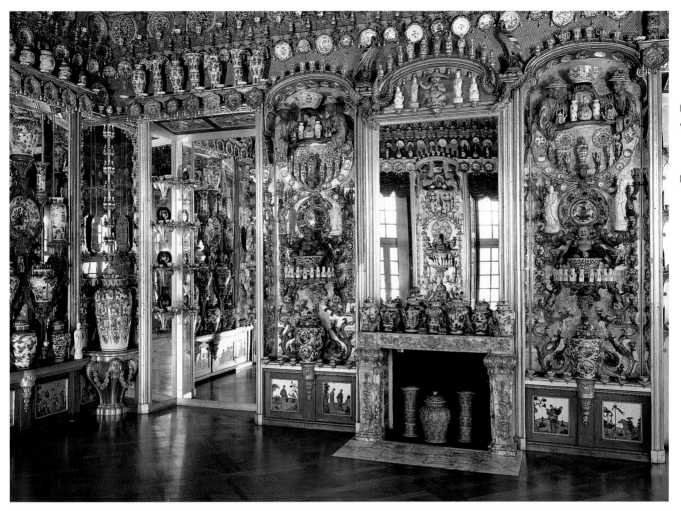

from 1788 to 1791. By 1902 this auditorium had been altered beyond recognition, and it was never rebuilt after its destruction.

Friedrich Wilhelm II converted the New Wing into a summer and a winter apartment (the Winter Chambers). Both suffered heavy damage in the Second World War. The Winter Chambers have been restored after major reconstruction begun in the early eighties.

Friedrich Wilhelm III and his Queen Luise used Schloss Charlottenburg as a summer residence. They lived in the apartments just completed for Friedrich Wilhelm II in the western section of the New Wing. When the royal family returned from Napoleonic exile in 1810, Schinkel was appointed to redesign the Queen's bedroom. This is the only room of the period to have been reconstructed after war-time damage.

Friedrich Wilhelm IV was the last Hohenzollern king to build his own apartment in Schloss Charlottenburg. He withdrew here after the Revolution of 1848. The King's and Queen's Apartments fell prey to the war damage. Only the Library has been restored to its original form.

A rich collection of paintings and furniture in the remaining rooms offer an impression of the royal home.

The court tableware and silver chambers, like the Crown Room, are open to visitors on the upper floor of the Old Palace.

Schloss Charlottenburg, Old Palace, Porcelain Room

◷ 1 April–31 October
10 am–5 pm
Closed on Mondays
1 November–31 March
Tu–Fr 12 noon–4 pm
Sa/Su 12 noon–5 pm
Closed on Mondays

🅿 outside Schloss
Charlottenburg

Public transport:
see Schloss Charlottenburg

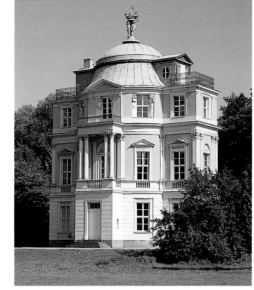

Belvedere in Charlottenburg Park

Belvedere

Karl Gotthard Langhans built the Belvedere in 1788 as part of his commission to redesign the park at Charlottenburg for Friedrich Wilhelm II. The three-storey structure on its oval plan combines baroque with early classical features. The interiors were lavishly appointed, especially on the upper floors, but they were lost to war damage. The building's shell has been reconstructed and it now houses a porcelain collection to illustrate the history of the Royal Porcelain Manufactory (KPM). The exhibits include porcelain by Wilhelm Caspar Wegely and Johann Ernst Gotzkowsky, who laid the foundations for the enterprise. The display focuses primarily on KPM porcelain made from 1763, when Friedrich the Great bought the manufactory, until the Biedermeier years.

Mausoleum

◷ 1 April–31 October
10 am–5 pm, closed for
lunch 12 noon–1 pm
Closed on Mondays

🅿 outside Schloss
Charlottenburg

Public transport:
see Schloss Charlottenburg

Mausoleum

The sudden death of Queen Luise on 19 July 1810 plunged all Prussia into mourning. So revered was she that calls were soon heard for a permanent monument. King Friedrich Wilhelm III chose the site and form for the Mausoleum personally. Karl Friedrich Schinkel was appointed to design it and Heinrich Gentz to implement his plans. The King also stipulated the details for the memorial tomb, selecting a design by Schadow's pupil Christian Daniel Rauch.

When Friedrich Wilhelm III died, his son ordered him to be buried alongside Queen Luise. Accordingly, Karl Friedrich Schinkel produced plans for enlarging the Mausoleum in 1841/42. Again, Christian Daniel Rauch was asked to design the sarcophagus.

In 1890 the Mausoleum was altered once more, this time by Albert Geyer, to accommodate the tombs of Kaiser Wilhelm I and his consort Augusta.

Mausoleum in Charlottenburg Park

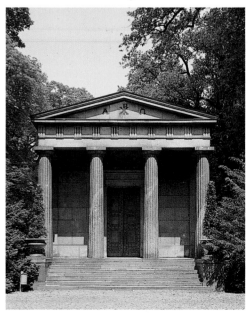

New Pavilion

In 1824/25 Friedrich Wilhelm III used drawings by Karl Friedrich Schinkel for a summerhouse outside Schloss Charlottenburg where he and his second wife, Auguste Princess of Liegnitz, would find some tranquillity.

The pavilion was completely destroyed in the Second World War and reopened in 1970 as a museum after its reconstruction. The exhibition is devoted primarily to Schinkel's prolific output and to art in Berlin from the early 19th century. Alongside paintings by Carl Blechen, Karl Friedrich Schinkel and Eduard Gärtner, there are sculptures by Johann Gottfried Schadow and Christian Daniel Rauch, as well as porcelain, furniture and samples of decorative cast iron made in Berlin.

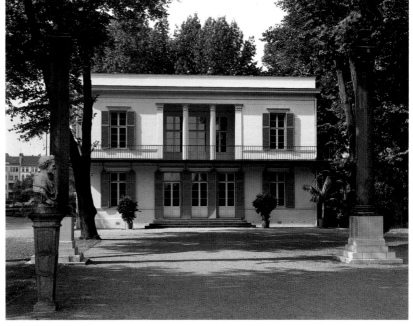

New Pavilion in Charlottenburg Park

🕐 10 am–5 pm
Closed on Mondays

🅿

Public transport:
see Schloss Charlottenburg

Grunewald Hunting Lodge

Elector Joachim II, an enthusiastic hunter, built his Renaissance palace on the shores of Lake Grunewald in 1542. Architect Caspar Theiss drew on Saxon prototypes in Dresden and Torgau. Its owner called it his lodge "in the green wood", and this is how the surrounding woodland received its name.

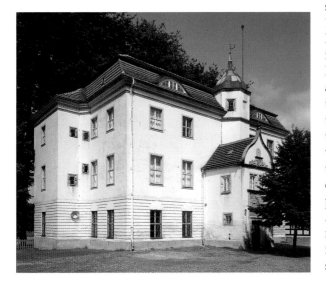

At the dawn of the 18th century, King Friedrich I commissioned baroque-style conversions, although without eliminating the Renaissance character entirely. In 1770 Friedrich the Great added an ancillary building to the south for storing the paraphernalia of the court hunt. The last construction work took place in 1901–1904 under Kaiser Wilhelm II, who revived the event, inviting large companies to hunt.

In 1932, when the lodge was almost devoid of furnishings, the Prussian Palace Administration used it to hang paintings of the 15th to 19th centuries. Surviving the war unscathed, it was the first museum in Berlin to open its doors again to the public in 1949.

A museum of hunting equipment was added in 1977, housed in the barn originally built to store it.

ℹ Tel. (+49/0) 30/8 05 30 41

🕐 1 May–31 October
10 am–5 pm, closed for lunch 1–1.30 pm
Closed on Mondays
1 November–31 April only Sa/Su 10 am–4 pm, closed for lunch 1–1.30 pm

🍴

🅿 by the restaurant

Ⓢ From Berlin or Potsdam: service S3 or S7 to Grunewald

Ⓤ From Berlin: service U1 to Onkel Toms Hütte, then walk

By car: Avus motorway to Hüttenweg exit

Grunewald Hunting Lodge

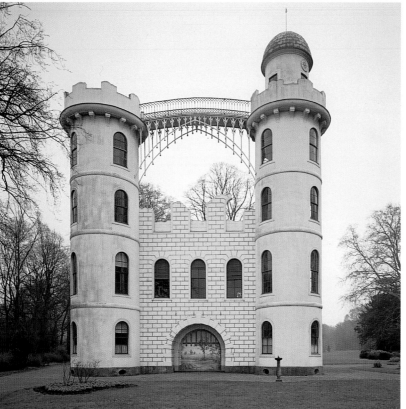

Palace on Pfaueninsel

Friedrich Wilhelm III and his wife, Queen Luise, used the palace as a summer residence. They commissioned Peter Joseph Lenné to transform the island into a landscaped garden. Several new buildings appeared, including Schinkel's Palm House (razed by fire in 1880) and the Cavalier House. Friedrich Wilhelm III kept exotic animals here, making the island a great attraction as a forerunner of Berlin Zoo. The public had access twice a week.

ℹ Visitors' Centre
Tel. (+49/0) 3 31/96 94-2 00
and -2 01
Fax (+49/0) 3 31/9 69 41 07

Island
🕐 November–February
10 am–4 pm
March/October 9 am–5 pm
April/September 8 am–6 pm
May–August 8 am–8 pm

♿

Palace
🕐 1 April–31 October
10 am–5 pm, closed for
lunch 1–1.30 pm
Closed on Mondays

✕

🅿 on the mainland

🚌 Service A16 from Wannsee,
ferry to the island

By car: from Potsdam or
Berlin (Wannsee) take
Königstrasse to Nikolkoer
Weg

Pfaueninsel

Friedrich Wilhelm II of Prussia bought the Pfaueninsel, or "isle of peacocks", in 1793. It was in visual range of the New Garden and provided the King with a new destination for his hobby of boating. In 1794 he appointed Potsdam carpenter Johann Gottlieb Brendel to build a summer residence there in the form of a Romantic rural ruin, which the King used with his mistress Wilhelmine Encke, the future Countess Lichtenau. Made almost entirely of wood, the palace is painted outside to create an illusion of stone, while the ornamentation suggests a stage backcloth.

The early classical interior, much influenced by the King's mistress, remains largely as it was originally, conveying an authentic impression of courtly living around 1800. The largest room is the banqueting chamber with ornate marquetry on the upper floor. Its classical clarity provides a counterweight to the exotic flavour of the Otaheiti Room.

Under Friedrich Wilhelm II the island retained its original character. The landscaped garden was confined to the area around the palace, while a neo-Gothic dairy was built at the other end of the island.

The Palace banqueting hall

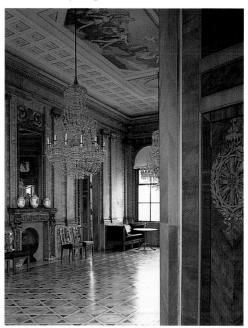

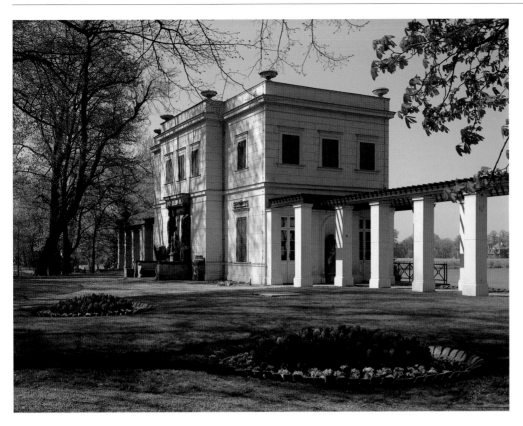

i Visitors' Centre
Tel. (+49/0) 3 31/96 94-2 00
and -2 01
Fax (+49/0) 3 31/9 69 41 07

The park is open daily all
year round from daybreak
until dusk.

15 May–15 October
Sa/Su only 10 am–5 pm

Tram service 93 from Pots-
dam Stadt station or Platz
der Einheit to the final stop
at Glienicker Brücke

Casino in Glienicke Park

Schloss Glienicke

Just beyond the gates of Potsdam, on the banks of the Havel, Schloss Glienicke with its park is a key component of the local cultural landscape. Prince Carl of Prussia bought the property in 1824 for himself and his future wife Marie of Saxe-Weimar. Deeply affected by a recent Italian journey, he commissioned extensions and conversions to plans by Karl Friedrich Schinkel in 1825–1827. Peter Joseph Lenné, who first began working on this pleasure ground in 1816, under the previous owner Prince Hardenberg, was able to complete his project for the new client. First, the old billiard house on the high riverbank was enlarged to create a casino oriented completely towards views across the lake. Then, until 1827, the old manor house was converted into a palace in the form of a classical villa. A tower was added in 1832, and the lion fountain to improve the street elevation dates from around 1840.

The drawings and illustrations on the ground floor provide background information on Potsdam's cultural landscape. The rooms upstairs convey an impression of how the princely couple lived. An ex-hibition in the west wing is devoted to Prussia's court gardeners, with original material from their posthumous papers.

Schloss Glienicke with lion fountain

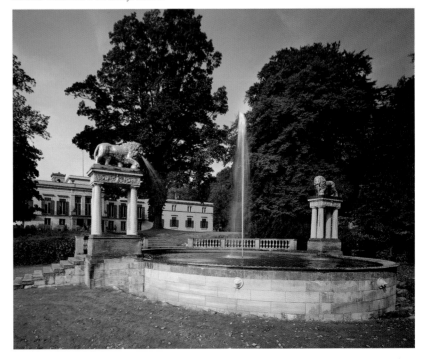

Stiftung Preußische Schlösser und Gärten Berlin-Brandenburg

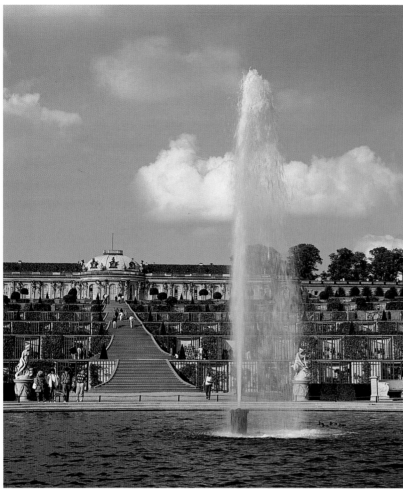

The park is open daily all year round until dusk

Wheelchairs for the park can be lent out at the Visitors' Centre

P near Schloss Sanssouci and the New Palace

Vine terraces with Great Fountain and Sanssouci Palace

The Hill of Ruins

Park Sanssouci in the 19th century, landscaped garden by Schloss Charlottenhof

Sanssouci Park

The park of Sanssouci is a composition of palatial buildings and gardens begun in the 18th century and terminated with the end of the Hohenzollern monarchy in 1918. Its focus is Schloss Sanssouci, the summer residence built for Friedrich the Great with its terraced vines laid out in 1744. Other buildings, from the Neptune Grotto to the New Chambers and parterre extensions, follow the undulating terrain north of the 2-kilometre main avenue. The sequence ends in the west with an imposing architectural ensemble behind the Deer Garden: the New Palace and the Communs.

The gardens laid out for Friedrich the Great were extended in the 19th century under Friedrich Wilhelm III to incorporate Charlottenhof and the Hops Garden. From 1840 Friedrich Wilhelm IV made more additions: the Marly Garden, the Church of Peace, parts of the Hill of Ruins, the Sicilian and Nordic Gardens and the Orangery. He entrusted his garden architect Peter Joseph Lenné with the

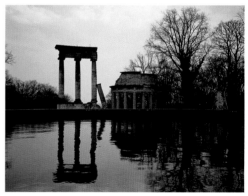

design. In 1908 Wilhelm II commissioned the Potente to round off the park in the north-west.

Schloss Sanssouci

Friedrich the Great chose this "desolate hill" by Potsdam for its attractive location and fine view. As the name "Sans souci" (or "without a care") on the garden front of the palace proclaims, this summer residence was intended primarily to serve the King's private diversions. He hoped here to pursue philosophy, music and literature and to be buried one day in the crypt alongside the palace.

The single-storey building in the manner of a French "maison de plaisance" was built in 1745–1747 under the supervision of Georg Wenzeslaus von Knobelsdorff to specifications by the King. The middle consists of two magnificent halls, with Friedrich's apartments to the east and guest rooms to the west. The King received chosen guests at his famous dining table in the domed Marble Hall. The Library and Concert Room are supreme accomplishments of rococo interior art.

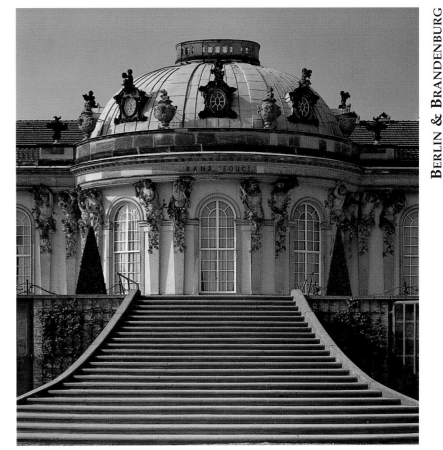

Schloss Sanssouci, garden front

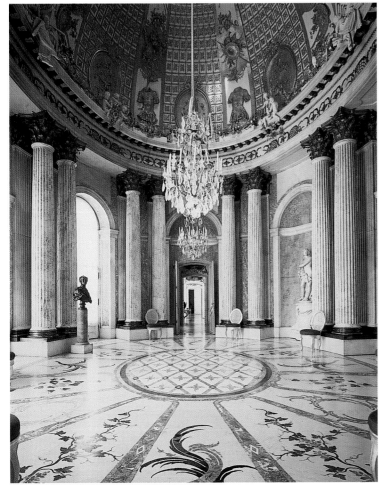

Schloss Sanssouci, Marble Hall

i Visitors' Centre
Tel. (+49/0) 3 31/96 94-2 00
and -2 01
Fax (+49/0) 3 31/9 69 41 07

Schloss Sanssouci
◷ 1 April–31 October
9 am–5 pm
1 November–31 March
9 am–4 pm
Closed: 12.30–1 pm
Closed on Mondays

&

Ladies' Wing
◷ 15 May–15 October
Sa/Su only 10 am–5 pm
Closed: 12.30–1 pm

Palace Kitchen
◷ 15 May–15 October
Sa/Su only 10 am–5 pm
Closed: 12.30–1 pm

&

✗

P

🚌 Service 695 between Potsdam Stadt station and Pirschheide, bus stops in both directions outside Schloss Sanssouci

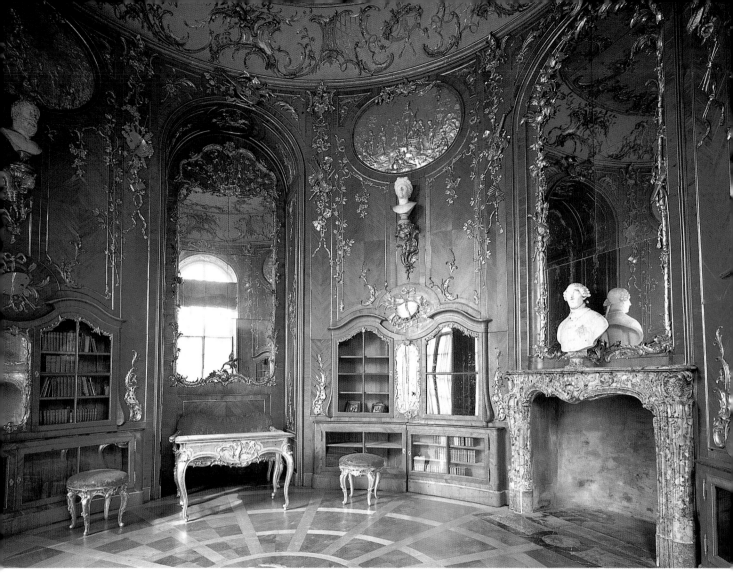

Schloss Sanssouci, Library

🚋 Trams 94 and 96 stop in both directions at Luisenplatz, then 15 min. walk

*Schloss Sanssouci,
Friedrich Wilhelm IV's kitchen*

The side tracts – the kitchen and the Ladies' Wing – acquired their present form in 1840–1842 under Friedrich Wilhelm IV. The drawings were by Ludwig Persius. The west (or "ladies'") wing was intended as "lodging for ladies of court and elsewhere". The kitchen was accommodated in the east wing.

The colonnades of the cour d'honneur open the view to the Hill of Ruins, where there is a reservoir feeding water to the garden fountains. Artificial ruins were added in 1748 to create the illusion of an Ancient landscape.

Picture Gallery

Friedrich the Great was a passionate collector of paintings. He filled his apartments with them, not very unlike his contemporaries. However, his idea of commissioning a building specifically to house his collection was an international novelty. The Picture Gallery was erected in 1755-1763 to drawings by Johann Gottfried Büring over the foundations of a former hothouse next to Schloss Sanssouci. It is one of the oldest surviving museum buildings in Germany and also one of the most beautiful galleries in the world. Divided in the middle by a tribuna, the hall is almost as long as the building itself, which appears very simple from the outside. The use of precious marbles and gilt stucco lends this room its unique festive atmosphere. Masterpieces by Caravaggio, Maratta, Reni, Rubens and van Dyck are hung frame to frame in baroque style. Caravaggio's "Doubting Thomas", one of the key attractions in today's collection, was a later addition. Friedrich the Great himself disdained paintings of "scoundrel saints who get martyred".

Picture Gallery, west wing

ℹ Visitors' Centre
Tel. (+49/0) 3 31/96 94-2 00
and –2 01

🕐 15 May–15 October
10 am–5 pm, closed for
lunch 12.30–1 pm
Closed on Mondays

✗

🅿 outside Schloss Sanssouci

Public transport: see Schloss
Sanssouci

*Michelangelo Merisi
da Caravaggio,
"Doubting Thomas"*

Stiftung Preußische Schlösser und Gärten Berlin-Brandenburg

ℹ Visitors' Centre
Tel. (+49/0) 3 31/96 94-2 00
and -2 01
Fax (+49/0) 3 31/9 69 41 07

🕐 1 April–14 May
Sa/Su only 10 am–5 pm
15 May–15 October
10 am–5 pm, closed for
lunch 12.30–1 pm
Closed on Mondays

♿

✗

🅿 outside Schloss Sanssouci

Public transport: see Schloss
Sanssouci

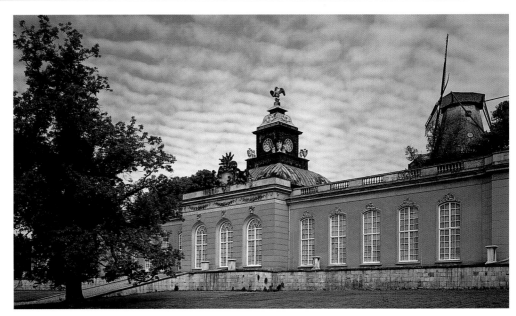

New Chambers, garden front

The New Chambers

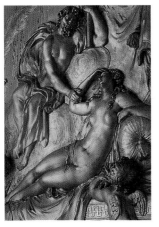

*New Chambers, detail from
Ovid Gallery bas-relief*

Although the King had adequate space to accommodate his guests in the New Palace, he had an earlier building on this site converted into a guest-house closer to Sanssouci.

Initially, in 1747, an orangery was built here, based on Knobelsdorff's drawings, as a pendant to the hothouse east of Schloss Sanssouci which later made way for the Picture Gallery. The orangery was converted in 1771–1775 by Johann Christian Unger.

The ground plan of the orangery was retained, but the structure now contained guest rooms and several halls for festive occasions. The interior decoration betrays a late yet high-quality rococo. This exultant splendour is well concealed by the simple austerity of the façade, especially now that its poorly preserved sculptural adornment has been lost. In the Ovid Gallery, a room in the fashion of a French gallery of mirrors, fourteen themes from the Roman poet's "Metamorphoses" exude a voluptuous sensuality in gilt stucco relief. The smaller guest rooms are ornately decked with marquetry, enamel or paintings. The marquetry finishing by the Spindler brothers is especially noteworthy.

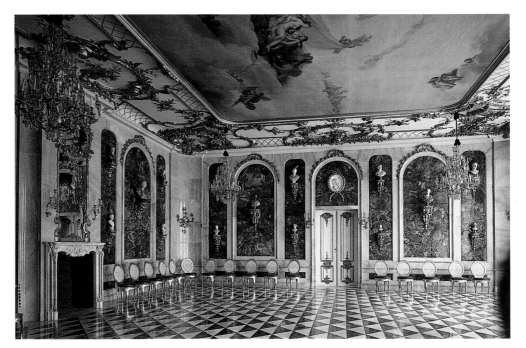

New Chambers, Jasper Hall

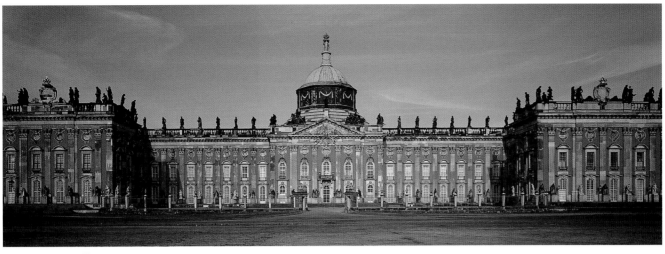

New Palace, cour d'honneur

The New Palace of Sanssouci

This spacious palace complex, described by the King himself as a "fanfaronade" (or "brag"), was intended to reflect Prussia's political power after the Seven Years War. Friedrich the Great set the New Palace, or Neues Palais, at the far western end of the main avenue, as a grand finale to this rigidly straight axis some two kilometres long. Designed by Johann Gottfried Büring, Heinrich Ludwig Manger, Carl von Gontard and Jean Laurant Legeay, it was built between 1763 and 1769. It is 22 metres long, one of the biggest palaces of its day, with over 400 statues on the façade, magnificent banquet halls, a theatre and lavishly fitted rooms for the Prussian King's guests.

The Schlosstheater in the New Palace is one of the few 18th-century theatres still extant, and the stage is used frequently for performances. Contrary to the fashion of the times, the seating is arranged as in an amphitheatre, with ascending rows. A royal box was superfluous, because Friedrich preferred to follow the proceedings from in front of the orchestra pit or from a seat in the third row.

Friedrich the Great's successors only used the New Palace for festive occasions or theatre productions. Not until Kaiser Friedrich III in 1859 did a monarch reside here

regularly in summer. His son Wilhelm II made the New Palace his principal residence, adding a garden terrace, riding stables and a station to the original complex. The Communs, or functional buil-

i Visitors' Centre
Tel. (+49/0) 3 31/96 94-2 00
and -2 01
Fax (+49/0) 3 31/9 69 41 07

🕑 1 April–31 October
9 am–5 pm
1 November–31 March
9 am–4 pm,
closed for lunch 12.30–1 pm
Closed on Fridays

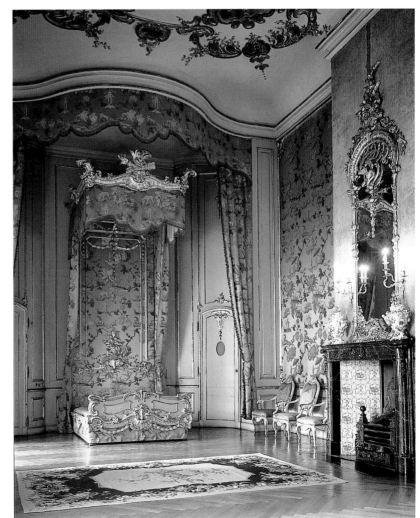

New Palace, bedroom

🚌 Service 695 between Potsdam Stadt station and Pirschheide, stops at Neues Palais

DB Regional train service from Potsdam Stadt to Wildpark, then approx. 10 min. walk

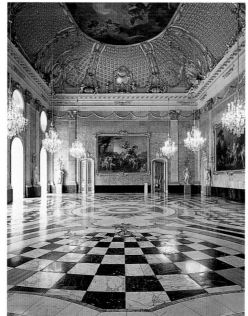

New Palace, Marble Hall

dings, opposite were conceived with their colonnade as an architectural backcloth to conceal the wasteland beyond. These buildings are now used by Potsdam University.

New Palace, theatre

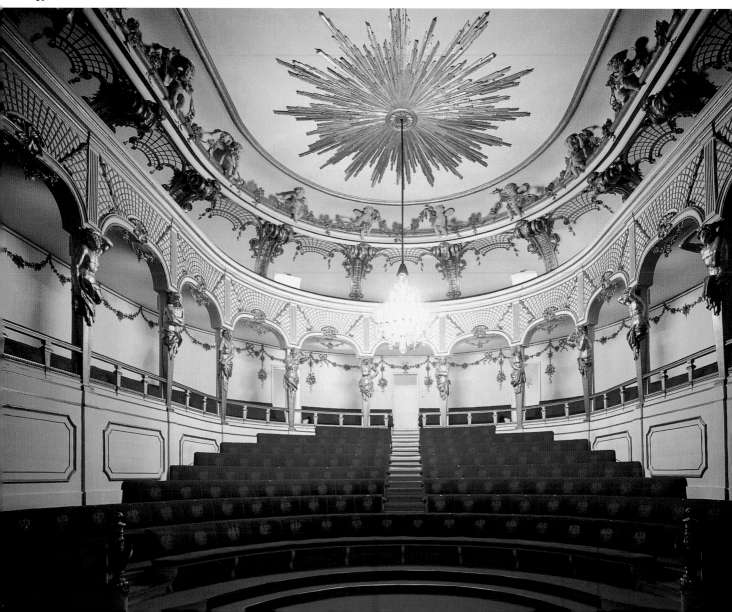

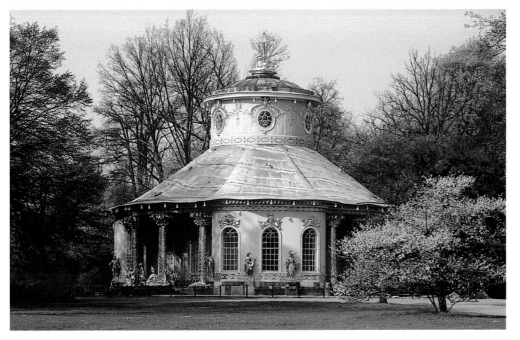

i Visitors' Centre
Tel. (+49/0) 3 31/96 94-2 00
and -2 01
Fax (+49/0) 3 31/9 69 41 07

🕙 15 May–15 October
10 am–5 pm, closed for
lunch 12.30–1 pm
Closed on Mondays

♿

Public transport: see Schloss
Sanssouci

Chinese House

Chinese House

The gilt figures clustered around the Chinese House can be seen glinting from a distance, arousing curiosity about the little fairy-tale building. It was designed by Johann Gottfried Büring while he was building the Picture Gallery in 1755–1764. The rococo forms combined with Oriental motifs make this pavilion a typical specimen of the 18th-century fashion for anything Chinese. The house has a clover-leaf plan and is thus open on all sides. Gilt sandstone palms, surrounded by "Chinese" figures drinking coffee and tea, support the porch roofs.

The Belvedere on Klausberg

The Belvedere on Klausberg

The last building by Friedrich the Great, on Klausberg at the north-western edge of Sanssouci Park, offers views and catches them, too. With its complex arrangements of columns, it was created in 1770–1772 by Georg Christian Unger. The Belvedere was severely damaged during the war and the interior was irreparably lost. The ground-floor hall, once clad with jasper, and the room above with its painted ceiling were once used for small festive gatherings. Since 1992 the Messerschmidt Foundation has been funding a substantial restoration programme.

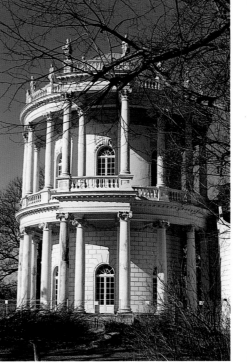

🕙 Re-opening after restoration
work in 2001

✖

Public transport: see Schloss
Sanssouci

Belvedere on Klausberg

Stiftung Preußische Schlösser und Gärten Berlin-Brandenburg

i Visitors' Centre
Tel. (+49/0) 3 31/96 94-2 00
and -201
Fax (+49/0) 3 31/9 69 41 07

🕐 15 May–15 October
10 am–5 pm, closed for
lunch 12.30–1 pm
Closed on Mondays

P Geschwister-Scholl-Strasse

🚋 Tram services 94, 96, 98
towards Pirschheide stops
at Schloss Charlottenhof

DB Regional train service from
Potsdam Stadt to Charlot-
tenhof, then approx. 20 min.
walk

Can also be reached from
other park entrances, notab-
ly by the New Palace

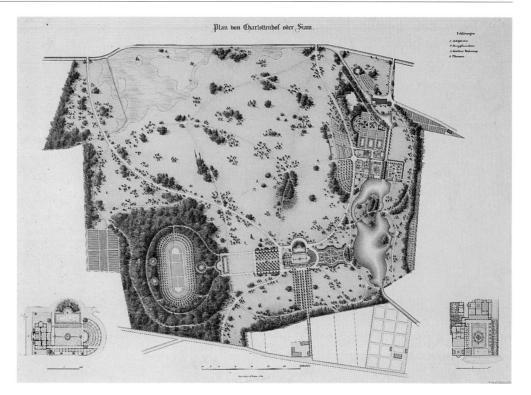

*G. Koerber, plan of
Charlottenhof Park, 1839*

Schloss Charlottenhof

The enchanting park and palace of Char-
lottenhof are the product of a happy col-
laborative venture between two brilliant
creative minds: architect Karl Friedrich
Schinkel and landscape gardener Peter
Joseph Lenné.

Friedrich Wilhelm III purchased the site
south-west of the original Sanssouci Park
in 1825 as a Christmas present for Crown
Prince Friedrich Wilhelm (IV) and his
wife Elisabeth of Bavaria. In 1826–1829
Karl Friedrich Schinkel converted the
existing manor house into a classical villa
to serve as a summer residence. The task
of landscaping this former farmland fell
to Peter Joseph Lenné. In the immediate
vicinity of the house he created a garden
of compact design and an east-west orien-
tation, beginning with a rose garden to
catch the morning sun, a terrace along the
house for the midday sun, and further
west the poets' grove and the Ildefonso
group for the evening and nocturnal
hours. The drive and broad sight-lines
skilfully link the new park with the old
park of Sanssouci. Not a single impact is
left to chance, be it a movement of terrain,
a cluster of trees or a free-standing struc-
ture. An artificial lake put the perfect fin-
ishing touch to this landscaped garden.

*Schloss Charlottenhof,
dining room*

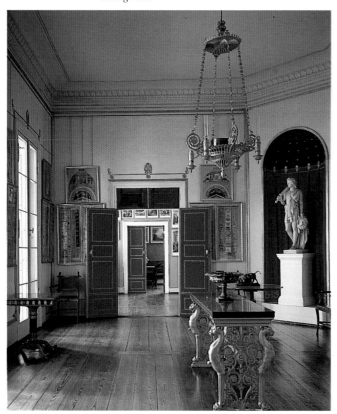

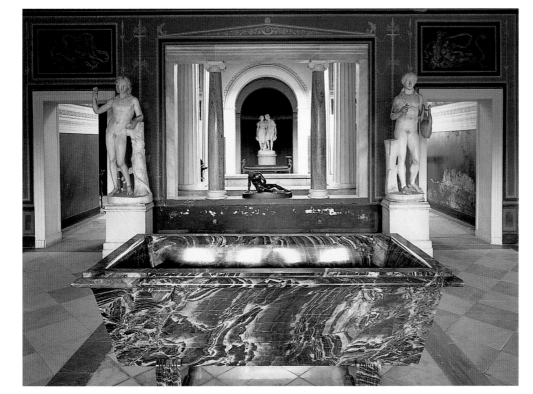

i Visitors' Centre
Tel. (+49/0) 3 31/96 94-2 00
and -201
Fax (+49/0) 3 31/9 69 41 07

⊙ 15 May–15 October
10 am–5 pm, closed for
lunch 12.30–1 pm
Closed on Mondays

&

P Geschwister-Scholl-Strasse

M Temporary exhibitions are
shown in summer in the
court gardener's villa

Public transport:
see Schloss Charlottenhof

Roman Baths, atrium

Roman Baths

The buildings which make up the Roman Baths were constructed in 1829–1840 to drawings by Karl Friedrich Schinkel and Ludwig Persius. The court gardener lived in the villa with a tower. From the charming little garden with its beds of "Italian cultures", including maize, hemp, artichokes and tobacco, the arcades lead to the Roman Baths themselves. This structure resembles a house in an Ancient civilisation and was used by the Crown Prince as a museum for his Italian souvenirs. Friedrich Wilhelm IV liked to take tea at the pavilion on the banks of the artificial reservoir.

Schloss Lindstedt

Off the beaten tourist track, north-west of Sanssouci Park, visitors may be surprised by a small but exquisite park with a little palace built in 1858–60 as a classical villa. Schloss Lindstedt is a typical example of Friedrich Wilhelm IV's passion for buildings. As with his bigger projects, the design phase lasted many years. From 1830 onwards he revised his ideas repeatedly in sketches before asking the architects – Persius, Hesse, Stüler and von Arnim – to produce drawings. The little park is about 2 hectares in size and was landscaped by Peter Joseph Lenné. Its regular layout makes reference to Schinkel's reconstruction of Pliny's gardens.

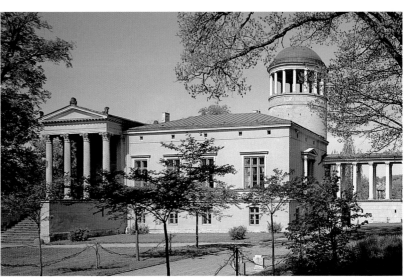

Schloss Lindstedt

The building is now used for events.
Enquiries:
Tel. (+49/0) 3 31/9 69 41 73

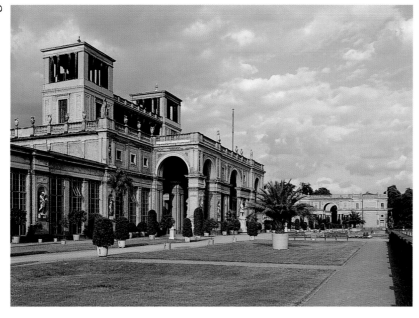

Orangery Palace

i Visitors' Centre
Tel. (+49/0) 3 31/96 94-2 00
and -201
Fax (+49/0) 3 31/9 69 41 07

Towers
🕑 1 April–14 May
Sa/Su and public holidays
10 am–5 pm

Palace and towers
🕑 15 May–15 October
10 am–5 pm, closed for
lunch 12.30–1 pm
Closed on Mondays

♿

✗

🅿

🚌 Service 695 between Pots-
dam Stadt station and
Pirschheide, bus stops in
both directions at Maul-
beerallee (downhill from
the Orangery)

Orangery Palace

Standing among the palms and Mediter-
ranean shrubs which adorn the Orangery
Palace terraces, visitors may wonder
whether they are in Italy. Friedrich Wil-
helm IV intended to build a grand hill-top
avenue to the north of Sanssouci Park in
honour of Friedrich the Great. The
Orangery Palace was the only major
structure in this project to be completed.

The king personally designed the archi-
tectural composition, entrusting the con-
struction in 1851–1864 to August Stüler
and Ludwig Ferdinand Hesse. His proto-
types were Italian villas and palaces such
as the Villa Medici and Villa Pamphili.
The central tract with its twin towers
accommodates apartments in Second
Rococo style and also the Raphael Hall,
inspired by the Vatican's Sala Regia. The
walls are hung with red damask as a
background for the world's largest collec-
tion of copies of the great master's paint-
ings. The viewing platform between the
towers offers a broad panorama of Pots-
dam's cultural landscape. The mezzanine
gallery displays temporary exhibitions
during the summer season. The side
pavilions in this architectural complex
provided quarters for court servants,
while exotic plants continue to spend the
winter in the long halls.

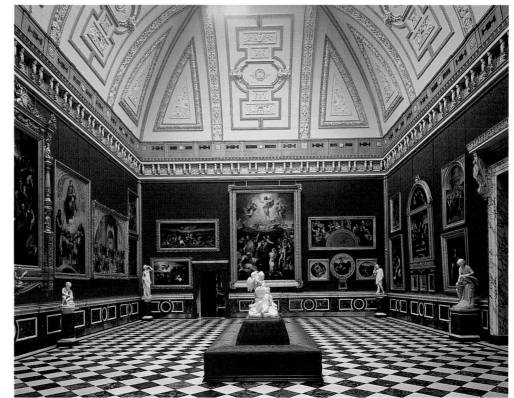

Orangery Palace, Raphael Hall

Church of Peace

Friedrich Wilhelm IV began planning a church for Sanssouci Park while he was still Crown Prince. In his own words, he sought to "confront the worldly negative idea of 'without a care' with the spiritually positive idea of 'peace'". Although architects Persius, Stüler and Hesse included many quotations from architectural history, they nevertheless transformed the king's proposals into an independent ensemble with a Romantic magnificence of its own at the entrance to

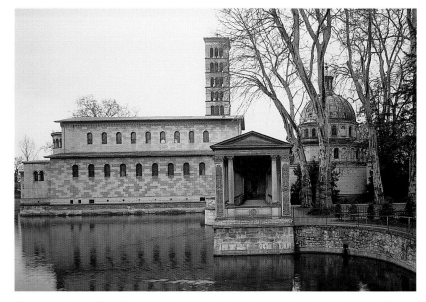

View across the artificial Pool of Peace to the church and mausoleum

Erected in 1888–1890, its interior is reminiscent of the Chapel of the Holy Sepulchre at Innichen in the Southern Tyrol. Friedrich III is joined in this place of rest by his wife Victoria and, since 1991, by Friedrich Wilhelm I, the "soldier king".

Church of Peace and Crypt of Friedrich Wilhelm IV
⊙ May–October daily 10 am–5 pm (except during worship)

Mausoleum
⊙ 15 May–15 October daily (can only be viewed through the wrought-iron railings)

✗

🅿 Schopenhauerstrasse/ Hegelallee

🚋 Tram services 94, 96 in both directions to Luisenplatz

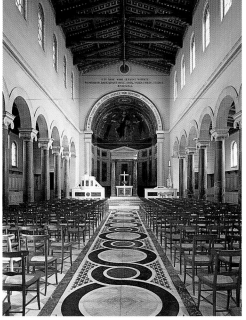

Church of Peace, the nave

Sanssouci Park. On the park side, it opens onto the Marly Garden, which condenses one of Peter Joseph Lenné's most intense and enchanting designs into only three hectares. The church, inspired by San Clemente in Rome, was built in 1845–1854.

Its interior is a revelation with its precious marble and the original 13th-century Venetian mosaic preserved in the apse. The king gave orders that he and his wife Elisabeth should eventually be buried in this church.

Wilhelm II commissioned Julius Carl Raschdorf to build a mausoleum on this site for his father, Kaiser Friedrich III.

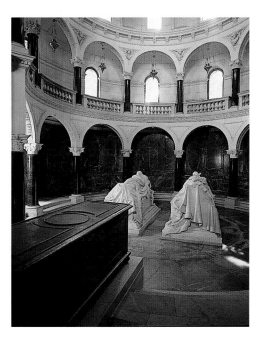

Mausoleum of Friedrich III with the tomb of Friedrich Wilhelm I in the foreground

i Tel. (+49/0) 331/292468

◷ 1 April–31 October
10 am–5 pm
Sa/Su only in
March/November

✕

P

Public transport:
see Schloss Sanssouci

Historical Windmill

Historical Windmill

The story is often told of a miller of Sanssouci whose rattling mill sails so disturbed the king that he ordered the mill to be pulled down. The miller retorted that he would take his case to the Courts in Berlin, where he would be sure to find justice. There is a grain of truth to the tale, but the mill was not in Sanssouci and the king concerned was not Friedrich the Great. Quite the reverse: the latter declared the mill to be "an adornment for the palace".

Today's mill replaces the one built in 1787–1790 by Van der Bosch, gutted by fire as the war raged to an end in April 1945. The sails have been turning again since 1993 thanks to the efforts of the mill societies in Minden-Lübbecke and Berlin.

Engine House

i Visitors' Centre
Tel. (+49/0) 331/9694-200
and -201
Fax (+49/0) 331/9694107

◷ 15 May–15 October
Sa/Su only 10 am–5 pm,
closed for lunch 12.30–1 pm

♿

✕

P

🚌 Services 692, 697 to Luisen-
platz

🚌 Tram services 94, 96, 98

Engine House

Friedrich Wilhelm IV ascended the throne in 1840 and began that same year to implement the project which had thwarted Friedrich the Great: making the fountains in Sanssouci work. He asked Ludwig Persius to build a structure to house a steam engine for this purpose, on the bay of the River Havel in Neustadt, "in the

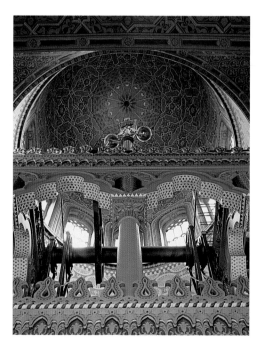

Inside the engine room

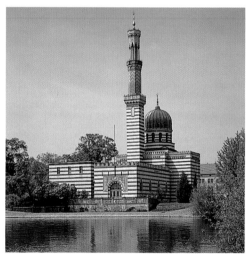

Engine House

manner of a Turkish mosque with a minaret as its chimney". The plan, carried out in 1841–1843, was so convincing that even today confusion occurs about the building's true function. Persius created a fairy-tale interior which borrows directly from the Alhambra at Granada and the Mosque in Cordoba. The steam engine was one of the first products to be commissioned from August Borsig's factory in Berlin, a milestone in Prussia's efforts to compete with England for an industrial image.

The New Garden

In 1786, just after succeeding Friedrich the Great, Friedrich Wilhelm II began landscaping gardens of his own. He asked Johann August Eyserbeck, the gardener at Wörlitz, to create a "sentimental" garden, an appeal to "sensibility", on the banks of the "Holy Lake" to the north-east of the "old" park of Sanssouci. The garden was composed of relatively self-contained elements and embellished with architectural gems, sculptures and memorial stones. The depth of sentiment unleashed by each element would depend on a person's ability to comprehend its meaning. The ideals of freemasonry, shared by the king, played a role. The kitchen, for example,

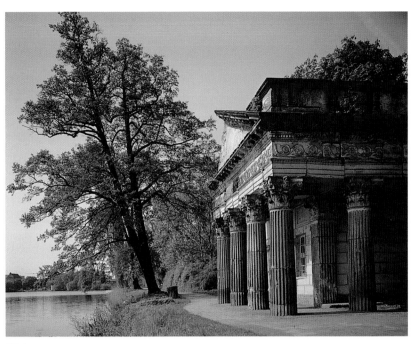

Kitchen

Between 1816 and 1828 Peter Joseph Lenné forged these disparate elements into a coherent landscape of more generous dimensions, with broad lawns and far-reaching vistas.

🕐 The park is open daily all year round until dusk

♿

✗

🅿 outside Schloss Cecilienhof

Pyramid

resembled a half-sunken Ancient temple, the ice store was a pyramid, and the library acquired "Gothic" forms which interacted with a "Moorish" temple, now lost. The spiritual centre of the garden is the Marble Palace on the shores of the lake.

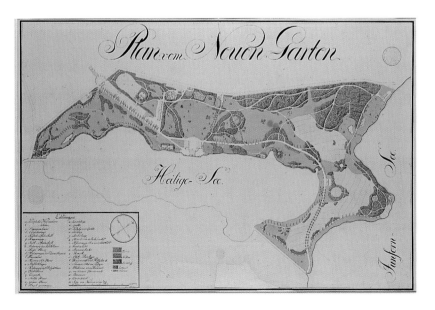

Fintelmann, plan of the New Garden, c. 1820

ℹ Visitors' Centre
Tel. (+49/0) 3 31/96 94-2 00
and -201
Fax (+49/0) 3 31/9 69 41 07

🕐 1 April–31 October
10 am–5 pm
Closed on Mondays
15 November–31 March
Sa/Su only 10 am–4 pm,
closed for lunch 12.30–1 pm

🅿 outside Schloss Cecilienhof

🚌 Service 694 towards Höhen-
strasse, bus stops at Birken-
strasse/Alleestrasse

🚌 Tram services 92 and 95
towards Kapellenberg,
tram stops at
Reiterweg/Alleestrasse

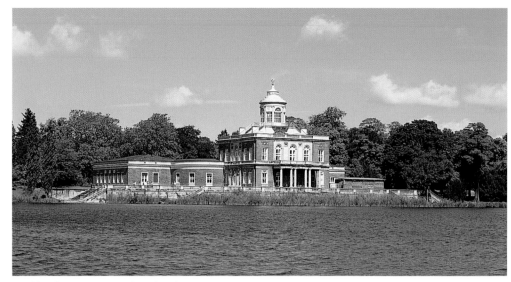

Marble Palace, view across the Holy Lake

The Marble Palace

Karl von Gontard designed this summer residence on the shores of a lake, Heiliger See, for Friedrich Wilhelm II. Construction began in 1787, marking Prussia's departure from the late rococo of Friedrich the Great towards neo-classical architecture.

The interiors were devised by Carl Gotthard Langhans. The king and Countess Lindenau acquired some of the furnishings themselves, including the paintings by Angelika Kaufmann, the English Wedgwood and a collection of Ancient sculpture.

Extensions commenced in 1797 with the addition of side wings, although these were not completed until the 1840s, to drawings by Persius and Hesse under Friedrich Wilhelm IV.

A wood-panelled room decorated with palms was inserted between the two halls of plants in the orangery. It served Friedrich Wilhelm II as a concert hall. The king (himself a cello player), the orchestra and members of the court heard concerts in this room, while the public sat in the adjacent halls of plants.

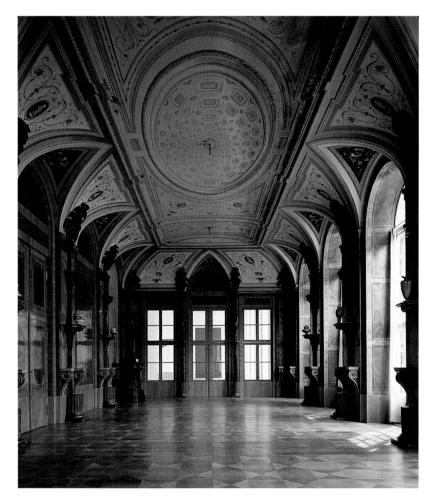

Orangery, Palm Hall

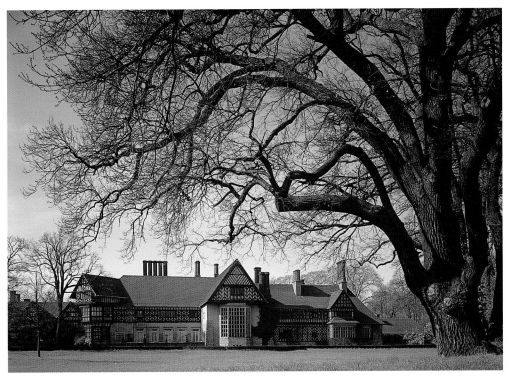

i Visitors' Centre
Tel. (+49/0) 3 31/96 94-2 00
and -201
Fax (+49/0) 3 31/9 69 41 07

🕐 1 April–31 October
9 am–5 pm
1 November–31 March
9 am–4 pm, closed for lunch
12.30–1 pm
Closed on Mondays

Video room

♿

✕

🅿

🚌 Service 694 towards
Höhenstrasse, bus stops at
Cecilienhof

Schloss Cecilienhof

Cecilienhof

Schloss Cecilienhof squats broadly on the banks of Jungfernsee in the style of an English manor house. This was the last palace for the Hohenzollern monarchs, built in 1913–1917, during the First World War, as a home for Crown Prince Wilhelm of Prussia and his family. The architect was Paul Schultze-Naumburg. The marital apartment upstairs is open to the public once more following restoration and illustrates how wealthier families furnished their homes in the early 20th century.

The building acquired fame as the venue of the Potsdam Conference, when Allied leaders met from 17 July to 2 August 1945 to discuss Germany's future after the Second World War. The downstairs rooms were equipped for the needs of the negotiators and have been preserved in this form as a memorial museum. The Great Hall was used for the talks. The study once used by Crown Princess Cecilie, next to the White Salon, served as the Soviet office, where Stalin worked. Crown Prince Wilhelm's smoking parlour was used by US President Truman, while Wilhelm's old library was the office of British Prime Minister Churchill until he was replaced after the British elections of summer 1945 by Attlee.

Schloss Cecilienhof, Great Hall

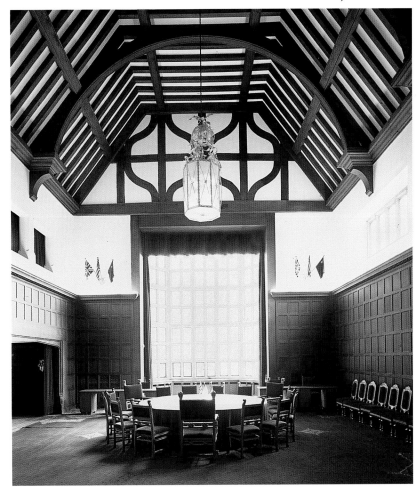

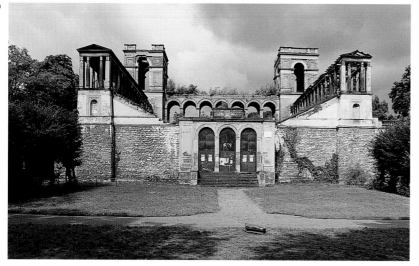

Belvedere on Pfingstberg

🕓 After partial restoration
accessible from May 2001

The Belvedere on Pfingstberg

One of Friedrich Wilhelm IV's biggest projects to set its stamp on the landscape in Potsdam is the Belvedere on Pfingstberg. Like so many of his ventures, it was only implemented in part. It had been intended as a large twin-towered structure with terraces, waterfalls and colonnades framing an area which stretched downhill almost as far as the New Garden. Friedrich Wilhelm was inspired, as so often before, by the Renaissance villas of Italy. Building began in 1847 and the first phase lasted until 1852. This and a flurry of construction in 1863 resulted merely in the twin-towered structure. The planning occupied architects Ludwig Persius, Ludwig Ferdinand Hesse and August Stüler for many years. Peter Joseph Lenné merged the slope of Pfingstberg with the New Garden to create a flowing garden landscape.

Temple of Pomona

ℹ Tel. (+49/0) 3 31/29 24 68

🕓 1 April–31 October
Sa/Su only
3–6 pm

✖

🅿

🚌 Service 694 to the last stop at Höhenstrasse

🚌 Tram service 95 to the last stop at Kapellenberg, then approx. 15 min. walk

Temple of Pomona

Downhill from the Belvedere is the first building ever constructed by Karl Friedrich Schinkel, in 1800 when the budding architect was only nineteen. This little, one-room pavilion in Classical style for the Oesfeld Vineyard is named after Pomona, the goddess of garden fruit. The roof terrace is a canopied viewing platform. Friedrich Wilhelm III bought the temple in 1817. It was popular for royal family excursions.

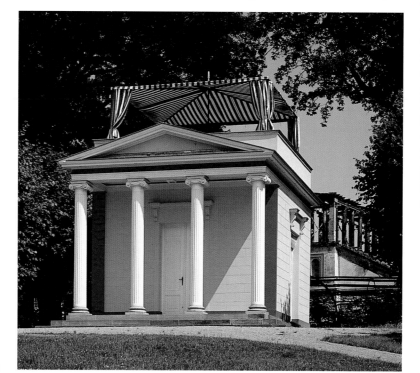

Temple of Pomona

ℹ Visitors' Centre
Tel. (+49/0) 3 31/96 94-2 00
and -201
Fax (+49/0) 3 31/9 69 41 07

🕐 The park is open daily all
year round until dusk

Schloss Babelsberg
🕐 1 April–31 October
10 am–5 pm
Closed on Mondays
1 November–31 March
Sa/Su only 10 am–4 pm

✳

🅿 University

🚌 Service 693 from Babelsberg
station, bus stops at Babels-
berg Nord

Schloss Babelsberg

Schloss Babelsberg and Park

Prince Carl and Prince Friedrich Wilhelm already had their own summer residences, Glienicke and Charlottenhof, when in 1833 Prince Wilhelm – eventually to become Kaiser Wilhelm I – was finally granted permission by his father Friedrich Wilhelm III to use the slopes of Babelsberg for a stately home and park.

Before the year was out, Peter Joseph Lenné had produced preliminary drawings for the park, and Karl Friedrich Schinkel had been appointed to design a neo-Gothic palace. Work proceeded apace, although hindered by meagre finances and disagreements with the owners. Lenné was plagued by a run of bad luck on this commission. His ideas did not appeal to Crown Princess Augusta, and many of the plants he introduced dried out for lack of irrigation. He was replaced by Prince Pückler-Muskau, who retained Lenné's network of paths, but added a multitude of narrow walks with delightful views of Potsdam. Closer to the palace, he redesigned the pleasure ground and the flower garden, adding ornate decoration on the terraces. When Schinkel died in 1841, his pupil Persius assumed responsibility for the building. However, he was unable to salvage the balanced proportions of Schinkel's blueprint, as the Crown Prince and Princess requested radical changes. Johann Heinrich Strack, who took over on Persius' death in 1845, catered rather more to their taste with his plans for a busier façade of more complex articulation.

Schloss Babelsberg, Tea Parlour

Flatow Tower
🕐 1 April–15 October
Sa/So only 10 am–5 pm
Closed for lunch
12.30–1 pm

Flatow Tower

The grounds offer many vantage points, but the Flatow Tower built in 1853–1856 is the most striking, and provides a rich diversity of views across the Potsdam landscape. Respecting Wilhelm's personal wishes, Strack's structure quotes the medieval Eschenheim Gate-Tower in Frankfurt am Main.

Other medieval references in the park include the Sailor's House, with a gable inspired by the Town Hall in Stendal, and the court-house arbour, which Strack built from remains of an earlier court-house arbour by the Town Hall in Berlin.

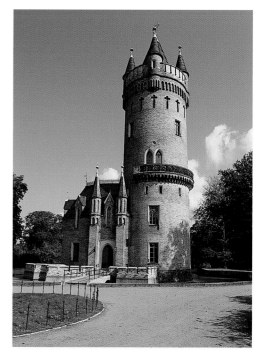

Babelsberg Park, Flatow Tower

Plan of Babelsberg Park, Franz Haeberlin, 1863

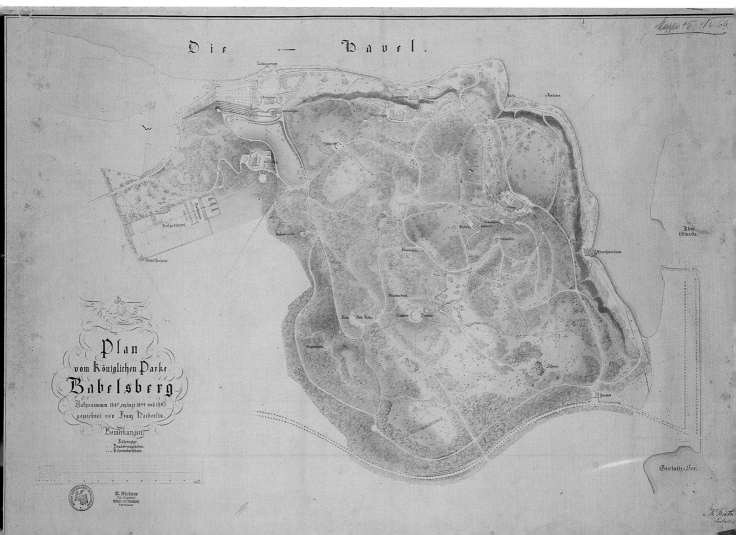

Stern Hunting Lodge

Stern Hunting Lodge

The great passions of Friedrich Wilhelm I were hunting and his "lange Kerls", the special guard selected for superior height. Although he ascended the throne issuing strict orders to budget in order to curtail the "wasteful ways" of his father Friedrich I, he spared neither expense nor effort for these two hobbies.

He created a star-shaped terrain southeast of Potsdam, "Parforce Heath", for the horse-back hunt. The hunting lodge at the centre of this star was built in 1730–1732 in the style of a Dutch town-house, similar to those in Potsdam's Dutch Quarter. The interior consists of a single room with hunting themes occupying about half the ground plan, along with a kitchen, an aide's room and the king's own austere bedroom.

i Visitors' Centre
Tel. (+49/0) 3 31/96 94-2 00
and -201
Fax (+49/0) 3 31/9 69 41 07

Visits by appointment only
with guide between May
and October

&

P By car: A 115 towards
Zehlendorf, exit at
Potsdam-Babelsberg

Service 692 from Babelsberg
station/Lutherplatz, bus
stops at Jagdhausstrasse

Tram services 92, 96, 98
from Lange Brücke (outside
Potsdam Stadt station),
tram stops at Gaussstrasse

Sacrow Park and Schloss

Sacrow Park and Schloss

When Lenné drew up his plan for park improvements in 1833, he realised that Sacrow would require particular attention. Friedrich Wilhelm IV had purchased the land, along with a manor house built in 1773, the year he ascended the throne. Lenné set to work here in 1842, opening up broad vistas to link this park with the New Garden, Glienicke and Babelsberg. Plans to transform the old house into a neo-Gothic palace never bore fruit. Visible from afar in this picturesque Havel setting, St Saviour's Church, built by Persius in 1840–1844 to resemble an early Christian basilica, testifies to the king's Romantic vision of a forgotten era of Christianity.

The house is currently
undergoing restoration
The park is open daily all
year round from daybreak
until dusk

✕

P

Service 697 from Bassin-
platz to Fährstrasse in
Sacrow

Lenné's Plan for the Improvement of the Park at Sacrow, 1842

Schloss Caputh, Hall of Tiles

ℹ Visitors' Centre
Tel. (+49/0) 3 31/96 94-2 00
and -201
Fax (+49/0) 3 31/9 69 41 07

🕐 15 May–15 October
10 am–5 pm, closed for
lunch 12.30–1 pm
Closed on Mondays
16 October–14 May
Sa/Su only 10 am–4 pm,
closed for lunch 12.30–1 pm

✗

🅿

🚌 Services 608 and 643

DB Regional train service RB 33 from Potsdam
Stadt station and Pirschheide to Caputh-Geltow

Caputh Park and Schloss

Caputh on Lake Templin is the oldest surviving stately home maintained by the Foundation in the architectural landscape of Potsdam. It was built in 1662, originally as a simple country house for Philipp de Chièze, the Elector's quartermaster general. In 1671 the Great Elector gave the property to his second wife Dorothea, who called for its conversion into a prestigious summer residence. From the middle of the 18th century, it served a somewhat outlandish function as a thread and leather factory, but eventually fell into private hands. During this period, the park was landscaped by Peter Joseph Lenné. The baroque apartments have been preserved with their precious painted ceilings and stucco dating from the age of the Elector. The summer dining-room in the basement, faced with about 7,500 blue-and-white Dutch faience tiles, acquired this form around 1720 under Friedrich Wilhelm I.

Königs Wusterhausen

🕐 Re-opening in 2000 after
restoration

Till mid–May 2001
Sa/Su only 10 am–4 pm
closed for lunch
12.30–1 pm

From 15 May 2001 open as
Schloss Caputh

Ⓢ Service S 46

Königs Wusterhausen

In 1698 Elector Friedrich III gave this stately home, which originated as a late medieval castle, to his son Friedrich Wilhelm (I) as a Christmas present. When his reign began in 1717 the "soldier king" converted it into a hunting lodge which soon became his favourite residence. The village was renamed Königs Wusterhausen in the king's honour. The future Friedrich the Great had painful memories of his childhood and adolescence here. His father raised him with military severity, denying him any scope for his artistic interests.

Under Kaiser Wilhelm I Königs Wusterhausen was again used frequently for hunting parties. One room was furnished as a tobacco parlour in recollection of the soldier king. Once restoration is complete, the building will re-open as a museum devoted to his era.

Schloss Königs Wusterhausen

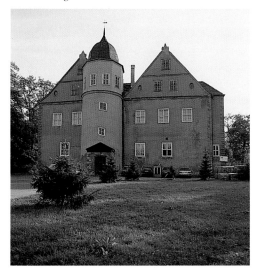

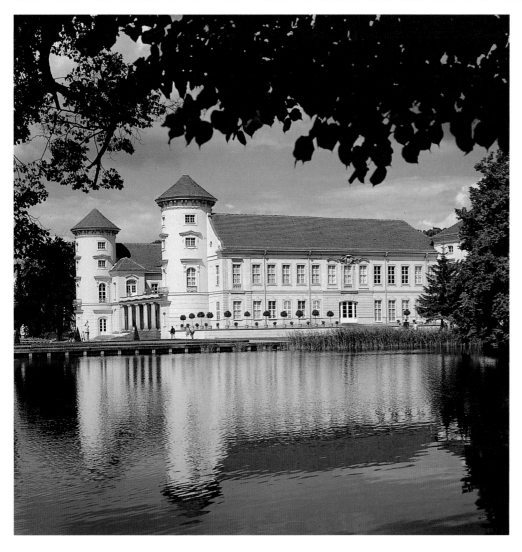

ℹ Visitors' Centre
Tel. (+49/0) 3 31/96 94-2 00
and -2 01
Fax (+49/0) 3 31/9 69 41 07
Rheinsberg
Tel./Fax (+49/0) 39 31/21 05

◷ 1 April–31 October
9.30 am–5 pm
1 November–31 March
10 am–4 pm,
closed for lunch 12.30–1 pm
Closed on Mondays

✕

🅿

DB Regional train service RB 12
from Oranienburg (Berlin)
to Rheinsberg (Mark)

M Kurt Tucholsky Memorial
Opening times as for
Schloss Rheinsberg

Kavalierhaus:
Rheinsberg Musikakademie

*View across Lake Grienerick to
Schloss Rheinsberg*

Rheinsberg Park and Schloss

The history of Rheinsberg is closely associated with Friedrich the Great as Crown Prince and with the life of his brother Prince Heinrich. After years of bitter conflict between father and son, "soldier king" Friedrich Wilhelm I granted 22-year-old Friedrich permission to run Rheinsberg as his official seat. By this time, the Crown Prince had married Elisabeth Christine of Brunswick-Bevern. The existing Renaissance building on the island in its picturesque Lake Grienerick setting was converted to meet the needs of its new occupants, first by Kemmeter from 1734 and then by Georg Wenzeslaus von Knobelsdorff from 1737. At a comfortable distance from his strict father, Friedrich created the "court of Muses", where for the first time in his life he was able to pursue his artistic interests unhindered among kindred souls. As yet unburdened by the responsibilities of

In the park at Schloss Rheinsberg

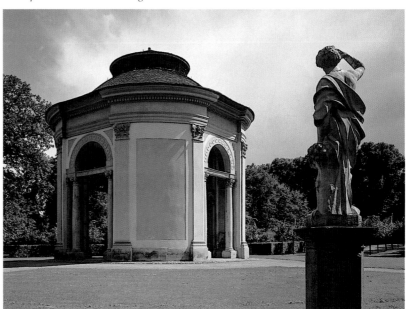

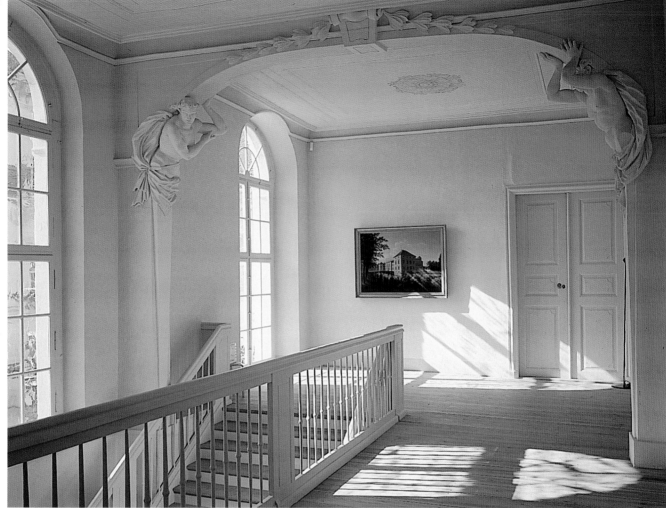

Schloss Rheinsberg, stairs

government, he spent extremely happy years here.

A few years after assuming the crown, he gave the palace to his brother, Prince Heinrich, who appointed Carl Gotthard Langhans to undertake conversions which would accommodate his own court. Friedrich's park was expanded, becoming one of Germany's earliest "gardens of sensibility".

After many twists and turns – the palace served as a sanatorium for diabetics after 1945 – the property was placed in the Foundation's care in 1991, when it reopened as a museum. A major restoration programme was initiated to regain the original character of both palace and park, and it is not yet complete. The setting entered literary history when Kurt Tucholsky published "Rheinsberg – A Picture Book for Sweethearts" in 1912.

Source of illustrations

Stiftung Preussische Schlösser und Gärten Berlin-Brandenburg
Jörg P. Anders: p. 86, 87, 88, 89 top, 91
Tilo Eggeling: p. 99 bottom
Klaus Frahm: p. 90, 92 centre, 92 bottom, 93 top, 96, top, 96 centre, 97, 98, 100 bottom, 101, 102 bottom, 103 top, 103 centre, 104 centre, 104 bottom, 105 top, 105 centre, 106 bottom, 107, 108 bottom, 109, 113, 114

Roland Handrick: p. 92 top, 94, 95, 99 top, 100 top, 102 top, 103 bottom, 104 top, 105 bottom, 106 top, 108 top, 110, 111, 112, top
Gerhard Murza: p. 93 bottom, 96 bottom, 99 bottom, 112 bottom
Map p. 84 top: Kontur GbR, Berlin, p. 84 bottom: Fa-Ro Marketing, Munich: p. 84 top, 84 bottom

Saxony-Anhalt

KULTURSTIFTUNG
DESSAUWÖRLITZ

CULTURAL FOUNDATION
OF DESSAUWÖRLITZ

Kulturstiftung DessauWörlitz

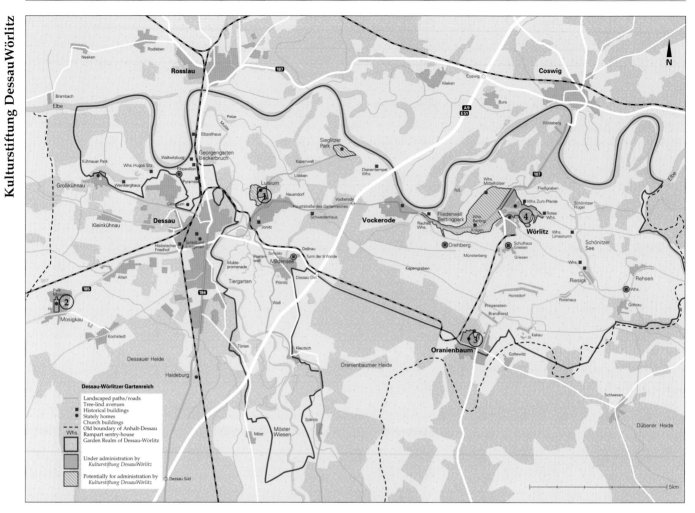

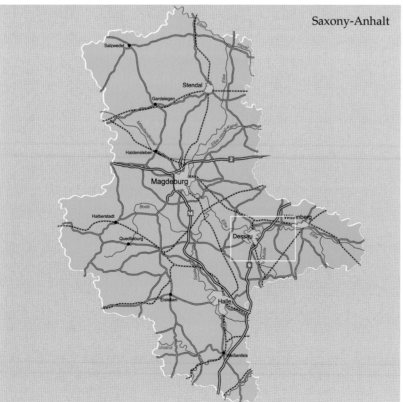

Dessau
(1) Luisium pp. 118–119
(2) Mosigkau pp. 120–121

Oranienbaum
(3) Oranienbaum pp. 122–123

Wörlitz
(4) Wörlitz Park pp. 124–129

◁ *Rousseau Island in Wörlitz*

Temple of Venus on the Kleines Walloch in Wörlitz

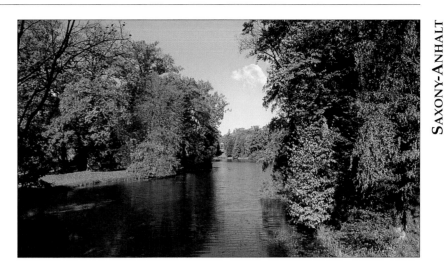

THE FINEST GARDENS IN THE PRINCIPALITY...

The *Garden Realm of Dessau-Wörlitz* in the heart of Saxony-Anhalt covers an area of approximately one hundred and fifty square kilometres (almost sixty square miles) in the Mid-Elbe Valley, between the Bauhaus town of Dessau and Luther's home of Wittenberg.

In this sweeping flood plain, Leopold III Friedrich Franz of Anhalt-Dessau (1740–1817, ruled from 1758) was primarily responsible, aided by his team, for an ambitious programme of "scenic improvement". This unique total art work combined the latest in architectural fashion and technology with garden landscaping in the English style, inspired by an Enlightenment will to educate the public.

It is a cultural landscape which has evolved over several centuries, and its great significance is underscored by its geographical incorporation into the Biosphere Reserve of the Mid-Elbe Valley and the campaign to include the historical *Garden Realm of Dessau-Wörlitz* among UNESCO's World Heritage sites. Wörlitz Park alone attracts over a million visitors a year. It is doubtless one of the oldest surviving examples on the continent of this type of landscaping. Together with the early Classical "Schloss" and the more or less contemporary Gothic House, these gardens compose a distinctive European cultural ensemble. With an outstanding clarity, they also reflect the aspirations of a philanthropic patron.

In addition to Wörlitz, the *Kulturstiftung DessauWörlitz* is currently responsible for about sixty discrete and clustered sites of varying sizes. Taken as a whole, they constitute by and large the core of the old *Garden Realm of Dessau-Wörlitz*. The baroque parks and stately homes of Oranienbaum and Mosigkau contrast with the gardens and palaces designed for later tastes at Luisium and Grosskühnau, where some superb original interiors and works of art have survived.

What is most impressive is that all this blends harmoniously into a hitherto unspoilt landscape. A network of cart tracks and roads, lined with poplars or fruit trees and sometimes raised by embankments, still connects parks of a thoroughly engineered composition, opening up vistas across essentially natural riverside meadows, where sheep and cows now graze again amid lone oaks many centuries old and harvests of autumnal windfalls. The restoration and regular maintenance of these garden artefacts with their authentic architecture, and also the reconstruction of these buildings and their original fittings, is the principal purpose for which the *Kulturstiftung DessauWörlitz* was established. The foundation receives its funding from the state of Saxony-Anhalt and from the "Lighthouse Programme" run by Germany's federal and state governments.

The foundation expresses its responsibility for the heritage with which it has been entrusted through the research it conducts and its publications describing the facts and the background to the genesis of this cultural landscape. It also maintains international relations and provides co-ordination and leadership in the active work of conservation, development and tourist management for this fabric of scenic monuments.

Apart from special exhibitions, the foundation offers its large public a broad and diverse annual programme of events, which includes the International Garden Festival in summer.

Even without this assistance, however, visitors will always find many opportunities to relax and to experience the environment: a guided tour provided by a palace museum, a walk through the gardens, a punted tour on the Wörlitz waterways, a trip by horse and cart along the river meadows, or a cycle ride on the section of the European cycle route which winds along the banks of the Elbe through the *Garden Realm of Dessau-Wörlitz*.

Kulturstiftung
DessauWörlitz
Schloss Grosskühnau
D-06846 Dessau
Tel. (+49/0) 3 40/6 46 15 41
Fax (+49/0) 3 40/6 46 15 10
http://www.ksdw.de
e-mail: KsDW-@t-online.de

Schloss Luisium
D-06844 Dessau
Tel. (+49/0) 3 40/2 18 37 11

Viewing with guide only
Last guided tour 1 hour
before closing

April–October
Tu–Su 10 am–5 pm
November–March
Tu–Su 10 am–4 pm
Open on Easter Sunday and
Whit Monday
(Closed on 24, 25, 31
December
26 December and 1 January
closed from 1 pm

Subject to alteration!

Schloss Luisium

Luisium

The Serpent House in the park is now rented out as a holiday home

Luisium, small and intimate, lies at the edge of Dessau. Franz of Dessau-Anhalt dedicated it to his wife Luise, by birth a princess of Brandenburg-Schwedt (1750–1811). The classical and neo-Gothic buildings are exquisitely combined, embedded harmoniously in an artistically contrived landscape. The country house in Palladian style (1774–1778) is a masterpiece by Erdmannsdorff. The rooms inside, like the outer structure, are of well-balanced proportions. The ground-floor banqueting hall, with its relief sculpture, paintings and dark green stuccolustro pilasters, betrays a formal austerity. The smaller rooms upstairs are serene and elegant in mood, with fine decorative stucco work and wall paintings.

Other particular attractions are the gate-houses at the east entrance to the garden and the charming neo-Gothic serpent house, which has been restored in recent years. The atmospheric garden draws vitality from its statuary, including the Pegasus Fountain and the two herms serving as footpath markers; the Flower Garden House is a tempting place to rest.

From the western embankment path we can see the stud farm buildings further off. In the foreground, horses, sheep and goats graze on the broad stretch of meadowland – a picturesque image typical of 18th-century garden landscapes.

Facing page: Luisium, Cabinet of Prints ▷

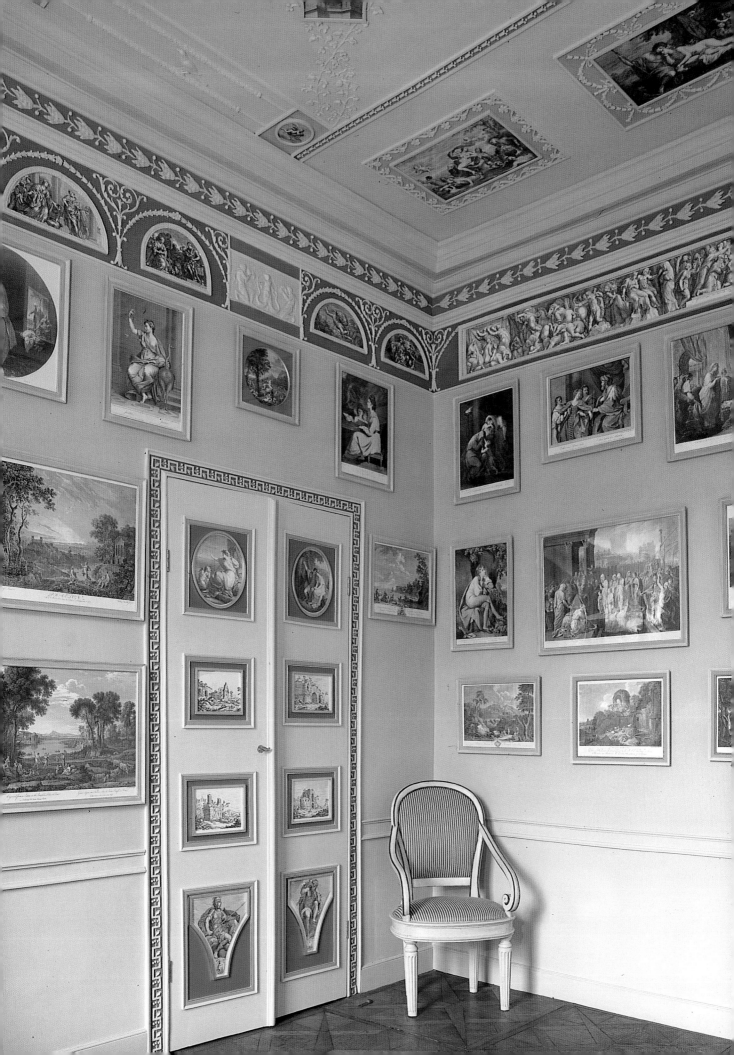

Kulturstiftung DessauWörlitz

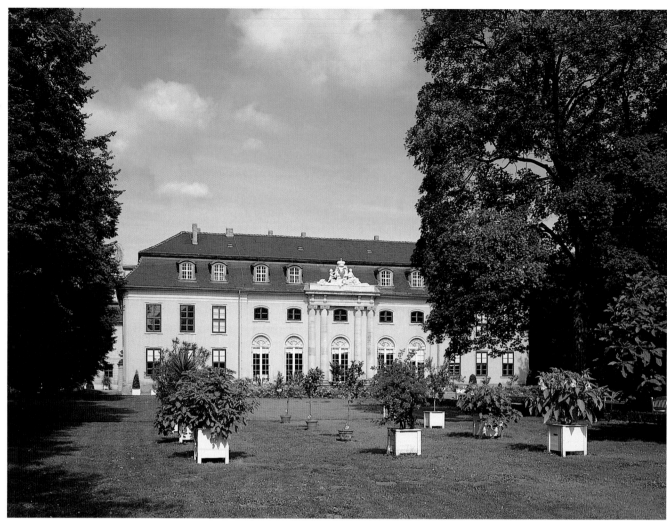

The country house at Mosigkau from the south

i Kulturstiftung
DessauWörlitz
Schloss Grosskühnau
D-06846 Dessau
Tel. (+49/0) 3 40/6 46 15 41
Fax (+49/0) 3 40/6 46 15 10
http://www.ksdw.de
e-mail: KsDW-@t-online.de

Schloss Mosigkau
Museum
Knobelsdorffallee
D-06847 Dessau
Tel. (+49/0) 3 40/52 11 39
Fax (+49/0) 3 40/52 11 81

Viewing with guide only
Last guided tour 1 hour
before closing

⊙ April, October
Tu–Su 11 am–5 pm
May–September
Tu–Su 10 am–6 pm
Open on Easter Sunday and
Whit Monday
(Closed on 24, 25, 31
December
26 December and 1 January
closed from 1 pm

Subject to alteration!

Mosigkau

The rococo country house of Mosigkau only a few miles west of central Dessau was built between 1752 and 1757. It was commissioned by Anna Wilhelmine, Princess of Anhalt. The construction was carried out by Christian Friedrich Damm, a master-builder in Dessau. The first drawings are believed to have been provided by Georg Wenzeslaus von Knobelsdorff, the architect of Sanssouci. Anna Wilhelmine's father, Leopold I of Anhalt-Dessau – widely known as the Old Dessauer – had given her a generous area of land and a considerable appanage, enabling her to build her superb house and gardens. Its importance can hardly be emphasised enough, as it is one of the last rococo ensembles in Central Germany to have survived more or less intact.

In the corps de logis, the linchpin and the art historian's gem is the Gallery Room. It is lavishly adorned with stucco, and in the deep wall panels valuable paintings hang edge to edge in unparalleled baroque proximity. Most of the artists are Flemish or Dutch: Peter Paul Rubens, Anton van Dyck, Jacob Jordaens, Hendrick Goltzius and Gerard van Honthorst. However, the building also boasts paintings by contemporary painters, such as Antoine Pesne, court painter to the Prussian kings. Smaller rooms lead off from the gallery: to the west one with an ingenious finish of "Yellow and Silver" and another known as the "Brown Chamber" because of its unfaced wood. Like the Music Chamber to the east, these have been preserved in their original condition. 17 rooms still contain some of their original furniture, along with decorative

crafts and paintings of the 17th and 18th centuries.

The rococo garden has retained its fundamental layout. Its main attraction is the orangery with rare potted plants, some hundreds of years old.

Temporary exhibitions and concerts take place regularly in the house and garden. The exhibitions in the orangery at Schloss Mosigkau change annually.

Anton van Dyck: Prince Wilhelm II of Nassau-Orange as a child

Mosigkau, Gallery Hall

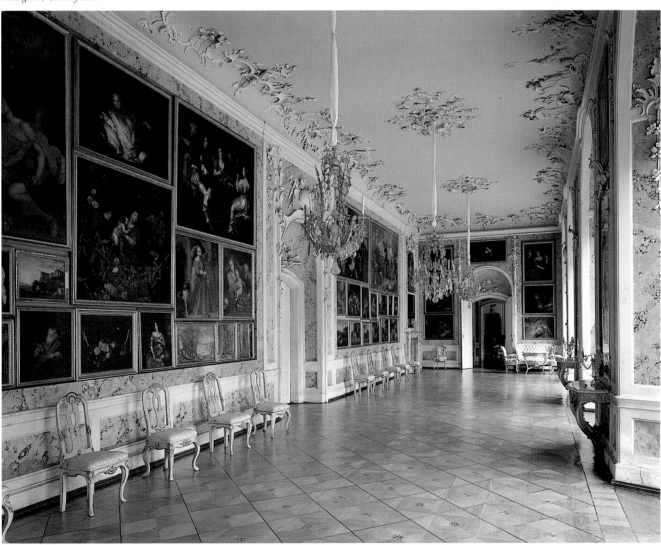

Kulturstiftung DessauWörlitz

ℹ Kulturstiftung
DessauWörlitz
Schloss Grosskühnau
D-06846 Dessau
Tel. (+49/0) 3 40/6 46 15 41
Fax (+49/0) 3 40/6 46 15 10
http://www.ksdw.de
e-mail: KsDW-@t-online.de

Museum
Schloss Oranienbaum
D-06785 Oranienbaum
Tel. (+49/0) 3 49 04/2 02 59

🕙 April–October
Tu–Su 10 am–5 pm
Open on Easter Sunday and
With Monday

Subject to alteration!

Pagoda in the Chinese
garden

🕙 Mai–September
Sa/Su 2–4 pm

Subject to alteration!

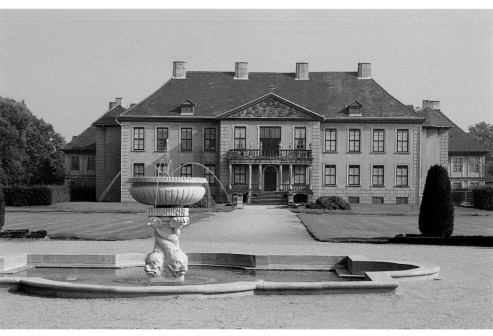

The stately home at Oranienbaum, view from the west

Oranienbaum

Oranienbaum, only a few miles from Wörlitz, is a fine baroque ensemble consisting of a town, stately home and park. It was built from 1683 for Henriette Catharina (1637–1708), a widowed princess of Anhalt-Dessau, née princess of Nassau-Orange. The dynasty of Orange gave the town its name.

The palace corps de logis was the work of Dutch architect Cornelis Ryckwaert. It was extended after his death in 1693 to create the present complex. During the cold season, valuable plants are tended in one of Europe's longest orangeries along the southern edge of the park. The traditional cultivation of citrus plants, which regained momentum from 1989, deserves special mention. The striking anglo-chinoise garden was laid out from 1793 to 1797 at the instigation of the founder's great-grandson Franz, inspired by his friendship with the English architect and garden theorist Sir William Chambers (1723–1796), who was the first European scholar to investigate the Chinese art of gardens. This Chinese garden is probably the only one in Germany from the time before 1800 to have survived. The garden design and the architecture – a pagoda, a Chinese house and a number of bridges – blend here into a total art work.

A little museum in the southern side wing of the house provides a well-researched introduction to the history of Oranienbaum, illustrated by a selection of original material, landscapers' drawings and clearly designed panels of explanatory text.

Oranienbaum Orangery

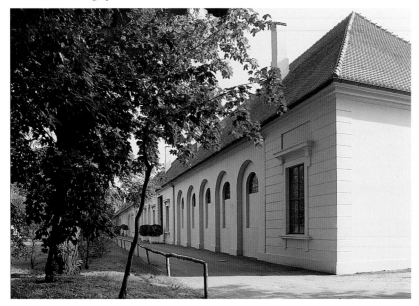

Pagoda in Oranienbaum's Anglo-Chinese Garden ▷

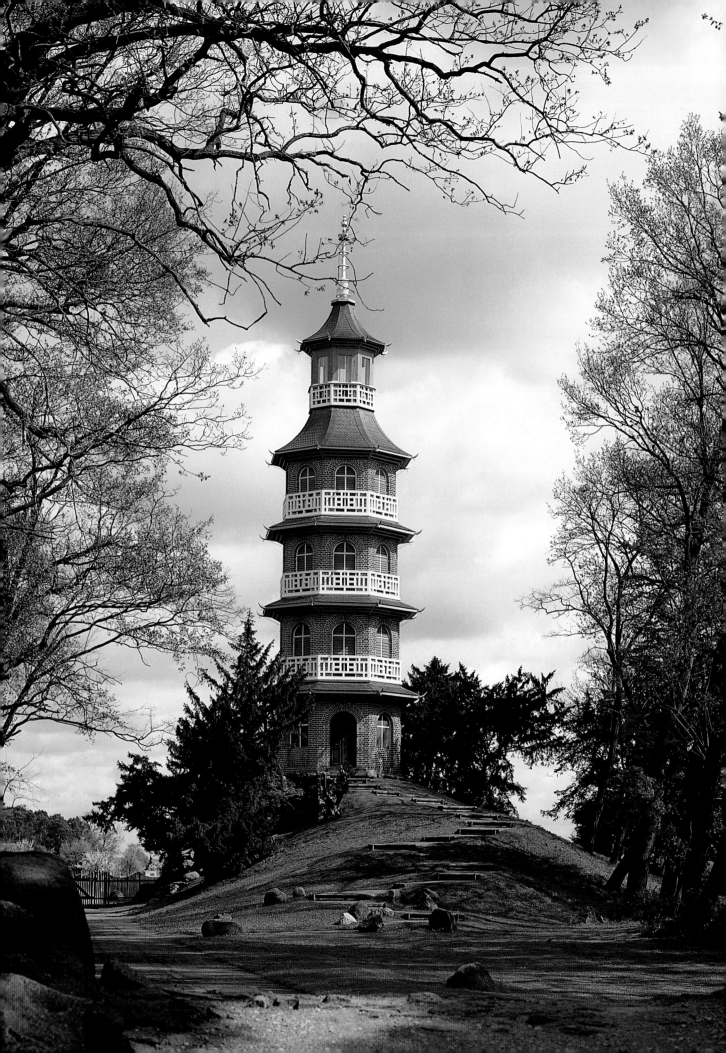

Kulturstiftung DessauWörlitz

ℹ Kulturstiftung
DessauWörlitz
Schloss Grosskühnau
D-06846 Dessau
Tel. (+49/0) 3 40/6 46 15 41
Fax (+49/0) 3 40/6 46 15 10
http://www.ksdw.de
e-mail: KsDW-@t-online.de

Museum
Schloss Wörlitz
D-06786 Dessau
Tel. (+49/0) 3 49 05/40 90
Fax (+49/0) 3 49 05/40 09 30

Viewing with guide only
Last guided tour 1 hour
before closing

🕐 April, October:
Mo 1–5 pm
Tu–Su 10 am–5 pm
May–September:
Mo 1–6 pm
Tu–Su 10 am–6 pm
Open on Easter Sunday and
Whit Monday
(Closed on 24, 25, 31
December
26 December and 1 January
closed from 1 pm

Subject to alteration!

Gothic House
Museum
Tel. (+49/0) 3 49 05/40 90
Fax (+49/0) 3 49 05/40 09 30

Viewing with guide only
Last guided tour 1 hour
before closing

🕐 April, October:
Tu–Su 11 am–5 pm
May–September:
Tu–Su 11 am–6 pm
Open on Easter Sunday and
Whit Monday
(Closed on 24, 25, 31
December
26 December and 1 January
closed from 1 pm

Subject to alteration!

�

Facing page (top):
The Library at Wörlitz

Facing page (bottom):
The Dining Room at Wörlitz

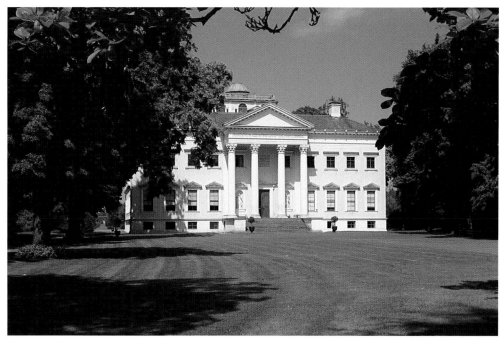

The stately home at Wörlitz from the south

Wörlitz Park

Wörlitz is the artistic culmination of the Garden Realm created by Leopold III Friedrich Franz of Anhalt-Dessau (1740–1817) in the latter half of the 18th century with his friend and advisor, the architect Friedrich Wilhelm von Erdmannsdorff (1736–1800).

They drew on the natural features of the Elbe Plain to devise a total art work founded on an unprecedented harmony of garden landscaping and architecture.

Contemporaries waxed enthusiastic about this sensational novelty, the English-style landscape garden, and its "country house" (1769–1773) with its noble, harmonious proportions, the harbinger of German Classicism. Even today, the building with its unaltered interiors accommodates precious collections, including Ancient sculpture, paintings and Wedgwood bowls.

There is no fence to partition the garden from the town. Everyone had free access. Even the stately home has been accessible for viewing since it was built. Admirers have travelled here from all over Europe to witness the gardens of Wörlitz. Franz of Anhalt-Dessau and Erdmannsdorff collected many ideas on their educational journeys to England, France, the Netherlands and, of course, Italy, home of the revered Ancients.

Many structures here are reminiscent of Roman prototypes, such the Temple of Flora, the Temple of Venus, or the Pantheon in the east of the garden and its reflection in the water of the embankment lake. Counterpoint is supplied by the neo-Gothic buildings which take walkers by surprise. The Gothic House (1773–1813) recalls a Venetian church on the canal side and an English Tudor Gothic on the garden side. It accommodates a unique collection of primarily Swiss stained glass windows from the late 15th to the 17th century, and also some noteworthy neo-Gothic fittings.

Wörlitz offers its visitors many opportunities to relax, enjoy the arts, experience the natural elements and acquire an education. The creation of over 200 years ago is European in class. It has lost nothing of its magic and still holds many visitors spellbound.

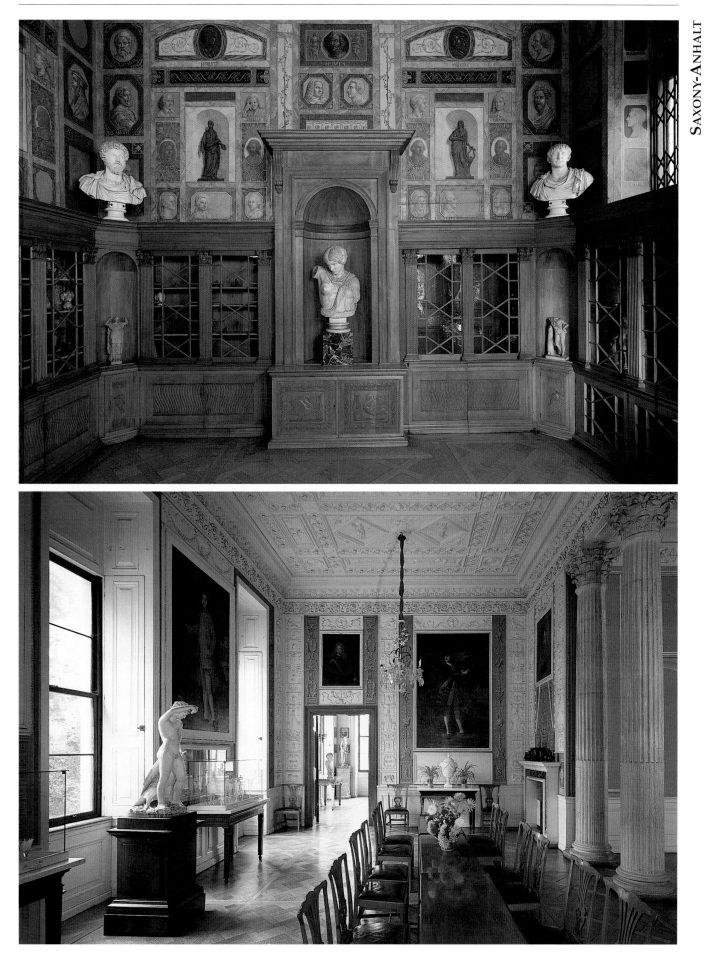

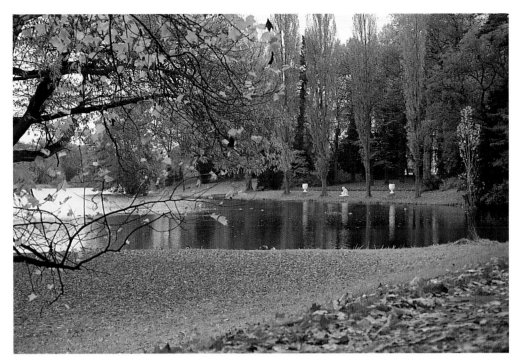

Wörlitz Park, view from Neumark's Garden to the Shell Nymph in the Schloßgarten

Rousseau Island in Wörlitz Park ▷

Pantheon, Wörlitz Park

Stepped Bridge, Wörlitz Park

Gondolas mooring, Wörlitz Park

The Gothic House, Wörlitz Park

Vista fan at the Golden Urn, Wörlitz Park

Friends of the Garden Realm of Dessau-Wörlitz

The Association of Friends – *Gesellschaft der Freunde des Dessau-Wörlitzer Gartenreiches* – is a non-profit body founded in March 1993 which now has over five hundred members, not only in Saxony-Anhalt, but throughout Germany and abroad.

It unites a deep interest in historical landscape gardens, a love for the grounds at Wörlitz with their buildings of European calibre, and a desire to recall and foster the reforming and enlightening traditions established by Franz of Anhalt-Dessau.

By joining our association, you will find yourself among friends in experiencing the beauty and diversity of the Garden Realm of Dessau-Wörlitz and you will help, by means of your interest and commitment, to protect and preserve this unique landscape of art, culture and monuments as a valuable heritage for coming generations.

Dr. Gert Hoffmann
Chairman of the Committee

Gesellschaft der Freunde des
Dessau–Wörlitzer Gartenreiches e.V.
Schloss Grosskühnau
D-06846 Dessau
Tel. (+49/0) 3 40/6 46 15 11
Fax (+49/0) 3 40/6 46 15 10

The benefits of membership

In addition to free access to all gardens, parks and associated features in the Garden Realm of Dessau-Wörlitz, you will

 be granted free admission to many historical buildings at Wörlitz, Oranienbaum, Mosigkau and Luisium by showing your member's card

 make use without payment of the gondolas and ferries on Wörlitz waters

obtain a 10% discount on all publications printed on behalf of the *Kulturstiftung DessauWörlitz*

receive a free copy of the annual programme of the *Kulturstiftung DessauWörlitz*

 receive the biennial report of the *Kulturstiftung DessauWörlitz*

be sent personal invitations to all events run by the *Kulturstiftung DessauWörlitz*, such as exhibition openings, concerts and lectures, the International Garden Festival

hear a keynote lecture by a prominent figure during the annual general meeting, together with an attractive support programme

 receive invitations from the Association to special events

rest satisfied in the knowledge that your commitment is helping to care for the historical buildings, monuments and landscape gardens and to preserve them for the future

Source of illustrations:

Map on top of p. 116:
Simone A. Frank, Markus Schmidt, Berlin
Map on bottom of p. 116:
Fa-Ro Marketing, Munich
Kulturstiftung DessauWörlitz
– Bildarchiv: p. 129 top
– Heinz Frässdorf: p. 118 bottom, 119, 120, 121 top, 121 bottom, 122 top, 122 bottom, 128 top

– Lutz & Löffelbein: p. 125 top
– Marie-Luise Werwick: p. 123, 126 top, 129 bottom
Hans-Dieter Kluge, Espenhain
Cover for separate edition, p. 125 bottom, 128 bottom
Uwe Quilitzsch, Dessau
p. 117, 118 top, 124, 126 bottom
Lutz Winkler, Leipzig
p. 115, 127

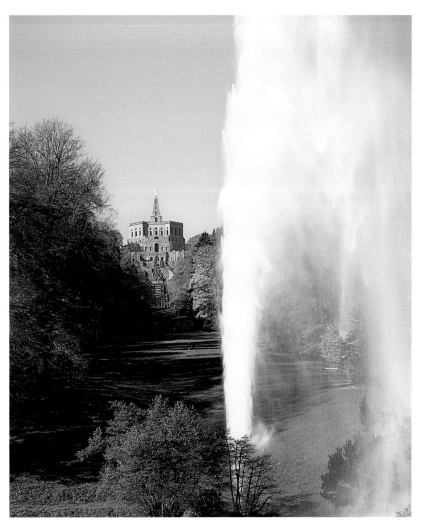

Hesse

STAATLICHE SCHLÖSSER UND
GÄRTEN HESSEN

STATELY HOMES AND GARDENS
OF HESSE

Staatliche Schlösser und Gärten Hessen

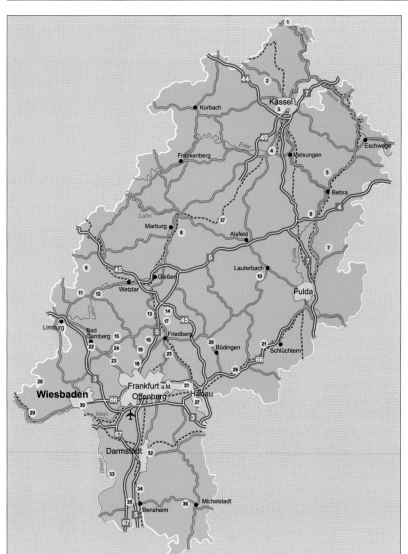

◁ *Kassel, Wilhelmshöhe Schlosspark*

Schloss Weilburg, a school trip before the tour begins

OVER 70 YEARS' SERVICE TO THE CULTURAL AND NATURAL HERITAGE

In the federal state of Hesse, at the heart of Germany, about forty important sites bearing witness to the architectural and artistic history of the last 2000 years are held in public trust by *Staatliche Schlösser und Gärten Hessen*. These sites include Roman fortresses on the "Limes" (the Roman frontier), medieval churches and abbeys, castles and defences, stately homes and gardens.

The trust is, on the one hand, an administrative body responsible for the upkeep of these cultural assets, and on the other, an educational institution addressing cultural, historical, ecological, economic and social objectives.

As a public agency of the State of Hesse, its articled remit is to preserve, research and repair Hesse's legacy of art and history and to make it accessible to the public. Many of these total art works – buildings which have evolved over time along with their contents and the grounds in which they are set – are:

– landmarks or symbols of local identity and authenticity,

– age-old treasuries of nature and human culture,
– places for education, recreation and contemplation,
– workshops for the arts and crafts,
– cradles of environmental protection with a high workplace identity.

Some 400 members of staff combine highly skilled care for the cultural and natural heritage for which they have assumed charge with a widely diverse presentation of history aimed at conveying to visitors the value and significance of each particular site.

Each year, millions of people make use of these wide-ranging opportunities to visit our monuments. The programme of events includes cultural highlights, such as the Bad Hersfeld Theatre Festival and the Weilburg Palace Concerts, but also local or private events organised with respect and understanding for the heritage in which they are set.

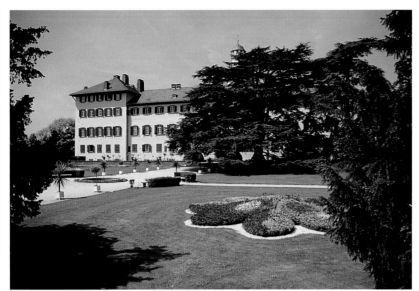

Carpet flowerbeds outside the Palace and cedar of Lebanon planted around 1807

i Bad Homburg vor der Höhe,
Schloss und Schlosspark
D-61348 Bad Homburg vor
der Höhe
Tel. (+49/0) 6172/9262-147
Fax (+49/0) 6172/9262-190

King's Wing, Stag Walk
Wing, Library Wing
(45 minutes):
⊙ Tu–Su: Nov–Feb
10 am–4 pm, last tour at
3 pm
Mar–Oct
10 am–5 pm, last tour at
4 pm
Mo: Jun–Aug 10 am–5 pm,
last tour at 4 pm

Palace Church and
Elizabeth Wing
(40 minutes):
⊙ So 11 am–3 pm, on the
hour, all year round
Closed 24–26 Dec, 31 Dec,
1 Jan

White Tower
⊙ Climp
Nov–Feb 9 am–3 pm
Mar–Oct 9 am–4 pm

Bad Homburg vor der Höhe: the Park

The gardens of Schloss Homburg were re-landscaped in the latter half of the 18th century, although some of the older baroque structure is still visible in places. To the east of the house, the Dutch Garden laid out at the end of the 17th century betrays its origins as a baroque parterre. The landscape garden south-west of the building centres around a large pool. To the north-west, the kitchen garden and orchard reveal traces of formal geometry. As part of the landscaping process in the vicinity of the house, the landgraves extended the gardens north-west of their residence into the Taunus Hills. The Avenue of Firs and the Elizabeth Vista along this lady's picturesque pleasure gardens were created between 1770 and 1840. The central palace park and the pleasure garden vista which extends to the Roman frontier, or Limes, constituted a total art work which has survived in its essential features down to the present.

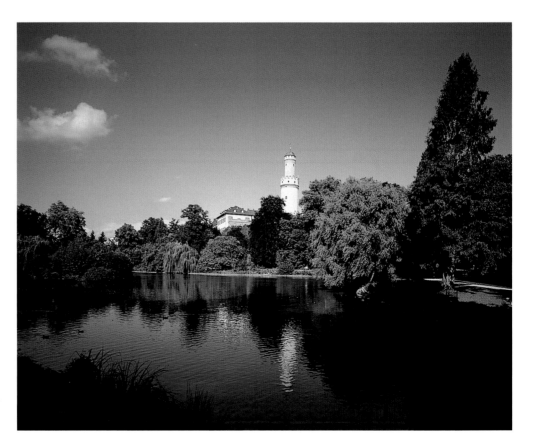

View from the Fantasy across the Palace Pool to the Palace and White Tower

Bad Homburg vor der Höhe: Schloss and Elizabeth Wing

The free-standing 14th-century keep towers high above the baroque buildings, grouped around two courts. Paul Andrich designed these in 1678 for Landgrave Friedrich II, the authentic hero of Kleist's play "Prince Frederick of Homburg". This originally two-storey palace was the first new addition to a larger residential complex to be built after the Thirty Years War.

The display rooms exhibit many precious artistic objects dating from the 17th to the 19th century, bringing to life the domestic conditions, not only of the landgraves, but also of their Hohenzollern Emperors, who used Homburg as a favourite summer residence until abdication in 1918. The residential apartment in the English Wing, re-opened in 1995, reflects the personality, wealth and tireless collecting of Princess Elizabeth, daughter of the British King, who became Landgravine of Hesse-Homburg upon her marriage in 1818.

One of Europe's finest baroque busts stands in the Palace vestibule: Landgrave Friedrich II, made in 1704 by the great German baroque sculptor Andreas Schlüter

Special tours:
"Schloss Homburg in Literature" tours the building and park in the footsteps of Goethe, Kleist, Hölderlin and the Landgraves (90 minutes) The "Historical Park Tour" takes place once or twice a month between May and Sep.

✗

P

DB

S

U

🚌

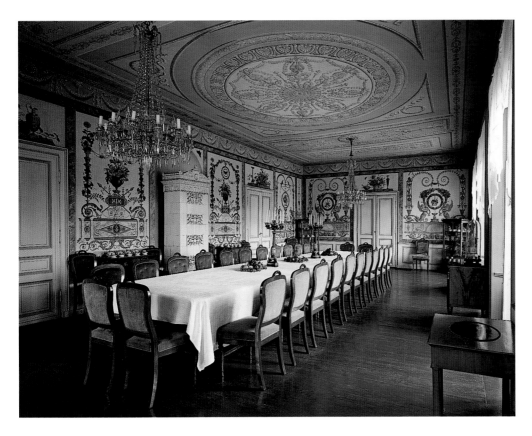

The Dining Room, known also as the Pompeian Room, with wall paintings c. 1826–1829

Staatliche Schlösser und Gärten Hessen

ℹ Saalburgmuseum/Saal-
burgkastell
D-61350 Bad Homburg vor
der Höhe
(on the B 456 between
Dornholzhausen in Bad
Homburg and Wehrheim)
Tel. (+49/0) 61 75/93 74 00
Fax (+49/0) 61 75/93 74 11

🕗 Daily 8 am–5 pm;
on 24 Dec and 31 Dec
8 am–12 noon
Guided tours by
arrangement
Special tours by request

✗

🅿

DB

Ⓢ

🚌

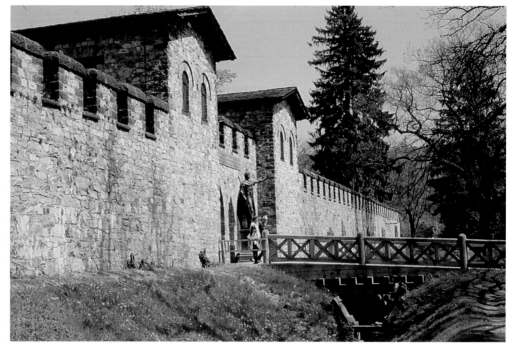

Saalburg Fort, main gate

Toga clasp

Saalburg Museum, reconstructed dining room (triclinium)

Saalburg: Roman Fort and Saalburg Museum

During the Roman Age (c. 90–260 AD) the Saalburg was a fort with a village encampment on the Limes, the frontier between the Roman Empire and Germania. After centuries of decay and the plundering of its fabric, the first excavations took place in the mid-19th century. At the turn to the 20th century, Kaiser Wilhelm II ordered a faithful reconstruction of the original fort and the establishment of a museum and research institute.

This is the only site of its kind in the world, and it depicts life in Roman times in a vivid manner. The tour takes visitors to buildings of stone and timber, replicas of bread ovens and interiors such as the legionnaires' quarters and the dining room. The objects on display illustrate wide-ranging aspects of everyday life. This site combines an education about the Roman Age with relaxation in the park landscape.

The Museum offers a number of particular features: thematic tours, lectures and supporting information designed for specific trades or professions, Roman Festivals with performers in original costume, bread-making with reconstructed Roman ovens, children's birthday parties with organised games which bring the Romans back to life, and much else besides. The Saalburg has its own Events Service, providing the full spectrum of incentive packages for business and private clients within this unique milieu.

Baking bread with a Roman oven

Bad Hersfeld: Ruined church

The architecture of the biggest church built in the 11th century speaks a powerful, gripping language which is bound to impress any visitor to this ruined minster. The barrel-vaulted entrance beside the High Romanesque west tower leads into a spacious western arm gutted by fire in 1761. The flames brought down the walls of the nave with its massive columns, the windowed clerestory and the roofs over the nave and side aisles. The vacancy grants added stature to the unbroken walls of the transept. The quire adjoins it with its once vaulted crypt. The first Christian mission came to Hersfeld in 736. It was replaced between 831 and 850 by a Carolingian church which burned down in 1038. Work on the present collegiate church began almost immediately and was finished in 1144. Since 1950 the ruins have provided an impressive set for the summertime Theatre Festival.

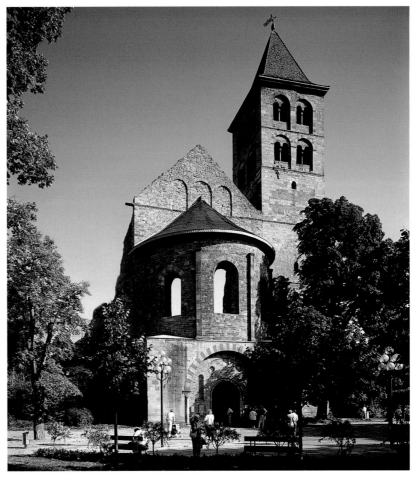

West quire and Romanesque bell-tower

i Bad Hersfeld, Stiftsruine
D-36251 Bad Hersfeld 1
Tel. (+49/0) 66 21/7 36 94

⊖ Between April and September opening times depend on rehearsals and set construction and removal for Festival performances.

Events:
Bad Hersfeld Festival.
Please consult the official listings.

P

DB

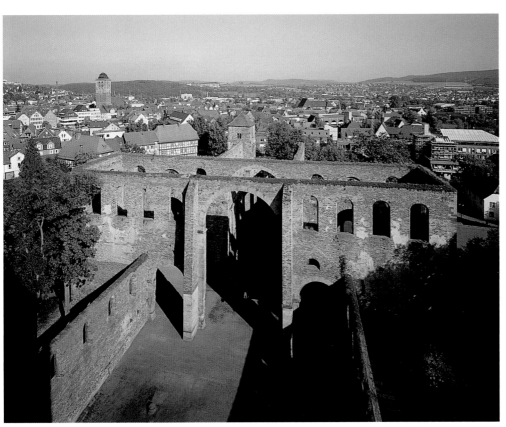

View from the west quire across the gutted nave, transept and quire

i Darmstadt,
Prinz-Georg-Garten
Schlossgarten 6b
D-64289 Darmstadt
Tel. (+49/0) 6151/125632
Fax (+49/0) 6151/125757

🕐 Admission free
Guided tours on request

M Grand Duchy Porcelain
Collection in Prince Georg's
Palace:
Verein Schlossmuseum
Darmstadt e.V.
Tel. (+49/0) 6151/24035

🕐 Mo–Thu 10 am–1 pm,
2–5 pm. Fr closed
Sa/So, public holidays
10 am–1 pm

[DB]

🚌

Prettlack's Garden-House

Darmstadt: Prince Georg's Garden

In the 18th century the landgraves laid out a pleasure garden of rural character just outside Darmstadt next to the manor garden, the "Herrngarten", with their official residence. Away from the ceremony of state, this little pleasure garden became the venue for the more leisurely festivities much enjoyed by court society during the rococo age.

The two main avenues which run perpendicular to one another, one beginning at Prince Georg's Palace and the other at Prettlack's Garden-House, indicate that there were originally two separate gardens later combined into one. High walls surround the summer residence, reflecting the desire for intimacy and privacy which inspired many a rococo garden. It was thanks, in part at least, to this "isolation" that Prince Georg's Garden escaped the re-landscaping carried out in the Herrngarten, preserving its essential rococo structures until today.

The sun dial

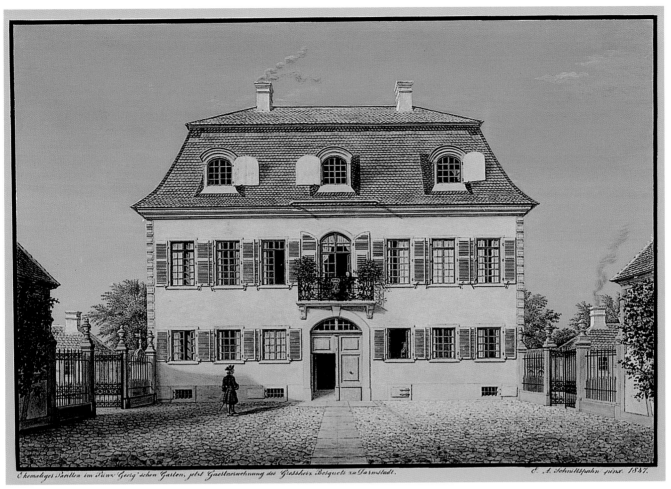

View of Prince Georg's Palace by E.A. Schnittspahn, 1846

Darmstadt: Prince Georg's Palace

The rooms of Prince Georg's Palace look out onto the garden and the surrounding countryside. The focus upstairs is a large hall with finely worked stucco haunches, where two balconies provided enjoyment of the garden. A little cour d'honneur in front of the palace was flanked by an orangery and coach-house. Landgrave Ludwig VIII granted the palace to his second son Georg in 1764, and since then it has borne his name. In 1908 Grand Duke Ernst Ludwig brought together all the porcelain which Hesse's ruling dynasty had collected for exhibition in Prince Georg's Palace. That is why the building is known to locals as the "little porcelain palace".

The "Niche", formerly on the north-south axis, Schnittspahn, 1846

Guard House with clock tower

View across the Lords' Meadow to the Lord's Building

ℹ Bensheim-Auerbach
Staatspark Fürstenlager
D-64625 Bensheim-
Auerbach
Tel. (+49/0) 62 51/9 34 40
Fax (+49/0) 62 51/93 46 46

Linen House Shop:
🕐 Mo–Fr 2–5 pm,
Sa/So, public holidays
10 am–12 noon and 1–5 pm

Summer residence of the
Landgraves and Dukes of
Hesse-Darmstadt
Guided tours:
One Saturday a month at
2 or 4 pm between March
and October and by
arrangement

Old Guard-House:
Park maintenance office for
Staatspark Fürstenlager
Sa/Su 10 am–5 pm

Permanent exhibition in the
Guest House:
– Originally furnished rooms
of Prince Emil of Hesse-
Darmstadt
– History of the baths and
summer residence
– Architectural history of the
Guests' Building
– Friends of Bergstrasse-
Odenwald Natural Park

✕

🅿

DB

Bensheim-Auerbach: Fürstenlager State Park

The landgraves once used the "Fürstenlager" near Bensheim-Auerbach as a spa. It is an artistic combination of simple buildings clustered like a village around the Good Well in the middle of a picturesque landscaped park. Like many territorial overlords of their day, its owners sought the peace of a rural idyll far removed from the pomp and circumstance of court.

The Fürstenlager has managed to preserve all its original impressive intimacy and the atmospheric quality of a design which made sensitive use of the many opportunities presented by its delightful topography.

Guest House, Prince Emil's Apartment, living room

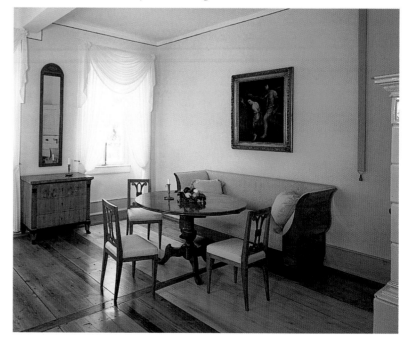

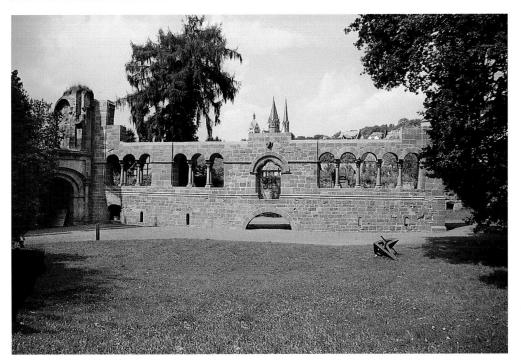

i Kaiserpfalz Gelnhausen
D-63571 Gelnhausen
Tel. (+49/0) 6051/3805
Fax (+49/0) 6051/16787

⊘ Tu–Su Mar–Oct 9 am–5 pm,
admission ceases 30 mins.
before closing;
Nov–Feb 9 am–4 pm,
admission ceases 30 mins.
before closing
Closed on Mondays except
public holidays.
Closed 24 Dec–15 Jan

Guided tours:
Castellan's House, Great
Hall, Gate-Tower and Gate
Chapel
Visitors can visit the castle
without taking the tour.

Additional guided tours by
special arrangement

P

DB

The Great Hall at Gelnhausen from the courtyard side, with town spires in the background

Gelnhausen: Emperor's Residence

A stout ring of rusticated masonry, with irregular contours following the course of the Kinzig, surrounds the buildings of this Imperial residence. The two broad arches of the entrance hall open onto the inner courtyard. This hall once provided access to the chapel above and the adjacent three-storey Great Hall. The gate-hall is adjoined on its south side by the massive gate-tower; a round keep in the east was apparently never finished. The architecture alternates between the solid defences of opus rusticum and finely formed open arcades of great craftsmanship. This residence for the itinerant Holy Roman Emperor was founded by Friedrich I Barbarossa in 1170, with work completed by 1180. Many a castellan built over the original complex during the Middle Ages, but at the beginning of the 20th century it was stripped of these additions. Today it is a striking example of a Romanesque moated castle.

The architectural ornamentation for the Great Hall is one of the most artistic accomplishments of the Romanesque age

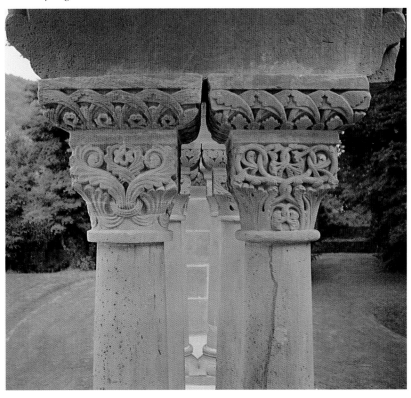

Staatliche Schlösser und Gärten Hessen

i Hanau, Staatspark
Wilhelmsbad
D-63454 Hanau-
Wilhelmsbad
Tel. (+49/0) 61 81/8 33 76
Fax (+49/0) 61 81/8 55 38

🕐 Burg mit Appartement
und Festsaal Führungen
Sa 2, 3 and 4 pm
Su 11 am, 12 noon, 2, 3 and
4 pm

Park open for viewing
Guided tours by
arrangement

✕

P

DB

🚌

M Wilhelmsbad Park is also
the home of the Hesse Doll
Museum:
Parkpromenade 4
D-63454 Hanau-
Wilhelmsbad
Tel. (+49/0) 61 81/8 62 12

Tu–So 10 am–12 noon and
2–5 pm;
admission ceases at 4.30 pm

Pool with Pyramid Island in Wilhelmsbad. Painting by A.W. Tischbein, c. 1785

Hanau: Wilhelmsbad Park with castle and carousel

Wilhelmsbad began its existence as an elegant spa between 1777 and 1785. It attracted both court society and the aspiring bourgeoisie. However, when its founder Wilhelm IX left Hanau in 1785 to take up the reigns of government as Landgrave in Kassel, the spa quickly fell from fashion. Thanks to its subsequent shadowy existence, it has survived almost unchanged as an 18th-century spa resort with baths. The late baroque spa buildings line an avenue, surrounded by a park in the style of an English landscape garden. This is one of the earliest of its kind in Germany, an outstanding specimen of the garden of "sensibility", with atmospheric little buildings (castle, pyramid, hermitage etc.) which illustrate how the designers of the day sought to achieve sentimental effect. The big carousel, a masterpiece of contemporary engineering, recalls the idyllic park's function as a place of play and pleasure. The horses and carriages seemed to be moved by an unseen hand as they pivoted on an ingenious hidden mechanism.

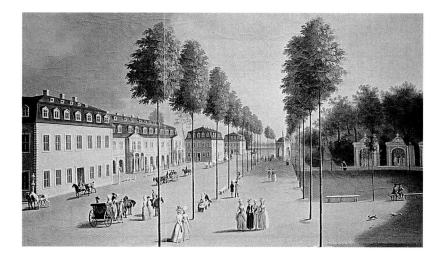

*The Promenade in Wilhelmsbad with spa buildings.
Painting by A.W. Tischbein, c. 1785*

Castle, 1779–1781, with kitchens front right and carousel beyond. Painting by A.W. Tischbein, c. 1785

Hanau: Castle in Wilhelmsbad Park

The Ruined Castle built between 1779 and 1781 close to the spa baths, although separated on its artificial island behind gnarled oaks, is the earliest pseudo-medieval castle on the European continent to have been purpose-built for a landscaped park in the form of a ruin. In fact, it served Wilhelm, the invested heir to Hesse-Kassel, as a summer residence. Its apparently dilapidated tower has been deliberately designed to bewilder the visitor, for it accommodates an elegant apartment on its ground floor and a magnificent domed hall with portraits of ancestors by Anton Wilhelm Tischbein on its upper floor.

Empty from 1866, the castle has recently reacquired its Louis Seize appearance with furniture and silken wall coverings which adhere closely to the original fittings.

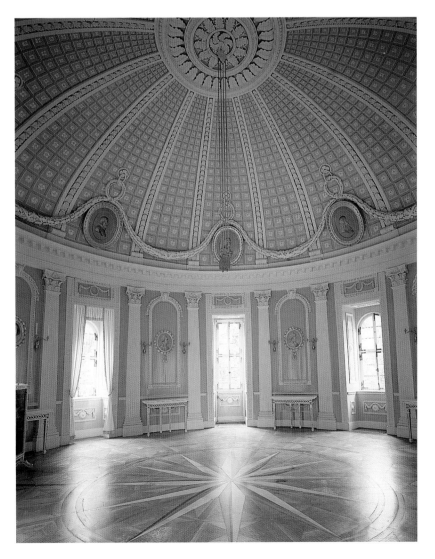

The early neo-classical banqueting hall with ancestral portraits by A.W. Tischbein

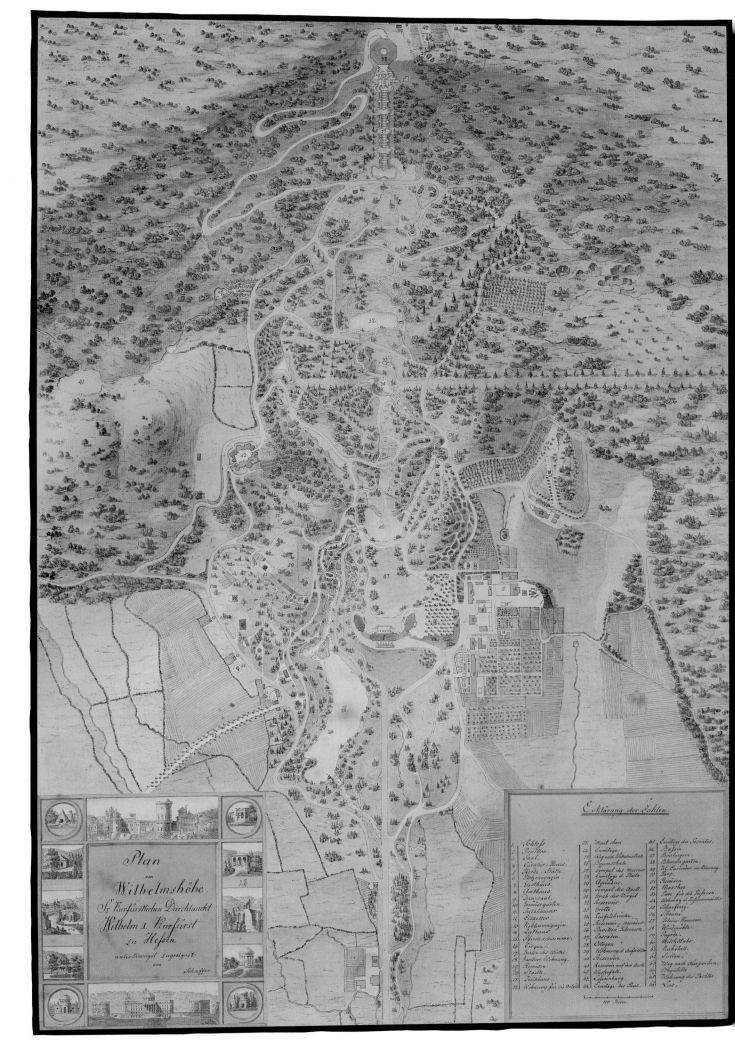

Plan
von
Wilhelmshöhe
Sr. Kurfürstlichen Durchlaucht
Wilhelm I. Kurfürst
zu Hessen
unterthänigst zugeeignet
von Schäffer

Erklärung der Zahlen.

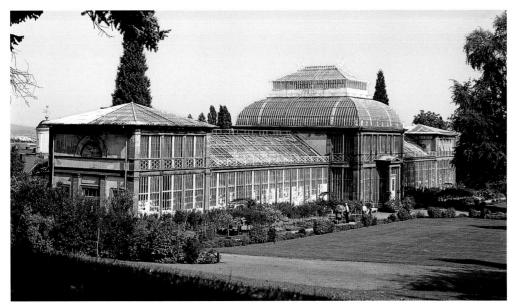

Elector Wilhelm II had the glass greenhouse built by J.C. Bromeis in 1822/23 to house his valuable collection of exotic plants. Even today, the iron and glass construction, the radiant light and the rich, partly tropical flora and exotic birds remain impressive

Kassel: Schloss Wilhelmshöhe and Park

This baroque complex built in the early 18th century to designs by the Italian architect Giovanni Francesco Guerniero consisted of a giant palace with a statue of Hercules and a waterfall 250 metres (820') long. The original plans envisaged a huge project, but only a third of it was ever implemented. The grounds were transformed into a landscaped park after the Seven Years War. The Early Romantic phase of this work under Landgrave Friedrich II was marked by a plethora of atmospheric outdoor structures. The Classical landscape garden was designed from 1785 under Wilhelm IX. Drawing on natural features, an extensive idealised "natural" landscape with artificial waterfalls and pools was created along the axis of the original waterfall. The linear baroque vista merged with the versatile landscape garden and its mimicry of nature to create this well-known garden artefact, which is now the biggest hill park in Europe.

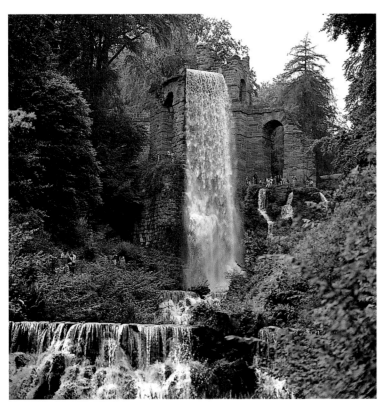

Across the Penaeus Waterfall to the Aqueduct

ℹ Kassel, Schloss and Schlosspark Wilhelmshöhe
D-34131 Kassel-Wilhelmshöhe
Tel. (+49/0) 5 61/9 35 71 00
Fax (+49/0) 5 61/9 35 71 11

Hercules, Octagon, Platform and Pyramid:
🕐 15 March–15 November daily 10 am–5 pm
Great Greenhouse, Plant Show-House
Late November–1 May daily 10 am–5 pm

Water Gardens:
Guided tours to Hercules, waterfalls, Steinhöfer Waterfall, Devil's Bridge, Aqueduct as far as the Great Fountain
Wed & Sat at 2 pm from May to October (100 mins.) Meet at the Octagon ticket office.

Special events:
"Illuminated Water Art": by Hercules, Aqueduct and Great Fountain after dusk every first Saturday in the month from June to September.
Additional dates by advance booking

Schlosspark:
Guided tours "From Hercules to the Palace" (120 mins.) and "Around the Palace" (approx. 90 mins.)

Special events:
"Palace by Candlelight": Rooms of the Weissenstein Wing lit by candles on display to coincide with illuminated water displays in the park on the first Saturday in the month from June to September.

Opposite page:
Plan of Wilhelmshöhe by
C. Schaeffer, c. 1810

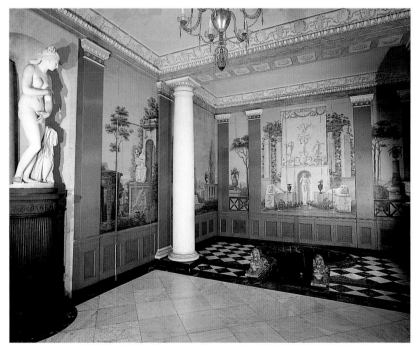

View of Schloss Wilhelmshöhe when it still had its dome and before the connecting structures were raised. Painting by L.P. Strack in the Aide-de-Camp's Room, pre-1810

Kassel: Schloss Wilhelmshöhe (Weissenstein Wing)

Architects S.L. du Ry and H.C. Jussow designed Schloss Wilhelmshöhe as a neo-classical residence for Landgrave Wilhelm IX, the future Elector Wilhelm I. It was built in 1786–1798. Since the damage suffered in the Second World War, only the Weissenstein Wing still boasts its original room arrangement and interior finishing. The latter incorporates some of the finest examples of art in the period around 1800. Neo-classical wall and ceiling stucco, furniture in Louis Seize and Empire style and marble sculpture based on Ancient originals vividly illustrate the taste of the aristocracy as it shifted away from the baroque. The noble simplicity of many domestic rooms testifies to the

Jérôme Bonaparte's desk made by F. Wichmann, 1810/11. After Napoleon's victory, his brother Jérôme lived briefly in the palace, altering the interiors to suit his own taste

more private character of stately homes in the late 18th and early 19th centuries as the rigid courtly ceremonies of absolutist rulers, designed to demonstrate their power, began to wane.

The bathroom, fitted in 1825. On the walls landscape painting on wood in the style of the Ancients. The marble tub is inserted into the floor

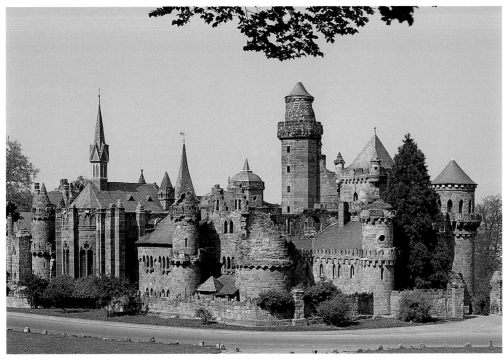

The Löwenburg, one of the first buildings in Germany to indulge Historicist nostalgia, was composed by H.C. Jussow between 1793 and 1801 as a neo-Gothic ruinous castle for a late 18th-century park landscape in the English style

Weissenstein Wing and Löwenburg
🕑 Tu–Su Mar–Oct 10 am–5 pm, last tour at 4 pm; Nov–Feb 10 am–4 pm, last tour at 3 pm. Closed on Mondays except public holidays. Closed on 24–26 Dec, 31 Dec, 1 Jan.

Weissenstein Wing: Reception rooms and living quarters on the main and first floors (45 mins.)

Löwenburg: Ladies' and gentlemen's apartments, stables, kitchens, weapons room (45 mins.)

Kassel: Löwenburg in the Schlosspark

In its picturesque setting on the edge of the Wolf's Gorge amid the slopes of Wilhelmshöhe, the Löwenburg, or "Lions' Castle", seems from the outside to be the stout fortress of a medieval knight. Inside, however, its baroque living quarters would accommodate a prince and his courtly entourage. Built at the end of the 18th century by Landgrave Wilhelm IX, at a time of turbulent social change, the ruinous Löwenburg not only evokes sieges, battering rams and rampart resistance, but also seeks, by conveying a sense of venerable age, to demonstrate the dynasty's long history and its right to rule in Hesse-Kassel.

Next to the Weapons Room, with its display of 16th- and 17th-century arms and armour, and the castle chapel with the founder's tomb, visitors have access to major sections of the princely quarters in the Ladies' and Gentlemen's Houses, some furnished as such and others used for museum purposes.

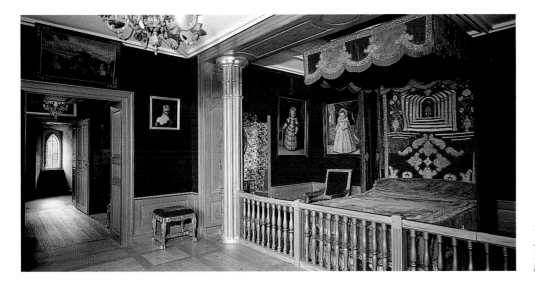

The bedroom of the Landgrave's Apartment in the Gentlemen's Building with a "Gothic column order" in front of the alcove

ℹ Kassel, Staatspark Karlsaue
D-34121 Kassel
Tel. (+49/0) 5 61/1 88 09
oand 9 18 89 50
Fax (+49/0) 5 61/1 24 16

🕐 Siebenbergen Island:
1 April till early October
daily 10 am–7 pm

Special tour:
"From the Orangery to
Siebenbergen Island"
(120 mins.) by prior
arrangement.

Marble Baths:
Reopening in spring 2001

✖

🅿

DB

🚌

M Orangery:
History of Technology
Department of the State
Museums with Planetarium
Tel. (+49/0) 5 61/7 15 43

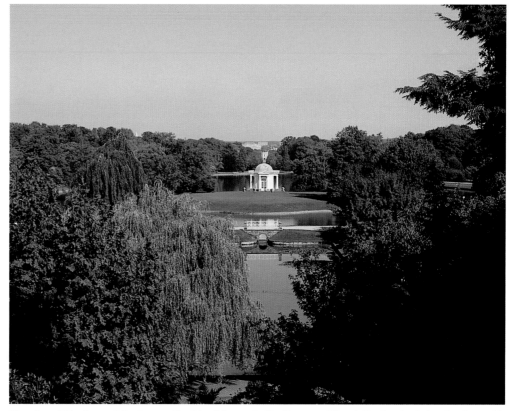

View from Siebenbergen Island across the Isle of Swans to the Orangery. The girdle of water induced a favourable microclimate on the island, where Hentze designed a botanically supreme garden of flowers and other plants

Kassel: Karlsaue Park and Siebenbergen Island

For almost 300 years the Landgraves and, later, Electors of Hesse-Kassel used Karls-aue as a summer residence. Skirted by two arms of the River Fulda, the water meadows form an island which fell section by section into the possession of the territorial overlords. Starting with the Renaissance Garden, laid out in the 16th century (close to today's stadium), the entire area was tamed to meet the formal requirements of its absolutist owners, resulting in a baroque park. The water was channelled into artistic forms, such as pools and an ornamental framework of canals. Like so many other baroque garden artefacts, the Karlsaue was altered from the late 18th century into a landscaped park, although its water framework survived almost entirely, as did the principal baroque vista, which on such a grand scale links the Orangery Palace via Karl's Meadow, the Middle Avenue, the Great Pool and its Isle of Swans, with Sie-benbergen Island in the Small Pool, offering panoramas across the picturesque botanical variety of this meadowland park.

This island was created while the river meadows almost encircled by the Fulda were being transformed into a baroque park under Landgrave Karl in the 18th century.

From the outset, Siebenbergen was thoughtfully planted as a "point de vue" at the southern tip of the principal baroque vista. From 1763, under Landgrave Friedrich II, some valuable woody varieties were added.

Siebenbergen was to enjoy a second heyday under Wilhelm Hentze who, as Director of Court Gardens in Hesse, took charge of the Electors' properties from 1822 until 1864. Today, the island is more or less as Hentze laid it out in the years from 1832 to 1864.

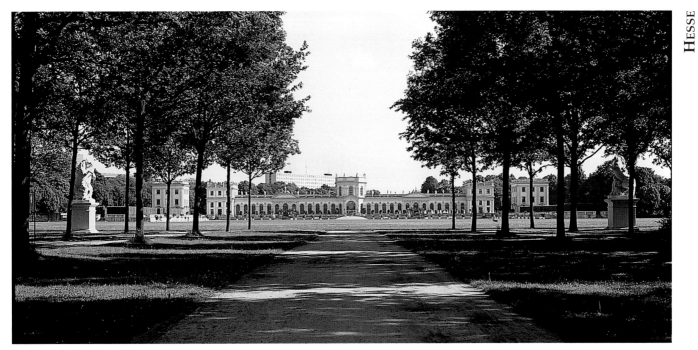

All paths in Karlsaue Park lead to the Orangery Palace

Kassel: Karlsaue Park, Orangery and Marble Baths

The Pavilion for the Marble Baths in Karlsaue

rence to this tale and their presence was obligatory. The sensuality of Monnot's figures, made of a white Carrara marble which shimmers like velvet, is reinforced by their fine framing in wall panels made of different coloured marbles and polished using a lavish technique for greater shine and depth.

Landgrave Karl had the Orangery built between 1701 and 1710 as a final point for the baroque vistas in Karlsaue Park. It served as a summer residence and in winter as a shelter for the orange, lemon and bay trees. A decade later a pavilion was added to the west to accommodate sculpture and bas-relief by Etienne Monnot (1657–1733). Monnot's works depict scenes from Ovid's *Metamorphoses*, including Daphne as she changes into a bay tree. The bay trees in the Orangery are a refe-

White marble sculptures of Greek gods are set against the polychrome marble cladding of the walls

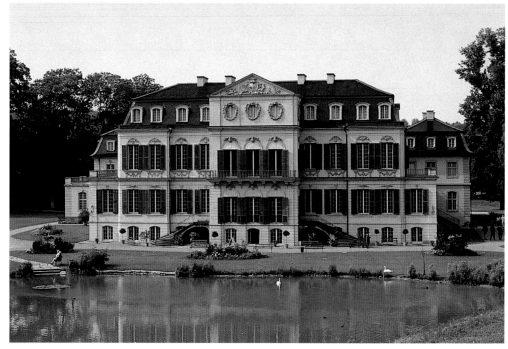

Wilhelmsthal Palace from the east

Allegory of taste, figurine of Meissen porcelain in the Landgravine's Closet, 1750–1755

Kassel District
Calden: Schloss Wilhelmsthal

This summer residence for the Landgraves of Hesse-Kassel was a major work by Munich's court architect François Cuvilliés. With its wealth of well-preserved interiors, it is a prime artistic accomplishment of German rococo. The three wings built for Governor and future Landgrave Wilhelm VIII, a connoisseur of the arts, between 1743 and 1761 has been decorated inside to designs by the Berlin sculptor Johann August Nahl. The residence thus combines the rococo of Bavaria with that of Friderician Prussia. Many outstanding objects have been preserved in the stately apartments, including a desk and clock by David Roentgen, about 50 paintings by Johann Heinrich Tischbein the Elder, the "peacock feather" chest (named after its mother-of-pearl pattern), and porcelain from Meissen (Dresden), Berlin, Fulda and Höchst.

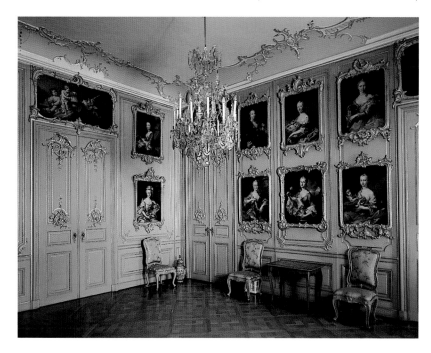

First Ante-Room in the Landgrave's Apartment, known as the Gallery of Beauty, with portraits by J.H. Tischbein the Elder

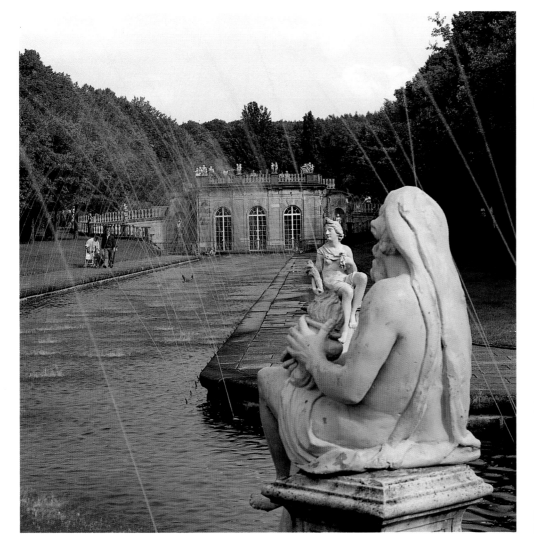

*The water axis with its
18th-century grotto*

ℹ Calden, Schloss und
Schlosspark Wilhelmsthal
D-34379 Calden 1
Tel. (+49/0) 5674/6898
Fax (+49/0) 5674/4053

🕘 Tu–Su, Mar–Oct 10 am–5
pm, last tour at 4 pm;
Nov–Feb 10 am–4 pm, last
tour at 3 pm.
Closed on Mondays except
public holidays.
Closed on 24–26 Dec,
31 Dec, 1 Jan

Guided tours:
Corps de logis and Kitchen
Wing (45 mins.)

Between Ascension Day
and 3 October the Rococo
Waterworks are switched
on after tours of the palace,
displaying about 370 foun-
tains along the canal and
Grotto.
Special tours of the park by
arrangement

🅿

Kassel District
Calden: Wilhelmsthal Park and Waterworks

Together, the park and palace formed an overall design which took its cue from its principal axes. Plans for the park were only implemented in part. The ornately adorned southern axis with its canal, pool and Chinese houses was completed in 1756. The central axis was partly constructed in 1760 as a watery stairway.

Around 1800 the grounds were transformed into a landscape garden by court gardeners Karl and Wilhelm Hentze for Landgrave Wilhelm IX, from 1803 Elector Wilhelm I (1785–1821).

The canal by Georg Wenzeslaus von Knobelsdorff's well-preserved Grotto was rehabilitated around 1963 and conveys some idea of the past glory which reigned in this rococo garden.

*Design for the Rococo Garden at
Calden, c. 1753/55*

<div style="writing-mode: vertical">Staatliche Schlösser und Gärten Hessen</div>

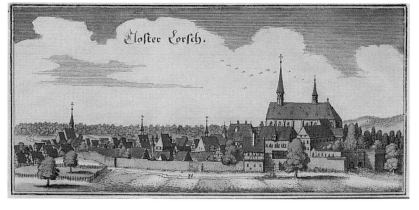

Lorsch Abbey, coloured copper engraving by M. Merian, c. 1615

Lorsch: Monastery with gate-hall and church remains

The Monastery of Lorsch was first mentioned in records in 764, and moved in 767 from the site of its original foundation (later named Altenmünster) to its subsequent location. From 772 until 1232 it was a King's Abbey, and in 876 it became the place of rest for East Franconian, or German, monarchs. It was one of the most important monastic centres of the Carolingian age and owned land from the North Sea coast down to Switzerland. Its large library testified to the major role which this abbey played in the accumulation of knowledge until it was dissolved under the Reformation in 1556. The Thirty Years War wrought havoc, leaving nothing of this monastic community to posterity but the Carolingian structure known as the King's Hall and the rump of an earlier Romanesque church. In 1991 the site was listed as a cultural monument in UNESCO's World Heritage.

i UNESCO World Heritage Kloster Lorsch with Museumszentrum Nibelungenstrasse 32 D-64653 Lorsch Tel. (+49/0) 62 51/59 67 - 4 10/4 11 and 0 62 51/5 14 46 Fax (+49/0) 62 51/58 71 40

Lorsch Museum Centre: Monastic History Department of the Stately Homes and Gardens Trust in Hesse; Local Ethnology Department of Hesse Regional Museum in Darmstadt; Tobacco Museum and Lorsch Municipal Collections.

🕐 Open all year round Tu–Su 10 am–5 pm. Opens specially on request.

Guided tours: Museum Centre, Monastery grounds with Herbal Garden, Romanesque church remains and Carolingian gate-hall (60 mins.); during Museum Centre opening times and also by special arrangement.

Educational events: Please book and make arrangements through the Museum management.

P

DB

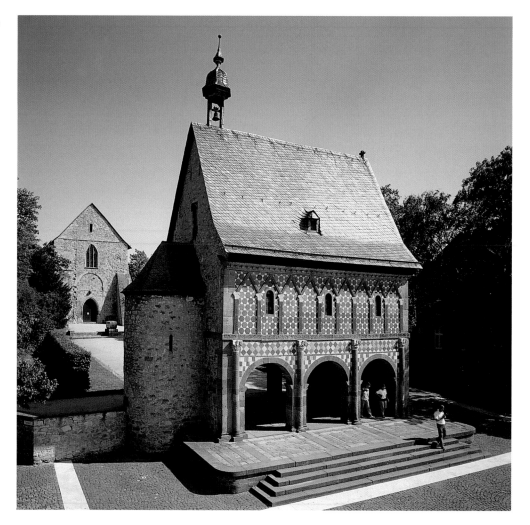

The King's Hall and the old church

Lorsch Museum Centre, looking into the Monastic History Department

Lorsch: Museum Centre

The Museum Centre near the King's Hall opened in 1995 as a regional museum. It actually unites three museums under one roof. One department is concerned with the history of monastic communities, describing factors which determined the culture of the religious orders in the early Middle Ages. Another illustrates the history of tobacco-growing and tobacco processing around Lorsch in the southern region of Hesse. The Local Ethnology Department of the Hesse Museum in Darmstadt has put together a display on everyday life in the territory.

The Museum Centre is funded by the state government of Hesse and the town council of Lorsch. It runs numerous education projects (including for adults) and a constant programme of exhibitions, lectures and concerts. The modern annexe is a convenient conference venue.

Lorsch Museum Centre, Monastic History Department, model of the settlement

Staatliche Schlösser und Gärten Hessen

ℹ Burgruine Münzenberg
D-35516 Münzenberg
Tel. (+49/0) 60 04/29 28
Fax (+49/0) 60 04/29 28

🕐 Tu–Su, April/May:
10 am–12 noon, 1–6 pm;
June–Aug: 10 am–12 noon,
1–7 pm;
Sep/Oct: 10 am–12 noon,
1–6 pm;
Nov–Mar: 10 am–12 noon,
1–4 pm

P

DB

🚌

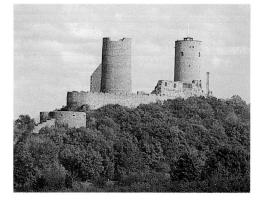

Münzenberg Castle ruin

Münzenberg Castle Ruins

Münzenberg Castle, visible from afar, once controlled the surrounding estates and those who lived there. It was built at the same time as the Emperor's residence in Gelnhausen between 1170 and 1190.

The oval encircling walls of massive rusticated ashlars follow the contours of the volcanic mound. The chapel was over the entrance hall, adjacent to the three-storey Great Hall. The doors and windows were of complex structure and framed. The open arcades of the main floor present distant views of the Wetterau Plains to the south. The Falkenstein Building and the western keep were added on the north side during the 13th century. The eastern keep built under the Hohenstaufen emperors now offers a panorama of the castle complex, which has fallen slowly into disrepair since the 16th century, and an impressive view across the slopes of Taunus, Spessart and Vogelsberg.

Michelstadt-Steinbach: Einhard's Basilica

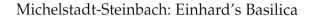

Michelstadt-Steinbach: Einhard's Basilica

ℹ Michelstadt-Steinbach,
Einhardsbasilika
D-64720 Michelstadt-
Steinbach
Tel. (+49/0) 60 61/7 39 67

🕐 April, May and Oct:
Tu–Su 10 am–12 noon,
1–6 pm;
June–Sep: 10 am–12 noon,
1–7 pm;
Nov–Mar: Tu–Su 10 am–
12 noon, 1–3 pm
Guided tour: 20 mins.
On Mondays by
arrangement

P

DB

Einhard was one of the most influential scholars at the court of Holy Roman Emperor Charlemagne and his son Louis the Pious. From 815 to 827 AD he had the basilica built in Michelstadt, far from worldly turmoil, presumably as a final place of rest for himself and his wife Imma. The simple architecture is delightfully well proportioned and still clearly visible outside in the cubature of the building's various elements and inside in the cohesion of the nave, apse, side quire and crypt. Almost twelve hundred years after its construction, the basilica still reflects Einhard's deep piety and exceptional creative powers. The careful bonding of the unfaced external masonry and the fragments of interior painting illustrate the high standards of craftsmanship which pertained during his era.

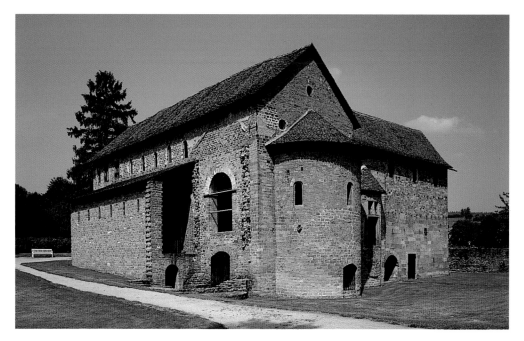

Einhard's Basilica from the southeast. Most of the apse and nave masonry dates from the 9th century.

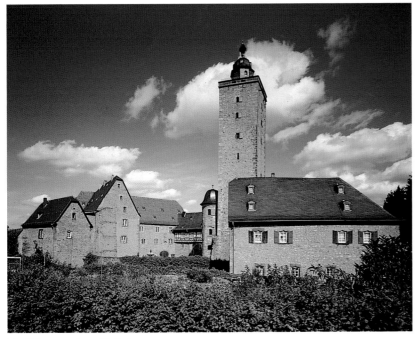

The Palace complex with its keep

ℹ Schloss Steinau
D-36396 Steinau an der Strasse
Tel. (+49/0) 6663/6843
Fax (+49/0) 6663/7518

🕗 18 Jan–22 Dec:
Tu–Su 9 am–5 pm;
Admission ceases 30 mins. before closing
Closed on Mondays except public holidays
Closed on 23 Dec–15 Jan

Keep Tu–Fr 9 am–5 pm
Guided tours:
Court kitchens and parlour, corps de logis, Grimm Monument, Puppet and Theatre Collection
Special tours by arrangement

The Monument to the Brothers Grimm and the Puppet and Theatre Collection can be visited without taking the guided tour.

Steinau an der Strasse: Schloss and Monument to the Brothers Grimm

Schloss Steinau had been in the possession of the lords of Hanau since 1278, but was rebuilt in the 16th and 17th centuries.

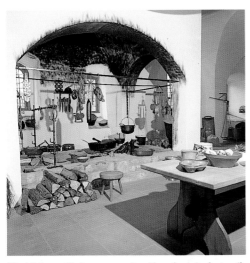

The kitchen with its masonry hearth and original utensils illustrates traditional methods of preparing and conserving food.

In its overall layout it still resembled a castle, with its sunken deer moat, gatehouses and compound, but its architectural and ornamental detail, such as the ornate blind tracery and the 16th-century wall painting (some of which has now been exposed), testify to the former splendour of one of Hesse's major Renaissance

palaces. While it was not the principal seat of the Hanau dynasty, it served as guest accommodation for travelling Electors, a hunting lodge for the local counts, and a tollbooth on the trading route from Frankfurt to Leipzig. The palace houses Steinau's Puppet Theatre collection and also a monument to the Brothers Grimm, who grew up in Steinau. It is above all dedicated to Wilhelm and Jacob Grimm and their collection of fairy-tales.

The Monument to the Brothers Grimm also exhibits original works by the artist and art professor Ludwig Emil Grimm, who captured Steinau's palace for posterity in his drawings and paintings.

Figurative door marquetry in the Hall

Staatliche Schlösser und Gärten Hessen

i Ehemalige
Benediktinerabtei
Seligenstadt
D-63500 Seligenstadt
Tel. (+49/0) 6182/22640
Fax (+49/0) 6182/28726

Guided tours: Abbot's
House, summer refectory,
cloisters
Special tour by
arrangement: Tel./Fax
(+49/0) 6182-20455 or
(+49/0) 69-595818
Heidrun Merk

◷ Tu–Su, Mar–Oct:
10 am–12 noon, 1–6 pm,
last tour at 5 pm;
Nov–Feb:
10 am–12 noon, 1–4 pm,
last tour at 3 pm.
Closed on Mondays except
public holidays.
Closed on 24–26 Dec,
31 Dec, 1 Jan.

Special tours
"Grinding corn at the
Abbey Mill": first Sunday
in May to first Sunday in
September, 1–5 pm by
members of the local
history society.

M Seligenstadt
Country Museum
Klosterhof 2
Tel./Fax (+49/0)
6182/20455

◷ Mar–Oct: Tu–Fr
10 am–6 pm, Sa 1–6 pm,
Su 11 am–6 pm
Nov–Feb: Tu–Fr
10 am–5 pm, Sa 1–5 pm,
Su 11 am–5 pm

✕

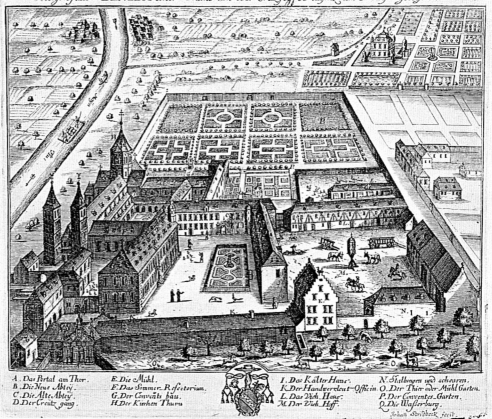

Copper engraving by Johann Stridbeck showing the Abbey (c. 1707). The various ornamental and kitchen gardens show how much the Benedictines knew about horticulture, botany and herbal medicine.

Seligenstadt: former Benedictine Abbey

The Benedictine Abbey in Seligenstadt was founded around 828. It is a rare and impressive example of an autonomous community, almost a town in its own right, with a church, secluded private quarters, functional buildings, gardens and an enclosing wall.

The abbey church, the largest Carolingian basilica north of the Alps, towers above the other buildings, most of which date back to 1685–1725. The Abbot's House is a lavish structure with a vestibule, a broad stairwell, a grand banqueting hall, splendid guest quarters and a generous apartment for the Abbot himself. It might be a prince's palace, indicating the self-esteem of the baroque prelates, whose status as territorial overlords was reinforced by an appropriate entourage.

The history of the Abbey, a key centre of political power and economic and cultural life in the region until its dissolution in 1803, is documented in the Country Museum, or "Landschaftsmuseum". The abbey mill, bake-house and cold store are also open to visitors.

Abbot's House, Emperor's Closet and alcoves. Located on the Via Regia, the Abbey constantly entertained noble and royal guests, including Emperor Karl VI in 1711 and Emperor Franz II in 1792.

Seligenstadt: Convent Garden

The extensive gardens within the abbey precincts played a fundamental role in enabling this self-contained economic entity to feed itself. The Convent Garden was redesigned in the 18th century as a symmetrical parterre, providing vegetables, fruit and cooking herbs for the monks' kitchens and medicinal herbs for the monastery's apothecary. Deer were kept in the Mill Garden (or Animal Garden). The Benedictines also cultivated their own vineyards.

These were kitchen gardens whose main purpose was to supply food, but there were also ornamental gardens, such as the traditional cloister garth. The "Angels' Garden" with its pretty flower parterre, created outside the Abbot's House around the year 1700 as a pleasure garden, shows that courtly habits were also imitated in the field of garden design. The same may be said of the Greenhouse (1760) with its sloping glass wall and underfloor heating, constructed specifically for the cultivation of exotic table fruits such as pineapple.

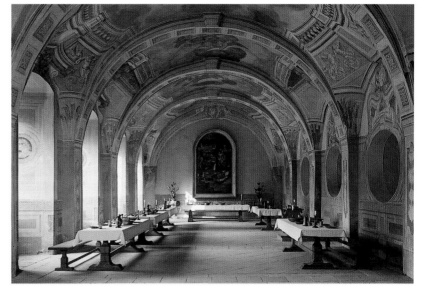

The summer refectory with trompe l'oeil painting and table replicas

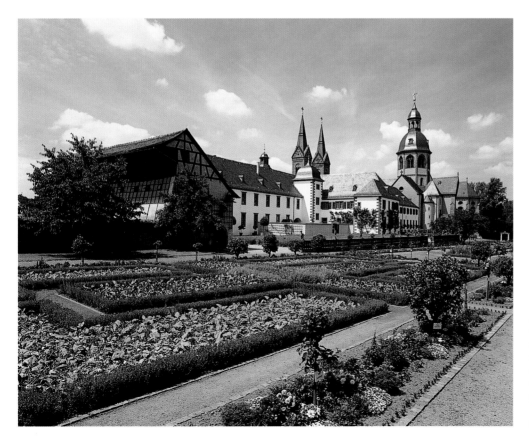

Full view of the Abbey with its Convent Garden, greenhouse and basilica. After Secularisation the original compartmentalisation of the beds and the 18th-century plantings were no longer retained, but they have been reconstructed since 1986 from garden records and engravings

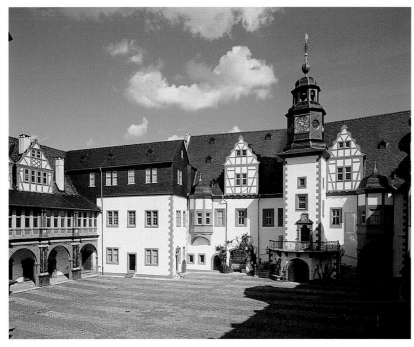

Palace courtyard with clock tower and arcades

rope. The guard-house, stables, utility yard and administrative buildings were all replaced. The palace church, built to Rothweil's designs in 1707–1713, ranks as one of the finest Protestant church buildings of the baroque period in Hesse.

Weilburg: Schloss

Schloss Weilburg lies high above the River Lahn. Among the many stately homes built by those absolutist overlords who were legion in German lands, this is one of the best preserved. The four-winged, 16th-century Renaissance palace has two parlours used for formal acts of state, such as legal proceedings or the tributes paid to a newly invested Count.

From 1702 the Schloss was developed into a baroque residence by J.L. Rothweil. To provide a worthy setting for official baroque functions and ceremonies of court, he built a grand stairway, a magnificent tract for guests, and new domestic and reception rooms for the Count's family. The structural sequence and splendid finish were inspired by the great courts of Eu-

Portal on the Pillar Tower. The Renaissance palace symbolises the power and artistic interest of the Counts of Nassau-Weilburg, especially in details such as the magnificent portals, which captured the eye of political guests as focal points of state ceremony.

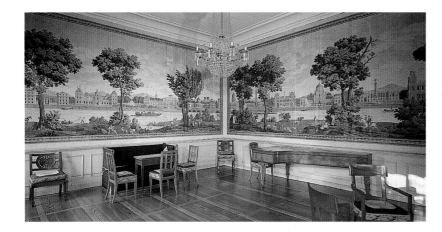

The landscapes which deck the walls of the Parisian Room present a panorama of buildings which line the Seine in the French capital.

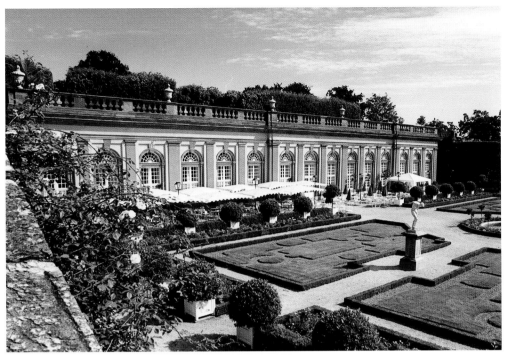

Garden parterre and Lower Orangery

i Schloss and Schlossgarten
Weilburg
D-35781 Weilburg/Lahn
Tel. (+49/0) 64 71/22 36
Fax (+49/0) 64 71/18 06

🕑 Nov–Feb:
Tu–Su 10 am–4 pm,
last tour at 3 pm
Mar, Apr & Oct:
Tu–Su 10 am–5 pm,
last tour at 4 pm
May–Sep:
Mo–Fr 10 am–5 pm,
last tour at 4 pm;
Sa/Su & public holidays
10 am–6 pm,
last tour at 5 pm.

Guided tours:
West, North, East and South
Wings, Upper Orangery
Climb of the Pillar Tower
possible by arrangement

Special tour:
The Palace Garden
(60 mins.), May–Sep:
Mo–Th 10 am–4 pm by
arrangement

Events:
Weilburg Palace Concerts,
stage plays; please consult
the official listings.

HESSE

Weilburg: Schloss Garden and Orangeries

The 16th-century Renaissance garden was restructured between 1700 and 1720 by court gardener F. Lemaire in the French manner. Two orangeries, waterworks, grottoes, sculpture and symmetrical compartments with the palace as their point of reference are the typically baroque features which adorn the terraces, surrounded by retaining walls, which stretch across two plateaux of the hill, linked by a linden bosquet. The upper orangery, rather more lavishly appointed, is both a home for plants and a banqueting hall. It also granted the Count direct access from his residence to his oratory in the palace church.

On the steep slope beneath the garden terraces, several planted rows of interweaving hornbeams, known as The Stoop, provide an impenetrable natural defence. From the Middle Ages well into the 18th century, this barrier marked the boundary and protected the grounds from military attack.

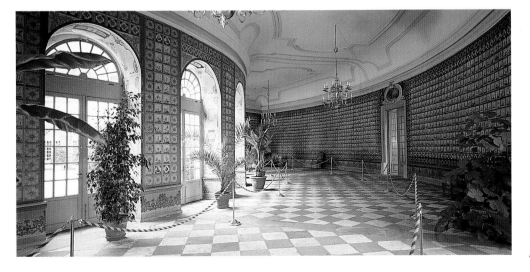

The Garden Hall of the Upper Orangery was finished with painted tiles by C. Seekatz.

Staatliche Schlösser und Gärten Hessen

ℹ Wiesbaden,
Schlosspark Biebrich
D-65203 Wiesbaden-
Biebrich
Tel. (+49/0) 6 11/69 46 22
Fax (+49/0) 6 11/69 46 22

☉ Park tours:
by arrangement

Event:
Whit Tournament held by
Wiesbaden Riding and
Driving Club.
Please consult the official
listings.

DB

🚌

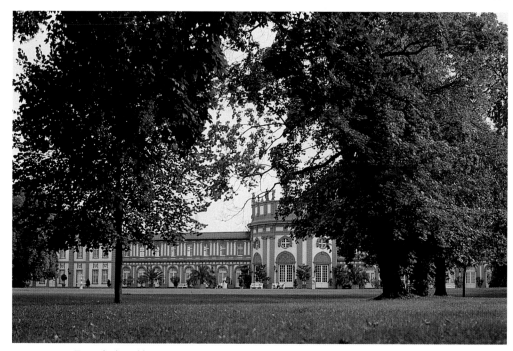

Towards the Schloss

Wiesbaden: Biebrich Schlosspark

Biebrich followed the same pattern as many other gardens when the Enlightenment spirit prompted its owners to transform their baroque garden, laid out in the first half of the 18th century, into a landscaped park. From 1817 Friedrich Ludwig von Sckell's designs imposed what appeared to be an entirely natural garden landscape. His artistic prowess is still evident in the harmonious combination of various distinct elements. The generous principal avenue, two smaller avenues emanating from the wings and three baroque fountains were retained and incorporated into the new structure, which draws its character from meandering walks through expansive plantings, watercourses which blend into their terrain, the picturesque scenery around the Mosburg, the long meadow valley which runs to the west of the main avenue and a multitude of views through the garden and out across the surrounding countryside.

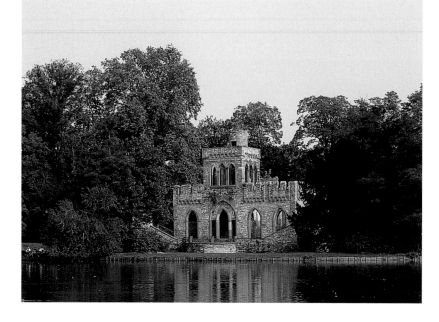

Schloss Homburg, Elizabeth Wing
The davenport used by Landgravine Elizabeth of Hesse-Homburg (1770–1840), by birth a British princess, in the library of her apartment

The Mosburg was converted into a pleasure castle for the park in 1805–1816.

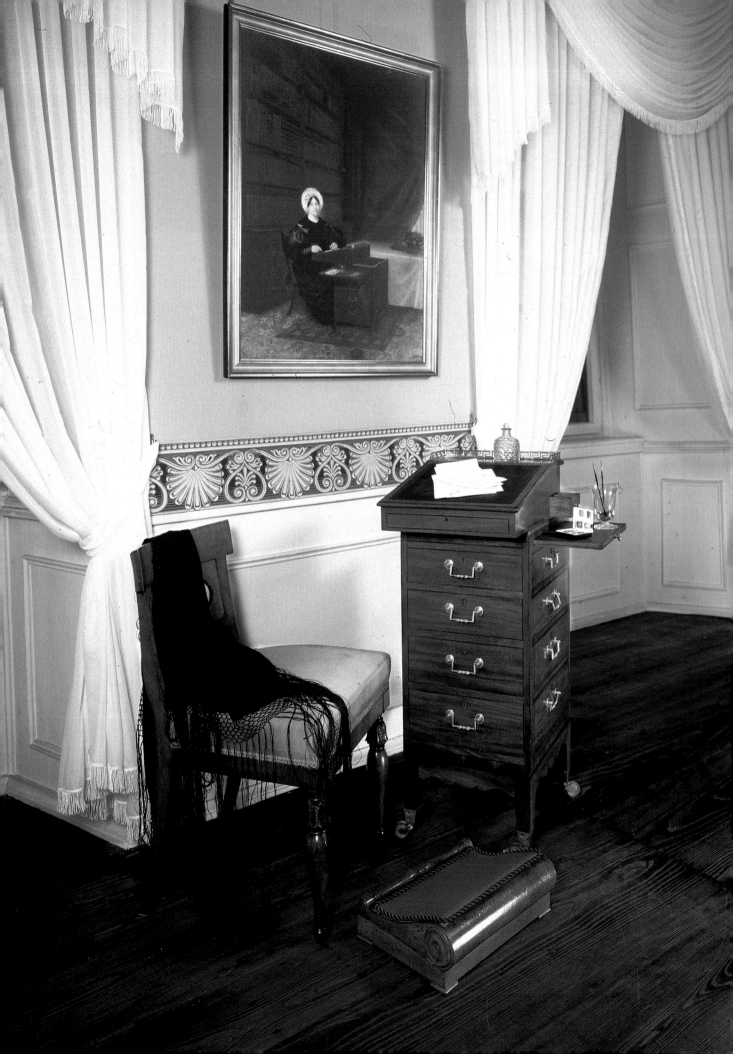

Staatliche Schlösser und Gärten Hessen

Altweilnau

Landstein Castle ruins and ruined church
D-61276 Weilrod

Bad Karlshafen

Harbour pool
D-34385 Bad Karlshafen

Bensheim

Goethe's Well in Hochstadt
D-64625 Bensheim

Butzbach

Princes' Crypt in St Mark's Collegiate Church
D-35510 Butzbach

Cornberg

Former Benedictine Convent
D-36219 Cornberg

Darmstadt

White Tower and Princes' Crypt in the parish church
D-64283 Darmstadt

Dickschied-Geroldstein

Haneck Castle ruins
D-65321 Heidenrod

Driedorf

Ruined castle and parish tower
D-35759 Driedorf

Eiterfeld

Fürsteneck Castle
D-36132 Eiterfeld

Felsberg

Ruined castle
D-34587 Felsberg

Friedberg

Emperor's Castle, Adolf's Tower and George Fountain
D-61169 Friedberg

Gernsheim

Zeppelin Monument
D-64579 Gernsheim

Hopfmannsfeld

Gallows
D-36369 Lautertal

Kaichen

Roman Well
D-61194 Niddatal

Konradsdorf

Premonstratensian Monastery
D-63683 Ortenberg

Merenberg

Ruined castle
D-35799 Merenberg

Neustadt

Junker Hansen Tower
D-35279 Neustadt

Oberreifenberg

Ruined castle
D-61389 Schmitten

Rosbach

Kapersburg Roman Fort
D-61191 Rosbach

Rüdesheim

Ehrenfels Castle ruins
D-65385 Rüdesheim am Rhein

Schmitten

Kleiner Feldberg Roman Fort
D-61389 Schmitten

Schröck

Elizabeth's Well
D-35043 Marburg

Walsdorf

"Hutturm" (tower)
D-65510 Idstein

Source of Illustrations:

Katharina Brunsing, Weilburg: p. 159
I. Dittrich, Karben: p. 136
Fa-Ro Marketing, Munich: p. 132
Werner Jagott, Oberursel: p. 134, 142, 143, 144, 146, 150, 155, 157
Gerd Kemmerling, Offenbach: p. 147, 155, 156, 158, 159
Gerd Kittel, Bad Homburg vor der Höhe: p. 157
Peter Knieriem: p. 136
Thomas Ludwig, Darmstadt: p. 135, 141, 149
H. Matern, Lorsch: p. 152
Margit Matthews, Frankfurt: p. 134, 135, 140, 153, 155, 156, 161

Norbert Miguletz, Frankfurt: p. 137, 140, 145, 147, 148, 150, 151, 152, 154, 158, 160
Frank Mihm, Kassel: p. 131, 133, 149, 150, 155
Bernd Modrow, Friedrichsdorf: p. 138, 160
Erich Müller, Kassel: p. 149
Saalburgmuseum: p. 136
Wolfgang Schick, Hüttenberg: p. 158
Schlossmuseum Darmstadt: p. 139
R. Woscidlo, Neu-Anspach: p. 136

Rhineland-Palatinate

RHINELAND-PALATINATE
CASTLES, STATELY HOMES AND
ANCIENT MONUMENTS

Burgen, Schlösser, Altertümer Rheinland-Pfalz

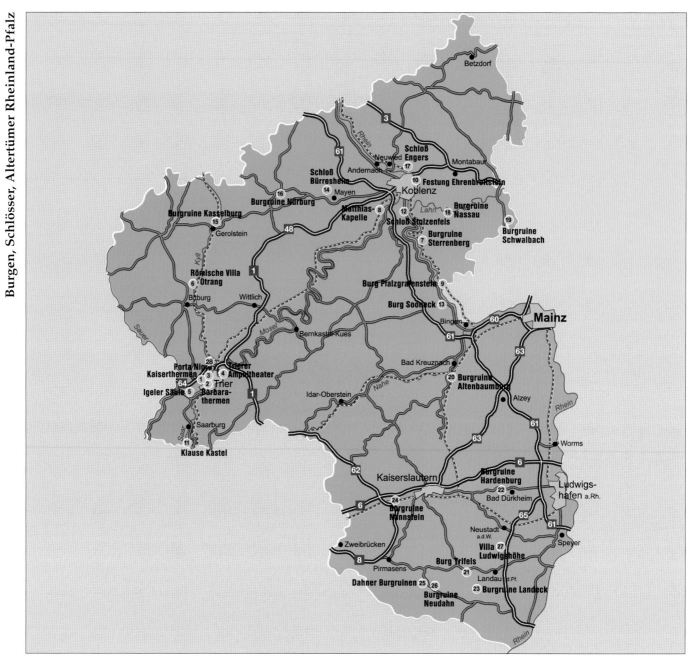

Trier

(1) Emperor's Baths p. 166

(2) Barbara's Baths p. 166

(3) Porta Nigra p. 167

(4) Amphitheatre p. 169

Igel

(5) Column p. 169

Otrang

(6) Roman Villa p. 170

Kamp-Bornhofen

(7) Sterrenberg Castle Ruins p. 171

Kobern

(8) St Matthew's Chapel p. 171

Kaub

(9) Pfalzgrafenstein Castle p. 172

Koblenz-Ehrenbreitstein

(10) Fort Ehrenbreitstein p. 173

Kastel-Staadt

(11) Kastel Hermitage p. 174

Koblenz

(12) Schloss Stolzenfels p. 175

Niederheimbach

(13) Sooneck Castle p. 176

Mayen

(14) Schloss Bürresheim p. 177

Gerolstein

(15) Kasselburg Castle Ruins p. 178

Nürburg

(16) Nürburg Castle Ruins p. 178

Neuwied-Engers

(17) Schloss Engers p. 179

Nassau

(18) Nassau Castle Ruins p. 179

Burgschwalbach

(19) Schwalbach Castle Ruins p. 180

Altenbamberg

(20) Altenbaumburg Castle Ruins p. 180

Annweiler

(21) Trifels Castle p. 181

Bad Dürkheim

(22) Hardenburg Castle Ruins p. 182

Gleiszellen

(23) Landeck Castle Ruins p. 183

Landstuhl

(24) Nannstein Castle Ruins p. 183

Bei Pirmasens

(25) The Ruined Castles of Dahn p. 184

Neudahn

(26) Neudahn Castle Ruins p. 184

Edenkoben

(27) Villa Ludwigshöhe pp. 185–186

Trier

(28) Bath at the cattle-market p.168

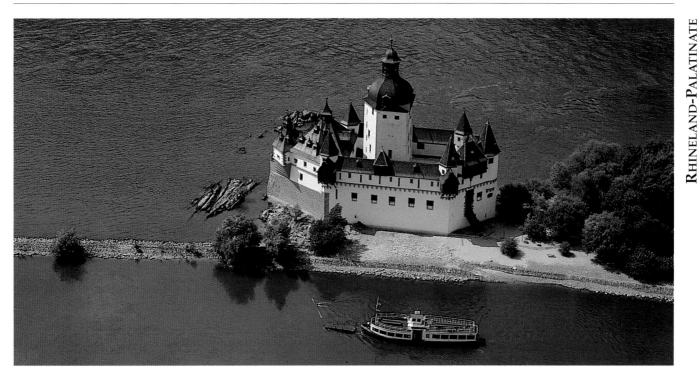

EXPERIENCE HISTORY

from the Romans through the Middle Ages to the Romantics

The Castles, Stately Homes and Ancient Monuments of Rhineland-Palatinate invite you to live history in stout Roman fortresses, enchanted ruins, lavishly decorated castles and palaces, a medieval customs office in the middle of the Rhine, and one of Europe's biggest fortifications.

Rhineland-Palatinate was created just over half-a-century ago as a federal German state, but the cultural landscapes which it unites within its borders look back over two thousand years.

Trier is often called "the Rome of the north", having been an important focus of power in the Roman Empire. The Palatinate and Rhine-Hesse were core territories of the medieval German constellation known as the Holy Roman Empire. Today's state contains three principalities once ruled by electors: Trier, Mainz and the Palatinate. Prussia's kings were bewitched by the magic of the Rhine, while Bavaria's followed the lure of Palatine scenery.

In many cases the sites which bore witness to this past harbour little more than stone ruins, for this region at the heart of Europe has been ravaged by many wars. Our organisation, *Burgen, Schlösser, Altertümer Rheinland-Pfalz,* has about seventy-five castles, stately homes and ancient monuments in its care.

This heritage reflects the full diversity of architectural history in all its styles and functions:

Ancient Roman structures in Trier, such as the Porta Nigra, the Amphitheatre, the thermae of Barbara's and the Emperor's Baths; castles and castle ruins such as Pfalzgrafenstein straddled by the Rhine, Nürburg in the Eifel Hills, Nassau on the River Lahn, and Trifels and Hardenburg in the Palatinate; richly endowed museums in stately homes like Schloss Bürresheim, which took several centuries to evolve as we know it, or Schloss Stolzenfels, built by the Romantics as a Gothic Revival castle; neo-classical palaces such as Villa Ludwigshöhe, and military fortifications like the Prussian fortress of Ehrenbreitstein in Koblenz.

Burgen, Schlösser, Altertümer Rheinland-Pfalz was founded in May 1998 under the roof of the Rhineland-Palatinate Preservation Agency, replacing the former Administration of Public Stately Homes in Rhineland-Palatinate. New budgetary instruments had been introduced, based on the financial accounting principles of commercial operation. Our task is to ensure that the cultural heritage entrusted to us is protected, maintained and preserved for future generations, and to make the buildings and collections in our care available for cultural education and tourism in a lively and understandable fashion. With this remit, visiting a cultural monument is a thrilling experience.

ℹ Altertumsverwaltung
Kaiserthermen
Weimarer Allee 2
D-54290 Trier
Tel. (+49/0) 6 51/4 42 62

Emperor's Baths
🕙 Easter week–30 September:
10 am–6 pm
1 October–30 November,
1 January–Palm Sunday:
10 am–5 pm
December: 10 am–4 pm
Admissions cease 30 mins.
before closing.

Barbara's Baths
🕙 Easter week–30 September:
10 am–1 pm, 2–6 pm
1 October–30 November,
1 January–Palm Sunday:
10 am–1 pm, 2–5 pm
Admissions cease 30 mins.
before closing.
Closed during December
and on the first working
day of each week.

Tour bookings:
Visitors' Centre
Tel./Fax: (+49/0)
1 80/5 22 13 60

*Emperor's Baths,
the caldarium apse*

Roman Architecture in Trier

Trier was once a capital of the Imperium Romanum, and Roman culture has left more traces in this town than any other in Germany. Excavation of these Ancient sites began under Prussian government, when the key Roman buildings in Trier became public property. Today they are in the care of our heritage administration.

The Emperor's and Barbara's Baths

The sturdy remains of the Imperial thermae, built around AD 300, are but modest vestiges of a once gargantuan complex. Romans of standing came to relax and enjoy themselves here in the public baths, which were probably begun under Emperor Constantine and, it seems, never finished. The masonry of the great apse – some of it original and some later restored – provided the walling for the hot bath, or caldarium. This was not the only facility. There was also a cold bath, sauna and massage rooms. Sports were played in the courtyards while poets and musicians provided entertainment in the lobbies. Slaves toiled without respite in the underground passages, preparing hot, clean water for the bathers.

Barbara's Baths are older, built around AD 150. Here, a horde of slaves "slogged" to death feeding the heating system in the cellars. These walls have survived particularly well. The masonry foundation walls of the ground floor, which housed two covered swimming pools, are also impressive. The rooms were lavishly adorned with marble, relief and sculpture.

Porta Nigra

Although the Porta Nigra was never finished, it is the most popular of the Roman buildings in Trier and attracts the largest number of visitors. It is the biggest Roman town gate to have survived north of the Alps and a typical expression of several different eras. The gateway fortress was built around AD 180 as part of the earliest town fortifications. The Roman masons piled block upon block with no mortar between. Iron "dogs" and the weight of the row above are still holding the masonry together. The Porta Nigra owes its survival to the itinerant Greek monk Simeon, who moved into it in 1028 to lead a pious life in solitude. When he died, it was converted into a church, and that was its salvation. The French Emperor Napoleon I was the first to remove most traces of its turbulent history. Centuries of weathering turned the stone of the Porta Nigra dark, and in the 11th century it had already acquired its name: the Black Gate.

i Porta Nigra
Simeonstrasse
D-54290 Trier
Tel. (+49/0) 6 51/7 54 24

☉ Easter week–30 September:
10 am–6 pm
1 October–30 November,
1 January–Palm Sunday:
10 am–5 pm
December: 10 am–4 pm
Admissions cease 30 mins.
before closing.

Tour bookings:
Visitors' Centre
Tel./Fax: 1 80/5 22 13 60

Porta Nigra from outside the walls

Above, below:
cattle-market baths, interior
view

ℹ Thermen am Viehmarkt
Am Viehmarkt
D-54290 Trier
Tel. (+49/0) 6 51/9 94 10 57

🕓 All year round
10 am–5 pm
Admissions cease 30 mins.
before closing.
Closed on Mondays

Information about events
(+49/0) 2 61/9 74 24-42

Baths at the cattle-market

The baths at the cattle-market offer a remarkable insight into the history of the town of Trier, unmatched by any of the other antique sites. The history of the cattle market-place began long before the first cattle-market was held there. Roman living quarters in the 1st century A.D. were followed by a large building, in which the inhabitants of Augusta Trevorum were able to enjoy the comforts of the Roman bathing culture in the 3rd and 4th century AD.

Due to the fact that the chapter of the cathedral used the ruins of the baths as a "quarry" in the 13th century the Middle Ages resulted in a loss of substance. In the 17th and 18th centuries the garden of a Capuchin monastery became the precursor of the cattle market-place, which was established when the monastery was dissolved in 1802.

Recalled to life from its long deep sleep by construction workers in 1987, the whole area was excavated by the Trier Museum of the Rhineland; their work was completed in 1994. The impressive remains from the early history of the cat-tle market-place are today protected by a no less impressive construction by the architect Oswald M. Unger. Modern and antique architectural features are thus brought together to form an unusual and exciting combination.

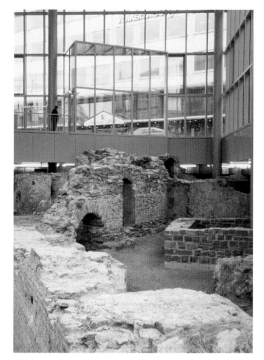

Amphitheatre

The Amphitheatre was built around AD 100. Over 70 ancient amphitheatres are still extant, and this is about the tenth in size, with room for an audience of some 18,000. Although these Classical amphitheatres varied in size, the ground plan remained the same, with a flat, usually oval surface for contests between beasts, against beasts and between gladiators, encircled by rising tiers of seating for spectators. The cages are in the arena, and in the middle there are steps down to subterranean cellars, where sets and accessories were kept for spectacles which frequently turned bloody.

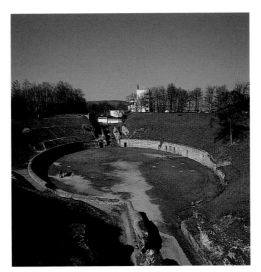

Amphitheatre

i Altertumsverwaltung
Amphitheater
Olewiger Strasse
D-54295 Trier
Tel. (+49/0) 6 51/7 30 10

☉ Easter week–30 September:
10 am–6 pm
1 October–30 November,
1 January–Palm Sunday:
10 am–5 pm
Admissions cease 30 mins.
before closing.
Closed in December

Tour bookings:
Visitors' Centre
Tel./Fax: 1 80/5 22 13 60

Igel Column

The Igel Column has been admired since bygone ages as a mysterious Ancient wonder. Goethe came here twice in 1792, and Victor Hugo also paid a visit, although an involuntary one, as his coach had broken down. In the Middle Ages the Igel Column narrowly escaped demolition when it was mistakenly identified as a monument to St Helena, the mother of Emperor Constantine the Great.

In fact, the Column is a monument to the Secundians, a family who acquired prosperity by making and trading in cloth. It was built around AD 250, and depicts members of the family, work in the family business, and the gods and heroes they worshipped. By illustrating these work routines, the Igel Column served not only as a memorial, but also as an effective advertisement.

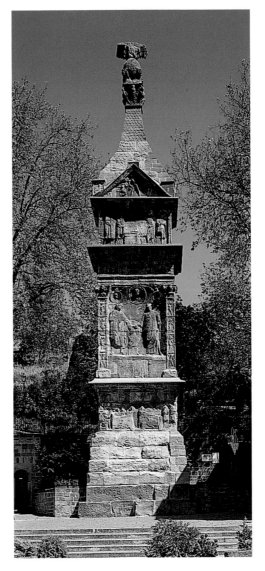

Igel Column

i Igeler Säule
near Igel
on the Mosel

P cars can park across the road

i Altertumsverwaltung
Römische Villa Otrang
Otranger Strasse
D-54636 Fliessem
Tel. (+49/0) 65 69/96 32 45
Fax (+49/0) 65 69/96 32 46

Easter week–30 September:
10 am–1 pm, 2–6 pm
1 October–30 November,
1 February–Palm Sunday:
10 am–1 pm, 2–5 pm
December: 10 am–4 pm
Admissions cease 30 mins.
before closing.
Closed during December
and January and on the first
working day of each week.

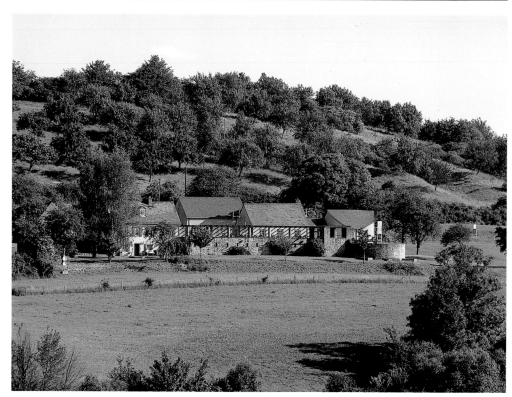

Villa Otrang

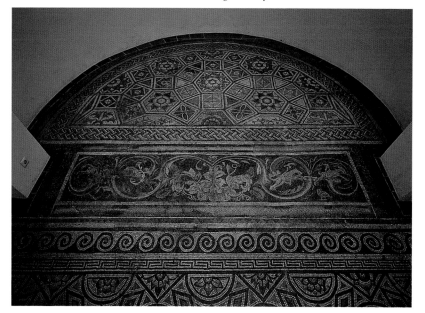

Villa Otrang, mosaic floor

Roman Villa, Otrang

The Romans set up many large-scale enterprises in the area around Trier. The Villa near Otrang was an agricultural estate with a house for the master. Roman settlers were already living here in the first century AD. The Villa was extended several times until it had 66 rooms and three bath-houses with several underfloor heating systems. This residence was destroyed around AD 400 during the great wave of migration.

Much later, from 1838 onwards, the Prussian king Friedrich Wilhelm IV had the rediscovered ruins excavated. The remains exposed in the process were placed in safe storage, an early act of monument preservation in Germany. The marvellous mosaic floors have survived in four rooms. Among other admirable features are the depictions of animals: beasts pursue their prey through arches of ornamental foliage, while a crane devours a serpent. This is the kind of luxury which the upper classes would have expected in their homes in Rome.

The Medieval Rhine and Mosel

Sterrenberg Castle Ruins

Standing together on the same ridge of hill, the castle ruins of Sterrenberg and Liebenstein are foes of the same ilk. Their extraordinary juxtaposition gave rise to a well-known legend, and in 1587 the tale was already being told of two brothers eyeing each other with hostility from their castle lairs. In fact, the inhabitants of these two castle were not fraternal rivals, but overlords of different territories: the Counts of Sponheim and the Archbishops of Trier. The outer defence wall, 10 metres high, was built around 1300. The rear wall within, just as massive, is 100 years older. The keep on its artificial rocky mound was the ultimate refuge. Sterrenberg's defences are still impressive, even as ruins; they also offer a wonderful view of the Rhine Valley from the castle restaurant and its terrace.

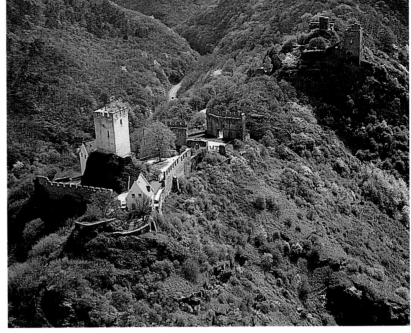

The enemy brothers with Sterrenberg in the foreground

i Burgruine Sterrenberg
Kamp-Bornhofen,
Rhine-Lahn District

✖

P below the castle, approx.
5-minute walk

St Matthew's Chapel

The Chapel of St Matthew, high above the Mosel Valley, stands amid the ruins of the Oberburg, long since destroyed. Not only is the location unique (though comparable with the castle chapel in Vianden), but so is its architecture, the result of its original function as a chapel of relics and pilgrimage: the head of the apostle Matthew was kept here. A knight from Isenburg may have brought this relic home from a Crusade. Around 1230 he had the chapel built to resemble the Church of the Holy Sepulchre in Jerusalem. St Matthew's Chapel is a central plan, hexagonal structure with a complex interior. The columns and capitals are Early Gothic masterpieces. The Oberburg's well-preserved Romanesque keep, immediately next-door, now houses a restaurant.

St Matthew's Chapel (before restoration)

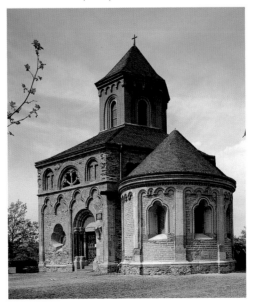

i Matthiaskapelle
in the Oberburg
D-56330 Kobern

◷ Palm Sunday–3 October:
11 am–5 pm on Saturdays,
Sundays and public holidays

Tour bookings:
Visitors' Centre
Tel./Fax (+49/0)
180/5221360

✖

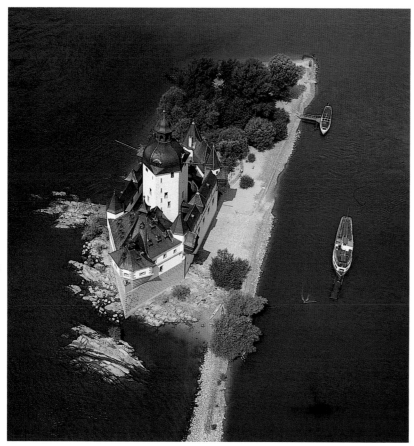

Pfalzgrafenstein

Pfalzgrafenstein Castle

The castle of Pfalzgrafenstein reminded the French writer Victor Hugo of a stone ship anchored for eternity.

Unlike most castles and stately homes along the Rhine, Pfalzgrafenstein was built for purely commercial purposes and has always functioned as a toll-house. Its location, on an island in the middle of the river, clearly reflects its role. King Ludwig the Bavarian built the castle in 1327 in order to extract money from traffic on the Rhine. Even the Pope caught wind of the annoyance this caused, as his abbeys and prelates were expected to pay duties on their shipments of wine. It is hard to imagine today that barges travelling between Mainz and Cologne stopped twelve times on their journey for customs officials. Although the castle was modernised in 1607 and 1755, most of its fabric dates from the 14th century. The austere rooms still convey the modest lifestyle of the 20- to 30-strong customs force.

Pfalzgrafenstein, inside the castle courtyard

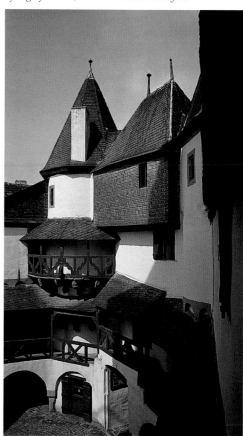

Pfalzgrafenstein

ℹ Burg Pfalzgrafenstein
D-56349 Kaub
Tel. (+49/0) 172/2 62 28 00

🕐 Easter week–30 September:
10 am–1 pm, 2–6 pm
1 October–30 November,
1 January–Palm Sunday:
10 am–1 pm, 2–5 pm
Ferries leave about every
half-an-hour.
Closed during December
and on the first working
day of each week

Visitors' Centre
Tel./Fax (+49/0)
1 80/5 22 13 60

Military and Romantic Prussia

Fort Ehrenbreitstein

The fortress of Ehrenbreitstein was built from 1817 to 1828 to replace the Elector of Trier's fort blown up by the French in 1801. When finished, it was regarded as impregnable. There was room here during hostilities for 1500 soldiers and 80 cannon. Provisions sufficed to withstand a six-month siege. Ehrenbreitstein actually forms part of the Fortress of Koblenz, with another two major complexes on the left bank of the Rhine and a multitude of smaller forts. At the time, Koblenz was Europe's second largest fortress after Gibraltar. However, apart from being one of the biggest, it was one of the most homogeneous, having been built in the neo-Prussian manner, and it has retained this stylistic consistency until today. In the 19th century, the view from Ehrenbreitstein across to the Deutsches Eck was already a must for any Rhine traveller, but nowadays the fortress has much more to offer: imposing architecture, the Army Monument, a museum devoted to valua-

Fort Ehrenbreitstein

ble items of technical and cultural interest, a youth hostel, two restaurants, an exhibition on the life of the Prussian soldier, the Visitors' Centre set up by *Burgen, Schlösser, Altertümer Rheinland-Pfalz*, and – since 1997 – a festival.

i Festung Ehrenbreitstein
D-56077 Koblenz-Ehren-
breitstein
Tel. (+49/0) 180/5 22 13 60

☉ Open all year round

Tour bookings:
Visitors' Centre Tel./Fax
(+49/0) 1 80/5 22 13 60

⊺ Chair lift

☉ Easter to end of May and
September to October:
10 am–5 pm
June–September:
9 am–5.50 pm
Tel. (+49/0) 2 61/7 37 66
Office: 2 61/7 51 90

✕

P In front of the fort

M Koblenz Regional Museum
State Collection of Technical
Monuments

☉ Mid-March to end of
November: daily 9 am–
12.30 pm, 1–5 pm
Admissions cease 15 mins.
before closing
Tel. (+49/0) 2 61/9 70 31 50
or 97030
Fax (+49/0) 2 61/70 19 89

Koblenz Youth Hostel
open all year round
Tel. (+49/0) 2 61/97 28 70
Fax (+49/0) 2 61/9 72 87 30

Looking south towards the curtain wall at Ehrenbreitstein

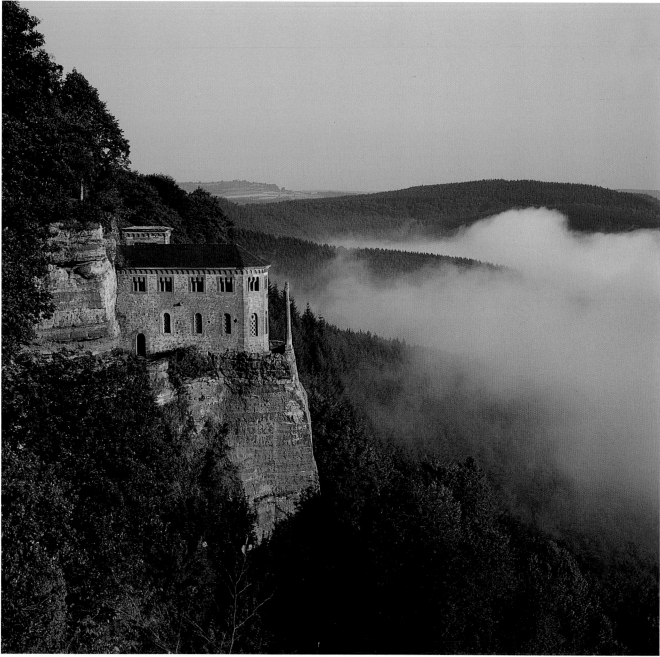

Kastel Hermitage

ℹ Altertumsverwaltung
Klause Kastel
Sauerblockstrasse 2
D-54441 Kastel-Staadt
Tel. (+49/0) 6582/535

🕐 Easter week–30 September:
10 am–1 pm, 2–6 pm
1 October–30 November,
1 January–Palm Sunday:
10 am–1 pm, 2–5 pm
Admissions cease 30 mins.
before closing.
Closed during December
and on the first working
day of each week

🅿 along the approach road,
approx. 5-minute walk

Kastel Hermitage

In the Middle Ages, pious hermits were already digging caves in the soft sandstone, seeking a secluded life far above the Saar valley. Around 1600 a Franciscan monk built a chapel on this narrow ledge. After 1833 Crown Prince Friedrich Wilhelm of Prussia had this long abandoned ruin converted into a chapel of rest for the Bohemian king John the Blind. Schinkel, Prussia's famous architect, produced the designs. John of Bohemia, of the House of Luxembourg, did not allow his lack of sight to exclude him from the Battle of Crécy in 1346, but he perished there. Prussia's crown prince revered him as a paragon of brave chivalry, and had his bones placed in the chapel over the River Saar. After World War I, King John's remains were moved to Metz, then returned to Germany, and ultimately placed in Luxembourg Cathedral in 1946.

Schloss Stolzenfels

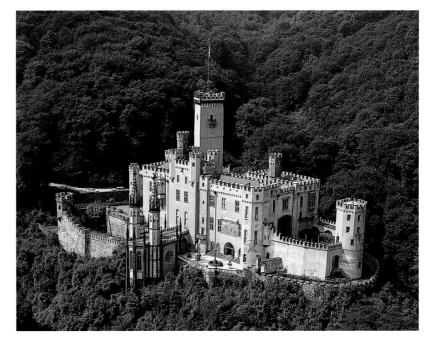

Schloss Stolzenfels

The French burned down the castle at Stolzenfels, but it was rebuilt, not only because of the contemporary Romantic enthusiasm for Rhenish landscapes and medieval history, but also to serve Prussia's cultural policy on the Rhine. In 1823 Crown Prince Friedrich Wilhelm, later King Friedrich Wilhelm IV of Prussia, received the ruined castle in this beautiful location as a gift. The original plan was confined to the parkland around the ruins, but when this work was finished Friedrich Wilhelm decided to build a neo-Gothic summer residence from drawings by the celebrated Berlin architect Karl Friedrich Schinkel. In 1842, the completed palace and park composed a picturesque backdrop for a festival in historical costume. The Schloss exudes an almost Italian serenity with its ochre paint, its fountains and walled gardens. The royal quarters are still appointed just as the Romantic monarch disposed: paintings, weapons and furniture many centuries old alternate with neo-Gothic creations of the mid-19th century. The wall paintings in the palace chapel and the Lesser Knights' Hall are among the finest achievements of High Romantic style in the Rhenish region. Friedrich Wilhelm IV set a monument to himself with this residence, illustrating both the revival of medieval symbolism and the political

i Schloss Stolzenfels
D-56075 Koblenz
Tel. (+49/0) 2 61/5 16 56

⊘ Easter week–30 September:
10 am–6 pm
1 October–30 November,
1 January–Palm Sunday:
10 am–5 pm
Admissions cease 45 mins.
before closing.
Closed during December
and on the first working
day of each week
Viewing with guide only

P in Stolzenfels, approx.
10-minute walk

*Schloss Stolzenfels,
the Queen's living room*

agenda of the future king, who sought to present himself as the direct and legitimate descendant of the medieval emperors, kings and electors.

The chapel at Schloss Stolzenfels

Sooneck Castle

i Burg Sooneck
D-55413 Niederheimbach
Tel. (+49/0) 67 43/60 64

🕘 Easter week–30 September:
10 am–6 pm
1 October–30 November,
1 January–Palm Sunday:
10 am–5 pm
Admissions cease 45 mins.
before closing.
Closed during December
and on the first working
day in each week
Viewing with guide only

Sooneck Castle

During a trip along the Rhine in 1842, King Friedrich Wilhelm IV of Prussia and his brothers, the Princes Wilhelm, Karl and Albrecht, discussed converting the ruined castle of Sooneck into a hunting lodge. The king and his brothers hoped to hunt in the forest of Soonwald without their courtly entourage. This typically Romantic idea was thwarted by the Revolution of 1848, family disputes in the royal house, and ultimately the king's own illness and death. The Hohenzollern monarchs did restore the castle, but never resided here. The main building was a well-preserved ruin around 1840, lacking only roofs and flooring. Extension work in the 19th century was so circumspect

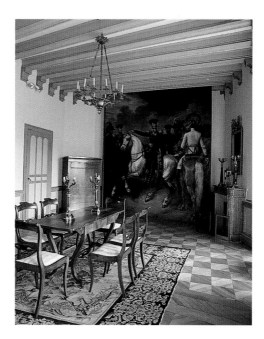

Sooneck Castle

that the Gothic masonry with its sawn-off beams and medieval rendering was carefully salvaged. The modest living quarters at the castle are furnished with items made in the first half of the 19th century and views of the Rhine from the Hohenzollern estate. In the dining room hangs a striking painting of 1825 depicting a battle scene during the Wars of Liberation against Napoleon I.

On the second floor, the Koeth-Wanscheid Foundation exhibits views of the Rhine, portraits of nobility and furniture made in the 18th and 19th centuries. They belonged to a family of Rhenish aristocracy.

Sooneck Castle, dining room

The Medieval, Renaissance and Baroque Eifel

Schloss Bürresheim

It is rare today to find such an old stately home which has stood in an undisturbed and uninhabited landscape for hundreds of years, alone with rippling streams and forested mountain slopes. Schloss Bürresheim has never been conquered or ransacked, unlike almost every other castle in the Rhineland. Over many generations, the aristocratic family who lived here until 1938 acquired a wealthy collection of furniture and paintings. It is unrivalled in showing how the Rhenish aristocracy lived and the interests they pursued. The buildings are clustered in a picturesque group which evolved from the 12th to the 17th century. The old keep has survived from the original complex. The little baroque garden south of the castle was already depicted on paintings around 1700. The delightful courtyard is rich in timber frames and variously shaped roofs with slates and spires. The arrangement of the late medieval great hall illustrates how simply people lived around 1490. On each floor there is a large room with oak pillars, beam ceilings and huge hearths. It was only in later centuries that this space was divided into smaller and cosier rooms. Furniture has been lovingly preserved from the 15th to 19th centuries. Numerous portraits depict members of the family and overlords of past ages.

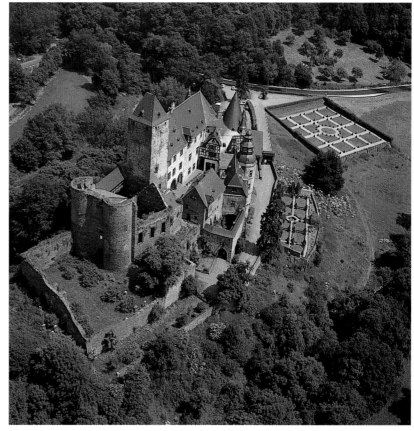

Schloss Bürresheim

Schlossverwaltung
Bürresheim
D-56727 Mayen
Tel. (+49/0) 26 51/7 64 40

Easter week–30 September:
10 am–6 pm
1 October–30 November,
1 January–Palm Sunday:
10 am–5 pm
Admissions cease 45 mins.
before closing.
Closed during December
and on the first working
day in each week
Viewing with guide only

P outside the Schloss

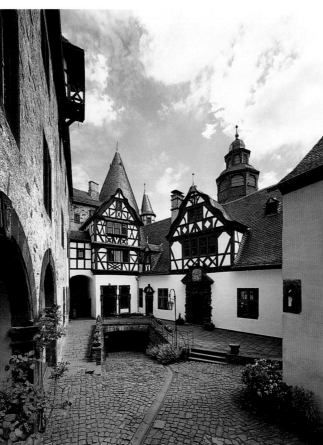

Schloss Bürresheim, castle courtyard

i Ruine Kasselburg
near Gerolstein

⊙ April–September:
9 am–6 pm
October–March:
10 am–dusk
Closed from 11 January to 20
February

✕

P outside the park

Kasselburg Castle Ruins

Kasselburg's 34-metre, eight-storey gate-tower looms above the forest like a sky-scraper. When it was built around 1350, it was a proud symbol of the power in the hands of Blankenheim's masters. Combining living quarters with a gateway, this tower is unique in the history of German castle architecture. With its steep slate roofs it would originally have been even more imposing, but unfortunately these fell prey to the passage of time. Although the stairs were narrow, accommodation in the tower was quite comfortable by medieval standards. The owners, however, had a great hall on the protected side of the precinct, a splendid building with a three-storey chapel annex. The oldest surviving structure is the square keep, which dates from around 1200. The Kasselburg is set within the Park of Eagles and Wolves, and birds of prey are kept in the ruins of the old castilians' houses.

Kasselburg castle ruins

Nürburg Castle Ruins

Nürburg Castle Ruins

i Burgverwaltung Nürburg
D-53520 Nürburg
Tel. (+49/0) 26 91/27 04

⊙ Easter week–30 September:
10 am–1 pm, 2–6 pm
1 October–30 November,
1 January–Palm Sunday:
10 am–1 pm, 2–5 pm
Admissions cease 30 mins.
before closing.
Closed during December
and on the first working
day in each week

P at the foot of the castle hill,
approx. 10-minute walk

As racing cars roar round the Nürburg Ring, few people are probably aware that the hill crowned by the Nürburg was first settled long ago in Roman days. Its name derives from "mons nore", the black hill.

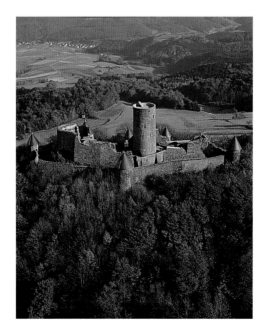

The Counts of Are built a castle here in the 12th century, but nothing remains except the extensive ruins. At the foot of the castle mound, visitors will find last vestiges of a Romanesque castle chapel, built around 1200. A serpentine path leads to the principal point of access, a massive double gate. With its myriad round turrets under their distinctive spires, it has an excellent command of the surrounding terrain. The inner castle, protected by a ring wall and its own gate, was built in the early 13th century. The sturdy circular keep still boasts its Late Romanesque ribbed vaults. The platform offers a sweeping view across the sprawling forests of the Eifel.

Nürburg castle ruins

RHINELAND-PALATINATE

Schloss Engers, detail from the ceiling fresco by Januarius Zick

Rhenish Baroque

Schloss Engers

One of the last Electors of Trier lived in a baroque palace on the banks of the Rhine. The hunting lodge for Johann Philipp von Walderdorff was built in 1759–1762. To make way for the new residence, his architect Johannes Seiz, a pupil of Baltha-sar Neumann, was instructed to demolish the medieval castle of Kunostein. A gem of Late Baroque architecture and art was then created right by the river. The Banqueting Hall is especially sumptuous, with lavish stucco work and an original ceiling fresco by Januarius Zick. Schloss Engers attracts tourists with a restaurant and its Villa Musica Foundation, a chamber music academy which regularly holds concerts in the Banqueting Hall.

i Villa Musica
Schloss Engers
Alte Schlossstrasse 2
D-56566 Neuwied-Engers
Tel. (+49/0) 26 22/9 26 40

Daily except Mondays:
11 am–5 pm

Tour bookings:
Visitors' Centre
Tel./Fax
(+49/0) 1 80/5 22 13 60

P nearby

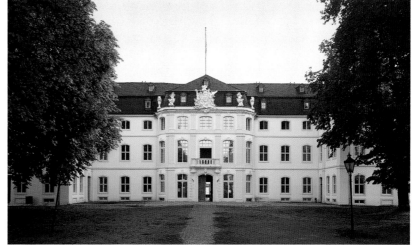

Schloss Engers, town side

Nassau Castle Ruins

The Medieval Lahn and Nahe

Nassau Castle Ruins

The keep and great hall rise above the forested slopes of the castle hill as if Nassau Castle were still intact. In 1976 the early 14th-century keep was re-topped with a slate spire and corner turrets, replicas of the originals created from old drawings. The view from here is breathtaking. After parts of the Romanesque building were discovered in the ruins, the manorial great hall was reconstructed in 1980–1982. It now contains a restaurant. The huge fireplace in the hall itself was put together following original traces. A genealogical tree shows how the Counts of Nassau are related to other European dynasties. In the Middle Ages, they fathered kings of Germany, and the royal families of the Netherlands and Luxembourg are their descendants.

i Burgruine Nassau
Rhine-Lahn District

P outside the castle gate
(not suitable for coaches)

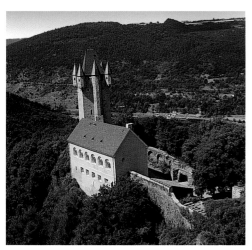

Nassau castle ruins

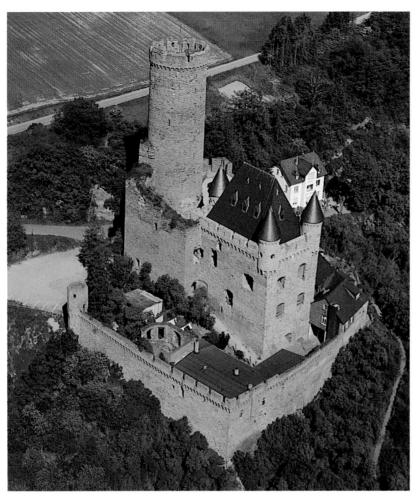

ℹ Burgruine Schwalbach
Burgschwalbach

��X

🅿 behind the castle

Schwalbach Castle

Schwalbach Castle Ruins

Ever since Schwalbach regained its imposing slate roof, it has been rather inappropriate to call it a ruin, but the familiar name has stuck. The Counts of Katzelnbogen built the castle at one go around 1370. It is striking for its regular symmetrical ground plan, with a round keep in the corner of the high protective wall. The lords of the castle lived in the great hall, which on its third floor is protected by massive vaulting designed to ward off stones from enemy catapults. In fact, the castle was not destroyed by assaulting adversaries, but by decades of neglect during the 18th century. To prevent the masonry of the finest castle in the Taunus Mountains from collapsing, the great hall was redeveloped in recent years. It now accommodates a restaurant.

Altenbaumburg Castle Ruins

ℹ Burgruine Altenbaumburg
Altenbaumburg

✖X

🅿 outside the restaurant

Altenbaumburg Castle Ruins

The Altenbaumburg, high above the wooded slopes of the Alsenz valley, was the medieval residence of the "Raugrafen", or "hairy counts". This was a sprawling castle complex, and some impressive masonry still remains. A deep moat in the rock protects the inner castle, built in the 13th century, from hill attack. In 1689 the lower castle was still used for accommodation. A late medieval house with stepped gables was reconstructed with the help of old drawings in 1980–82 and fitted out as a restaurant.

Burg Altenbaumburg

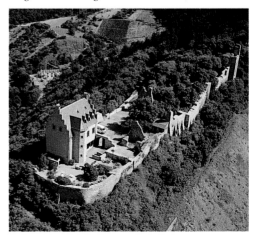

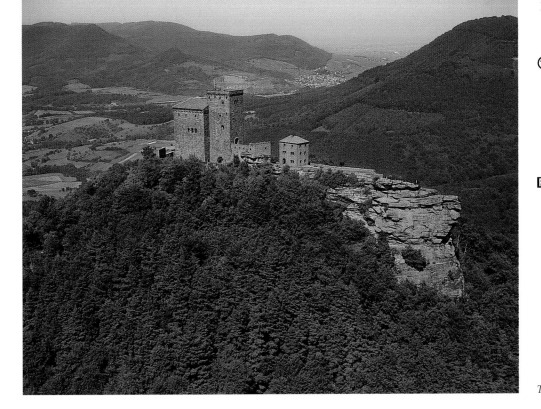

i Burgverwaltung Trifels
D-76855 Annweiler
Tel. (+49/0) 63 46/84 70

⊘ Easter week–30 September:
10 am–6 pm
1 October–30 November,
1 January–Palm Sunday:
10 am–5 pm
Admissions cease 30 mins.
before closing.
Closed during December

P at the foot of the castle hill,
approx. 20-minute walk

Trifels Castle

The Medieval and Renaissance Palatinate

Trifels Castle

In the High Middle Ages, Trifels Castle served the defence of the Imperial territories around Annweiler. In the 12th and 13th centuries the emperors and kings of Germany kept their crown jewels here. Since the right to rule the Holy Roman Empire was invested in whoever possessed these insignia, there was a medieval proverb which claimed: "If you have Trifels, you have the Empire." Trifels also gained something of a reputation for its prisoners. The English king Richard the Lionheart was incarcerated here in 1193 and, possibly, 1194 by Emperor Heinrich VI. The main tower was built during the castle's heyday around 1200. It served as a gate-tower, chapel tower and treasure vault. The sturdy, rusticated ashlars of the Hohenstauffen monarchs and the chapel oriels have survived. The Imperial treasure was kept in the beautifully vaulted Romanesque castle chapel on the upper floor. In the room above, the principal items are on display as modern replicas: the Emperor's crown, cross, orb, sceptre and sword. The originals have been in Vienna since 1800. The great hall was entirely rebuilt between 1938 and 1947.

Trifels Castle from the south

Burgen, Schlösser, Altertümer Rheinland-Pfalz

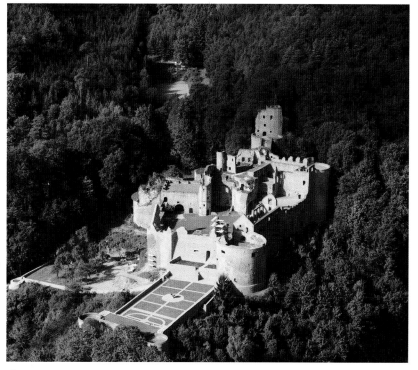

ℹ Burgverwaltung Hardenburg
D-67098 Bad Dürkheim
Tel. (+49/0) 63 22/75 30

🕙 Easter week–30 September:
10 am–1 pm, 2–6 pm
1 October–30 November,
1 January–Palm Sunday:
10 am–1 pm, 2–5 pm
Admissions cease 30 mins.
before closing.
Closed during December
and on the first working
day in each week

🅿 at the foot of the castle hill,
approx. 10-minute walk

Hardenburg Castle Ruins

The massive Hardenburg is one of the largest ruined castles in the state of Rhineland-Palatinate. It has been the seat of the Counts of Leiningen since the 13th century, although the present complex was built between 1500 and 1590. The robust fortifications indicate that the Counts of

Burgruine Hardenburg

Leiningen were contentious gentlemen. They were party to about twenty belligerent feuds with neighbours during the 15th and 16th centuries. The trouble began at the same time as the work on the castle, for which the counts had illegally appropriated land belonging to the Abbey of Limburg. Unlike other defence installations in Rhineland-Palatinate, the Hardenburg was not vacated when firearms were invented, but converted into a residential palace for the dynasty from the 16th to the early 18th century. Today the Renaissance garden and the orchard have been restored. They had been destroyed, along with the sumptuous interiors, when revolutionary French soldiers burned the Hardenburg down in 1794. The round artillery tower which protected the castle from hill attack at its weakest point is impressive even as a ruin. Its mighty walls, more than twenty feet thick, withstood even enemy cannon. Little remains of the lavish living quarters apart from stair towers, windows and elegant portals. Visitors may well wonder at the huge cellars with wide spans of ribbed vaulting built in 1509, which survived both the flames and the process of decay.

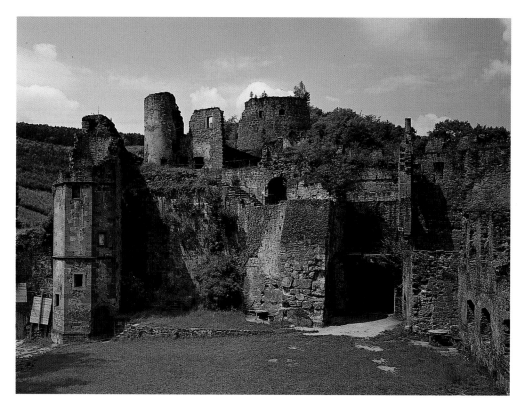

Hardenburg, the ruined courtyard

Landeck Castle Ruins

The castle of Landeck is perched proudly above the old monastery of Klingenmünster, which it was built to protect around 1200. The angular keep and sturdy mantle wall of the inner ward still contain extensive samples of the stonemason craft under the Hohenstauffen monarchs. The ring walls of the outer ward were built in the 14th and 15th centuries, when the need arose to create a defence against firearms with a lengthening range. In 1689 the French destroyed the castle during the Palatine War, and since then it has fallen into disrepair. The ruins now accommodate a restaurant.

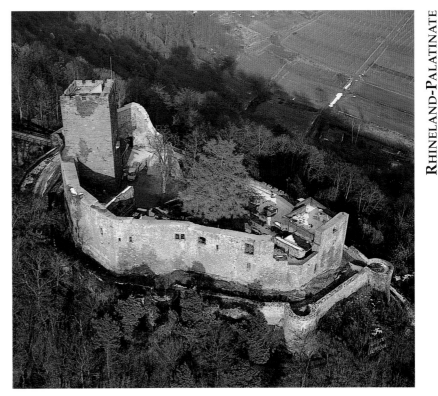

Landeck Castle

ℹ Burgruine Landeck
near Klingenmünster

Guided tours
April–October from 3 pm

✗

🅿 outside the castle ruins

Nannstein Castle Ruins

From the 12th century onwards the castle of Nannburg protected a vital trading route from Metz via Kaiserslautern to the Rhine. We owe the surviving remnants largely to the 16th century and above all to a man who made history during that period: Franz von Sickingen, Knight of the Holy Roman Empire. He built the "great rondel" in 1518. This massive artillery tower had walls almost 20 feet thick on the ground floor and a cannon-proof ceiling, state-of-the-art military technology in the 16th century. Today the ruin is still three storeys high. When Nannstein was under fire from Palatine and Hessian troops in 1523, the upper section of the fortification collapsed, fatally wounding the lord of the castle. The renowned and valiant knight died in an austere room chiselled into the rock of the higher castle.

Nannstein castle ruins

Nannstein Castle Ruins

ℹ Burgruine Nannstein
near Landstuhl
Tel. (+49/0) 63 71/1 34 60

🕐 Easter week–30 September:
9 am–6 pm
1 October–30 November,
1 January–Palm Sunday:
10 am–4 pm
Admissions cease 30 mins.
before closing.
Closed during December

✗

🅿 below the castle

The Castles of Dahn

ℹ️ Dahner Burgen
Tel. (+49/0) 63 91/36 50

🕐 Good Friday–31 October:
10 am–5 pm

✗

🅿️ below the castle, approx.
10-minute walk

The Ruined Castles of Dahn

Three castles in succession grew from a sandstone cliff of five rocks. They are impressive examples of the craggy castles scattered across the Vosges Mountains. As their dilapidation proceeded, weathered walls fused with hewn rock faces as nature and architecture blended into one. The archaeological evidence shows that Tanstein is the oldest castle. Old Dahn probably dates back to the 13th century. Grafendahn, the middle structure, is mentioned in 1287 as a recently completed fortress. The three castles crown the cliffs like eyries. In days of yore, they would have been able to withstand each other's attacks.

A reconstructed house in the complex contains an interesting museum with finds from the excavation sites. The display illustrates how many things can go astray in a castle: not only broken jugs, but numerous bowls, a corset chain, toys, a pocket sundial of ivory, many valuable silver coins and the beautifully worked silver wedding spoon for Johann Christoph von Dahn and Maria von Wallbronn.

Neudahn Castle Ruins

Neudahn Castle Ruins

Neudahn, in the forest two miles northwest of Dahn, was built around 1230 by Heinrich Mursal, descended from a collateral line of the knights of Dahn. The castle was adapted to resist gunpowder thanks to rigorous improvements in the early 16th century. Henri II of France visited in 1552, and he must surely have admired the robust battery towers which defended the approach to the lower castle and are still three impressive storeys high.

Neudahn castle ruins

Bavarian Neo-Classicism in the Palatinate

Villa Ludwigshöhe

"A villa in the Italian manner, designed only for the warmer season and in the mildest region of the kingdom" was Ludwig I's great wish, and the Bavarian king was to accomplish it with Villa Ludwigshöhe near Edenkoben. The neo-classical building draws on prototypes of Antiquity, its "Pompeii style" decoration set in a landscape reminiscent of Italy replete with vineyards and groves of sweet chestnut.

i Schlossverwaltung
Villa Ludwigshöhe
Villastrasse
D-67480 Edenkoben
Tel. (+49/0) 63 23/9 30 16

Easter week–30 September:
10 am–1 pm, 2–6 pm
1 October–30 November,
1 January–Palm Sunday:
10 am–1 pm, 2–5 pm
Admissions cease 45 mins.
before closing.
Closed during December
and on the first working
day in each week

Tour bookings:
Visitors' Centre
Tel./Fax (+49/0)
1 80/5 22 13 60

The period interiors can
only be viewed with a
guide.

P outside the villa

M Slevogt Gallery
Mainz Regional Museum
Tel. (+49/0) 61 31/2 85 70

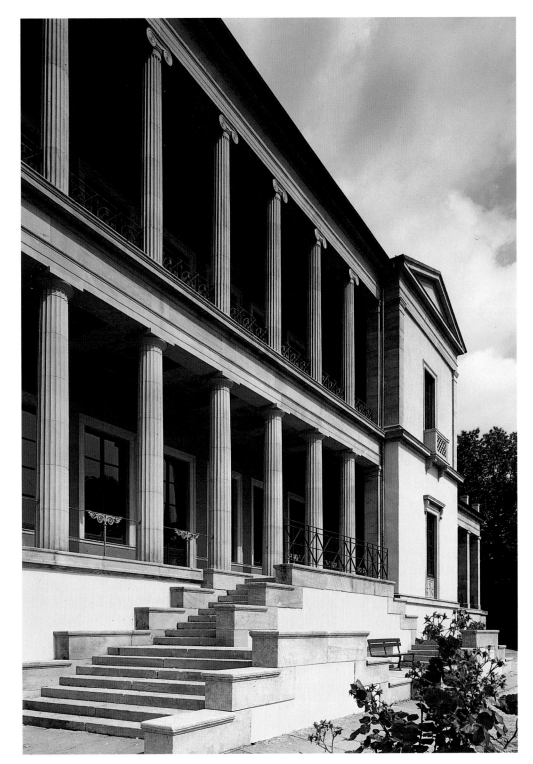

Villa Ludwigshöhe

The villa was built from 1846 to 1852 from drawings by the architect Wilhelm von Gärtner, who died a year after construction began. Then, in 1848, Ludwig I was forced to abdicate, and so the work dragged on until 1851. Finally, the king acquired his magnificent home, financed from his private wallet.

In 1975 the state of Rhineland-Palatinate acquired this unique ensemble from the Wittelsbach settlement fund, entrusting it to the care of the Administration of Public Stately Homes (now *Burgen, Schlösser, Altertümer Rheinland-Pfalz*).

Today, the rooms of Villa Ludwigshöhe also accommodate the Max Slevogt Gallery of Mainz Regional Museum. Slevogt ranked with Liebermann and Corinth among the great German Impressionists.

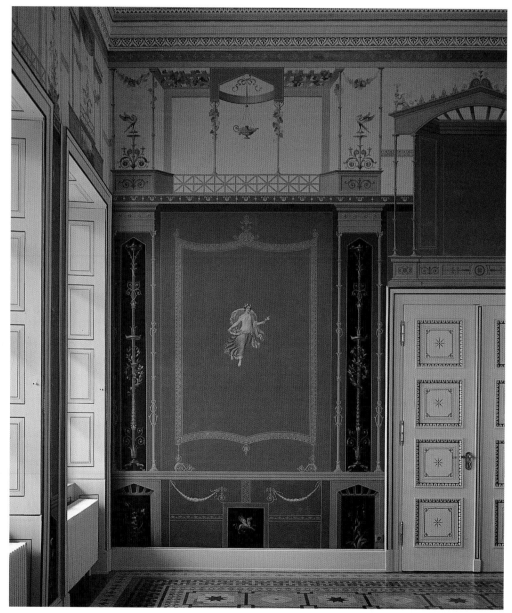

Villa Ludwigshöhe, dining room, detail

Source of Illustrations

BSA-Bilddokumentation: p. 168
Czerwinski: p. 182 top
Fa-Ro Marketing, Munich: p. 164
Michael Jordan: p. 170 top, 179 top, 179 centre
Landesamt für Denkmalpflege Rheinland-Pfalz: p. 176 top
Landesamt für Denkmalpflege Rheinland-Pfalz; Sigmar Fitting: p. 175 bottom, 176 bottom, 181 bottom

Landesamt für Denkmalpflege Rheinland-Pfalz; Heinz Straeter: p. 170 bottom, 172 bottom, 173 bottom, 174, 178 top, 182 bottom, 186
Landesmedienzentrum Rheinland-Pfalz: p. 166, 167, 169 bottom, 169 top, 171 top, 171 bottom, 172 top, 173 top, 175 top, 176 centre, 177 top, 178 bottom, 179 bottom, 180 top, 180 bottom, 181 top, 183 top, 183 bottom, 184 top, 184 bottom, 185

Saxony

SÄCHSISCHE SCHLÖSSERVERWALTUNG

ADMINISTRATION OF THE CASTLES
OF SAXONY

Sächsische Schlösserverwaltung

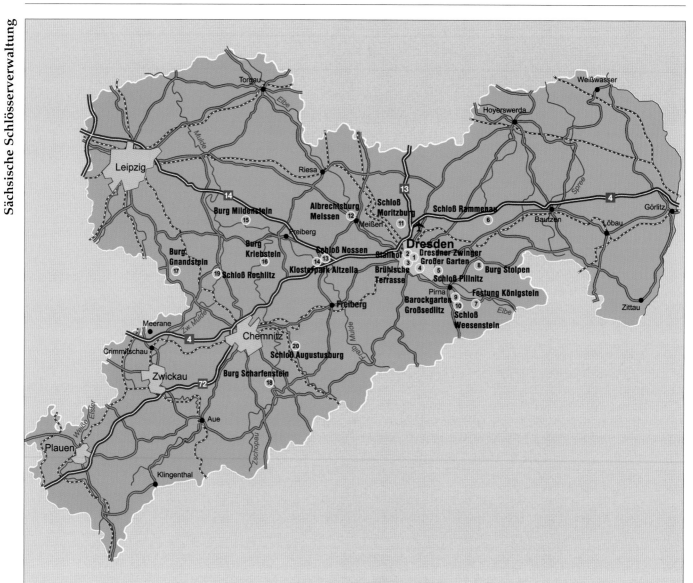

Dresden
(1) The Dresden Zwinger p. 190
(2) The Stallhof p. 191
(3) Brühl's Terrace p. 192
(4) The Grosser Garten p. 193
(5) Schloss Pillnitz and Park pp. 194–195

Rammenau
(6) Schloss Rammenau p. 196

Königstein
(7) Fort Königstein p. 197

Stolpen
(8) Stolpen Castle pp. 198–199

Heidenau
(9) Grosssedlitz Baroque Garden p. 200

Müglitztal
(10) Schloss Weesenstein p. 201

Moritzburg
(11) Schloss Moritzburg pp. 202–203

Meißen
(12) The Albrechtsburg pp. 204–205

Nossen
(13) Schloss Nossen p. 206
(14) Altzella Abbey Park p. 207

Leisnig
(15) Mildenstein Castle pp. 208–209

Kriebstein
(16) Kriebstein Castle pp. 210–211

Gnandstein
(17) Gnandstein Castle p. 212

Scharfenstein
(18) Scharfenstein Castle p. 213

Rochlitz
(19) Schloss Rochlitz pp. 214–215

Augustusburg
(20) Schloss Augustusburg pp. 216–217

◁ *Festung Königstein*

"THE MOST BEAUTIFUL MANOR-HOUSES, CASTLES AND GARDENS IN SAXONY"

The most beautiful manor houses, castles and gardens in Saxony – this slogan is the motto for the Saxonian heritage department, which wants to make the treasures of Saxony's history accessible to visitors. The Federal state of Saxony has entrusted the Saxonian heritage department with the care of around 20 of the total of 50 state-owned castle properties. These are the properties which are accessible to the general public as museum-like establishments and which – due to their importance and popularity – are well-known beyond the borders of Saxony – for example the castle "Albrechtsburg" in Meissen, the hunting lodge Moritzburg and the fortress in Königstein.

These holdings not only include former properties of the Saxonian margraves, electors and kings, but also buildings once owned by Saxonian gentry which played a very significant role in Saxony's cultural history. These include for example the manor-house "Schloss Rammenau", which is situated in the middle of a landscape of ponds and forests, the castle "Burg Kriebstein", which rises romantically above the river Zschopau, or the fortified castle "Burg Gnandstein", near Kohren.

All these historical buildings have one thing in common: in the past couple of years there have been considerable changes. The Federal state of Saxony has invested in numerous large-scale building measures and thus performed long overdue restoration work on these properties, some of which had been neglected for decades.

These investments made it possible to safeguard the buildings' substance for many years to come, and also opened up a lot of previously not accessible rooms for visitors to see. New museums and permanent exhibitions, for example, in the former official castle in Nossen and in castle "Burg Scharfenstein" provide attractive highlights and add to the museums which Saxony has to offer.

Every year the possibilities for making cautious use of historical sites are extended by the consistent continuation of building work.

The Federal state of Saxony already created the basis for making optimum economic use of the manor-houses, castles and gardens in 1993, when these 20 selected sites were established as state-run enterprises, allowing the local heritage agencies to operate independently and made it possible for them to reinvest their takings into the castle or site in question.

The diversity of the existing premises is of great benefit for the strategy of the heritage department, which is oriented towards earning a profit. Every year there are around 2 million visitors, but these are no longer just visitors of museums – events and guided tours specialising in making the visit an experience to remember as well as private functions in attractive surroundings are very popular with visitors. Of course, the historic and precious rooms and collection do set limits to these activities. After all, the main task of the Saxonian heritage department is to pass the gems it has been entrusted with on to future generations, so that they may also experience Saxonian art and cultural history and thus learn about the cultural development which took place over many centuries.

The approx. 250 employees of the heritage department working on site ensure that the properties are maintained in a professional manner, but also pass on their knowledge about these historico-cultural treasures to interested visitors.

The head office of the Saxonian heritage department located in Dresden provides specialised support for museum-related and garden-historical issues, but also with regard to marketing, legal and commercial aspects. It is also responsible for the administration of further buildings which played an important role in Saxony's history, but are not managed as "state-run" castle properties. However these are also very popular with visitors and are therefore mentioned here.

The Saxonian heritage department would now like to invite you to discover Saxony's thousand-year-long past.

Welcome to Saxony's most beautiful manor-houses, castles and gardens.

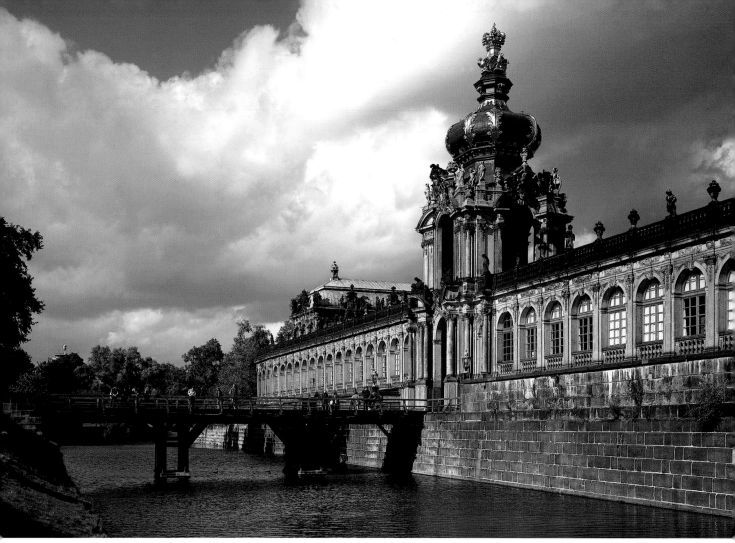

Long Gallery with Crown Gate

The Dresden Zwinger – Poetry in Sandstone

i Staatliche Schlösser und
Gärten Dresden
(Office: Brühlsche Terrasse/
Zwinger/Stallhof)

Zwinger/Theaterplatz
D-01067 Dresden
Tel. (+49/0) 3 51/4 91 46 01
Fax (+49/0) 3 51/4 91 46 25

🕐 Courtyard 6 am–11 pm

✕ – **P** – **DB**

🚌

⛴

♿

M Informations on museums
and collections
Tel. (+49/0) 3 51/4 91 46 19

The architect Matthäus Daniel Pöppelmann and the sculptor Balthasar Permoser created for August the Strong, Elector of Saxony, a world-famous work of art and masterpiece of Baroque architecture – the Dresden Zwinger, originally a wooden construction built as a festival ground for courtly society. In 1709 Pöppelmann was commissioned to build an orangery on the site of the city ramparts. However, in the absence of a suitable "playground" to celebrate the marriage of his eldest son, August the Strong decided that the original trio of orangery buildings should be repeated on the side facing the town. From then on the Zwinger was to serve as a venue for grand court festivals and games. After the darkest day in Dresden's history, in February 1945, the Zwinger seemed lost. But the painstaking work of restoration was boldly tackled, and with the help of photographs was an outstanding success. Enter the complex through the Crown Gate, the distinctive silhouette of which

has made it one of Dresden's foremost landmarks. Walk down to the secluded Nymphs' Pool or inspect the carillon with its 40 bells of Meissen china. The Porcelain Pavilion contains one of the world's leading and most extensive collections, while the Mathematical and Physical Salon houses an exhibition of one of the earliest world-ranking natural science and technical collections. The original Zwinger was open on the side facing the River Elbe. The gap was closed by Gottfried Semper's art gallery, which now houses the world-famous Old Masters collection. One of the finest art collections anywhere, it includes, among others, works by Dürer, Holbein, Cranach, Raphael and Titian. The armoury in the second wing of the Semper Gallery, with its collection of valuable suits of armour, weaponry and firearms, is also worth a visit. Among the best-known of its 15,000 exhibits are the sword of Elector Friedrich the Valiant and the coronation regalia of August the Strong.

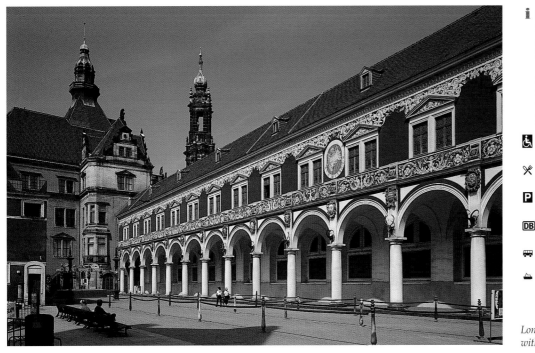

ℹ Staatliche Schlösser und
Gärten Dresden
(Office: Brühlsche Terrasse/
Zwinger/Stallhof)

Zwinger/Theaterplatz
D-01067 Dresden
Tel. (+49/0) 3 51/4 91 46 01
Fax (+49/0) 3 51/4 91 46 25

*Long Walk
with Tuscan columns*

The Stallhof – Where Horse and Rider Felt at Home

Though it is slightly in the shadow of famous Dresden buildings such as the Zwinger, the Semper Opera House, the electoral princes' palace and the Hofkirche, the Stables of the Electoral Knights, with the Stallhof (Stable Yard) and the "Long Walk" arcade adjoining part of the palace, is one of the most interesting buildings of the Renaissance era. The knightly sports and tournaments staged amidst these splendid surroundings once attracted onlookers from Saxony and all over Europe. Allow the unique spatial effect of the Stallhof to exercise its magic on you, admire the Renaissance architecture with its Tuscan-style round-arched arcade, trophies and coats of arms. Two well-preserved bronze pillars used in jousting tournaments are a special treasure. The overhead sundial will serve as a reminder that you need a little more time to see the famous Fürstenzug (Princes' Procession) on the outside of the Stallhof arcade. The 102-metre-long Fürstenzug was painted in the late 19th century in sgraffito technique, which at that time was so popular that various outside walls of the palace and other buildings were similarly adorned. However, the original painting did not stand the test of time. In 1907 the Fürstenzug was trans-ferred to Meissen china tiles, the form in which it can be seen today. In 1978/79 the tiles, many of which had been damaged, cracked or blackened in World War II, were thoroughly cleaned and restored. Of 25,000 tiles, only 212 had to be completely and 442 partially renewed. And so today you can take aesthetic delight in discovering a piece of illustrated Saxon history.

Princes' Procession (detail)

Sächsische Schlösserverwaltung

ℹ Staatliche Schlösser und
Gärten Dresden
(Office: Brühlsche Terrasse/
Zwinger/Stallhof)

Zwinger/Theaterplatz
D-01067 Dresden
Tel. (+49/0) 3 51/4 91 46 01
Fax (+49/0) 3 51/4 91 46 25

Fortress Museum
Dresden/Casemates
(entrance Georg-Treu-Platz)

🕐 April–October
daily 10 am–5 pm
November–March
daily 10 am–4 pm
Guided tours every hour
on the hour
1 Januay 1–4 pm
24, 31 December closed
booking of guided tours
Tel. (+49/0) 3 51/4 91 47 86

The Brick Gate, Dresden's oldest remaining town gate

Brühl's Terrace and the Casemates – Europe's Balcony

Originally built by Count Brühl for private recreation at a cost of 20,000 talers, the Brühlsche Terrasse, a stately riverside promenade, was opened to the public as long ago as 1814, immediately acquiring the nickname "Europe's Balcony." Directly beneath it lie parts of Dresden's Renaissance fortifications. Originally, they formed a stalwart ring of walls surrounded by a wide moat. Small and large bastions gave the fortress extra security. The openings were sealed by wooden town gates by which one could pass through the ramparts. Inside the fortress weapons were stored, and from the top of the ram-parts and from the bastions enemies could be fought with heavy artillery and hand-held firearms. A visit to the subterranean complex holds surprising effects in store – just allow yourself to be taken back into Dresden's history. Down there you will find the 400-year-old Brick Gate and guard-rooms, the last remaining town gate of the former royal seat of the electors and kings of Saxony. The remains of the old town bridge and the small bastion are equally impressive. Explore the large and small gun courtyards, the embrasures, battlement walkways and the famous casemates. Winding corridors and gloomy vaults lead into a unique subterranean world. In 1707 Johann Friedrich Böttger was brought to the Jungfernbastion (Virgin's Bastion), where he worked on the formula for European porcelain. Here was his "smelting kitchen" for the manufacture of the "white gold." Later the casemates served a less exciting, though no less important, purpose as stores for food and drink. Among the fascinating sights of the old fortifications are the guard-rooms with their "casemate telephones" and archaeological finds such as coats-of-arms, bullets and fragments of earthenware and glass.

Brühl's Terrace in morning mood

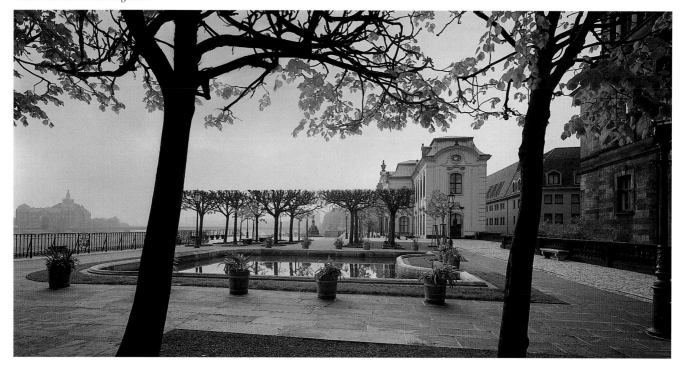

Dresden's Grosser Garten – Courtly Recreation Ground and Park Railway

Saxon Elector Johann Georg III's decision in 1676 to establish a royal park some way outside his capital certainly displayed an appreciation of nature and sense of style. Originally designed in the Renaissance manner, over the centuries several landscape gardeners made their marks on the park. As a result, today you will find alongside an English-style landscaped park a Baroque pleasure-garden in the French style, in the centre of which stands the Palais im Grossen Garten, the first example of Saxon Baroque architecture.

"Palais im Grossen Garten" with the palace lake

Mosaic fountain

discoveries in store for visitors all year round. If you visit the Grosser Garten between April and October, a further treat awaits you, in the shape of Dresden schoolchildren dressed and equipped as staff of the Dresden Park Railway, who will take good care of your comfort and safety during the 5.6-kilometre ride: past the new "fully transparent manufacturing plant" of VW AG. There visitors can witness the final assembly of the new "luxury cars" – and the glass tower adds a modern town-planning touch to the old baroque town on the river Elbe.

i Staatliche Schlösser und
Gärten Dresden
Office:
Großer Garten
Kavaliershaus G
Hauptallee 5
D-01219 Dresden
Tel. (+49/0) 3 51/4 45 66 00
Fax (+49/0) 3 51/4 45 67 22

Park Railway
🕐 For current timetable please phone
Tel. (+49/0) 3 51/4 45 67 95

♿

✖

P

DB

🚌

This impressive building, in whose spacious interior the Semper Opera's gigantic decorative curtain was made, is currently undergoing restoration. Soon it can be seen again in all the magnificence and splendour of days gone by. Take a walk beneath ancient trees, ask for the programme of the Grosser Garten Open Air Theatre, the Baroque Park Theatre or the Sonnenhäusl Puppet Theatre. Enjoy a boating party on the Carola lake or find out for yourself why Dresden Zoo is so popular with young and old. The Botanical Garden has a wide variety of amazing

Park Railway – run by Dresden schoolchildren

Sächsische Schlösserverwaltung

ℹ Staatliche Schlösser und
Gärten Dresden (Office:
Schloss und Park Pillnitz)

Schloss Pillnitz
D-01326 Dresden
Tel. (+49/0) 3 51/2 61 32 60
Fax (+49/0) 3 51/2 61 32 61

🕐 The park is open from 5 am
to dusk
Guided tours at Easter
April Sa, Su, from May to
October daily at 11 am,
12 noon, 1 and 2 pm and
by arrangement

Information Centre in
the Old Guard House
May–October 9 am–6 pm
Nov.–April 10 am–4 pm
25/26 December 11 am–3 pm
24/31 December cloused

🕐 The House of Camellia is
open when the camellias
are in blossom at the end of
February to the mid–April
Mo–Fr 10 am–4 pm
Sa, Su 10 am–5 pm

♿

Ⅿ The Art Collections are
open from May to October

✕ – 🅿 – DB – 🚌 – ⛴

*View of the waterside palace
from the Elbe*

Schloss Pillnitz and its Park – Light-Hearted Splendour and Exotic Plants

From the royal palace in Dresden, the Saxon court used to travel by magnificent gondolas up the Elbe to Pillnitz. When you see the superb open staircase leading up to the waterside palace, you will be able to feel for yourself the splendid display and joie-de-vivre that prevailed in the "summer palace for park and aquatic festivities." August the Strong began redesigning the Pillnitz palace site in 1720, and commissioned the buildings from his architect Matthäus Daniel Pöppelmann. It took more than a century to complete the complex you see today. The extensive park, which now covers an area of 28 hectares, was repeatedly altered. Originally a place of enjoyment and recreation for the Saxon court and its guests, by the end of the 18th century the Wettin princes, who were interested in botany, had already turned it into a centre of plant cultivation and research. As a result the uniquely harmonious architectural ensemble of waterside palace (a superb Chinese-style building with a sweeping staircase leading down to the Elbe), new palace and hillside palace was complemented by a spacious orangery, an English and a Chinese pavilion. The visitor will find a large number of botanical rarities, foremost among them some very rare trees. In this connection, mention should be made of a special attraction, a camellia which is over 250 years old, the only surviving specimen of four which were brought to Europe from Japan in the late 18th century. The Japanese camellia is approximately nine metres tall and the diameter of its crown is 12 metres. To ensure that it continues to bear up to 35,000 blossoms each year, a specially-designed glasshouse on rails is placed around it at the start of the cold season. The palace was also touched by world history. In 1791, at the invitation of the Elector of Saxony, the monarchs of Austria and Prussia met here with representatives of the French aristocracy and issued the Declaration of Pillnitz. That was the basis of Napoleon's famous exclamation on his visit to Pillnitz: "I was born here!" Concerts and festivals in the park round off these delightful surroundings with culture and entertainment.

Hillside palace ▷

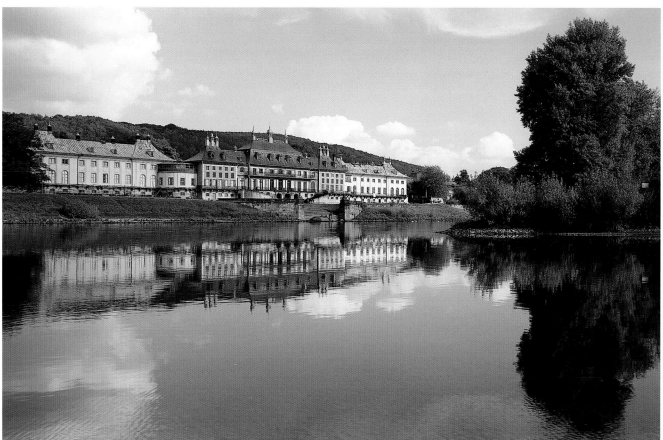

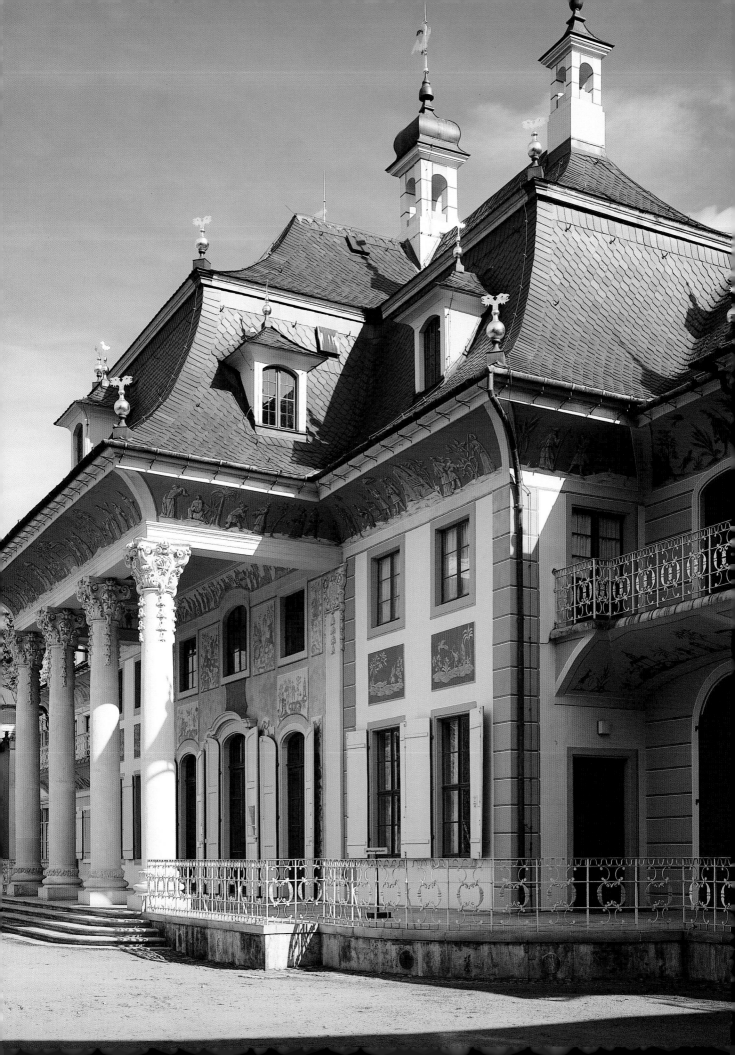

Sächsische Schlösserverwaltung

Barockschloss Rammenau
Am Schloss 4
D-08177 Rammenau
Tel. (+49/0) 35 94/70 35 59
Fax (+49/0) 35 94/70 59 83

Summer: open daily
10 am–6 pm
Winter: open daily
Su–Fr 10 am–4 pm
Su 12 noon–4 pm
Closed on 24 December

*Linen wall-hangings
in the Chinese Room*

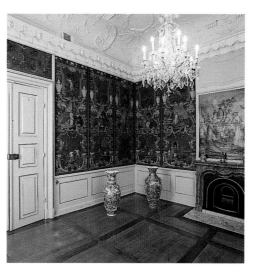

Schloss Rammenau – Saxony's Finest Baroque Country Palace and Park

When a person is said to have charm, it means more than just beauty. It means that everything about that person has a pleasing harmony. Can the same be true of buildings and gardens? Yes, it can. Saxony's finest preserved Baroque country palace and park are the proof. Nowadays, this charm is probably described as a perfect ambience. Rammenau, where the famous philosopher of the Enlightenment Johann Gottlieb Fichte was born, where the only Fichte Museum in the German-speaking countries can be found, is a superb backdrop for functions and festivities, for cultural and scientific events. Schloss Rammenau is a jewel in every respect. The valuable wall-hangings and wall-paintings, the artistic illusionism of the Classical architecture in the stairwell, the Hall of Mirrors – the palace's pride and joy, reaching right up to the gable – will transport you into the world of sumptuous festivities. This perfection in interior architecture is continued, though not in such opulent style, in the other rooms of the palace. In the Chinese Room, the Golden Room, the Blue Drawing-Room, the Hunting Room, the Bulgarian Room and the Devil's Room, decorated with painted figures of erotic demons in vermilion, orange and black, now open again to the general public. However, this palace was not only used for fine balls and galas. The fine arts have always had a home here, too. Chamber music and poetry readings are the highlights in today's wide-ranging cultural programme.

Or would you prefer to take part in one of the popular park events? Incidentally, the culinary virtues of the palace restaurant are extolled far and wide.

The palace seen from the park

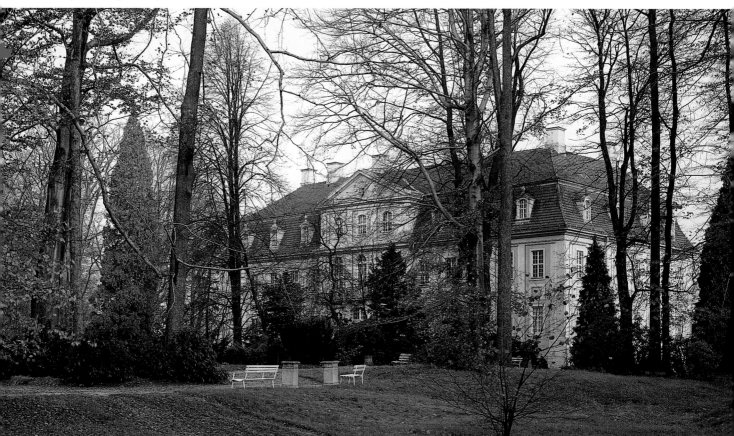

Festung Königstein – Hilltop Fortress in Saxon Switzerland

This mighty and magnificent fortress towering high over the countryside of Saxon Switzerland bears testimony to both glorious and hard times. Incidentally, the German socialist August Bebel and the Russian anarchist Mikhail Bakunin were both imprisoned here... But to start at the beginning: more than 750 years old and only once captured – and that was during the Dohna Feud back in the early 15th century! At the time, the castle changed from Bohemian to Saxon ownership. The new owners were the house of Wettin. In the late 16th century the Wettin princes began to extend Königstein into a fortress. From that time on, Königstein fortress was always kept militarily up to date. In other words, it was untakable, which enabled the Saxon rulers to seek refuge here in troubled times – accompanied by their artistic and state treasures. They also came here to celebrate. Königstein became a favourite destination for court outings. The Russian Tsar Peter the Great, King Friedrich Wilhelm I of Prussia, Friedrich the Great of Prussia and Napoleon were all here. In addition to Saxon hospitality they enjoyed the picturesque scenery of the Elbsandsteingebirge with its sandstone cliffs. Nowadays, Königstein is a particular attraction for those interested in military history. That having been said, it also enthrals thousands of nature-lovers and walkers, not to mention lovers and connoisseurs of art and architectural history. Covering an area of 9.5 hectares, surrounded by a 2.2 kilometre wall built on rock walls up to 40 metres

high, the fortress offers you a unique ensemble of buildings from the Romanesque period into the nineteenth century. Admire the architectural details, and don't forget to take a look down Saxony's deepest well, which reaches a depth of 152.5 metres. If you wish, you can travel to Königstein by river, on an Elbe steamboat of the Saxon Steamship Company. Bring a little time along with you to take a look in peace at the interesting exhibitions in the old and new armouries, the Georgenburg, the well-house, the supplies store and the gatehouse.

The Commander's Stables (Exhibition of Interiors)

A view of the fortress amidst the delightful scenery of Saxon Switzerland

i Festung Königstein
Postfach 02/06
D-01824 Königstein
Tel. (+49/0) 3 50 21/6 46 07
Fax (+49/0) 3 50 21/6 46 09
www.festung-koenigstein.de
e-Mail: festung-koenigstein@t-online.de

🕐 Apr–Sept 9 am–8 pm
October 9 am–6 pm
Nov–Mar 9 am–5 pm
Closed on 24 December

♿ – ✘ – **P**

🅢 approx. 30–45-minute walk

🚌 – ⛴

Sächsische Schlösserverwaltung

ℹ Burg Stolpen
Schlossstrasse 10
D-01833 Stolpen
Tel. (+49/0) 3 59 73 / 2 34 10
Fax (+49/0) 3 59 73 / 2 34 19
www.burg-stolpen.de

🕐 Summer 9 am–5 pm
Winter 10 am–4 pm
Winter viewing subject to
weather
Closed on 24 December

♿
✕
🅿
🚌

Stolpen Castle – Medieval Flair and the Fate of a Mistress

Stolpen, the castle custodian sometimes says with a sigh, is much more than just Countess Cosel. He points out that of the castle's 800-year history, only 49 were spent here by the renowned Countess Cosel, renowned mistress of the renowned August the Strong, Elector of Saxony and King of Poland – and that by force! August seems not to have had bad taste, for this is how contemporaries described his beloved: "a longish face, a well-shaped nose, a small mouth, big black, flashing eyes that noticed everything, all her features were delicate, her smile enchanting, her figure could be regarded as a masterpiece." Countess Cosel possessed remarkable beauty and intelligence, but when she began to interfere in the affairs of state, she was imprisoned in Stolpen. Her imprisonment lasted from 1716 to 1765, thus 49 years, until she died in the castle at the age of 84. She rests there to this day. A permanent exhibition preserves her memory for posterity. The medieval feel of a castle is particularly alive in Stolpen. Anyone who knows how hard it is to work in basalt is intrigued by the fact that most of the remaining castle buildings are made of this rock. The castle of the bishops of Meissen and electoral princes of Saxony towers over the surrounding countryside, visible from far and wide. The Middle Ages are often depicted in a mysterious and cruel way. Many ideas of medieval torture and imprisonment in dungeons live on. In Stolpen you will find them confirmed. Burg Stolpen played a role in many Saxon wars. During the Thirty Years' War, the castle was besieged by both Hussites and imperial Croatian forces. Extended and fortified, Stolpen was used as a garrison and during the Northern War had to hold out against the Swedish army. During the

A winter sunset over the castle

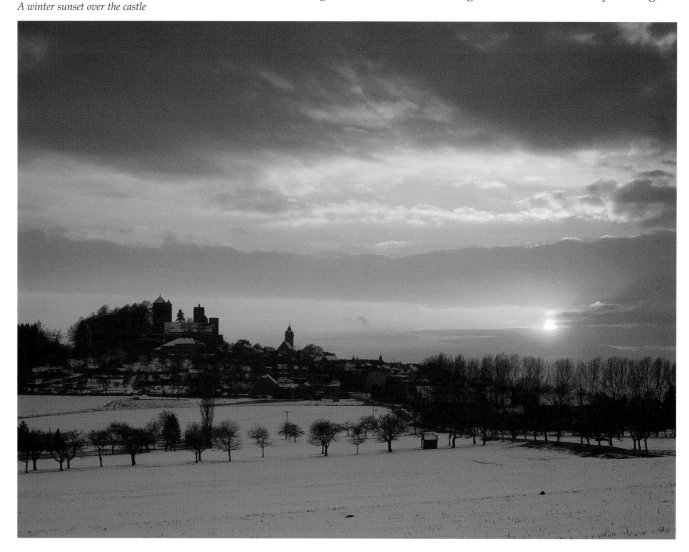

Anna Constantia, Countess Cosel, 1715

Silesian wars and the Seven Years' War, the Prussians were here. Napoleon's troops were largely responsible for the castle's partial ruin. But the parts which have remained intact make Stolpen one of Saxony's most interesting castle complexes, and well worth a visit. They include four castle courtyards, ramparts, a granary and main guard-room, the royal stables, a torture chamber, the marksmen's tower, the Johannis (Cosel) tower with its courtroom, dungeon and oubliette, not forgetting the three rooms used by the countess and her guard, a herbal kitchen in the Siebenspitzen (seven-pointed) tower with its unique viewing platform, and a basement labyrinth. And to the delight of all children, a ghost still haunts the castle.

A bird's-eye view of the castle and town

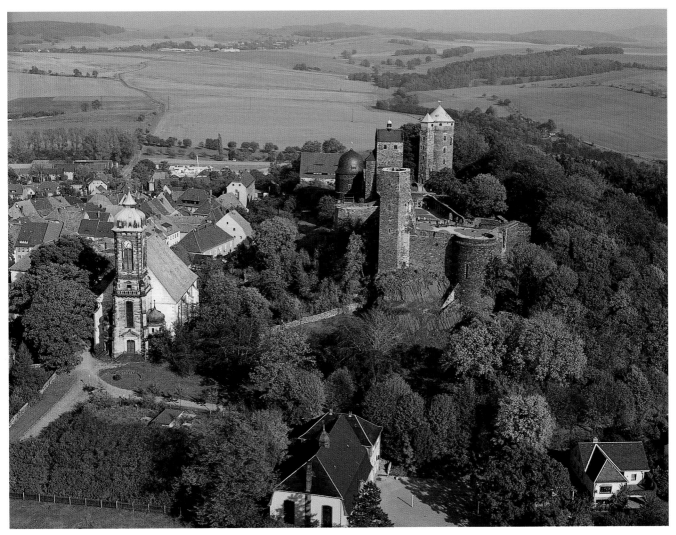

Sächsische Schlösserverwaltung

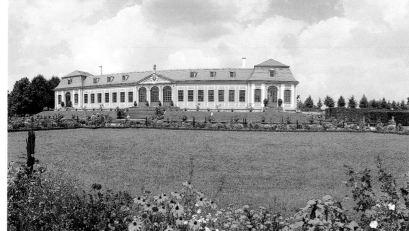

Friedrichschlösschen and Upper Orangery

ℹ Barockgarten Grosssedlitz
Parkstrasse 85
D-01809 Heidenau
Tel. (+49/0) 3529/56390
Fax (+49/0) 3529/563999

🕐 April–September
daily 7 am–8 pm
October–March
daily 8 am–4.30 pm

♿ – ✕ – 🅿

🚉 approx. 20-minute walk

🚌

Grosssedlitz Baroque Garden – Playing-Field of Princes and Kings

In Dresden especially, incomparable examples of the art of Baroque building have been preserved for us. This art reflects power, pomp and circumstance and the joy of living.

As do Baroque music and the gardens of the time. Even nature had to play its part in the glorification of high-ranking persons, as we see in one of the most perfectly designed gardens of the Baroque era –

the Baroque garden of Grosssedlitz. It is regarded as August the Strong's most magnificent garden. Admittedly, his money ran out from time to time and the complex was never completed. Even so it is one of the most idiosyncratic compositions in the field of German Baroque landscape gardening, with French and Italian influences clearly recognisable.

The small Friedrichschlösschen palace and the orangery blend with pleasing charm into the harmony of the garden landscape. And where once "high society" partied and promenaded, the present-day visitor will find beauty in peace and relaxation. The world of the ancient gods will capture you. Apollo and Daphne, Eros and Psyche will smile and whisper to you. Sculptures of a high degree of artistic perfection, some of them of the Permoser school, are as essential a part of the whole ensemble as the numerous ponds and the fountains. If you are seeking relaxation for mind and spirit, here it is possible to find them. How about, for example, attending a concert here on a glorious summer's day?

Across to the Lower Orangery

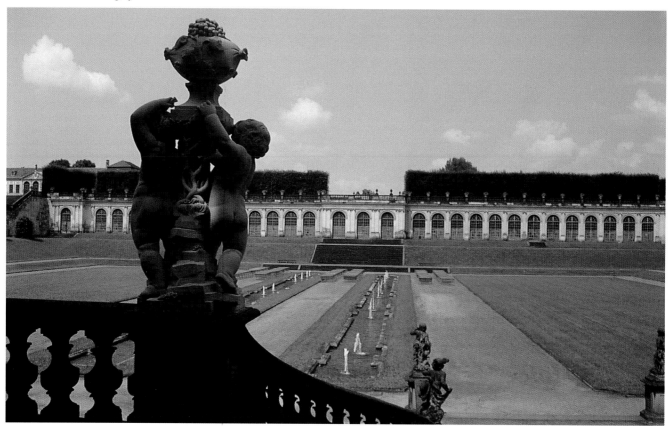

Schloss Weesenstein – A Palace of Kings

Only a stone's throw from Dresden, in one of the small side valleys whose rivers flow into the Elbe, is the sleepy town of Weesenstein. It is dominated by a mighty seat of the nobility which the centuries seem to have bypassed without a trace. Where, if not here, might one still find Sleeping Beauty? And yet the appearance is deceptive. There are very few buildings in Germany's rich landscape of palaces which can demonstrate such adaptability. Fortress, knight's castle, Renaissance palace, Baroque residence, romantic royal palace – all are linked with the same name, the name Weesenstein. Each of these transformations preserved the previous forms in its heart. A good spirit preserved the castle from ill-considered modernisation mania, which is why today buildings from 700 years still cling in a unique ensemble round the rock on which they are built. And the Weesenstein still lives. An unusual museum, with stables on the fifth floor and the Baroque ballroom two floors below, and the park will remain engraved on your memory. The palace chapel, the Knights' Hall and the theatre are still used for artistic performances. In the medieval vaults and in

Schloss Weesenstein

the royal palace kitchen, which has been restored in original style, you can enjoy what the cellars have to offer. To your health in both mind and body!

ℹ Schloss Weesenstein
Am Schlossberg 1
D-01809 Müglitztal
Tel. (+49/0) 3 50 27/54 36
Fax (+49/0) 3 50 27/55 52
www.schloss-weesenstein.de

🕤 Summer: open daily
9 am–6 pm
Winter: open daily
9 am–5 pm
Closed on 24 December

♿

✕

🅿

DB

🚌

Die Schlosskapelle

Arbeitszimmer von König Johann

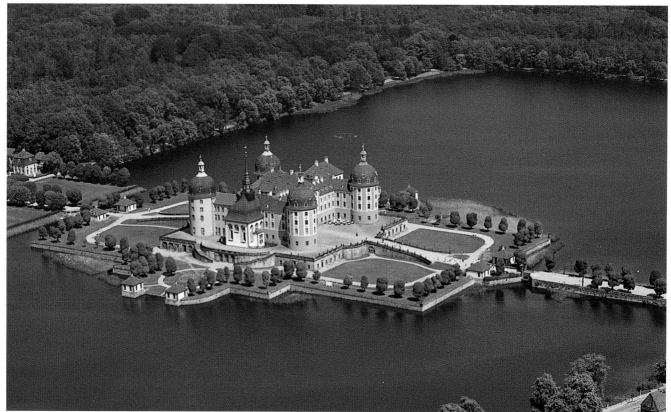

Moritzburg: the centre of a unique cultural landscape

ℹ Schloss Moritzburg
D-01468 Moritzburg
Tel. (+49/0) 3 52 07/87 30
Fax (+49/0) 3 52 07/87 311

🕑 April–October
10 am–11 pm daily
November–March
Tuesday–Sunday
Guided tours:
10, 11 am, 1, 2, 3, 4 pm
Closed on 24 and
31 December

♿

✕

🅿

DB

🚌

Schloss Moritzburg – Saxony's Most Majestic Lake Palace

The landscape exudes harmony. The exterior of Schloss Moritzburg, one of Saxony's leading Baroque buildings, is aesthetic perfection, while the interior brings the past alive in the present.

Harmoniously set amid an enchanting pond landscape, the palace building and grounds as a whole are a very special experience. It was back in the 16th century that Duke Moritz of Saxony had a royal hunting lodge – the Moritzburg – built in the Friedewald forest.

In the early 18th century August the Strong commissioned Matthäus Daniel Pöppelmann, architect of the Dresden Zwinger, to build the present-day castle surrounded by water as a hunting palace in keeping with his station. Once you have looked enough – no matter from which side – at this masterpiece of Saxon architecture, you should allow yourself to be intrigued by the palace interior. Above all, you will find precious Baroque furniture from Saxony and France, china from Meissen, Japan and China and paintings by French, Italian and German masters of the 18th century. Of unique art-historical value are the leather wall-coverings. They consist of individual pattern repeats covered with silver leaf and skilfully decorated with gold lacquer and paints. There are three types of leather wall-covering

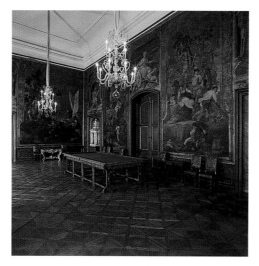

Billiard Room

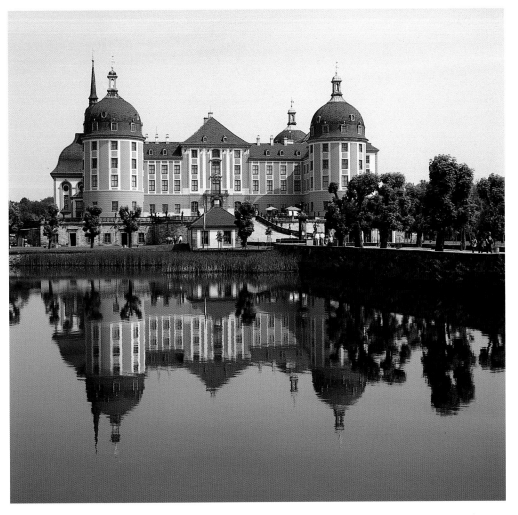

The palace in full view

here in Moritzburg: those painted with figures, making them look almost like Gobelin tapestries; those printed by woodcut before being decorated, and those patterned with an iron punch and likewise decorated with ornamentation. Schloss Moritzburg also possesses one of Europe's leading collections of antlers, including trophies of red deer, reindeer and elk. In the dining-room hangs the world's largest set of red-deer antlers, an asymmetrical 24-pointer. For those in the know, it was evaluated at 298.25 points. The castle complex is surrounded by woods, in the midst of which you will find a small, 18th-century Rococo palace, the Fasanenschlösschen. It is built in the chinoiserie style and its interior decor is enchanting. Added to which there are surprises you certainly don't expect to find here – a miniature harbour and lighthouse on the great lake, and the Dardanelles in the shape of artificial ruins, created as a backdrop for courtly festivities. Explore Schloss Moritzburg and enjoy a walk through a cultural landscape unique in Europe.

Stone Room with extensive collection of antlers

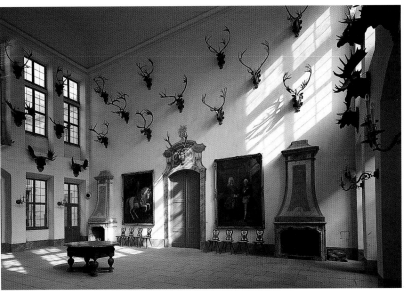

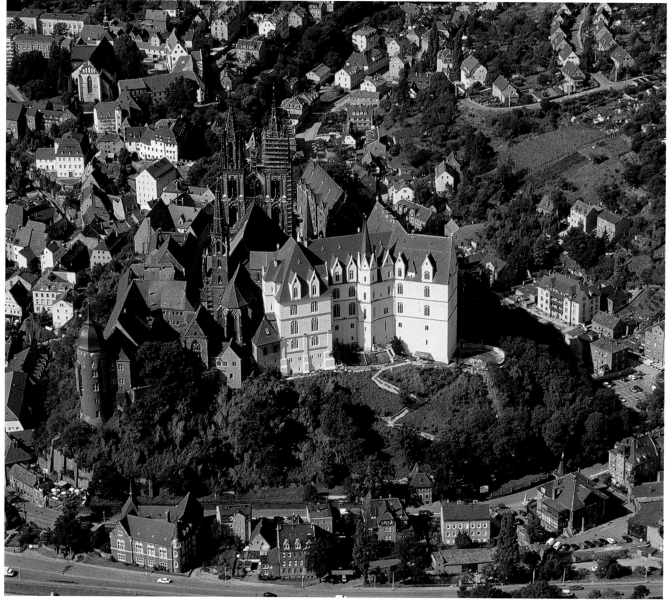

The Albrechtsburg on its castle mound in Meissen

i Albrechtsburg Meissen
Domplatz 1
D-01662 Meissen
Tel. (+49/0) 3521/47070
Fax (+49/0) 3521/470711
www.albrechtsburg-meissen.de

◷ March–October
daily 10 am–6 pm
November–February
daily 10 am–5 pm
Closed on 24, 25 and 31
December, 1, 10–31 January

♿ – ✕ – P

DB – Ⓢ – 🚌 – ⛴

The Albrechtsburg in Meissen – "Cradle of Saxony"

Inhabitants of Meissen know it is so, though many Dresdeners prefer not to believe it – outside Germany, Meissen is better-known than Dresden, the "Florence on the Elbe." The emblem of this internationally renowned "porcelain town" is the castle hill with its magnificent collection of cathedral, bishop's palace, granary and the Albrechtsburg, the first palace built in Germany, the first seat of the Wettin rulers and one of the finest Late Gothic secular buildings in Germany.

The Albrechtsburg was built on its current scale in the 15th century, when the ruling house of Wettin rose to become the most important electoral princes apart from the imperial dynasty itself. The court architect Arnold von Westfalen revolutionised the Late Gothic architecture which prevailed at the time. Completely new – and still there to be admired today – are the "curtain arched" windows, the absence of typical Gothic buttresses and the uniquely-shaped "cell vaults" which earned him the title "master of the art of arches." The Grosser Wendelstein, or Great Spiral Staircase, is a masterpiece of staircase architecture. It has yet to meet its match in terms of lightness and delicate beauty based on a daring design solution. In 1705 August the Strong had a certain Johann Friedrich Böttger imprisoned in the Albrechtsburg. Böttger had claimed he could make gold. That came to noth-

ing, but he did discover the secret of porcelain manufacture – who can say for certain whether it was here or in the Dresden casemates? What is certain is that August the Strong ordered the first Saxon porcelain factory – and thus the first ever workshop for producing European hard porcelain – to be set up in the Albrechtsburg. Since that time the castle's fame has winged its way round the world. In the late 19th century, to mark the 800th anniversary of Wettin rule, the castle was magnificently painted and decorated and furnished in the historicist style of the time. A popular attraction nowadays is the large permanent exhibition of medieval sculpture, a true delight for art-lovers and the new exhibition production "Schaff Gold Böttger!" ("Create gold Böttger"). Here modern exhibition technology is used to show how the world-famous Meissen porcelain is produced. And whether the programme is cabaret in the Fireplace Hall, authors' readings or concerts, parties, festivities or banquets, the present has found its place in this jewel among Saxony's Elbe castles and legacy of medieval German culture. A proud past in a most attractive present. You are sure to be delighted.

Courtyard facade with the Great Spiral Staircase

The Great Hall of Court

Ceiling detail

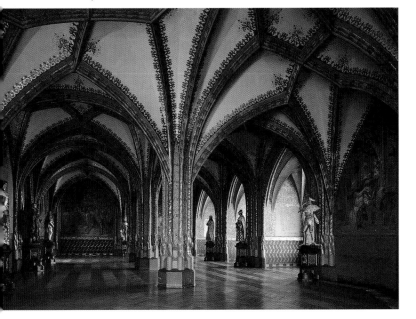

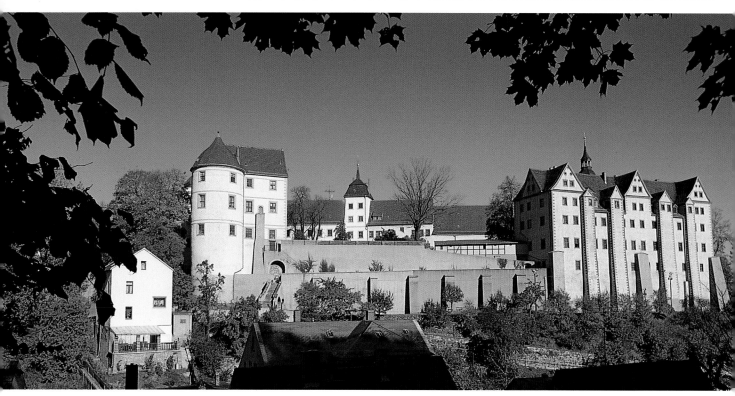

View from the south

ℹ Schloss Nossen
D-01683 Nossen
Tel. (+49/0) 3 52 42/5 04 30
Fax (+49/0) 3 52 42/5 04 33

🕐 April–October
Tu–Fr 10 am–5 pm
Sa/Su/pub. hols.
10 am–6 pm
November–March
Tu–Fr 10 am–4 pm
Sa/Su/pub. hols. 1–5 pm
Closed on 24 and
31 December
and in January

♿

✕

🅿

DB

🚌

Schloss Nossen – A Tranquil Piece of Saxony

Unlike in so many other castles and palaces, great history was not made here. What took place here was the everyday life of town and region. Even so, it left behind proud traces in the shape of the imposing castle of Nossen. The castle does not even have a "birth certificate". All we know is that the knights of Nuzzin inhabited the site until 1316, in a constant state of feud with the neighbouring monastery of Altzella. The Bishop of Meissen then became lord of the castle, after which Schloss Nossen became part of the property of the abbey of Altzella. In the wake of the Reformation, Nossen came into the possession of the prince electors. It was altered again and again until finally towards the end of the 18th century they lost interest in these "ancient walls". Though it is said that August the Strong was still often seen hunting in the surrounding woods... Nossen fell into a long slumber. Otherwise, we should report that Countess Cosel, the former mistress of August the Strong, spent a month here seriously ill in 1716 before being imprisoned in Stolpen, and that Napoleon spent a night at the castle in 1813 while his soldiers ransacked the town. The "well-known murderer, thief and robber Lips Tullian" and his band got up to their mischief in this area. He lives on as a "Robin Hood" figure in popular memory.

Now that restoration work in the castle is essentially complete, visitors can discover many interesting details about its history in the castle museum. The magnificent library of over 6,000 volumes on theology, natural sciences, government and local history will also be part of the museum. Initially, it will be open for research purposes only. Nossen – an interesting piece of Saxony.

... a prime specimen

Altzella Abbey Park – Monks, Painters and Pure Romanticism

It all began with a gift! In 1162 Emperor Friedrich Barbarossa granted the Margrave of Meissen 275 square kilometres of land, on condition that it was made cultivable. This task was passed on to the Cistercian Order, which at that time was spreading from Burgundy all across central Europe. Before long the monastery of Altzella was one of the Order's "string of pearls", and in the course of time it became one of the richest and most influential abbeys in Germany. Science, too, flourished here. Altzella had an important scientific library and from 1506 a Library Hall in which "960 works of scholarship rested on 28 desks for daily use". With the Reformation in Saxony, all that came to an end. The monastery was dissolved, the library given to Leipzig University and the buildings were turned into a "stone quarry", among other things for the castle and church in Nossen. The present romantic landscaped park was laid out in around 1800, with the ruins incorporated into the park's design. These ruins are among the oldest architectural testimony

Mausoleum

to a proud Saxon past. They still convey an impression of high-quality artistic design and accomplished use of materials. The mausoleum, one of the Wettin burial places, was built in 1804. Succumb to the enchantment of mighty beech trees, many of them up to 190 years old, of the carefully restored community building and the lapidarium (a collection of stones), or linger reverently in the Wettin mausoleum. By the way, Caspar David Friedrich, the brilliant Romantic painter, found inspiration for some of his paintings here. For if Romanticism means harmony of nature and art, here you find it to perfection.

i Klosterpark Altzella
Am Schloss 3
D-01683 Nossen
Tel. (+49/0) 3 52 42 / 5 04 30
Fax (+49/0) 3 52 42 / 5 04 33

🕐 March–September
Mo–Fr 9 am–5 pm
Sa/Su/pub. hols.
10 am–6 pm
October–November
daily 10 am–4 pm

A Romantic view of the ruins

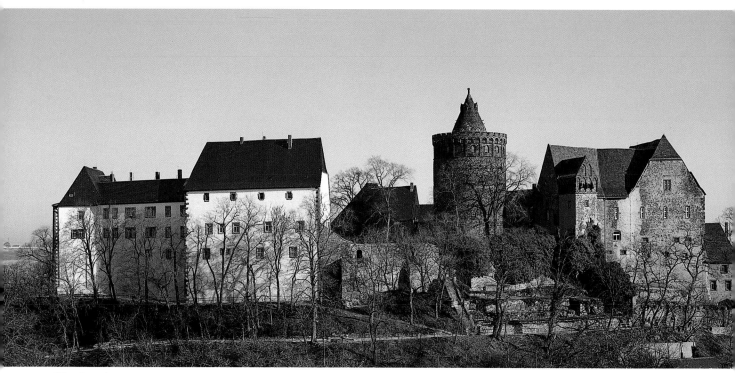

View from the east

i Burg Mildenstein
Burglehn 6
D-04703 Leisnig
Tel. (+49/0) 3 43 21 / 1 26 52
Fax (+49/0) 3 43 21 / 5 15 37

🕐 April–October
Tu–Su/pub. hols.
9 am–5 pm
November–March
Tu–Fr 9 am–4 pm
Sa/Su/pub. hols.
9 am–5 pm
Closed on 24/25,
31 December

♿

✖

P

DB

🚌

Mildenstein Castle – A Journey Back Through a Thousand Years

How does a castle get into the Guinness Book of Records? Perhaps because of its age, its size, the height of its keep? Certainly, Mildenstein Castle cuts a respectable figure on those counts, too. But frankly, there are older and bigger

castles with higher towers. So what is so fascinating about this "monument to Saxon and German history"? It is built on the top of a 60-metre high porphyry cliff close to Markt Leisnig in the heart of Saxony. In almost one thousand years of history, Burg Mildenstein was used by Salians, Hohenstauffens and Wettins to protect their territories. The first record of a castle bailiff goes back to 1046. Burg Mildenstein experienced a heyday under Wiprecht von Groitzsch, who was given the castle by Emperor Henry IV as a reward for his loyal service. All that survives from that period is the Romanesque

Courtyard and manorial residence

chapel, which complete with late Gothic sculptures is now a special treasure. One of the most interesting rooms is the grain loft. One of the largest and best preserved in Germany, its roof is a masterpiece of medieval carpentry. Nowadays, exhibitions and events are held in these surroundings full of atmosphere. However, that is not the reason for the entry in the Guinness Book of Records. That honour goes to a top boot. The castle museum contains one which, until 1997, was "the biggest top boot in the world". Its successor, just a few inches higher and once again a fine example of Saxon craftsmanship, is not yet on display. You should not miss climbing to the top of the castle keep to enjoy the view across the wonderful scenery of the Freiberger Mulde valley. Your attendance is requested at a culinary audience in the castle cellar, where you can spend hours of enjoyment, perhaps at a wine-tasting. All good reasons for discovering Burg Mildenstein, a living monument to Saxon culture!

The grain loft in the corn-house

The Top Boot

Chapel

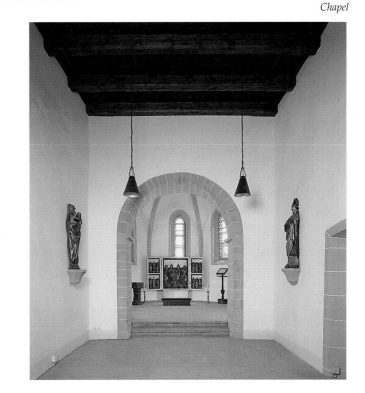

Sächsische Schlösserverwaltung

ℹ Burg Kriebstein
D-09648 Kriebstein
Tel. (+49/0) 3 43 27/95 20
Fax (+49/0) 3 43 27/9 52 22
www.burg-kriebstein.de

🕐 Middle of February–April,
October, November
Tu–Su 10 am–4 pm
May–September
Tu–Fr 9 am–5 pm
Sa/Su 10 am–6 pm
Viewing by arrangement
outside these times

♿
✖
🅿
DB
🚌

Late Gothic wall painting in the chapel

Kriebstein Castle – Saxony's most attractive Knightly Castle

What do you imagine a knightly castle to be like? It has to be Gothic, in a wildly romantic setting high above a river, stalwart and intimidating, difficult to access. The interior should convey a sense of how former generations lived – without the modern conveniences taken for granted nowadays, but in "chivalrous" style. Agreed? Then come to Burg Kriebstein! A self-contained, fully-preserved group of late Gothic buildings awaits you

- built on a steep rock face overlooking the wild Zschopau valley
- a bit off the beaten track in virtually unspoiled romantic countryside
- reached via "Saxony's steepest road"
- ideally situated in the centre of the Leipzig-Dresden-Chemnitz triangle.

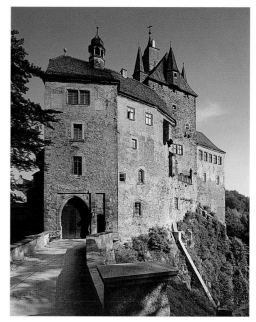

The ascent to the castle

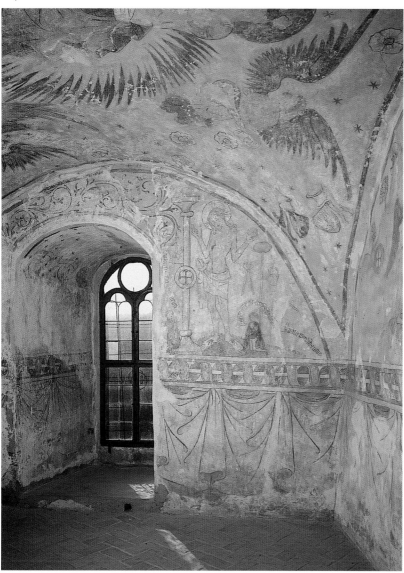

Kriebstein stands there, proud and stalwart, conveying a sense of the glory of days gone by to all who come to visit. In its heyday, the castle ruled over two towns and 33 villages. The 45-metre high late Gothic residential tower with its wonderfully preserved interior decor and astonishing arrangement of roofs still provides testimony to that era. And what does the castle's "inner life" have to offer? Among other things, a surprisingly large number of Gothic and Renaissance wall paintings in various rooms. Art historians enthuse over the paintings in the 15th-century castle chapel. You'd like to see how people used to live? Rooms furnished in styles from Gothic to 19th-century with original furniture, painted wooden ceilings, stoves, portraits and so on provide plenty of food for thought, as do the Gothic Hall, the Knights' Hall, the Hunting Room, the Treasure Vault and the 1520 Alexius Altar, a particularly rare winged altar. And after long years of absence the famous 15th-century Kriebstein Room has returned, fittings and all, to its original location. It goes without saying that you can partake of a "medieval banquet" at this castle, too. For historical flair, there is an annual festival with knightly tournaments.

View from the River Zschopau ▷

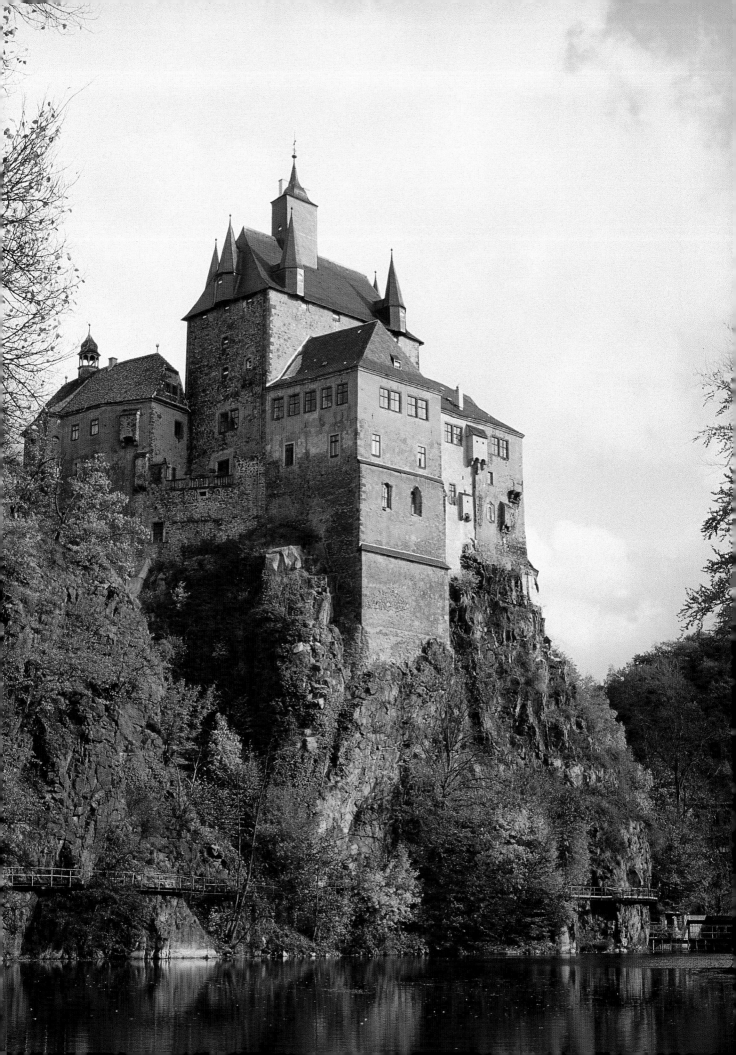

Sächsische Schlösserverwaltung

The altars in the Late Gothic chapel

i Burg Gnandstein
 D-04655 Gnandstein
 Tel. (+49/0) 3 43 44/6 13 09
 Fax (+49/0) 3 43 44/6 13 83

🕓 January
 Sa/Su 10 am–4 pm
 Feb–April Tu–Su 9 am–5 pm
 May–Oct Tu–Su 9 am–6 pm
 Nov Tu–Su 9 am–5 pm
 Dec Tu–Sa 10 am–4 pm
 Ascension, Closed on 25,
 31 Dec and 1 Jan

♿ – ✕ – 🅿 – 🚌

Gnandstein Castle – Five Hundred Years of Family Tradition

The Kohrener Land region in western Saxony is known for its fruit-tree blossom. The centre of this austerely beautiful region is Burg Gnandstein, its 800 years making it Saxony's oldest preserved castle complex. How often palaces and castles changed owners in the course of their history! In history lessons it was hard to keep up with all the names and dates – but not in the case of Burg Gnandstein. Just imagine: for more than 500 years the castle, built in the late 12th century, was in the possession of a single family. Burg Gnandstein has many special attractions to offer its numerous visitors from far and wide. The massive, 33-metre-high castle keep affords an all-round view of a landscape in which nature and the work of man still blend harmoniously together. In the late Gothic castle chapel with its star-shaped cell vaulting, art-lovers will find three winged altars. Peter Breuer played a role from 1501 to 1503 in creating the valuable wood-carvings from the Riemenschneider school. The altar to St Anne is famous for the Gnandstein panel paintings. Those who are interested in Christian art will find a surprising variety of examples. The Romanesque Knights' Hall has been preserved in excellent condition, more so than any other in Saxony. In the magnificent living quarters you can admire old furniture, valuable porcelain and awe-inspiring paintings. Then there are the superb collections of country-style furniture, pewter, weapons, and so on. There is a great deal more to tell, but why not see for yourself the culture of former centuries which has been preserved for us in this castle? Best of all, combine your visit with one of the castle fetes, concerts, special exhibitions, or the Kohren cherry-blossom festival.

Gnandstein Castle

i Burg Scharfenstein
Schlossberg 1
D-09435 Scharfenstein
Tel. (+49/0) 37 25/7 07 20
Fax (+49/0) 37 25/70 72 50
www.augustusburg-
schloss.de

🕓 April–October
Tu–Su 9 am–6 pm
November–March
Tu–Su 10 am–5 pm
Also open on Mondays
if they are public holidays
Closed on 24 December
31 December 10 am–3 pm
1 January 11 am–5 pm

Scharfenstein Castle

Scharfenstein Castle – Feel the "Longing for the Light"

People from the Erzgebirge have always had a reputation for a life-long attachment to their starkly beautiful home region and its unmistakable tradition. People all over Germany come in contact with this tradition every year in the pre-Christmas period, when the wood-carvings typical of these "Ore Mountains" – light pyramids, angels, miners, nutcracker men – make their appearance in shops, Christmas markets and homes. A son of the Erzgebirge, now living far from his native place, has systematically, lovingly and expertly collected examples of this local craftsmanship for decades. Now this unique collection has found a home in Burg Scharfenstein, which is 600 years old and experienced its heyday in the Renaissance era. The motto for this "adventure museum", the only theme centre of this kind in Saxony, is "Longing for the Light." It is intended to recall how Erzgebirge craftsmanship originally came into being, in dimly-lit living-rooms on long winter evenings. Visitors get to see traditional and modern Erzgebirge folk art, but not only as ready-made exhibits. The whole environment, the stages of manufacture, the tools, etc., can all be explored. You can pick up a lot – quite literally. For the special thing about this museum is that many exhibits can be touched, moved, felt, leaving you with the feeling of having "picked up" an essential part of the tradition of Germany's most compact cultural landscape. It goes without saying that in Scharfenstein you can buy Erzgebirge figures, enjoy the exhibitions on castle history and the legendary figure of Karl Stülpner, visit the keep, the cistern and also interesting temporary exhibitions shown here in this "adventure castle".

*From the exhibition
"Longing for the Light"*

Sächsische Schlösserverwaltung

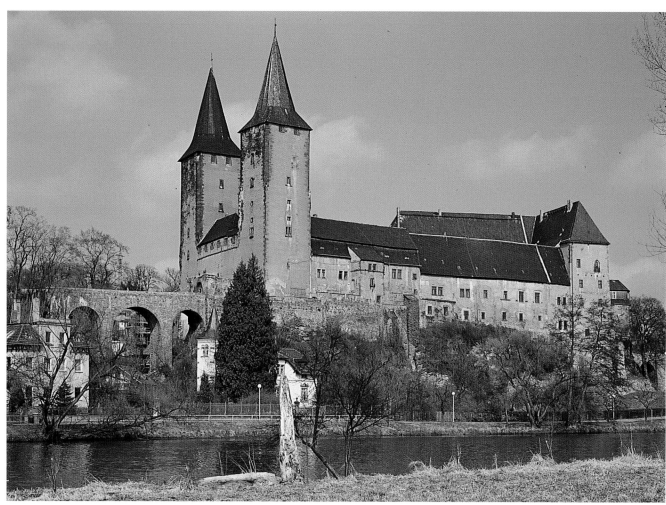

The view from the banks of the Zwickauer Mulde

ℹ Schloss Rochlitz
Sörnziger Weg 1
D-09306 Rochlitz
Tel. (+49/0) 37 37/49 23 10
Fax (+49/0) 37 37/49 23 12

🕐 January–December
Tu–Su 10 am–5 pm
Admissions cease one lour
before closing
Closed on 24/31 December

♿

✗

🅿

DB

🚌

Facing page:

*The Late Gothic chapel
The Choristers' Balcony with
(left) the Duke's Balcony and
(right) the pulpit*

The court's great kitchen (14th c.)

Schloss Rochlitz – Former Seat of Emperors, Kings and Electoral Princes

This proud, prestigious castle has towered high above the Mulde valley since AD 995. You will find Schloss Rochlitz stalwart and impregnable, dainty and playful, full of nuances and architectural surprises. Its history is linked with distinguished names of German emperors and kings and Saxon electoral princes. The 14th-century castle kitchen will give you a vivid impression of life in a late medieval

castle, and the storage vaults and wine cellars will show you how people in the Middle Ages went about enjoying themselves. The other rooms of the castle, too, still convey an impression of what the castle looked like when the high nobility resided here. Be impressed by the mighty architectural ensemble around the castle courtyard, stroll through the extensive rooms of the delightful castle museum. Find out why the castle's two distinctive towers are called "Jupen" (skirts). Enjoy fun and games, art and culture at one of the interesting cultural events, parties, lectures or concerts, for which Schloss Rochlitz provides a worthy backdrop with a charm all of its own. And if you are a castle fan, ask about the many other castles in central Saxony, the "Saxon Castle and Heath Country".

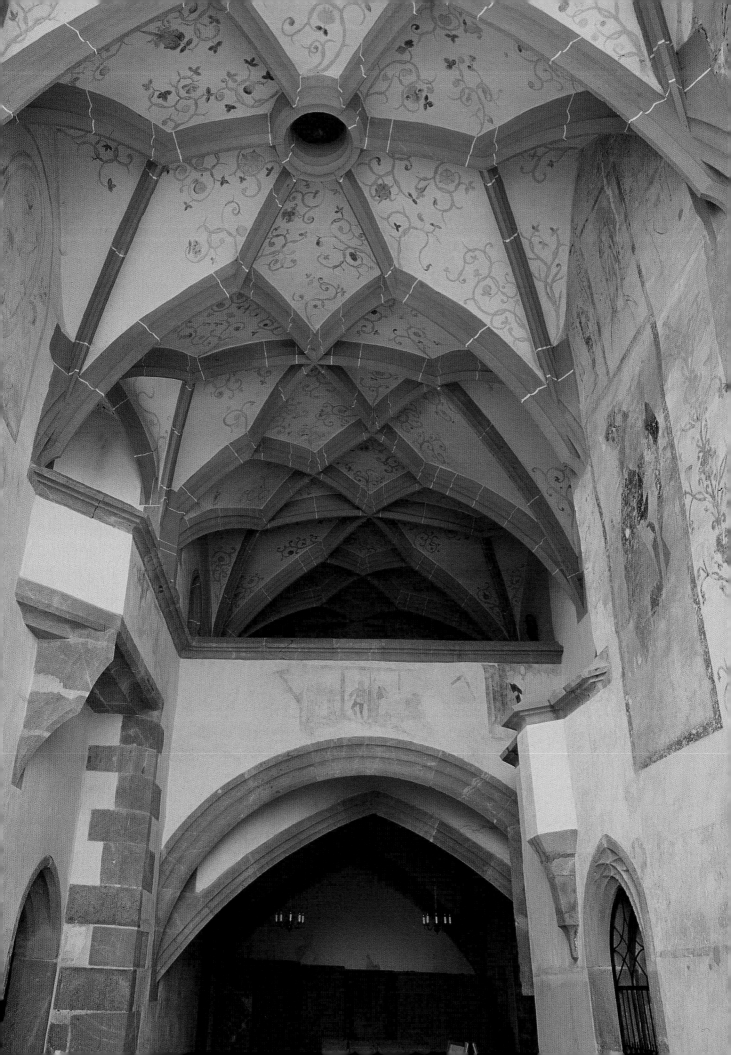

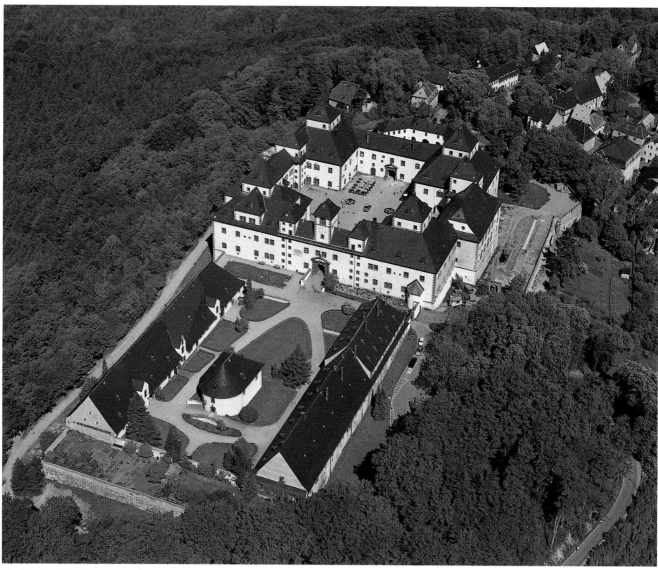

The imposing Renaissance complex

i Schloss Augustusburg
D-09573 Augustusburg
Tel. (+49/0) 3 72 91/38 00
Fax (+49/0) 3 72 91/20591
www.augustusburg-
schloss.de

⊘ April–October
daily 9 am–6 pm
November–March
daily 10 am–5 pm
Over Christmas and
New Year:
Closed on 24 and
25 December
1 January 11 am–5 pm

♿
✕
🅿
🆔
🚎

Schloss Augustusburg –
A Mecca for Motor Cycle and Horse-Drawn Carriage Fans

One of Germany's foremost Renaissance palaces awaits you. Visible from afar, the monumental scale and architectural beauty of the "Crown of the Erzgebirge" will capture your attention.

Elector August (1526–1586) built the Augustusburg as a hunting and summer palace more than 400 years ago. Building works were completed in just four years. Step inside and you will be amazed. Still now the palace exudes the power and pomp of its owners and the interior is unique of its kind. The palace church is one of the few German Renaissance churches to survive the Reformation. An altarpiece by Lucas Cranach the Younger dominates the magnificent, carved wood altar. On show in the carriage museum are around 20 horse-drawn carriages and sledges spanning the past 300 years. In fitting surroundings, you will find everything from a coach of state from the former royal stables in Dresden to 19th- and 20th-century town and society carriages. The motor cycle museum holds one of Europe's leading and highest-quality collections of motor cycles. Since 1961 around 170 machines have documented the 100-year-plus history of motorised cycles. Here you will find numerous rare specimens, supreme engineering achievements and many original vehicles unduplicated elsewhere. The museum of game animals and ornitholo-

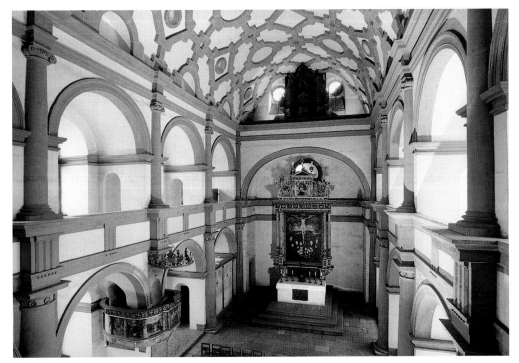

Palace chapel

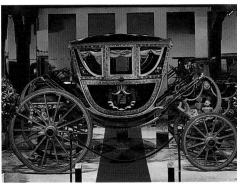

State coach

Illusionistic painting in the Hares' Hall

gy will introduce you to the Erzgebirge fauna and flora. Forty-eight dioramas show more than 120 animals of the region. A paradise for nature-lovers, and not just for children. We hope you have brought enough time along. For there is still the viewing tower – from where else does one have such a splendid long-distance view across the Erzgebirge? Then there is the eagle and falcon court with exciting flight demonstrations, the dissection workshop, the guided tours of the castle, not forgetting the special guided tour "Secrets behind closed doors" for fans of art and architectural history. All await you – on this visit or the next.

Manor-house "Schloss Lichtenwalde" near Chemnitz

After a big fire the former baroque manor-house above the Zschopau valley was rebuilt in neo-baroque forms in 1905. The building has three wings; the outstanding feature of the property is the large baroque garden, which covers approx. 25 acres and is regarded to be one of the most beautiful gardens in Saxony. Restored parts of the manor-house, which was vacated in 1995, have been open to the public since September 1999. There are cultural events such as exhibitions and concerts as well as catering facilities, shops, rooms for commercial use and facilities for creative leisure-time activities.

Castle "Residenzschloss" in Dresden

The castle was first mentioned in documents dating back to 1289 and was converted into a complex with four wings in the 15th century. It became the permanent residence of the Albertine "Wettiner", who ruled the country from here for more than 400 years, after the country was divided in 1485. The castle was characterised by conversions which were conducted in the 17th century, after the fire in 1701 and in the last decades of the 19th century until it was destroyed in 1945. On 13th February 1945, the castle burnt out almost completely, with the exception of the underground vaults and some rooms on the ground floor. At present the residence is being re-built. In the "Georgen" gate there is an exhibition by the state-owned art collections, Dresden. However, construction work is still underway in large parts of the castle. The magnificent rooms of August the Strong – the shell of which is restored today – can already be used for large exhibitions or prestigious events.

Hunting lodge "Jägerhof" in Dresden

The hunting lodge – the preserved part of a magnificent renaissance building for storing hunting equipment – today accommodates the museum for Saxonian folk art, which was founded by Oskar Seyffert. The upper floors of the building burnt out in 1945 and were restored in the time up to 1950. The museum is owned by the state-owned art collections Dresden.

Albertinum Dresden

The Albertinum was built in 1884-1887 within the building complex of the former armoury near the "Brühlsche" terrace to serve as a museum. It was named Albertinum in honour of the ruling King Albert. The building partly burnt out in 1945. Since the 1960s the restored building has accommodated the art gallery "new masters" and the collection of sculptures. At present the "Grünes Gewölbe" ("Green Vault") and parts of the coin cabinet can also be viewed in the Albertinum. All museums are owned by the state-run art collections Dresden.

Catholic court church Dresden

The Catholic court church built by the Roman architect Gaetano Chiaveri resulted from August the Strong's conversion to the Catholic faith. Subsequent re-catholicization of the court made it necessary to build an imposing court church. The building was one of the largest church buildings in Germany, a basilica with three naves and an extensive range of sculptures. The procession aisle in the interior of the church around the main nave is a special feature – it was constructed to express the aspect that the Reformation had been introduced in Saxony in 1539. In February 1945 the church burnt out completely. In the meantime restoration of its interior has been completed. In 1980 the former court church became St. Trinitatis Cathedral in the diocese of Dresden-Meissen.

Burial-place of the "Wettiner" in Freiberg cathedral

Duke Henry the Pious and all following Lutheran Albertine sovereign princes until John George IV., who was August the Strong's brother, were all buried in the burial chapel in Freiberg Cathedral – one of the most beautiful late Gothic hall churches in Upper Saxony. Duke Henry founded the burial place. The entombment is therefore one of the most important testimonies of the history of the sovereign princes.

The dominant centre of attention is the magnificent marble tomb for the Elector Maurice of Saxony, who became Elector of Saxony for the Albertine line of the House of "Wettin" in 1547 and died in the battle of Sievershausen in 1553. The tomb built by his brother is regarded as the first detached renaissance tomb in Saxony and the chapel designed by Giovanni Maria Nosseni as the "most magnificent mannerist burial-place North of the Alps".

Colditz castle

In the Middle Ages the castle, which was presumably built in the 11th century, was the centre of power in the imperial territory around the river Pleisse. Under the rule of the "Wettiner", Colditz was used as the widows' residence for Saxonian electoresses, an administrative centre and a hunting lodge. In the late 18th century the castle was used as an armoury; furniture and paintings were sold in a public auction. In the first third of the 19th century it served as a working-house for the poor, sick and those held in custody and in the end it served to accommodate mentally ill people who could not be cured. In the time of the Nazis the castle was used as a concentration camp and labour camp. The castle became well-known, as it was used as a prisoner of war camp for English, French, Dutch and Polish officers in the Second World War.

After the war it was an old people's home and nursing home as well as a hospital and psychiatric hospital. Since 1996 most parts of the castle have been left empty, at present plans for future utilisation are being developed. Visitors can view parts of the castle and the extensive grounds as part of a guided tour of the town museum of Colditz.

Source of Illustrations

Herbert Boswank, Dresden: p. 187, 197, 199 top, 200 top, 201 bottom re., 202, 203 top, 204, 206 bottom, 211, 213 top, 214, 215, 217 bottom
Fa-Ro Marketing, Munich: map p. 188
Fotoatelier Heim, Flöha: 217 top
Jürgen Karpinski, Dresden: p. 203 bottom
Wolfgang Krammisch, Dresden: p. 190, 192 bottom, 194, 196 bottom, 198, 207 bottom
Foto Krüger, Nossen: p. 206 top, 207 top
Dieter and Evelyn Krull, Dresden: p. 205 top
Christof Münch/DWT: p. 191 bottom

Udo Pellmann, Dresden: p. 191 top, 193 top, 193 bottom, 201 bottom left
Christa Pohle: p. 200 bottom
Jörg Schöner, Dresden: p. 192 top, 196 top, 199 bottom, 201 top, 205 bottom, 208, 209, 210, 212, 216 centre, 217
Foto-Weber, Augustusburg: p. 213 bottom
Klaus-Dieter Weber, Pirna: p. 193 centre, 195
Graphik Steiner & Steiner, Dresden p. 188

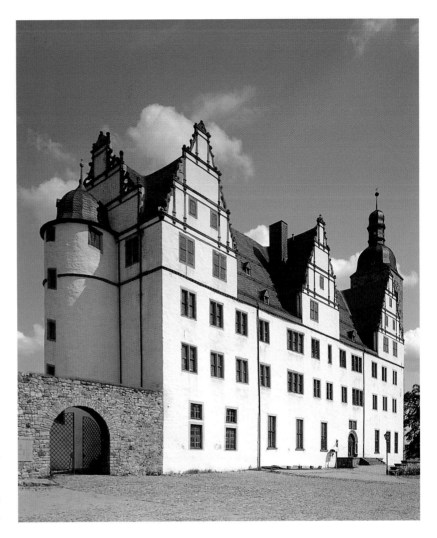

Saxony-Anhalt

STIFTUNG SCHLÖSSER, BURGEN UND
GÄRTEN DES LANDES SACHSEN-ANHALT

STATELY HOMES, CASTLES AND GAR-
DENS SAXONY-ANHALT

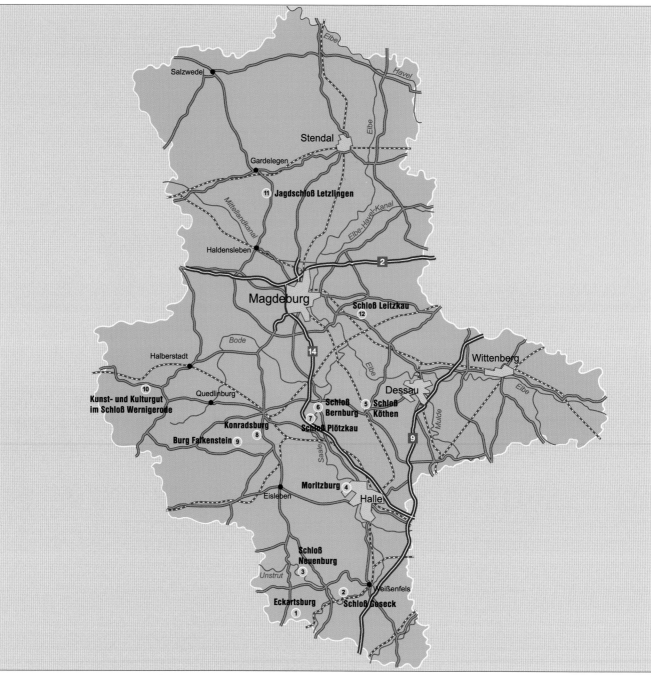

Eckartsberga (Burgenland District)
(1) Eckartsburg p. 222

Goseck (Weißenfels District)
(2) Schloss Goseck p. 223

**Freyburg a. d. Unstrut
(Burgenland District)**
(3) Schloss Neuenburg p. 224

Halle/Saale
(4) Moritzburg p. 225

Köthen (Köthen District)
(5) Schloss Köthen p. 226

Bernburg (Bernburg District)
(6) Schloss Bernburg p. 227

Plötzkau (Bernburg District)
(7) Schloss Plötzkau p. 228

Ermsleben (Aschersleben-Stassfurt District)
(8) Konradsburg p. 229

**Burg Falkenstein (Aschersleben-Stassfurt
District)**
(9) Burg Falkenstein p. 230

Wernigerode
(10) Schloss Wernigerode p. 231

Letzlingen (Salzwedel-Altmark District)
(11) Letzlingen Hunting Lodge p. 232

Leitzkau (Anhalt-Zerbst District)
(12) Schloss Leitzkau pp. 233–234

◁ *Schloss Leitzkau (1996)*

Schloss Leitzkau (1998) – ornamental basilica floor reconstructed from original traces

grave (presumed) of Bishop Wigger of Brandenburg

DIE KULTURELLE VERGANGENHEIT IM AUFTRAG DER GEGENWART FÜR DIE ZUKUNFT BEWAHREN

Compared with many other regions of Germany, Saxony-Anhalt boasts a high density of listed buildings. It is exceptionally rich in castles, stately homes and local manor houses reflecting the wide stylistic variety of architectural history in Germany. We still do not have fully reliable statistical records, but the Office of Monuments, a state government department based in Halle, estimates that there must be considerably more than 1,500 special interest sites.

To preserve, maintain and run castles and stately homes owned by the federal state of Saxony-Anhalt, the government set up a Foundation (*Stiftung*) under public law on 16 January 1996. It now administers this unique heritage from the Renaissance palace of Leitzkau near Magdeburg.

The following castles (*Burg*) and stately homes (*Schloss*) of particular architectural and artistic interest are currently Foundation sites:

1. Eckartsburg,
2. Schloss Goseck,
3. Schloss Neuenburg,
4. Moritzburg (Halle),
5. Schloss Köthen,
6. Schloss Bernburg,
7. Schloss Plötzkau,
8. Konradsburg,
9. Burg Falkenstein,
10. Letzlingen Hunting Lodge,
11. Schloss Leitzkau with the administrative offices of the Foundation.

In addition, the Foundation has been asked to manage works of art and other cultural assets owned by the state which are kept in Schloss Wernigerode. This includes ensuring their proper conservation and designing their presentation for the public.

Some castles and stately homes house excellent museums. The State Gallery at Moritzburg, for example, is a regional art museum, while the Museum at Burg Falkenstein is associated with Eike von Repgow, author of the *Sachsenspiegel*, a 13th-century compendium of Saxon tribal laws. For other sites we hope to devise similar new functions, helping to sustain them in the long term, but taking care not to impair their historical and artistic quality.

The Foundation has two focal tasks. One is thorough renewal and restoration of the buildings, and the other is to develop new soft functions of the kind just described. The resources for this are primarily provided by the state government of Saxony-Anhalt, but the Foundation is grateful for any voluntary or financial commitment above and beyond this.

Our castles and stately homes look forward to your visit. This cultural landscape at the heart of Germany is over a thousand years old, and full of unforgettable memories for you to share.

Stiftung Schlösser, Burgen und Gärten des Landes Sachsen-Anhalt

i Eckartsburg
D-06648 Eckartsberga
Tel./Fax: (+49/0)
3 44 67 / 2 04 15

Residential Tower,
Diorama and Great Hall
March–October
daily 11 am–8 pm
November–February
Sa/Su 11 am–8 pm
Mo–Fr by previous
arrangement

Eckartsburg

Eckartsburg, where Goethe created his "faithful Eckart", stands on a ridge above the little town of Eckartsberga on the southern edge of the Finne Hills.

Its founder was probably Ekkehard I, Margrave of Meissen, a faithful follower of Emperor Otto III.

Later chroniclers were to give AD 998 as the year of foundation, although the first actual records extant date from 1066 and 1074, by which time Ekkehard's line had died out and the castle had passed to the Empire.

In 1121 Emperor Heinrich V granted the castle in feoff to the Thuringian landgrave Ludwig the Leaper.

It was his descendants, notably Ludwig III and Hermann I, who began the construction which shaped today's castle. Eventually this dynasty also came to an end. There were disputes over the inheritance, and in 1247 the castle was taken by Heinrich the Illustrious, Margrave of Meissen and member of the House of Wettin.

His son Albrecht the Decadent made it his favourite home. Albrecht maintained an extravagant court which devoured huge resources. From 1457 to 1462, Duke Wilhelm III of Saxony, who was also Landgrave of Thuringia, chose this fortress as a place to banish his outcast wife, Anna of Austria.

The stout castle was frequently seized in forfeit and was thereby unable to fulfil its original purpose of defending the territory and its people.

On 14 October 1806 Prussian grenadiers in Eckartsburg exchanged final fire with French troops advancing from the battlefield at Hassenhausen. A diorama in the residential tower recalls the dual battle of Jena and Auerstedt.

A major renewal programme launched in 1990 was completed by the Foundation in 1998, and a broad spectrum of cultural activities are now open to the public.

*The castle from the south-east
(1997)
Prison tower (right) and
residential tower (left)*

Schloss Goseck from the south (1997)
Church (right) restored from 1615 by Chancellor von Pöllnitz and consecrated in 1620

Schloss Goseck

Schloss Goseck stands on a steep slope above the Saale valley. The Hersfeld Register of Tithes mentions a Goseck Castle, which was probably built in the 9th century by counts of Thuringia. From this line came Friedrich I, Lord of Goseck and Weissenburg, Count of Wettin, Brehna and Eilenburg and Burgrave of Zörbig.

Friedrich I left three sons: Adalbert, Dedo and Friedrich II. Adalbert became Archbishop of Bremen and tutor to Emperor Heinrich IV. In 1040 Dedo was granted a hereditary peerage as count palatine by Emperor Heinrich III. Friedrich II later inherited this title.

In 1041, after the brothers had decided to turn Goseck Castle into an abbey, work began on a church with a crypt and various monastic buildings.

The Benedictine abbey seems to have been consecrated on 29 September 1053. Dedo and Friedrich II, who now styled themselves the Saxon Counts Palatine of Goseck, took up residence at Weissenburg.

In 1540, during the Reformation, the abbey was dissolved and the property passed to Elector Moritz, who sold it as a manor estate to his field sergeant Georg von Altensee in 1548. The site changed hands frequently during this period, undergoing conversions in the 16th and 17th centuries which transformed it into a grand residence.

Its last private owners, from 1840 to 1945, were the counts of Zech-Burkersroda. After 1945 the church was used for a time to store grain, while valuable works of art and other items of cultural interest were damaged, destroyed or, in some cases, removed. After 1945 the church was neglected and became unstable, but the structure was made safe in 1990, and Romanesque sections of the original abbey church were salvaged.

The stately home was used until 1992 for tourist accommodation, including a youth hostel. The Foundation acquired it in 1997. Thanks to major structural measures, the process of decay was then halted. Since 1998 the ground has been prepared for long-term cultural use and other functions compatible with listed status.

ℹ Schloss Goseck e.V.
Herr Sebastian Pank
06667 Goseck
Tel. (+49/0) 34 43/28 44 88
Fax (+49/0) 3 92 41/28 44 83

🕒 Only the grounds of Schloss Goseck are currently open to visitors, subject to prior arrangement

✕

🅿

Stiftung Schlösser, Burgen und Gärten des Landes Sachsen-Anhalt

ℹ Museum Schloss
Neuenburg
Schloss 1
D-06632 Freyburg (Unstrut)
Tel. (+49/0) 3 44 64/2 80 28
Fax (+49/0) 3 44 64/2 80 29

Schloss Museum
🕐 April–October
Tu–Su 10 am–6 pm
November–March
Tu–Su 10 am–5 pm

Guided tours every hour
and by arrangement

Wine-Growing Museum
🕐 April–October
Tu–Su 10 am–6 pm
November–March
Tu–Su 10 am–5 pm

Guided tours every hour
and by arrangement

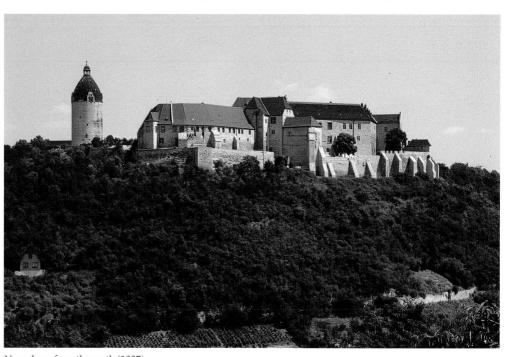

Neuenburg from the south (1997)
A distinctive skyline: the masonry, completely rehabilitated after 1990, and the new roofing – The keep on the left was
built around 1200 and is now nicknamed Fat Wilhelm

Schloss Neuenburg

Neuenburg, in its picturesque setting above the town of Freyburg, is one of the finest medieval castles in Saxony-Anhalt. It was built by the Thuringian landgrave Ludwig the Leaper between 1062 and 1090 to defend his territories on the eastern flank.

His descendants, the Ludovingians, kept extending the buildings until the early 13th century. As a result, Neuenburg is now the biggest and strongest castle to have survived in Saxony-Anhalt.

The landgraves of Thuringia, who expanded their territories thanks to various strategic marriages, chose Neuenburg as one of their centres.

When Ludwig IV married Elizabeth, daughter of the Hungarian king Andras II, his land and power looked set to grow again, but Ludwig died during the Crusade of 1227. His brothers Konrad and Heinrich left no children, and his son Hermann II died at the age of 19. The expansion was at an end.

The War of Succession lasted from 1247 to 1262. Margrave Heinrich of Meissen carried the day, and Neuenburg lost its status as a medieval centre of political and cultural life.

After the landgraves of Thuringia died out, Neuenburg changed hands frequently. Elector August of Saxony and the dukes of Saxe-Weissenfels exerted the biggest influence on the castle's architectural development. From 1850 the Prussian government provided ongoing maintenance, contributing decisively to the survival of the original fabric. A local museum has been based here since 1935. After the war it became Schloss Neuenburg State Museum.

In 1989/90 the castle and museum exhibits were in sorry condition after many years of structural neglect. Since then a major programme of repair and renewal has been underway in the inner ward, and the most serious damage has been overcome. Neuenburg is once again an attractive place for an outing.

The Foundation acquired the property in 1997. A museum of wine-growing opened on the premises in 1998.

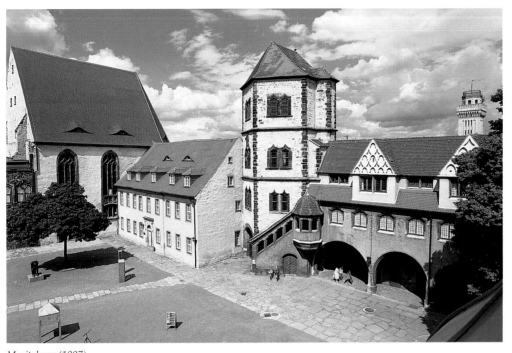

Moritzburg (1997)
Courtyard – University Chapel of St Mary Magdalene (left), field hospital (right)

Staatliche Galerie
Moritzburg
Friedemann-Bach-Platz 5
D-06108 Halle
Tel. (+49/0) 3 45/2 81 20 10
Fax (+49/0) 3 45/2 02 99 90

Tu 10 am–8.30 pm
(admission free)
Mi–Fr 10 am–5.30 pm
Sa/Su 10 am–6 pm
Closed on Mondays
Guided tours by request

Moritzburg, Halle

Moritzburg in Halle was built as a "fortified palace", protecting its tenants from the town. Begun in 1484 by Ernst of Wettin, Archbishop of Magdeburg, it was completed under Cardinal Albrecht of Brandenburg. Both used it for a period as their seat of residence. Cardinal Albrecht had a famous collection of relics, the "Hallesche Heilthum", which was initially held here, before he moved it to Aschaffenburg in 1541.

The four-wing complex burnt down in the Thirty Years War, and Swedish troops blew up the Powder Tower in the southwest. The castle fell into disrepair. In 1829, Karl Friedrich Schinkel produced plans to convert Moritzburg for use by the university, but they were never carried out.

The Prussian government acquired the property in 1852, and at the end of that century commissioned the installation of gymnastics and fencing facilities, as well as the restoration of the chapel – subsequently used as a university church – from 1894 to 1899.

A new structure to house a museum was built in the south wing from 1902 to 1904. It was inspired by the Valley Salt-Panning Authority in Halle. During the 1920s, this museum built up a major collection of modern art. In 1937 it lost over 150 works of international acclaim during the Nazis' "purge of Decadent Art".

After the war Moritzburg was a warehouse for art works and items of cultural interest confiscated during the redistribution of land. Today the castle houses the State Gallery, one of the leading art museums in Saxony-Anhalt.

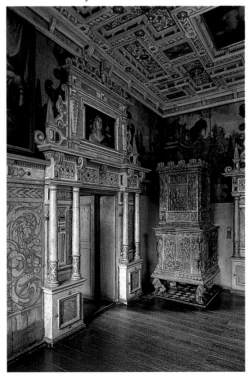

Moritzburg 1996
Bridal Room

Stiftung Schlösser, Burgen und Gärten des Landes Sachsen-Anhalt

ℹ️ Köthen District Council
(cultural sites dept.)
Springstrasse 18
D-06366 Köthen
Tel. (+49/0) 34 96/21 22 02
Fax (+49/0) 34 96/21 22 09

Historical Museum
Schlossplatz 4
D-06366 Köthen
Tel. (+49/0) 34 96/21 25 46
Fax (+49/0) 34 96/21 40 68
🕐 Tu–Fr 9 am–5 pm
Sa 2–5 pm
Su 10 am–12 noon
and 2–5 pm
Guided tours by request

Naumann Museum
Schlossplatz 4
D-06366 Köthen
Tel. (+49/0) 34 96/21 20 74
Fax (+49/0) 34 96/21 20 74
🕐 Tu–Fr 9 am–5 pm
Su 10 am–12 noon
and 2–5 pm
Guided tours by request
(including Mondays)

♿
✕
🅿️
DB
🚌

Schloss Köthen (1997)
from the south-west

Schloss Köthen

Köthen was originally a moated castle, but following a fire it was rebuilt by Franz and Peter Niuron between 1597 and 1608. In the early half of the 17th century this Renaissance residence became one of the most important centres of intellectual and cultural life in the German-speaking territories. Ludwig I of Anhalt-Köthen, a patron of science and education, was one of the founders of the first association devoted to the German language, known as the "Fruit-Bringing Society".

In 1717 the incumbent Prince Leopold summoned Johann Sebastian Bach to Köthen as master of the court music. In the years till 1723, Bach composed primarily secular instrumental music here, including the famous "Brandenburg Concertos".

When the Anhalt-Köthen dynasty died out in 1897, parts of their residence were used for a school, court-room and museum. Today much of the site is devoted to the Naumann Museum, one of Germany's biggest ornithological collections, and the Historical Museum. Since 1997 the Foundation has been responsible for the upkeep and use of the palace, which is located in the centre of the town and surrounded by a park.

Schloss Köthen (1997)
Hall of Mirrors

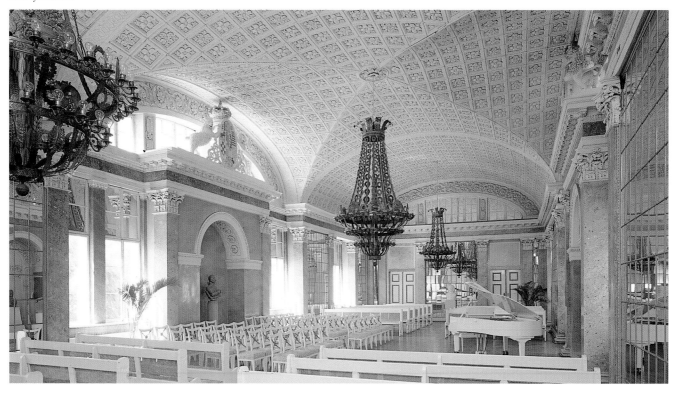

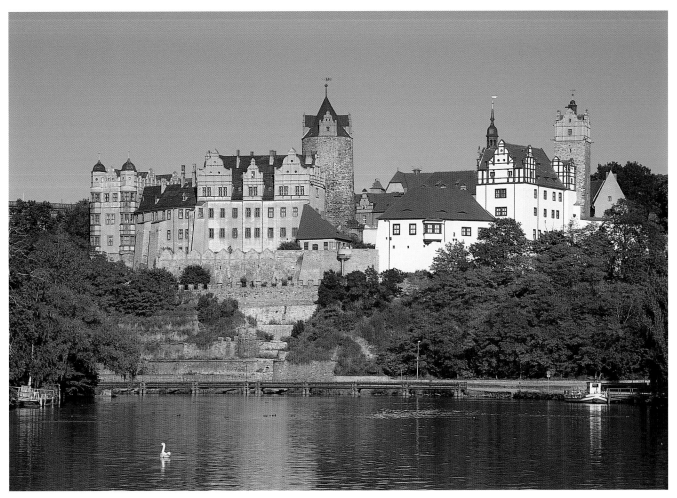

Schloss Bernburg (1997)
from the north bank of the Saale, with Eulenspiegel Tower in the middle

Schloss Bernburg

On the old trade route from Magdeburg to Halle and Leipzig, Schloss Bernburg now guards a disused ford across the River Saale. There was probably a castle here from the 11th century, although the first recorded reference we have is to a "Berneburch" in 1138.

Andreas Günther began the work of converting the castle for Wolfgang of Anhalt in 1538. The real treasures of the Wolfgang Wing built during that period are its two oriels, known as the "lanterns", richly ornamented and displaying portraits in bas-relief of Protestant noblemen and Emperor Karl V. Wolfgang's son Joachim Ernst extended the building eastwards from 1567 to 1570. The task was entrusted to Nickel Hoffmann of Halle. Alongside Andreas Günther he was one of the most accomplished master builders in Central Germany.

The principality of Anhalt was divided in 1603, and the palace became the residence of the younger line, now known as Anhalt-Bernburg. Although building proceeded steadily, the palace ceased to be the official residence in 1765. After the Anhalt-Bernburg line died out, the government of Anhalt acquired the property in 1863. The southern section now houses the Schloss Bernburg Museum, its particular attraction being a collection of minerals begun by Prince Friedrich Albrecht in 1738, prompted by the development of mining in the Harz Mountains. Another exhibit is the first atmospheric steam engine for the mining industry in Germany, built in Bernburg in 1745.

Today the buildings belong to the Foundation, but they are used by the District Court, Bernburg Cultural Foundation, the Friends of Lower Saale Natural Park, the Association of Museums in Saxony-Anhalt, and the museum itself.

ℹ Kulturstiftung Bernburg
Schlossstrasse 24
D-06406 Bernburg
Tel. (+49/0) 3471/370195

🕗 Tu–Th 9 am–4.30 pm
Fr 9 am–1 pm
Sa/Su 10 am–5 pm
Guided tours by prior request

Stiftung Schlösser, Burgen und Gärten des Landes Sachsen-Anhalt
Schloss Leitzkau
D-39279 Leitzkau
Tel. (+49/0) 39241/9340
Fax (+49/0) 39241/93434

Bernburg
Tourist Information
Tel. (+49/0) 3471/372030
Fax (+49/0) 3471/372032

Schloss Plötzkau (1996)
from the south

Schloss Plötzkau

Schlosscafé Plötzkau
D-06425 Plötzkau
Tel. (+49/0) 3 46 92 / 3 15 49

Stiftung Schlösser, Burgen
und Gärten des Landes
Sachsen-Anhalt
Schloss Leitzkau
D-39279 Leitzkau
Tel. (+49/0) 3 92 41 / 93 40
Fax (+49/0) 3 92 41 / 9 34 34

Closed on Mondays
Tu–Th 2–10 pm
Fr–Su 12 noon–12 midnight
and by arrangement

In the 11th century the counts of Plötzkau built a castle on a rocky ledge above the Saale, some four miles north of Alsleben. It was destroyed in 1139 by the Guelph Heinrich the Proud, when the Guelphs were fighting the Ascanians for Saxony. Not many years passed before the Ascanian Albrecht the Bear was granted the Plötzkau lands as an Imperial feoff.

From 1435 the castle belonged to the princes of Anhalt-Bernburg, and from 1566 to 1573 Prince Bernhard converted the castle into a Renaissance palace, though incorporating the old fabric. His new home boasted over 70 rooms, halls and parlours, including a top-security "secret chamber". The sandstone fireplace which still adorns the Prince's Hall dates from that period. The resplendent upper section is attributed to Georg Schröter, a sculptor from Torgau. A Latin inscription claims that this work was completed on 9 November 1567.

Another spectacular feature is the stucco ceiling in the Prince's Hall bearing the ini-

tials VF, a reference to Victor Friedrich of Anhalt-Harzgerode (1700–1765). Since 1665, Plötzkau had belonged to his line of the Ascanian dynasty.

The castle moat had been filled in, but excavations in 1938 revealed not only human bones, but also a large quantity of 17th- and 18th-century coins, indicating that Plötzkau was also a mint. The palace ceased to function as a residence in the 18th century, and from 1741 it housed a paint factory. From 1841 to 1874 it was a "penal institute and place of improvement", its inmates ranging from "vagabonds, drunkards and suchlike work-shy rabble" to convicts released from hard labour who were to be incited to adopt "endeavour and orderly habits by means of confinement and constant occupation".

When the penal institute closed down, Schloss Plötzkau became community property. After the war, it was a provisional home for refugees, and the Regional Museum of Pre- and Early History used it to store collections until 1992.

The Foundation acquired the site in 1996. Since then, much effort has been invested in restoring the palace and establishing new functions in keeping with its listed status.

Schloss Plötzkau (1996)
Prince's Room with sandstone fireplace and stucco ceiling

Konradsburg

Ancestors of the lords of Konradsburg were first mentioned in records in the 10th century. In 1080 "Conradesburg" first appeared as the name of a castle above the old army road from Quedlinburg to Eisleben. A few years later the owners of Konradsburg decided to make their new home on Falkenstein above the Selke valley, ceding the old site to a monastery. Legend claims that this deed was to atone for the murder of Adelbert of Ballenstedt by Egino of Konradsburg.

The grounds include impressive remains of the monastery church, built around 1200. The simple choir survives, along with a hall-type crypt of five aisles beneath, a gem of Romanesque architecture here in the Harz Mountains, with richly sculpted capitals.

Rebellious peasants came plundering in 1525, and the Carthusian monks who lived here felt compelled to close their community. Most of their buildings were demolished, giving way to new living quarters and stables, as the estate was held in deed of feoffment. The wellhouse, built in 1805/07 and now owned by the Foundation, is a rare technical monument: its donkey wheel still functions.

After the war Konradsburg housed refugees. Thanks to the commitment of

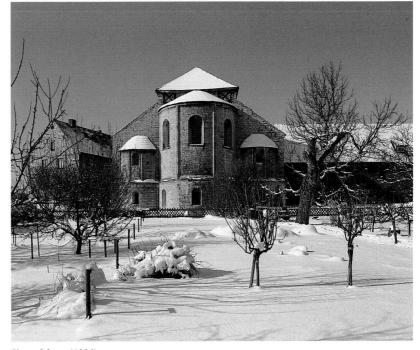

Konradsburg (1996)
Choir of the old monastery church

local enthusiasts, the process of decay was stemmed in the late 1970s. Today the site is used and managed by the Friends of Konradsburg, a registered charity founded in 1990.

ℹ Förderverein
Konradsburg e.V.
Schlossstrasse 24
D-06463 Ermsleben
Tel./Fax (+49/0)
3 47 43/9 25 65

🕐 April–October
Mo–Fr 9 am–5 pm
Sa/Su 10 am–6 pm
November–March
Mo–Fr 9 am–4 pm
Sa/Su 10 am–5 pm
Guided tours by request

✗ "Burgcafé"
April–October
Sa/Su 2–6 pm
November–March
Sa/Su 2–5 pm

♿

✗

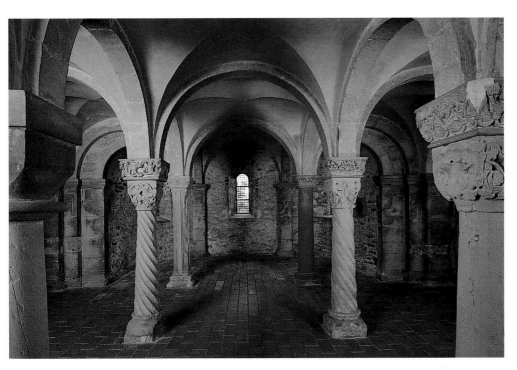

Konradsburg (1996)
Romanesque hall crypt with five aisles

Stiftung Schlösser, Burgen und Gärten des Landes Sachsen-Anhalt

Burg Falkenstein (1996) from the north

i Local Foundation office:
Museum Burg Falkenstein
D-06543 Burg Falkenstein
Tel./Fax (+49/0)
3 47 43 / 81 35

⊘ Closed on Mondays
Tu–Fr 9 am–5 pm
Sa/Su 9 am–6 pm
November–February
closes 1 hour earlier
Guided tours by prior
request

✗

P approx. 15-minute walk
or pony and trap

Falkenstein Castle

The castle, six miles south-east of Ballenstedt on a spur above the Selke valley, has three wings, seven gates, five outer wards and three moats. It was built between 1115 and 1120 and ranks among the finest and best-preserved castles in the Harz Mountains. Its original owner, Burchard the Younger of Konradsburg, later changed his surname to Falkenstein. Burchard VII, the last of the Falkensteins to reside here, granted the tenancy in 1332 to the Diocese of Halberstadt. From 1437 to 1945 the castle belonged to the Asseburg dynasty. The castle's composition was decisively altered in the 16th century,

when it was converted into a manor house and hunting lodge in Renaissance style. A castle museum first opened to the public around 1800, and today's exhibition is primarily devoted to the architectural history of this site, the book of law known as the *Sachsenspiegel*, and the domestic culture of the castle.

The 19th century witnessed major extensions. In 1830, for example, the old Great Hall was repaired and converted into a neo-Gothic structure by the well-known Berlin architect Friedrich August Stüler.

Restoration in 1992 brought stabilisation of the masonry around the "spinning hall", the object of a long-cherished confidence: just before the end of the war, the Asseburg family had hidden valuable works of art and items of cultural interest in the windowless mezzanine below. Karl-Christoph, Count of Asseburg-Rothkirch, decided to reveal the family secret, concerned that the building work might otherwise damage them. The items thus uncovered included silver tableware and china from the 18th- and 19th-centuries, and an edition of the *Sachsenspiegel* dated 1561.

The restoration of the "black kitchen", which is still functional, was completed in 1998.

*Burg Falkenstein (1996)
The "Sachsenspiegel" –
the first book of German laws*

*Burg Falkenstein (1998)
Black Kitchen restored and
functional*

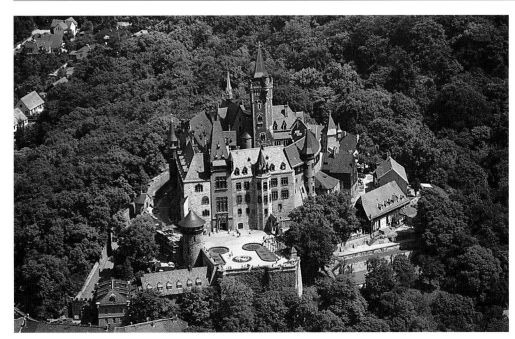

Schloss Wernigerode (1996) from the south

i Schloss Wernigerode GmbH
Am Schloss 1
D-38855 Wernigerode
Tel. (+49/0) 39 43/50 03 96
Fax (+49/0) 39 43/50 04 14

Local Foundation office:
Schloss Wernigerode
D-38855 Wernigerode
Tel. (+49/0) 39 43/54 15 30
Fax (+49/0) 39 43/54 15 34

Schloss Museum:
🕗 May–October
daily 10 am–6 pm
November Sa/Su only
10 am–5 pm
December–April
Tu–Su 10 am–5 pm
Closed on Mondays

Guided tours by prior
request

♿

✗

P approx. 10-minute walk
or by light rail

Art and artefacts at Schloss Wernigerode

Over 230,000 visitors a year visit Schloss Wernigerode, enthroned high above the colourful town. Redesigned almost completely between 1862 and 1883 in historical style, little of it now recalls the medieval castle defended by knights in the early 12th century, and there are few traces of the baroque residence built by later counts. Today it inspires admiration as a "fairy-tale palace" and has been open as a museum since 1930/31.

The foundation has been entrusted with over 20,000 regional works of art and cultural artefacts preserved here in 50 deposits. They include over 5,000 paintings and prints, about 1,000 items of furniture, over 1,000 textile specimens, almost 1,700 weapons, well over 1,000 pieces of porcelain and faience, 2,000 valuable items of silver and glassware, and nearly 6,000 archived records, from posthumous papers and historical documents to maps and architects' drawings. A large proportion of the inventory belonged to the family of Stolberg-Wernigerode, who once ruled in this region.

One feature well worth a visit are the living quarters, restored in 1991/1993 and furnished just as they were in the latter half of the 19th century. They include studies, living rooms, guest rooms and the grand Ancestral Hall. Although restoration was long overdue, it was left until after 1990/91, when the government of Saxony-Anhalt also gave valuable financial support. In many respects, this work proved highly complex. One example on display is the King's Green Room, where the furniture had to be re-upholstered with material woven to resemble the original. The king in question was Wilhelm I of Prussia, who later became Kaiser Wilhelm I. He came to Wernigerode several times, where he enjoyed hunting. His host, Count (from 1890 Prince) Otto zu Stolberg-Wernigerode (1837–1896), was once deputy to Bismarck as Chancellor of the German Reich.

*Schloss Wernigerode (1996)
Wall safe in the Silver Chamber*

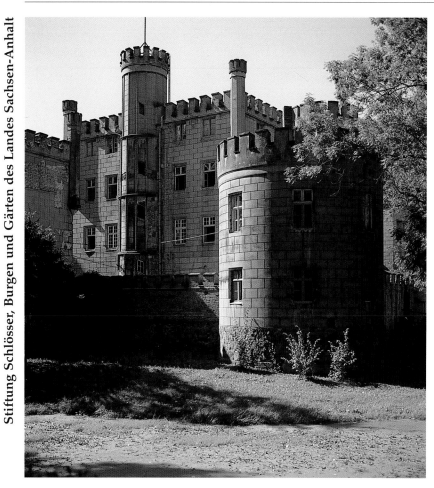

Schlossensemble Letzlingen (1996)
Südostturm und Hauptgebäude

Community, where pupils received an education independent of state and church, with the emphasis on craft training. This was closed in autumn 1933, and Hitler's SA took over the premises for training its leadership.

During the Second World War there was an army field hospital here. In civilian times, until 1991, the facility was used by Gardelegen Hospital, and there was also a school for children with learning difficulties.

From 1992 the buildings were empty until the Foundation acquired them in 1996. A plan for redevelopment and restoration has now been drawn up, and will serve as a basis for developing cultural and commercial uses, including tourism.

Letzlingen Hunting Lodge

i Letzlingen Council
D-39638 Letzlingen
Tel. (+49/0) 3 90 88/63 45
Fax (+49/0) 3 90 88/2 22

Stiftung Schlösser, Burgen und Gärten des Landes Sachsen-Anhalt
Schloss Leitzkau
D-39279 Leitzkau
Tel. (+49/0) 3 92 41/93 40
Fax (+49/0) 3 92 41/9 34 34

⊘ Only the grounds are currently accessible to visitors, subsequent to prior arrangements.

The Prussian King Friedrich Wilhelm IV appointed architects Friedrich August Stüler and Ludwig Ferdinand Hesse to implement his ideas for a neo-Gothic hunting palace in the middle of Letzlingen Heath, rich in game and a favourite hunting ground of the Hohenzollern monarchs. Letzlingen incorporated remains of Hirschburg Hunting Lodge, which was begun in 1560 on the same site for Elector Johann Georg of Brandenburg. The Letzlingen Court Hunt, held here in late autumn from 1843 to 1912, attracted personages such as Otto von Bismarck, Archduke Franz Ferdinand, who was heir to the Austrian throne, and Paul von Hindenburg. Burning political issues were sometimes thrashed out during the occasion.

Ownership of the lodge passed to the Prussian government in 1918, and its movable assets were sold in 1922, once items of particular value had been removed to Berlin. From 1922 to 1933 the lodge housed the Free School and Craft

The Letzlingen complex (1996)
Cavalier's House

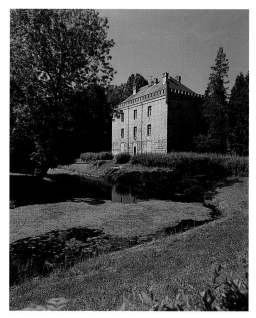

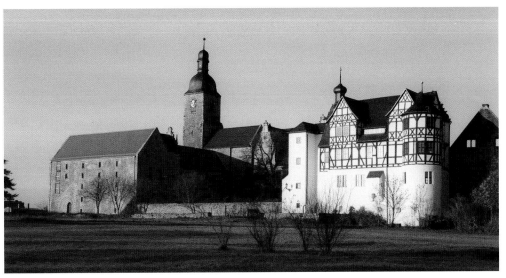

The Leitzkau complex (1998)
Restored transept (left), restored Schloss Hobeck (right)

i Headquarters of the
Stiftung Schlösser, Burgen
und Gärten des Landes
Sachsen-Anhalt
Schloss Leitzkau
D-39279 Leitzkau
Tel. (+49/0) 3 92 41/93 40
Fax (+49/0) 3 92 41/9 34 34
e-mail: Stiftung-Leitzkau@
t-online.de
Internet:
http://www.kulturserver.
de/home/ssbg

Leitzkau Society for the
Preservation of Culture
and Monuments
Schloss Leitzkau
D-39279 Leitzkau
Tel. (+49/0) 3 92 41/93 40
Fax (+49/0) 3 92 41/9 34 34
Tel. (+49/0) 39241/4168
🕗 Sa/Su and public holidays
10 am and 2.30 pm
Guided tours by prior
request

Schloss Leitzkau

On account of its geostrategic importance, the settlement of Leitzkau is first mentioned in records in AD 995. Located between Magdeburg and Dessau, it was a base for campaigns to reconquer areas of Brandenburg lost during the Slav uprising of 983. In 1138/39 Bishop Wigger of Brandenburg founded a chapter of Premonstratensian canons here. Their church, consecrated in 1155 as "Sancta Maria in monte", and their cloister buildings formed the "cornerstone" for the future Renaissance residence of Leitzkau. On 2 April 1564 Colonel Hilmar of Münchhausen acquired the former abbey, now fairly dilapidated, for 70,000 talers. In the years which followed he converted it into a palace in the style of the Weser Renaissance. It has been called the "most important palatial building of that period in the Mid-Elbe region" (Dehio). Work focussed on the building west of the cloisters, which was transformed into a three-storey residence (the New House) with transverse gables, a round stair-tower and an ornately decorated portal. The building to the east was raised by an additional floor, and later came to be known as the Old House. This building was damaged in the Second World War and demolished in 1950. All that remain are an octagonal stair-tower, a gable front on the basilica transept and an imposing loggia (with Romanesque columns on the ground floor), which linked the Old House to the 15th-century Schloss Hobeck, named after a nearby settlement.

The Romanesque church built for the original chapter had three aisles. It was turned into an early baroque church for the use of the residence, with a single nave, a Renaissance courtside portal, pulpit and baptismal font. Two-storey functional buildings complete the complex to the north. The palace now houses the headquarters of Saxony-Anhalt's Foundation of Stately Homes, Castles and Gardens, which shares the premises with the Cathedral Foundation of Saxony-Anhalt.

The Leitzkau complex (1996)
Wedding Room in Schloss Hobeck

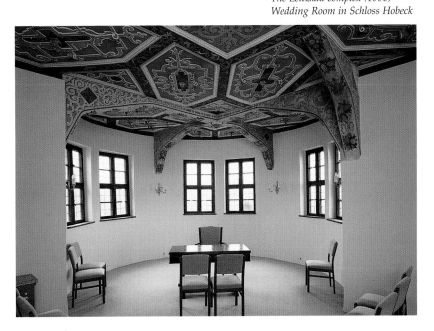

Stiftung Schlösser, Burgen und Gärten des Landes Sachsen-Anhalt

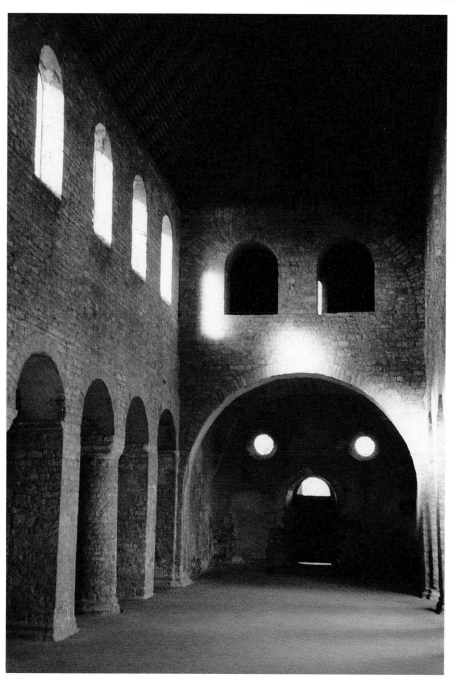

The Leitzkau complex (1998)
Restored basilica

Source of Illustrations

Raik Baumgarten (Stiftung Schlösser, Burgen und Gärten des Landes
 Sachsen-Anhalt): p. 233 top, 234
Fa-Ro Marketing (Munich): map p. 220
Roland Krawulsky (Dessau): p. 225 top, 227

Maurizio Paul (Berlin) p. 221
Janos Stekovic (Halle): p. 219, 222, 223, 224, 225 bottom, 226 top, 226
 bottom, 228 top, 228 bottom, 229 top, 229 bottom, 230 top, 230 bot-
 tom left, 231 top, 231 bottom, 232 top, 232 bottom, 233 bottom

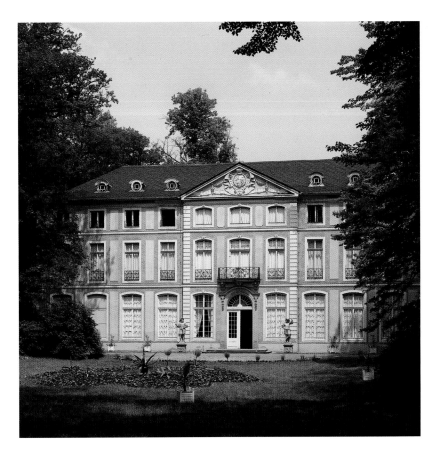

Thuringia

STIFTUNG
THÜRINGER SCHLÖSSER
UND GÄRTEN

STATELY HOMES AND GARDENS
OF THURINGIA

Stiftung Thüringer Schlösser und Gärten

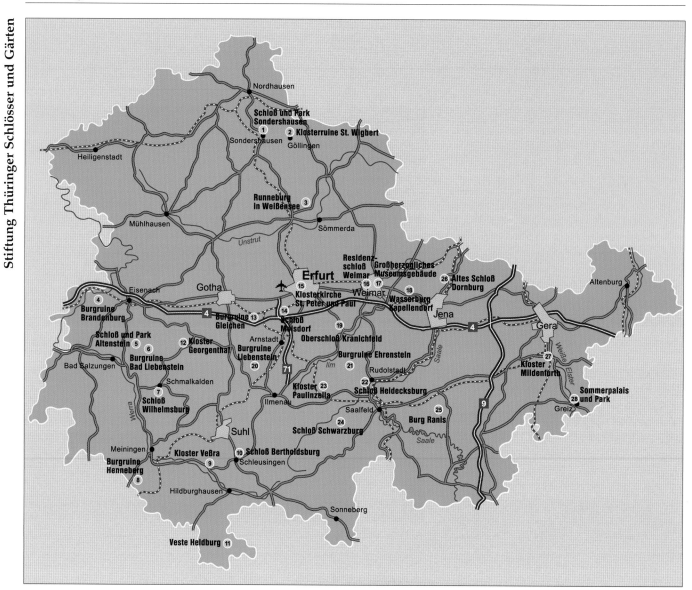

Kyffhäuser District
(1) Schloss Sondershausen and Park p. 238
(2) St Wigbert Abbey Ruins in Göllingen
 p. 254

Sömmerda Rural District
(3) Runneburg in Weissensee p. 239

Wartburg District
(4) Brandenburg Castle Ruins in
 Lauchröden p. 254
(5) Schloss Altenstein and Park
 near Bad Liebenstein p. 240
(6) Bad Liebenstein Castle Ruins
 near Bad Liebenstein p. 254

Schmalkalden & Meiningen Rural District
(7) Schloss Wilhelmsburg in Schmalkalden
 pp. 242–243
(8) Henneberg Castle Ruins p. 254

Hildburghausen Rural District
(9) Vessra Abbey p. 239

(10) Schloss Bertholdsburg in Schleusingen
 p. 241
(11) Fort Heldburg p. 241

Gotha Rural District
(12) Georgenthal Abbey p. 250
(13) Gleichen Castle Ruins near
 Wandersleben p. 243

Erfurt Urban District
(14) Schloss Molsdorf and Park p. 244
(15) SS. Peter and Paul Abbey Church in
 Erfurt p. 250

Weimar Urban District
(16) Dukes' Residence in Weimar
 pp. 246–247
(17) Grand Duchy Museum
 (New Museum) in Weimar p. 254

Weimar Rural District
(18) Kapellendorf Castle p. 247
(19) Oberschloss in Kranichfeld p. 250

Ilm District
(20) Liebenstein Castle Ruins p. 254
(21) Ehrenstein Castle Ruins p. 254

Saalfeld & Rudolstadt Rural District
(22) Schloss Heidecksburg in Rudolstadt
 p. 245
(23) Paulinzella Abbey p. 248
(24) Schloss Schwarzburg p. 252–253

Saale & Orla District
(25) Ranis Castle p. 251

Holzland District
(26) Old Castle, Dornburg p. 249

Greiz Rural District
(27) Mildenfurth Abbey near Wünschendorf
 p. 254
(28) Greiz Summer Palace and Park p. 249

◁ *Greiz Summer Palace, view from the south*

Schloss Molsdorf, south facade

GEMS OF A CULTURAL LANDSCAPE ...

The Thuringian heritage of stately homes and gardens

Thuringia boasts a unique cultural landscape which has taken shape over many centuries with a wealth of castles, stately homes, parks, gardens and abbeys. Since it was the custom to divide the land of local overlords between their heirs, tiny principalities proliferated from the Middle Ages, and noble residences vied with one another, promoting the arts which so profoundly influenced the cultural identity of Thuringia's different regions. These buildings and gardens have made an important contribution to the architecture, art and history of the state we know today, and are major landmarks in its towns and landscapes, reflecting a long established interplay between political and cultural ambitions.

To care for this often fragile heritage, a Foundation was created in March 1994: the *Stiftung Thüringer Schlösser und Gärten*. It is responsible – or in some cases preparing to assume responsibility – for the upkeep, restoration, appropriate use and prospective development of 37 of Thuringia's most valuable historical sites, including stately homes such as Schloss Heidecksburg in Rudolstadt, Schloss Sondershausen and the ducal residence in Weimar, religious buildings such as the well-known abbey at Paulinzella built by the Hirsau School and the abbey

church of SS. Peter and Paul on Erfurt's Petersberg. Outstanding examples of landscape gardening in the English fashion include the parks in Greiz and on the Altenstein.

The Foundation maintains and restores the properties entrusted to its care, carries out the tasks of administration and research, and also manages tourism, working closely in the course of its duties with local authorities and government institutions devoted to similar objectives.

Moreover, the Foundation is upholding an old dynastic tradition, for local princes were much devoted to promoting the arts in their territories, using their palaces to establish collections of art, natural history and various curiosities. Unlike similar museums in other federal states of Germany, those of Thuringia's stately homes, most of which play a role well beyond their own region, are funded and run within the community. These local institutions are above all responsible for the inventory – the period interiors and collections – and for individual exhibitions. In addition to this, castles, palaces and abbeys often house permanent displays which illustrate the history and significance of the local community.

Stiftung Thüringer Schlösser und Gärten

ℹ Information office
Schloss Sondershausen
D-99706 Sondershausen
Tel. (+49/0) 36 32/66 31 02

Schloss Museum
Permanent exhibition of original interiors from Renaissance to historicist, regional history and history of music, Schwarzburg Portrait Gallery, special tours by request, temporary exhibitions

🕑 Summer Tu–Fr 10 am–5 pm,
Sa/Su 10 am–6 pm,
Winter Tu–Su 10 am–4 pm
Closed on Mondays
Tours daily at 10 am
and 2 pm
Tel. (+49/0) 36 32/66 31 20
Fax (+49/0) 36 32/66 31 10

✕

🅿

DB Nordhausen–Erfurt

Schloss Sondershausen and its Park

Schloss Sondershausen in northern Thuringia is the most impressive architectural legacy of the Counts, and later Imperial Princes, of Schwarzburg-Sondershausen. The complex was in their possession from 1356 to 1918, and the many styles it represents reflect several centuries of dynastic history and palace culture. Traces of the medieval castle, substantial elements of Renaissance and baroque architecture and the historicist interiors of the 19th century combine to create an artistic built ensemble with a charm all of its own. The appointment of the magnificent Renaissance and baroque halls is especially noteworthy. Vestiges of figurative and decorative painting from the 16th century are of a quality which suggests some affinity with Cranach's atelier. By contrast, the vaulting over the spiral stone stairway, which dates from 1616, is an outstanding and rare specimen of late mannerist stucco art in Germany. Its complex iconography, with themes drawn from engravings by Virgil Solis, Hendrick Goltzius and Jakob Matham, indicates the educational ideals of its humanist patrons. Twenty rooms show ornamental stucco of the high baroque period from the workshop of Nicola Carcani. The sixteen gods of superhuman proportions in

Schloss Sondershausen, courtyard

the room known as the Giant Hall are a particularly lively expression of the baroque predilection for monumental style. The palace enjoys the added benefit of a fine location predestined for the creation of a landscape garden. Carl Eduard Petzold, a garden architect who had helped to implement Prince Pückler-Muskau's designs, was appointed to plan this project in 1851.

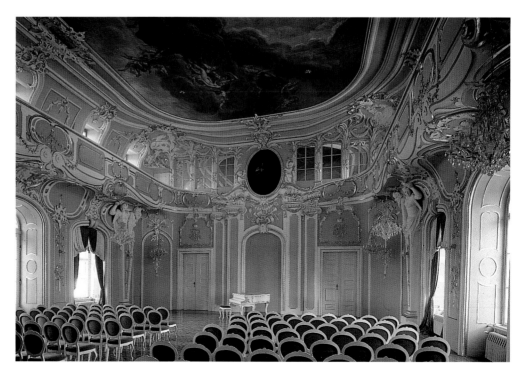

Schloss Sondershausen, Blue Room

Runneburg in Weissensee

The Runneburg in Weissensee is one of the best-known monuments of the Hohenstauffen age in Germany. This Romanesque castle, built in the second half of the 12th century by Thuringian landgraves of Ludovingian descent, has survived with its great hall and residential tower intact. Unspoilt by 19th-century historicist additions, the surviving structures in this castle precinct permit an undisrupted view of secular medieval architecture which, in architectural design and decorative statuary, was a match for any residence built by the Emperor.

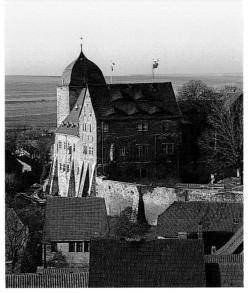
Runneburg, view from the east

ℹ Information office
Runneburg
D-99631 Weissensee
Tel. (+49/0) 3 63 74/2 07 85
Fax (+49/0) 3 63 74/2 07 48

Archaeological open-air museum, Vault (plate and jewellery), permanent exhibition of excavation finds, temporary exhibitions

⊘ Summer
Tu–Su 8.30 am–4.30 pm
Winter
Tu–Fr 9.30 am–3.30 pm
Sa/Su 1.30–3.30 pm
Closed on Mondays
Daily guided tours, hourly
Tel. (+49/0) 3 63 74/2 07 85
Fax (+49/0) 3 63 74/2 07 48

✗ – 🅿

DB Großheringen–Straußfurt

Vessra Abbey

The Premonstratensian Monastery founded in Vessra in 1131 enjoyed an outstanding status among the religious communities of Thuringia because of its closer personal links with the Counts of Henneberg, outshining other communities in the vicinity in terms of its political influence, economic power and cultural reputation. Even today, the ruins of the Romanesque basilica, the burial chapel of the Hennebergs with its wall paintings, the largely intact cloister wings and the walls which enclose the six-hectare grounds of the monastic community convey a sense of its medieval significance. In addition to this, an open-air museum has been constructed on the site, using original buildings to illustrate the diversity of rural timber-frame architecture.

ℹ Henneberg Museum
Kloster Vessra
D-98660 Kloster Vessra
Tel. (+49/0) 3 68 73/2 15 05
Fax (+49/0) 3 68 73/2 19 29

Henneberg Museum
Vessra Abbey
The old monastic complex, timber-frame houses from the Henneberg area and exhibition of abbey history, temporary exhibitions

⊘ April–September
9 am–6 pm
October–March
10 am–5 pm
Admission ceases one hour before closing
Closed on Mondays
Tel. (+49/0) 3 68 73/2 15 05
Fax (+49/0) 3 68 73/2 19 29

✗

🅿

DB Themar–Erfurt

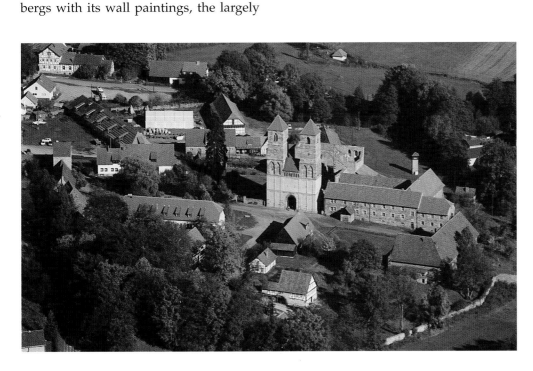
Vessra Abbey,
aerial view from the west

Stiftung Thüringer Schlösser und Gärten

i Information office
Schloss and Park Altenstein
D-36448 Bad Liebenstein
Tel. (+49/0) 3 69 61/7 25 13
Fax (+49/0) 3 69 61/33 40 8

Little Museum in the
Chamberlain's Office

🕐 Mo–Fr 7 am–4 pm
Admission free

✗

P

🚌 Eisenach–Bad Liebenstein

M Exhibitions by Thuringian
Forest Natural Park,
special exhibitions on
regional flora and fauna
Tel. (+49/0) 3 69 61/3 34 01
(forthcoming)

Schloss Altenstein,
view from the east

Schloss Altenstein and its Park near Bad Liebenstein

In its present form, the park at Schloss Altenstein near Bad Liebenstein is a fine specimen of late 18th-century and 19th-century landscape gardening. The palace itself, begun in 1888, was gutted by fire. The park owes its origin to Dukes Georg I, Bernhard II and Georg II of Saxe-Meiningen. The location's natural features offered garden architects such as Prince Hermann von Pückler-Muskau, Carl Eduard Petzold and Peter Joseph Lenné excellent terrain for the creation of a landscaped park, and panoramic views across the Werra Valley and the distant Rhön Hills were incorporated into their designs. The bizarre cliff formations which rise from the Altenstein ridge evoke Alpine associations. The visitors' walk through the garden leads past a number of Romantic structures and also to the Knight's Chapel. The layout also absorbs vestiges of Altenstein's turbulent history, such as the medieval castle ruins and the site of legendary sermons by the missionary St Boniface.

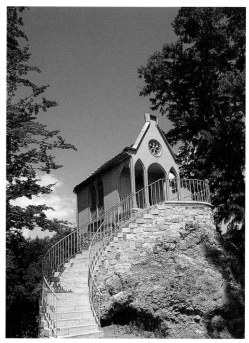

Altenstein Park, Knights' Chapel

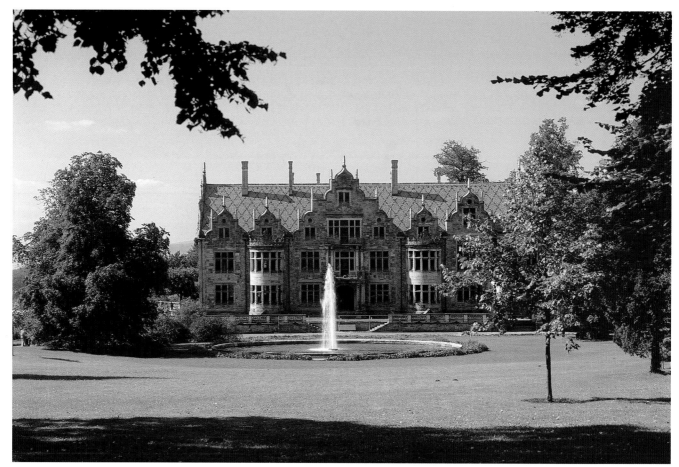

Schloss Bertholdsburg in Schleusingen

In the 13th century Schloss Bertholdsburg became the leading residence of the Counts of Henneberg, who played a significant role in German history during the Middle Ages and the early Modern era. Around 1275 Count Berthold V initiated the conversions which adapted this fortress to the functional demands of his day. However, the complex as we know it was essentially the result of building in the late 15th and early 16th century, which introduced the distinctive stepped gables and the double-storey loggia with its wealth of Renaissance ornament in the courtyard. Today Schloss Bertholdsburg houses the Natural History Museum and an exhibition on the history of the castle and the town.

i Information office
Schloss Bertholdsburg
Burgstrasse 6
D-98553 Schleusingen
Tel. (+49/0) 3 68 41/4 73 34
Fax (+49/0) 3 68 41/4 79 61

M Natural History Museum
Permanent exhibition of minerals, cabinet of natural curiosities, exhibition of regional history, panoramic tower
Guided tours on request
Temporary exhibitions

⊘ May–September
Tu–Fr 9 am–5 pm,
Sa/Su 10 am–6 pm
October–April
Tu–Su 10 am–5 pm
Admissions cease one hour before closing
Closed on Mondays
(except public holidays)
Tel. (+49/0) 3 68 41/4 79 61

P on the market square

DB Themar–Arnstadt–Erfurt

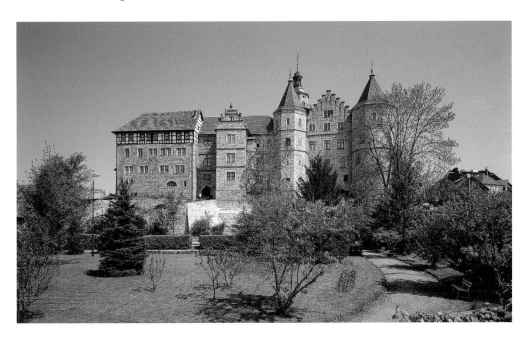

Schloss Bertholdsburg, view from the west

Fort Heldburg

Fort Heldburg

Perched on a steep hilltop, the Heldburg is a prominent example of the fortresses which dominate the South Thuringian landscape. The first documented reference to the Heldburg in 1317 describes it as a seat of administration and jurisdiction for the Counts of Henneberg. A few decades later the castle fell to the Wettin dynasty, who in the 16th century – primarily in the reign of the "Middle" Johann Friedrich – converted it into a Renaissance palace. The highlight of this construction phase is the French Building by Nikolaus Gromann, a masterpiece of Renaissance palace architecture in Germany. In the 19th century, the now dilapidated Heldburg fell to the Dukes of Saxe-Meiningen. Georg II commissioned restoration work, during which the original fabric was altered in part to satisfy idealised Romantic conceptions of the Middle Ages.

i Information office
Veste Heldburg
D-98663 Bad Colberg-Heldburg
Tel. (+49/0) 3 68 71/2 12 10
Fax (+49/0) 3 68 71/2 01 99

Exhibition on the history of the fortress and its construction by Friends of Fort Heldburg, panoramic tower, lady's bowers, display centre with historical furnishings

⊘ Aril–Oct, Tu–Su 10 am–6 pm
Nov–Ma, Tu–Su 10 am–5 pm
Admissions cease 30 minutes before closing
Tel. (+49/0) 3 68 71/2 12 10
Fax (+49/0) 3 68 71/2 01 99

P 800 m
100 m for visitors with disabilities

🚌 Hildburghausen–Heldburg

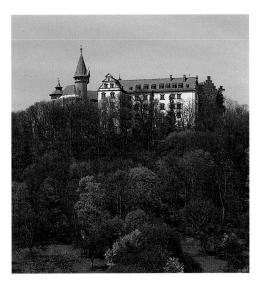

Fort Heldburg, view from the south

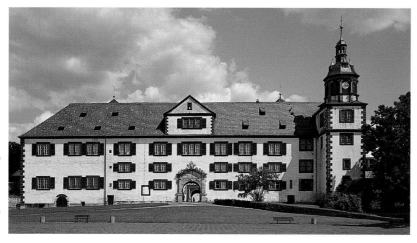

Schloss Wilhelmsburg, view from the west

ℹ Information office
Schloss Wilhelmsburg
Schlossberg 9
D-98574 Schmalkalden
Tel./Fax (+49/0)
36 83/40 19 76

Schloss Wilhelmsburg
Museum
Permanent exhibition of the
building's construction and
use, court culture and life-
style
Guided tours on request
Temporary exhibitions

🕐 Summer Tu–Su 9 am–5 pm
Winter Tu–Su 10 am–4 pm
Closed on Mondays
Tel. (+49/0) 36 83/40 31 86
Fax (+49/0) 36 83/60 16 82

DB Wernshausen–Zella-Mehlis

Schloss Wilhelmsburg in Schmalkalden

The Wilhelmsburg, a Renaissance palace for the Hessian landgrave Wilhelm IV and his son Moritz, stands above Schmalkalden on the southern rim of the Thuringian Forest. The regular four-wing structure by architects Hans and Christoph Müller, apparently aided by Wilhelm Vernukken (a Dutch artist at the court in Kassel), was begun in 1585. With wall painting and stucco of the highest quality, the Wilhelmsburg offers interior art of the Renaissance and mannerist styles in an all-embracing variety hardly rivalled in Germany. One feature of particular note is the palace chapel, regarded as a major achievement of German Renaissance architecture. Its composition as a hall with three-storey arcades takes its architectural cue from the palace chapel in Torgau. These were early days for Protestant church-building, and a trend was set here for the vertical arrangement of the altar, pulpit and organ, as key liturgical elements, along the main axis of the interior. The historical organ is the oldest in Thuringia and is considered an outstanding Renaissance specimen of the organmaker's craft. Another feature worth special mention is the Giant Hall with its coffered ceiling containing ninety canvas

Schloss Wilhelmsburg, Giant Hall

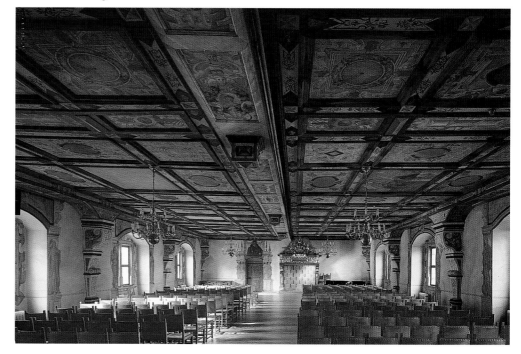

Schloss Wilhelmsburg, palace chapel

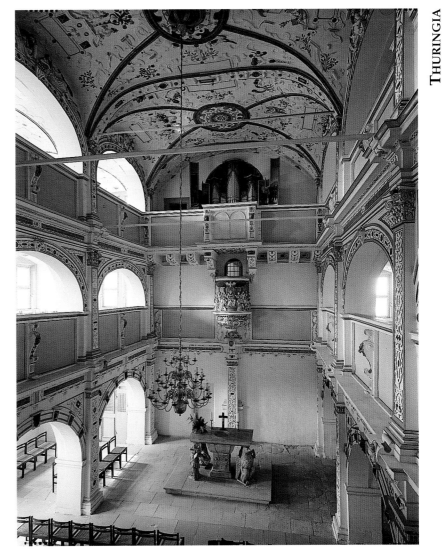

paintings attributed to Jost vom Hoff. The striking frescoes by the hall portals depict the Duke's bodyguards, his *"Trabanten"*, in dimensions larger-than-life. The museum now housed in the palace provides much additional information on the contemporary context in which the building was constructed.

Gleichen Castle Ruins near Wandersleben

Gleichen Castle Ruins near Wandersleben

Burg Gleichen and the two nearby castles of Wachsenburg and Mühlburg are known jointly as the "Three Gleichen" or "Three Equals" and often regarded as Thuringia's symbolic landmarks. Much of the building fabric from the 11th to the 16th century has survived here at Gleichen. The castle acquired a significant status under margrave Ekbert of Meissen, who defended himself successfully here in 1088 against attacks by Holy Roman Emperor Heinrich IV. In the 12th century the castle changed ownership: its new overlords were the Prince Electors and Archbishops of Mainz.

ℹ Information office
Schloss Molsdorf
Gothaer Strasse 1
D-99192 Erfurt-Molsdorf
Tel./Fax (+49/0) 3 62 02/9 05 05

Burg Gleichen Museum
Permanent exhibition of the castle's history and the Drei Gleichen natural environment
Guided tours of castle ruins by arrangement

🕑 March–November
Mo–Su 9 am–5 pm
December–February
Sa, Su 9 am–5 pm
Tel. (+49/0) 3 62 02/8 24 40

DB Fulda–Erfurt

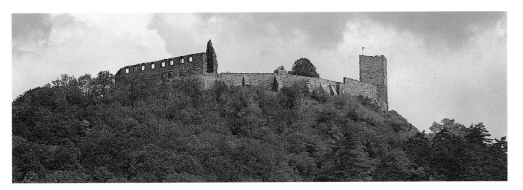

*Burg Gleichen,
view from the west*

Stiftung Thüringer Schlösser und Gärten

i Information office
Schloss Molsdorf
Gothaer Strasse 1
D-99192 Erfurt-Molsdorf
Tel./Fax (+49/0) 3 62 02/
9 05 05

Schloss Museum
Permanent exhibition of
interior decoration and fur-
nishings, temporary exhibi-
tions

🕐 Tu–Su 10 am–6 pm
Closed on Mondays
Tel./Fax (+49/0) 3 62 02/
9 05 05
Guided tours
every hour on the hour

✗

P

🚌 Stadtbus Erfurt–Molsdorf

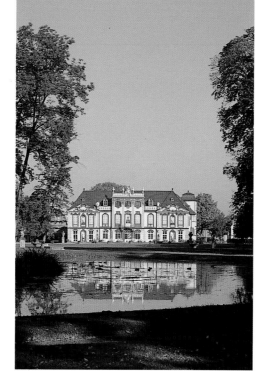

Schloss Molsdorf, view of the south front from the park

Schloss Molsdorf and its Park

From the 1730s, the old feudal estate of Molsdorf was transformed into one of Thuringia's finest baroque stately homes and gardens by Gustav Adolph von Gotter, a diplomat and commoner who had been made a count of the Empire. Thanks to his close links with the most prestigious courts of his day, Gotter persuaded some outstanding names to help. Gottfried Heinrich Krohne, the court architect of Saxe-Weimar, is believed to have designed the building. Painter Johann Kupetzky and stucco artist Jean Baptiste Pedrozzi, from the entourage of the margrave of Bayreuth, decorated the grand reception rooms, and Prussia's court painter Antoine Pesne apparently provided a painted ceiling in the Marble Hall. During the early half of the 19th century, Rudolph Eyserbeck – son of Johann Friedrich Eyserbeck, the court gardener of Wörlitz fame – turned the one-time baroque garden, in which nature was moulded by architecture, into a little paradise founded on the Romantic ideal of a landscape garden which seems to be natural.

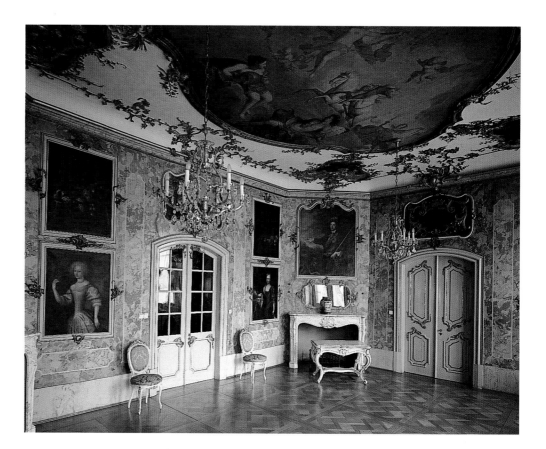

Schloss Molsdorf, Marble Hall

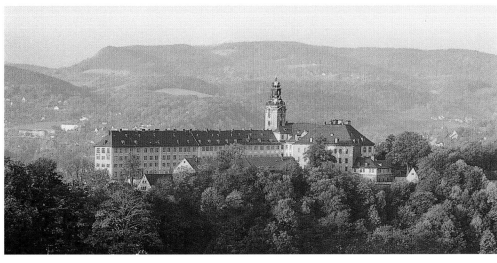

*Schloss Heidecksburg,
view from the north*

i Information office
Heidecksburg
Schloss Heidecksburg 1
D-07407 Rudolstadt
Tel./Fax (+49/0) 3672/
447210

Heidecksburg Museum of
Thuringia
Banqueting halls and apart-
ments of the Schwarzburg-
Rudolstadt princes, wea-
pons collection, museum of
Schwarzburg history, natu-
ral history collection, tem-
porary exhibitions, concerts

🕐 Tu–Su 10 am–6 pm
Last admission 5.30 pm
Closed on Mondays
Tel. (+49/0) 3672/42900
Fax (+49/0) 3672/429090

✂

P

DB Nürnberg–Leipzig

Schloss Heidecksburg
in Rudolstadt

The conversions and extensions at Schloss Heidecksburg in Rudolstadt, triggered when fire gutted the old building in 1735, reflected the new status of the Schwarzburg-Rudolstadt dynasty, raised to the highest nobility in 1710. The west wing was arranged in the late baroque fashion, with a magnificent banqueting hall at the centre, flanked on each side by a grand sequence of rooms. Prince Friedrich Anton initially appointed Saxony's chief architect Johann Christoph Knöffel to plan the building, but replaced him in 1743 with Gottfried Heinrich Krohne from the court at Weimar. The latter designed the stucco in the reception halls, skilfully carried out by Jean Baptiste Pedrozzi. The palace now houses the Heidecksburg Museum of Thuringia and the Rudolstadt Archives of the Thuringian government. It is also the headquarters of the heritage foundation *Thuringer Schlösser und Gärten*.

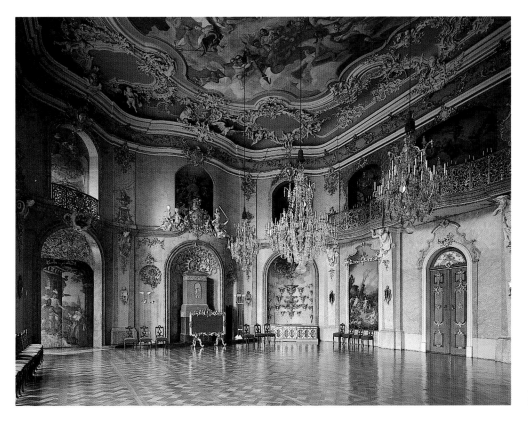

*Schloss Heidescksburg,
banqueting hall*

Stiftung Thüringer Schlösser und Gärten

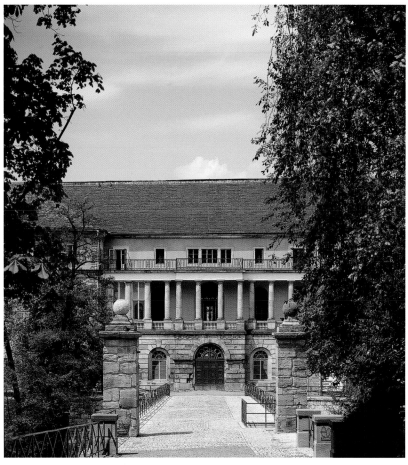

*Dukes' Residence in Weimar,
view from the east*

Dukes' Residence in Weimar

The "Residenzschloss" in Weimar was the seat of the Dukes of Saxe-Weimar. Its construction underwent a turbulent history which can be traced back to the early Middle Ages. The tower of the medieval castle was preserved to record those origins, with a baroque spire added in 1728. The Renaissance conversions by Conrad Krebs and Nikolaus Gromann are best illustrated by the former gatehouse, known as the "bastille". The palace itself, a four-wing complex not completed until the 20th century, principally owes its significance in art history to the structures contributed by Heinrich Gentz, including the stairs, the banqueting hall and the Falcon Gallery, all ranked among the finest specimens of neo-classical architecture in Germany. Their origins are inextricably associated with Johann Wolfgang von Goethe, who maintained a productive exchange with the architect as Chairman of the Palace Building Committee. The palace now houses the Weimar Art Collections and the offices of the *Stiftung Weimar Klassik*, devoted to preserving the town's Classical heritage.

i Information office
Residenzschloss Weimar
Burgplatz 4
D-99423 Weimar
Tel. (+49/0) 36 43/54 61 57
Fax (+49/0) 36 43/54 61 02

Weimar Art Collections
Permanent exhibition
Art Gallery and reception halls, temporary exhibitions, guided tours by arrangement

🕐 April–October,
Tu–Su 10 am–6 pm
November–March,
Tu–Su 10 am–4.30 pm
Tel. (+49/0) 36 43/54 61 30

P outside the Schloss

DB Halle–Erfurt
Jena–Erfurt

Dukes' Residence in Weimar, banqueting hall

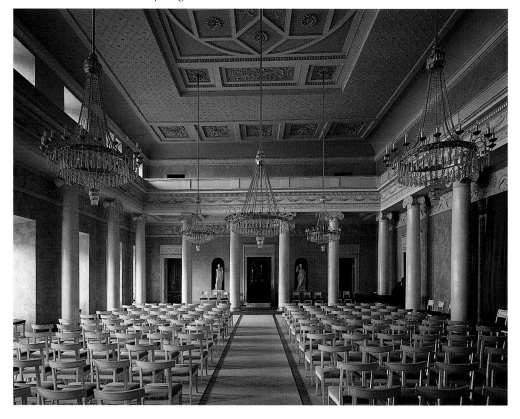

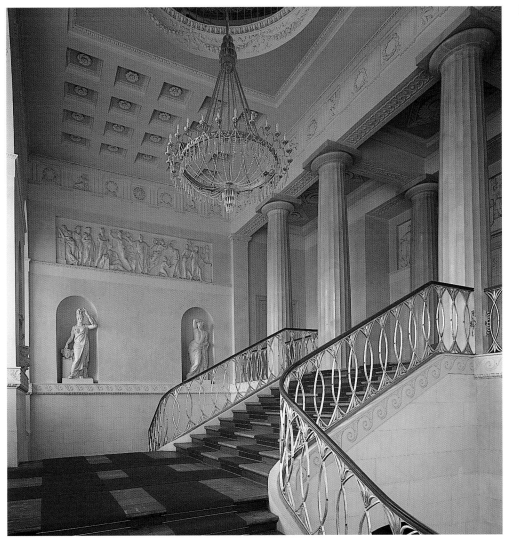

Dukes' Residence in Weimar, stairs

Wasserburg Kapellendorf

Moated castle

The buildings in the interior of the moun-
ted castle, which date back to the Count of
Kirchberg, were constructed on top of the
remains of a former wooden tower hill
castle in the 12th century. The preserved
kitchen and multi-storied lady's apart-
ments as well as the remains of the keep,
cistern and the living and banquet hall give
an impressive overview of the construction
history of the circular castle in the High
Middle Ages. After the town of Erfurt took
possession of it in 1348-1509 the castle
developed into the shape as we know it
today. Its exterior is mainly characterised
by the circular wall in the style of the late
Middle Ages which includes a gate and
keep tower. The buildings converted and
added in the time after the "Erfurt era" and
the Saxonian-Weimar times have left its
medieval appearance largely unchanged.

*Kapellendorf Castle with moat,
bridge and gate-tower*

i Information office
Wasserburg Kapellendorf
Am Burgplatz 1
D-99510 Kapellendorf
Tel./Fax 3 64 25 / 2 24 85

Castle Museum
⊘ Guided tours by
arrangement
Castle
daily 9 am–8 pm
Castle Museum
Wed–Fr 9–12 am, 1–5 pm
Sa–Su 10–12 am, 1–5 pm

P

🚌 Weimar–Jena

i Information office
Altes Schloss Dornburg
Max-Krehan-Strasse 1
D-07778 Dornburg
Tel. (+49/0) 3 64 27/2 25 30

🕐 construction in progress

DB Leipzig–Nürnberg

Old Castle, Dornburg

The three castles of Dornburg are perched on a towering cliff above the Saale Valley. The oldest of the three incorporates the masonry of the original Dornburg, a fort developed into a seasonal residence by the Ottonian Emperors from the 10th century. Renaissance conversions integrated the keep, initially a free-standing structure, and the medieval great hall, creating a three-wing complex. The three-storey south wing with its Knights' Hall was built on top of the old encircling wall.

Old Dornburg, view from the west

Ruined Abbey of Paulinzella

i Information office
Heidecksburg
Schloss Heidecksburg
D-07407 Rudolstadt
Tel./Fax 36 72/44 72 10

🕐 Abbey ruins freely accessible

P 200 m away in the village

DB Saalfeld–Erfurt

Ruined Abbey of Paulinzella

The former Benedictine monastery at Paulinzella, named after Paulina, the lady of noble Saxon birth who founded it, is ranked among the most striking Romanesque monuments in central Germany. The largely preserved 12th-century complex is regarded as a valuable specimen of architecture by the Hirsau School, with a formal stringency which sought clarity and simplicity in church-building. Listed in the 19th century, Paulinzella was one of the earliest monuments to benefit from preservation laws. Its dilapidated state at the time prompted a sentimental Romantic age to contemplate the transience of all things worldly.

Paulinzella Abbey Ruins, view from the south-east

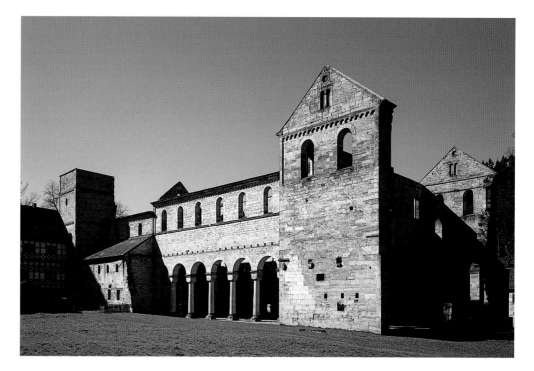

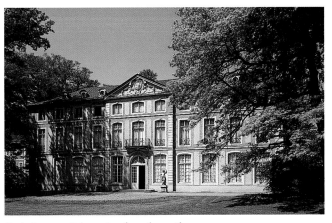

Greiz Summer Palace, view from the south

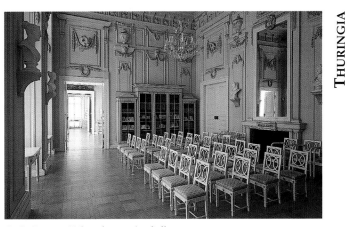

Greiz Summer Palace, banqueting hall

Greiz Summer Palace and Park

In the last third of the 18th century Heinrich XI, the lord of Thuringia's smallest principality Reuss Older Line, had a summer palace built which would serve him, as the gable inscription declares, as a "maison de belle retraite". The enlightened nobleman found the personal freedom here to pursue his own interests away from the burdens of court. Although it did not require the prestigious trappings of an official seat, the elegant architecture, derived entirely from clear proportions and the beauty of simple line, reflects the undoubted status of the owner. The exceptional architectural quality of the palace betrays some knowledge of contemporary thinking at the French Academy of Building, indicating that Heinrich XI was an educated and widely travelled patron. The garden, laid out at the same time, was the embryo of today's park, but did not begin to acquire its present form until 1873, when Carl Eduard Petzold, then Director of the Gardens at Muskau, was entrusted with the planning. The park at Greiz is one of the great accomplishments of 19th-century garden landscaping, setting up an interplay between its own generous expanse and the surrounding countryside, creating a variety of backcloths from individual trees and clusters, and guiding walkers skilfully between its attractions. The rooms of the summer palace now house a state collection of books and copper engravings along with the Satiricum.

i Greiz Tourist Information
Mr Zürnstein
Markt 12
D-07973 Greiz
Tel. (+49/0) 3661/703510
Fax (+49/0) 3661/703598

M State Collection of Books
and Copper Engravings
with Satiricum
Tel. (+49/0) 3661/70580
Fax (+49/0) 3661/705825
May–September

⊘ April–September
Tu–Su 10 am–5 pm
October–March
Tu–Su 10 am–4 pm
Closed on Mondays (except
at Easter and Whitsun) and
on 24, 25, 31 Dec and 1 Jan.
Guided tours by arrangement

Greiz Park
Tel. (+49/0) 3661/7030
Fax (+49/0) 3661/703598
Park tours by arrangement
Free public access

DB Gera–Weischlitz

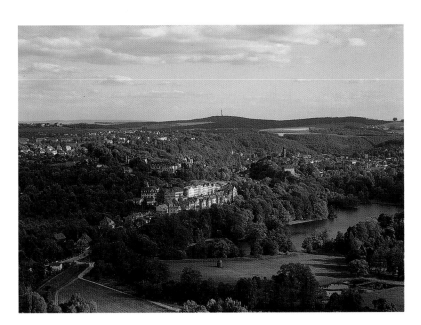

Greiz Park looking south

i Schlossverwaltung
Oberschloss Kranichfeld
Schlossberg 28
D-99448 Kranichfeld
Tel./Fax (+49/0)
3 64 50/3 04 60

🕐 Exhibition about the history
of the castle
Guided tours by appoint-
ment

May–October
Tu–Su 10 am–6 pm
November–April
Mo–Fr 10 am–3.45 pm

DB Weimar–Kranichfeld

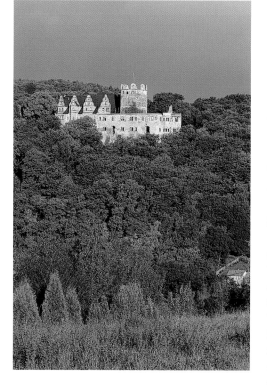

Oberschloss Kranichfeld

Castle

Kranichfeld castle, which is situated in an exposed position high above the valley of the river Ilm, represents a type of castle/manor-house which is particularly common in Thuringia. Whilst the core building with the living and banquet hall, castle chapel and keep is one of the leading buildings of the Romantic period in Thuringia, the outer facade already includes elements of the renaissance. The "Reußens" of Plauen converted the castle into a manor-house in the time between 1530 and 1550. Magnificent ornamental gables of the renaissance mediate between the fortified appearance as a castle and the new prestigious requirements of a stately home. A great part of the castle was destroyed by a fire in 1934. After restoration work to the brickwork, the ruined part now forms a picturesque counterpart to the building of the core castle.

Former monastery church St. Peter and Paul in Erfurt

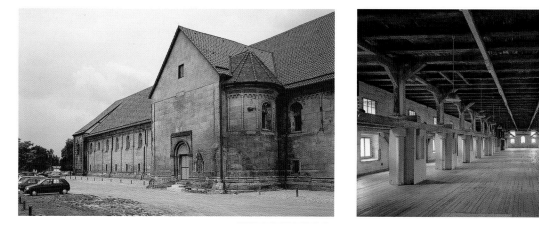

*The former monastery church
St. Peter and Paul.
On the left: view from South
On the right: upper floor*

i Schlossverwaltung
Stadt Erfurt
Kulturdirektion
Lowetscher Straße 42c
D-99089 Erfurt

🕐 Exhibition
Forum konkrete Kunst
Wed–Su 10 am–6 pm

DB Leipzig–Frankfurt

Former monastery church St. Peter and Paul in Erfurt

The historic roots of the monastery on the Petersberg hill in Erfurt date back to the year 706. Converted into a Benedictine monastery, it gained importance at a national level by adapting the Benedictine reform of the order, which started at the Suabian monastery in Hirsau. Work on the basilica in the style of the high Romantic era began in 1103. With its design, which is at the same time ascetic and monumental, it represents the reform spirit of Hirsau. This architectonic impulse from Erfurt had an effect on the whole of Thuringia. The building of the high Romantic era is therefore rightfully regarded to be one of the most important sacred buildings in the Romantic style in the whole of Germany. After the monastery was dissolved in 1803 it was converted to be used for a profane purpose - as a warehouse. Here architectonic changes accompanied by a re-use of the former monastery church in the 19th century provide an exemplary illustration for the profanation of sacred architecture often occurring in connection with secularisation. At present the former monastery church is used for exhibitions and events.

Ranis Castle

The elongated former ministerial castle of the empire, which rises up high, was first mentioned in 1199. Extensive parts of the main castle, including a chapel and ancillary buildings as well as the castle precincts, date back to the late period of the "Staufen" dynasty. After several changes of ownership the castle became the property of the sirs of Breitenbuch in 1571. They gave the castle a renaissance and palace-like character when they constructed the Southern wing: the well-proportioned ornamental gables on the side facing the town reveal the influence of Nikolaus Gromann, the most famous Thuringian renaissance master builder, who also carried out work on the "Residenzschloss" in Weimar and the castle in Heldburg. The impressive architectonic appearance of the castle crowns the townscape of Ranis.

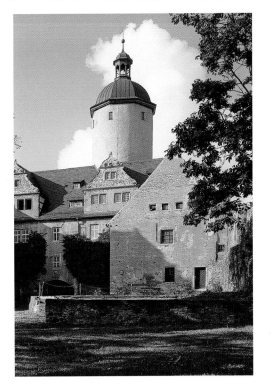

i Schlossverwaltung
 D-Burg Ranis
 07389 Ranis
 Tel./Fax 0 36 47/41 33 45

 Local heritage museum
 Exhibition about the history
 of the castle

🕐 May–October
 Tu–Su 10 am–5 pm
 November–April
 Tu–Fr 10 am–4 pm
 Sa/Su 1–4 pm

DB Saalfeld–Gera

Above: Ranis Castle, courtyard of the castle

Below: Ranis Castle, view from the South

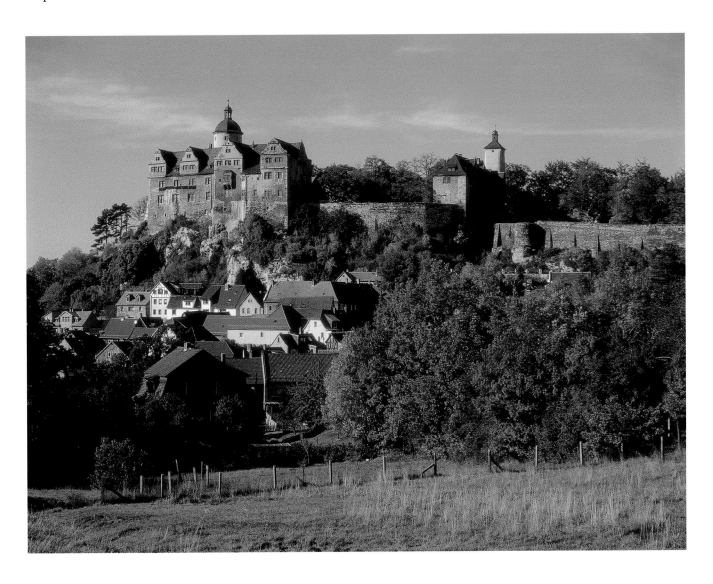

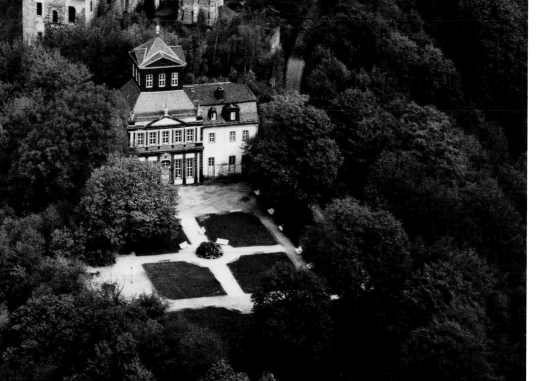

Schloss Schwarzburg, Aerial photograph from the south

Schloss Schwarzburg, Imperial hall building and parterre ▷

Manor-house

Schloss Schwarzburg rises on a picturesque hill of the North-Eastern Thuringian Forest, above the river Schwarza. Its predecessor was the former ancestral castle of the counts, and later princes of the empire, called von Schwarzburg, who in 1349 for a short time even included a Roman-German emperor, Gunther XXI. Schloss Schwarzenburg and its predecessor castle played a special role in the country's history. From the 16th century onwards, the castle was gradually converted to become the summer residence of the counts of Schwarzburg-Rudolstadt. Count Frederick Anthony took a catastrophic fire in 1726 as an opportunity to rebuild the castle. The late baroque building became a ruin due to building work to convert it into the guest-house of the German Foreign Office, which was begun in 1940 and later discontinued. The multi-storied, unique imperial hall building still bears witness to its former baroque splendour. The imperial hall with canvas paintings and medaillons of Roman kings and emperors was intended to support the dynastic claims of the Schwarzburg imperial princes.

ℹ Schlossverwaltung
Heidecksburg
Schloss Heidecksburg
D-07407 Rudolstadt
Tel./Fax (+49/0)
36 72/44 72 10

Thuringian State Museum
Heidecksburg Rudolstadt
Imperial hall with portraits
of Roman emperors

☉ March–October
daily 10 am–12 noon
1–5 pm
Tel. (+49/0) 3672/42900

DB Saalfeld–Katzhütte

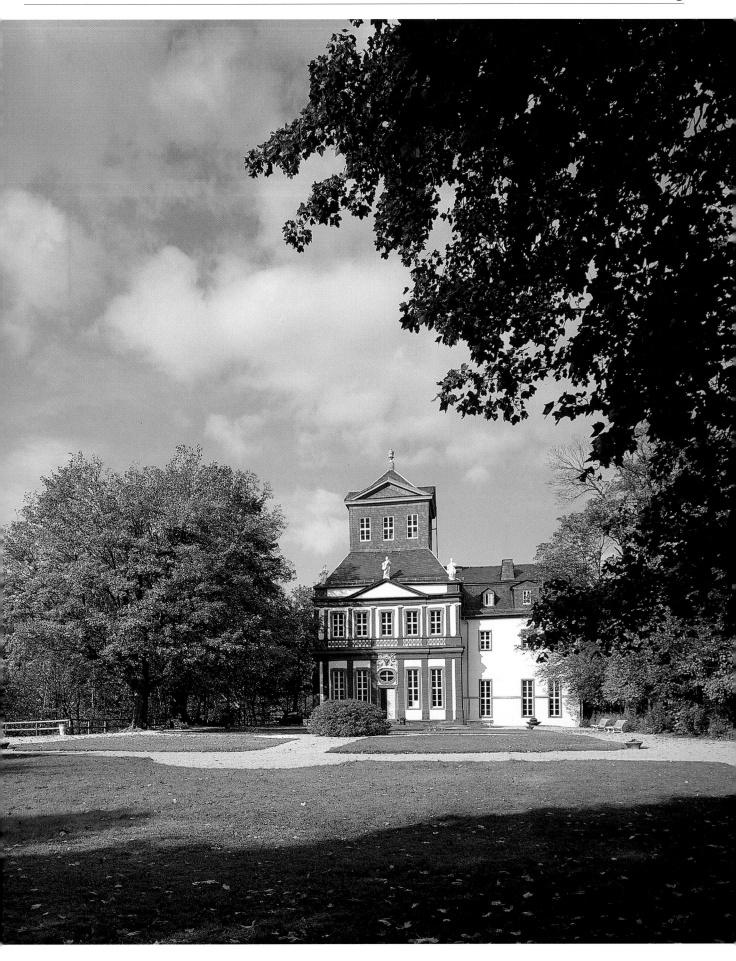

Stiftung Thüringer Schlösser und Gärten

Bad Liebenstein

Liebenstein Castle Ruins
D-36448 Bad Liebenstein
Tel. (+49/0) 3 69 61/36 10
Fax (+49/0) 3 69 61/3 61 20

Ehrenstein

Ehrenstein Castle Ruins
D-99326 Ehrenstein
Tel./Fax (+49/0) 36 29/81 26 76

Erfurt

SS. Peter and Paul Abbey Church
D-99084 Erfurt
Tel./Fax (+49/0) 3 61/73 57 42

Georgenthal

Georgenthal Abbey
D-99887 Georgenthal
Tel. (+49/0) 3 62 53/3 81 18
Fax (+49/0) 3 62 53/3 81 02

Göllingen

St Wigbert Abbey Ruins
D-06567 Göllingen
Tel./Fax (+49/0) 3 46 71/7 96 21

Henneberg

Henneberg Castle Ruins
D-98617 Henneberg
Tel. (+49/0) 3 69 45/5 01 78

Kranichfeld

Oberschloss Kranichfeld
D-99448 Kranichfeld
Tel./Fax (+49/0) 3 64 50/3 04 60

Lauchröden

Brandenburg Castle Ruins
D-99819 Lauchröden
Tel. (+49/0) 36 91/25 81 36
Fax (+49/0) 36 91/25 82 99

Liebenstein/Ilm District

Liebenstein Castle Ruins
D-99330 Liebenstein/Ilmkreis
Tel./Fax (+49/0) 3 62 05/9 50 91

Ranis

Ranis Castle
D-07389 Ranis
Tel./Fax (+49/0) 36 47/41 39 71

Schwarzburg

Schloss Schwarzburg
D-07427 Schwarzburg
Tel./Fax (+49/0) 36 72/44 72 10

Weimar

Grand Duchy Museum
D-99423 Weimar
Tel. (+49/0) 36 43/54 60
Fax (+49/0) 36 43/54 61 01

Wünschendorf

Mildenfurth Abbey
D-07570 Wünschendorf
Tel. (+49/0) 3 66 03/8 82 45
Fax (+49/0) 3 66 03/8 82 46

Source of Illustrations:

Constantin Beyer, Weimar: p. 235, 237, 238, 239 top, 240, 241, 242, 243, 244, 245, 246, 247, 248 top, 249 top right, 249 bottom, 250, 251, 253
Lehmann + Partner, Schmerbach: map p. 236

Jürgen M. Pietsch, Spröda: p. 248, 249 top left
Thüringisches Landesamt für Denkmalpflege, Erfurt, p. 239 bottom, 252

Index

Addresses

Staatliche Schlösser und Gärten Baden-Württemberg
Baden
Oberfinanzdirektion Karlsruhe
Moltkestraße 50
76133 Karlsruhe
Tel. (+49/0) 721/926-0
Fax (+49/0) 721/926-6570

Württemberg
Oberfinanzdirektion Stuttgart
PO box 103641
70031 Stuttgart
Tel. (+49/0) 711/6673-0
Fax (+49/0) 711/6673-3534

Bayerische Verwaltung der Staatlichen Schlösser Gärten und Seen
Schloss Nymphenburg, Eingang 16
80638 München
Tel. (+49/0) 89/17908-0
Fax (+49/0) 89/17908-154

Stiftung Preussische Schlösser und Gärten Berlin Brandenburg
PO box 601462
14414 Potsdam
Tel. (+49/0) 331/9694-0
Fax (+49/0) 331/9694-106

Kulturstiftung Dessau Wörlitz
Schloss Großkühnau
06846 Dessau
Tel. (+49/0) 340/64615-0
Fax (+49/0) 340/64615-10
http://home.t-online.de/home/ksdw

Verwaltung der Staatlichen Schlösser und Gärten Hessen
Schloss
61348 Bad Homburg v.d. Höhe
Tel. (+49/0) 6172/9292-00
Fax (+49/0) 6172/9292-190

Rheinland Pfalz
Burgen, Schlösser, Altertümer
Festung Ehrenbreitstein
56077 Koblenz
Tel. (+49/0) 261/97424-0
Fax (+49/0) 261/97424-50

Sächsische Schlösserverwaltung im Landesamt für Finanzen
Stauffenbergallee 2
01099 Dresden
Tel. (+49/0) 351/8274602
Fax (+49/0) 351/8274602
www.sachsen.de/schloesser

Stiftung Schlösser Burgen und Gärten des Landes Sachsen-Anhalt
Schloss Leitzkau
39279 Leitzkau
Tel. (+49/0) 39241/9340
Fax (+49/0) 39241/93434
www.kulturserver.de/home/ssbg

Stiftung Thüringer Schlösser und Gärten
Postfach 100142
07391 Rudolstadt
Tel. (+49/0) 3672/447-0
Fax (+49/0) 372/447-119
www.Thueringen.de/schloesser